ESSENTIAL ART HISTORY

ESSENTIAL ART HISTORY

PAUL DURO
and
MICHAEL GREENHALGH

BLOOMSBURY

This paperback edition first published in 1994
by Bloomsbury Publishing Plc
2 Soho Square, London W1V 5DE

The moral right of the authors has been asserted.

Cover illustration: detail from *Venus and Mars* by
Sandro Botticelli, by courtesy of The Bridgeman Art Library

A copy of the CIP entry for this book
is available from the British Library.

ISBN 0 7475 1585 9

10 9 8 7 6 5 4 3 2 1

Designed by Elizabeth Pitman
Typeset by Hewer Text Composition Services, Edinburgh
Printed in Britain by Cox & Wyman Ltd, Reading, Berks

CONTENTS

INTRODUCTION

WHAT IS ART HISTORY?

The alphabetical section of this book is designed to offer access to the discipline of art history through a series of headings, so that the reader may seek guidance on topics ranging from the > Antique to > Post-Modernism, > Romanticism to > Performance Art. In this Introduction we set the scene by surveying what art history is, where it has come from, what it is doing now, and where it might be going in the future.

Art history studies the development of and changes in visual culture through history, and seeks to understand its application within different societies. We have used the term 'visual culture' here because the very word 'art' is contentious. A painting by Raphael is certainly 'art', and so is the work of the > pop-artist Roy Lichtenstein; but what about the comic books from which the latter derives his imagery? Fifty years ago the discipline would have been clear about its answer: comics, as well as advertising material, > photography, film and the > decorative arts, were not the concern of the 'real' art historian, because fine – not applied – art was the proper material for consideration. Painting, sculpture, > architecture and > prints were produced for a limited group of people whose shared backgrounds of wealth and education contributed to their similar world-view.

Today, however, there exists a growing interest not only in different constructions of the past in terms of art history, but also in the decorative arts and non-European art. Most crucially, there is an increasing recognition that splitting art into 'high' and 'low' is artificial, culturally determined and prejudicial to the understanding of any society in any country. Art historians, whether university or polytechnic lecturers, museum > curators, researchers, independent scholars or students, have in recent years debated the question of the limits, function and direction of the discipline. These debates have touched on both the content of art history and what we might call its ideological complexion, and have focused interest on the once neglected 'minor' arts. These have now found their own forum within art history, and although this has brought in its wake a loss of certainty about the traditional values of art history, the discipline has benefited from their inclusion, not least because they have introduced new > methodologies to place alongside the mainstream approaches to the discipline such as > connoisseurship, > formalism, > iconography and social history (> Marxist art history).

From 'Old Master' paintings in the great galleries to the newest > computer-generated graphics of 'virtual reality', the number and variety of images continue to multiply. Hence any redefinition of the subject today would need to acknowledge that art history is concerned with the analysis and discussion of visual images from all periods and places. Traditionally this has tended to mean the situating of a visual examination of the art work – be it sculpture, painting, building or > artefact – in a historical, social and cultural context. But as the inclusion of, for example, film or

1

advertising within the province of art history suggests, these new areas of subject-matter have engendered new problems of interpretation. The answer has been found in the deployment of methodologies more familiar to other disciplines. Thus methodologies appropriate to the analysis of the visual presentation of a narrative sequence in a film may have been borrowed from the field of literary criticism – for example, > structuralism and > semiology – which were in turn borrowed by literary criticism from the social sciences, linguistics and anthropology.

But how can we know about the past? Information on the art of the past provides the building blocks of the discipline and, like bricks, these blocks can be solid and durable. Nevertheless, they must be treated carefully. There is no such thing as a self-evident 'fact', because no fact is inviolable or beyond question, although some may seem so for a short period of time. However, the alternative attitude of 'all history is fiction' is inaccurate, misleading and intellectually lazy, and anyone adopting it must rely on personal opinion or be under the influence of some current ideology. A characteristic of facts is that, like bricks, they may be assembled into many different patterns and structures. Although individual facts can be remarkably friable if they are expected to bear the whole weight of the argument, when successfully arranged into a coherent structure they can offer us a coherent picture of the past. The crucial point to remember is that, like bricks, facts can be rearranged to draw different conclusions from the same material.

The question is rather more frightening when considered in the abstract than when sensibly borne in mind by the intelligent historian. We should never, of course, expect objectivity, even from ourselves. The incantation 'I am objective; you are misled; she wilfully misinterprets the evidence' should give pause for thought. Rather than fighting to maintain a judgement that may no longer seem adequate, reasonable, appropriate or pertinent, we would be better off recognizing that within a dynamic discipline the potential, indeed need, to change is part of its structure. Far from being a dry-as-dust academic pursuit, art history has the potential to intervene in important debates concerning the role and value of culture in our late-twentieth-century society.

High/low, fine/applied, methodology versus fact, cultural determinism – these, then, are the issues that now confront art historians. To embrace art history adequately today means not only to range across the ever-widening terrain occupied by the subject, but also to understand the various approaches that provide new tools for the analysis of an enlarged discipline.

THE HISTORY OF ART HISTORY

Current art-historical practice implements many of the approaches developed by earlier generations, and most art historians, irrespective of their choice of methodology, regard them as central to their work. These include biography, connoisseurship, the *catalogue raisonné* (> catalogues), formalism, iconography and the social history of art.

The practice of art history, if by that we mean no more than writing and speaking about paintings and sculpture, may be found in almost every period from antiquity onwards. Giorgio >Vasari is sometimes said to have founded art history in the sixteenth century, although some might give that honour to Pliny, one of ancient Rome's polymaths who wrote on art in his *Natural History*, or to Lorenzo >Ghiberti, whose *Commentaries* contains notes on fellow artists and is the first autobiography written by an

artist to have survived. The choice of Vasari as the founder of the discipline rests on his monumental book on > Renaissance art and artists, *The Lives of the Most Excellent Italian Architects, Painters and Sculptors* (1550). It is to Vasari that we owe the idea that what we witness in the development of Renaissance art is a progression from good to better to best. Vasari's pattern is close to the biological cycle of birth, youth, maturity and death: the rebirth of art after the darkness (to him) of the Middle Ages, the stumbling inventions of Giotto and his contemporaries, the youthful vigour of the > quattrocento, come to rest finally with the triumph of the High Renaissance itself, personified by Michelangelo. Much more dangerous than any of his inaccuracies and misstatements, however, is the idea that art progresses towards perfection. This tends not only to devalue the individual art work (which becomes a mere cog in the juggernaut of history), but also to present it as a striving away from something the author undervalues (> Gothic art, > mediaeval darkness) towards something at which the present generation can only guess. Art as process rather than product can therefore seem mechanistic; everything is made to fit a pattern.

It is a testimony to the success of Vasari's model of history that many art historians still place the Renaissance at the centre of the art-historical universe. The idea of progress, the view that an art work and its creator should be judged historically, the idea of influence, whereby the stylistic traits of an individual or > school may be traced through successive generations, these are all hallmarks of Vasari's methodology that remain current. We know, and can prove, that he is annoyingly inaccurate in some areas, and we may suspect that there are many other inaccuracies we cannot uncover; nevertheless, his book provides the largest body of 'fact' we have for this period. Of course, his account is no more objective than any other, for his aim was to promote his own age and the artists he prized (especially Michelangelo and the Florentines) over those of earlier centuries.

Many of the ideas and aspirations of the Renaissance (and of theorist-practitioners such as Ghiberti, > Alberti and Vasari) were formalized by the development of > academies, first in Italy, then in France (1648), Germany and the Low Countries, but only later (1768) in England. Handbooks and treatises were written which explained theories of art, offered advice on practice, and reinforced the hierarchy of > genres. Art was considered an intellectual pursuit, and as such could be prescribed and then learned. Such codification suited the authoritarian tendencies of the seventeenth century, and tended to generate a certain uniformity in art and architecture, a > Classicism that served the political and social purposes of absolutism. For example, Giovanni Pietro Bellori (1615–96) wrote biographies in the Vasarian manner, and in his writings supported the attainments of the High Renaissance as a model for contemporary art. This confirmation of the crucial role of the ideal (> idealism) in art was adopted by > Lebrun and the French Academy, which, by championing the manner of Poussin, dictated the complexion of artistic training to the end of the nineteenth century. Some theorists did point to the importance of artistic traditions that diverged from the Roman and Classical ideal, with its emphasis on > *disegno* rather than *colore*. One such was Roger de > Piles, who constructed 'league tables' that accorded points to artists under a variety of headings, underlining the importance of > colour and championing the alternative tradition of > Rubens.

Many of the techniques of the subject common today were elaborated by the German scholar > Winckelmann and others in the later eighteenth century. Most important of these was the development of a methodology for dating and attributing (> attribution)

art works. What previous generations had lacked was a sense of historical perspective, which meant that they tended to lump art works together in an undifferentiated, ahistorical mass. Vasari, for example, is clear about the importance of the > antique, but unable to differentiate clearly works produced over the course of nearly a millennium. In his influential book *Reflections on the Painting and Sculpture of the Greeks*, first published in 1755, Winckelmann recognized that the art of antiquity was the product of a particular time and place, and attempted to produce order out of chaos by providing a historical framework and attributing works within it. It is ironic, however, that this early champion of > Greek art never went to Greece (despite several opportunities), and erected his stylistic categories on the basis of Roman copies available in Europe. Winckelmann's works, together with his promotion of the painter Anton Raffael Mengs, provided an essential theoretical foundation for both the further development of the discipline of art history and for the intellectual horizons of > Neoclassicism. For example, his ideas influenced Sir Joshua > Reynolds, whose *Discourses* (delivered between 1769 and 1790) exemplify eighteenth-century attempts to reconcile ideal > beauty and > nature.

Why were such ideas and trends so influential? Because in the eighteenth century a new interest in the study of history developed. Two important factors in the high profile granted to historical studies of all kinds were the twin beliefs that lessons learned from the past would be applicable to the present, and that the civilizations of Greece and Rome were to be imitated and if possible equalled. This was also the case with art, the rationale behind much art school training, as well as the background to the continuing imitation of the antique in the Neoclassical period. Not everyone was chained to the antique, however, because such voluntary enslavement ran counter to the concept of progress by which the great inventions of the modern world (from distillation to the mechanization of agriculture and industry) might be explained. In literature, but especially in art, the focus on apparent contemporary progress was the subject-matter of the > quarrel of the ancients and moderns between believers and non-believers in the superiority of the antique. In such a context, history and the history of art were important. Far from being mere academic pursuits, they were studied because scholars, artists and politicians understood that the past could teach the present, and help to control it.

During the eighteenth and nineteenth centuries, the authority of the past was seen as a way of bolstering national identities and origins. This was signalled by the appearance of encyclopaedic works in all European languages and in many areas of knowledge, from the law and natural history to science and the arts. > Diderot's > *Encyclopédie* encompasses all these subjects, and its attempt to systematize knowledge is indicative of a new way of looking at the past. For art, this meant the gradual disappearance of the > cabinet of curiosities (with its catch-all approach to collecting) in favour of the > museum, which, whether public or private, would be stocked by making more and more collections of art works. Travel for education – the > Grand Tour – both fuelled and diffused the thirst for art works, and travel further afield – to Greece, Asia Minor and > Egypt – brought new objects and new systems of art to be understood and assimilated.

These eighteenth- and early nineteenth-century developments were the work of Northern Europeans, from Winckelmann, Joshua Reynolds and > Goethe to > Hegel and > Kant, urged on by their perceived artistic inferiority towards southern lands. Recognizing in Greece and Rome the primary roots of their own culture, they were at pains both to assimilate and to equal it, not least by collecting specimens of the art of

the South and by imitating its architecture in their own buildings. By the end of the eighteenth century a growing nationalism put the same historical tools to use in resurrecting their own past, so that > revivalism produced not just imitations of Greece, Rome and the Renaissance, but also of the Gothic and then the > Romanesque. We might say that art history was, along with the study of literature, one of the main tools used to explore national identities.

The nineteenth-century engagement with both kinds of > historicism typified this change from a generalized sense of antiquity to specific national identities. Unlike the eighteenth century, the involvement with the past of most art theorists and practitioners of this period served not as a focus for the concerns of the present (as had conspicuously been the case with the work of David during the French Revolution) but, weakly, to evoke a nostalgia for the past. (> Marx's view of history, on the other hand, was prescriptive rather than nostalgic.) So strong was historicism that its exponents wished to turn their backs upon the newly industrialized present in favour of a Utopian vision of the past. Inevitably this was a mediaeval past: John > Ruskin's aesthetic philosophy presented the case for rejecting the classical tradition in favour of an alternative northern tradition that stretched from the Gothic to the Romantic.

ART HISTORY IN OUR CENTURY

The rise of academic art history is a feature of the twentieth century, and was built upon the methodological work of historians including Michelet and Ranke, philosophers such as Kant and Hegel, and aestheticians such as > Pater. It began its rise to popularity in German-speaking countries, and its debt to 'straight' history is evident in the work of > Burckhardt, whose enormously popular work on the Italian Renaissance is a cultural rather than a strictly artistic history, where he was writing about the concerns of his own century in his ideal vision of the Renaissance. > Wölfflin was Burckhardt's pupil and successor at the university of Basle, and we can recognize his *Principles of Art History* (1915), focusing as it does on questions of stylistic development, as the first modern book in our discipline. Indeed, both men attempted to put a degree of intellectual rigour into the study of art and culture through the analysis of the stylistic characteristics of schools and periods known as formalism. Formalism flourished in the early part of the present century and may be thought of as 'art history without names' – a salutary corrective to the obsessive interest in authenticity and individuality of the connoisseurs, who labelled anything they were unable to identify positively as 'after', 'school of', or a > forgery. Formalism, on the other hand, would treat the characteristic appearance of > Baroque painting, for example, as an expression of the Baroque 'way of seeing'.

The origins of modern art history have been concerned with the identification of the art work as the product of a particular artist, school or period, and if possible with establishing the precise time of its making, for whom it was made, why, and what has happened to it from that date to the present. This approach is for the public, and indeed for many art historians, what art history is all about, and periodically we see paraded on television for our edification an art historian, perhaps an expert on mediaeval manuscripts or the work of Painter X, who has been called on to pronounce on the authenticity of a recent find at some rural auction. This work is known as connoisseurship, and the expert in question may not be interested in the broad

development of the arts, but only in establishing the chronology of Painter X's > *œuvre*, taking an interest in history merely as the means to better understanding Painter X. Of course, the work accomplished by such scholars in the earlier part of the present century, when much of this work was done, is of the highest value and a necessary part of the knowledge we need to develop more modern approaches to our discipline. The problems begin when connoisseurship takes over from history as the core of the study of art, or when we allow ourselves to believe that connoisseurship – an approach based on the personal study and intuition of one very specialized individual – is as infallible as a papal bull.

These questions should alert us to another central concern – that of quality. There is a great deal of debate amongst art historians over this issue because of the ways in which the concept of quality can be defined. The whole methodology of connoisseurship is based on proving that a given painting is by a particular artist, that its intrinsic qualities – the skilful way the paint is put on, the intelligence of the > composition, the sense of authority emanating from it – mean it cannot be by a follower or forger. The problem here is that the terms of the debate are chosen to siphon off a tiny number of significant pictures and occlude the vast reservoir of images that constitute, just as much as the > masterpiece, the history of art. This is close to saying that 'everybody knows the *Mona Lisa* is a great painting'. Although the writers of this introduction firmly believe it is, the problem seems to be that we have accepted as a 'fact' the truth of the statement without sufficient historical investigation. Do we think the *Mona Lisa* great because it is a magnificently perceptive portrait of a Renaissance lady by an artist at the height of his powers, or because we see the image endlessly reproduced and held up as an example of 'great art', the most famous painting in the world and so valuable no price can be put on it? Expressed this way, the arguments employed by connoisseurs to 'prove' the worth of a painting begin to look rather circular.

The expansion of the discipline and hence its popularity as an academic subject was partly a result of the great diaspora of the 1930s and after, when refugee-scholars such as > Saxl, > Warburg, > Panofsky and > Gombrich emigrated to the United Kingdom and the United States. These four scholars countered Wölfflin's overt formalism by concentrating on the subject-matter (> iconography) of art works, elucidating them within a specifically historical context. Iconography focuses on the content of the images, studying, for example, the > symbolism of flowers, or the > attributes of saints. When done well, such as in Panofsky's *Early Netherlandish Painting* (1953), the approach offers a fascinating account of the interaction between the different branches of the humanities. But the very means of the approach may also be a problem. What is missing from Panofsky is a discussion of the essential properties of the art work, what makes it art in the first place. We are given instead an erudite account of humanism in its golden age, with copious notes and scholarly asides, all of which serve to place the work in its intellectual milieu, yet which also push it away from the kind of concerns many historians feel to be relevant to the study of visual imagery.

One approach that seems to offer some of the answers to these problems is that of social history. Art exists in society, and the context forms and affects the product in a variety of ways. If earlier art historians were generally content to place the art work on a pedestal, the general movement over the past quarter-century has been towards a greater sensitivity to the context. The result is that the 'great masterpieces' approach has failed in the face of a 'contextual' one that questions the very concept of a masterpiece. In place of this, issues such as social status, patronage, the influence of

> popular culture on painting and sculpture, the social conditions pertaining at a given time and place, all serve to place the art work historically. Thus John > Berger in *Ways of Seeing* (1972) has argued that what is central to understanding a painting like Gainsborough's *Mr and Mrs Andrews* (1749) is that the two sitters, shown against a bucolic landscape, are the owners of the property, and that instead of seeing the painting as a proto-Romantic expression of humanity's oneness with nature, one should see first and foremost a landowner and his lady enjoying the fruits of their wealth.

Unsurprisingly, Berger's approach has elicited bellows of rage from incensed conservative art historians for the way he interposes squalid reality in front of this rural idyll, marring our enjoyment of a very good painting. These critics of Berger, however, have signally failed to justify why they think his remarks are out of order, or how the picture is damaged. As Marcia Pointon has remarked in her introduction to art history, *History of Art: A Students' Handbook* (1980), 'This view is a bit like the notion that knowing the ingredients of a recipe, recognizing the method of cooking and seeing the utensils used detracts from the taste of the dish.' The point, of course, is that politics have a part in art-historical analysis, in understanding both the tensions built into the art work, and our reactions to it.

A problem with the social history of art is that in the hands of some practitioners it has become a crude form of Marxism, in which the art work is 'explained' as the reflection of a given society. Thus Dutch seventeenth-century interiors are said to be about the representation of bourgeois notions of comfort. These paintings are not 'about' any such thing. They are participating in a tradition of representation that stretches from > Early Netherlandish painting to nineteenth-century English landscape painting. Certainly money, class, status and power are all written into them, but the meaning of an individual art work will continually flee such a reductive analysis.

There is another approach to append here that reflects what its practitioners believe to be an unwarranted bias in the interpretation of art history, especially by the Modernists. > Revisionism, as its name suggests, seeks to revise the > canon, not to overthrow it. It has come about principally in the work of historians of the nineteenth century who believe, quite possibly with justification, that Modernist interpretations of the period are selective and ignore artists of great importance to our understanding of the period, such as Thomas Couture and Jean-Léon Gérôme. These painters were hugely successful or famous in their own day and certainly deserving of study if we are to have a balanced view of the period. Unfortunately, too many revisionists appear to assume that *because* the Modernists have ignored these artists, they must be important. As this introduction has no doubt made clear by now, art history is a construction, and artists are included in its account because their work has proved, either in its own time or since its own time (or often both), to be critical for the telling of that account. They do not become important by virtue of being left out. Nevertheless, much revisionism, such as the work of Francis Haskell or Albert Boime, has provided a valuable corrective to rather complacent accounts of the development of modern painting.

There are two further points to make about the various methods of art history. The first is that these approaches are rarely employed without recourse to other, rival approaches. For example, even the most dyed-in-the-wool formalist tends to rely on the scholarship of the connoisseur, and will take it as read that a particular painting or sculpture is indeed a work of the Renaissance, just as the social historian will borrow data from the iconographer to show that in *The Ambassadors* (1533) temporal as well as intellectual power is written into Holbein's depiction of two powerful diplomats whose

learning and wealth are paraded through a range of symbols and attributes. The second point is that this brief survey has not dealt with all the many approaches to art history. The next section will introduce us to some of the most popular, and contentious, ways of studying art current today. But we should remember that no survey can adequately cover all the different methods of thinking about art. Every art historian works slightly differently, and as a creative pursuit, art history needs and welcomes this diversity.

THE DISCIPLINE TODAY

In the view of some, the discipline of art history is currently in crisis, or, to put it more neutrally, in a state of flux. Some of its practitioners seem subversive, but this is only natural; since new, bold and often strongly phrased approaches must always rely for their effect upon attacking the citadel of orthodoxy, and they increase their impact according to the strength of the assault. The alarm bells have been heard in print and at conferences for nearly a decade, as can be judged from such book titles as Donald Preziosi's *Rethinking Art History*, or Hans Belting's *The End of the History of Art?* Cynics will remind us that just as disasters sell newspapers, so the scent of bad blood, contention and unsavoury revelation will sell books. Realists will point out that the discipline is indeed not stable, not least because its younger members seem content to destroy past approaches without having anything solid to put in their place.

Belting describes a 'loss of faith in a great and compelling narrative, in the way that things must be seen', the absence of any consensus about what art history is and what it should be doing, as the present bugbear of the discipline. Although his book is by no means as doom-laden as its title suggests, he nevertheless questions the continuation of the discipline because of the twin possibilities that 'contemporary art indeed manifests an awareness of a history of art but no longer carries it forward; and that the academic discipline of art history no longer disposes of a compelling model of historical treatment'. But, in a plea for plurality of approach, he returns at the end of his essay to the balanced position where there can no longer be any one coherent method of study, as there was in the past, concluding that 'The object of study (the "work" in the old sense) is not expected to testify to a general system of representation – such as "history", "art", or the "history of art" – but rather to disclose its own particular truth or message, and always according to what the historian is asking of it'.

But we should always remember that crises are the very stuff of academic dialogue, and disagreement in art history is as common as it is in any other subject. Agreement is, after all, very boring, and suggests not only complacency but the monolithic approach to which we have already referred. What is more, destroying preconceptions can often be fun, as John Barrell's *The Dark Side of the Landscape* (1980) makes clear. In this respect, the disciplines of > archaeology and anthropology have had much to offer art historians, because both study humanity in a societal context, and both have developed strong methodologies of their own that throw into relief the relative poverty of art history. No archaeologist today would claim that a gold face mask was necessarily more 'important' than the contents of a corpse's stomach, and perhaps art historians have something to learn from both the range and the apparent neutrality of such an approach. Indeed, it may be argued that art history, in the face of such strongly theoretical disciplines, has felt insecure by comparison, and is now developing its own corpus of theory alongside its existing empirical methodologies.

One trend in archaeology has found its parallel in art history, and that is an increased focus on theoretical approaches borrowed from other disciplines. Archaeology has borrowed extensively from systems theory, from sociology and anthropology, and from various branches of mathematics, especially statistics. In art history, theoretical concerns have also been bulking ever larger over the past decade, to such an extent that it is easy to feel naked unless clothed by at least one 'theoretical' garment. At this point the more conservative art historian begins to contemplate the conundrum of the chicken and the egg. Should an examination of the data precede the formulation of a theory, or should the data be examined through 'theoretical spectacles', which may permit other kinds of insight, but which run the risk of ignoring the data? For those with a touching faith in their own objectivity, and remembering Ranke's dictum that historians should rebuild the past 'to show things as they really were', data should be examined without preconceptions. However, the appearance of a new series of art-historical studies entitled *Cambridge New Art History and Criticism* is perhaps intended to emphasize the *renovatio* of the empire of art history, and to suggest that the discipline is ready to embrace theory.

An important prerequisite for these new approaches is the demotion of the artist in the making of the art work. Formerly, the artist was interrogated in order to discover the 'meaning' of the art work. What he or she did, thought, looked like, ate, how that individual lived, where, with whom, for how long, what his or her sexual preferences were, were all seen as the means of reaching the central meaning of the art work. But the problem remained of who is to decide which of these factors was influential in the making of the art work, and to what extent? Most famously, > Freud himself set a precedent for this kind of approach in a celebrated study of > Leonardo in which he attempted to 'analyse' a dead patient. Obviously there are problems here, and those who aspire towards scientific rigour might justifiably point out that the analyst needs to listen to *how* the patient relates his or her life in order to grasp the truth. But as Freud himself has been accused of not paying attention to how the story is told, listening only to what is said, then it is perhaps unreasonable to criticize art historians for doing the same thing. The psychological approach does have the advantage of considering the individual rather than an abstract concept such as society. But the residual problem is that the unconscious replaces 'social production' as the determinant of identity – the psychological equivalent of vulgar Marxism.

Against this, the critique of authorship and the focus on the artist as individual owes much to the French critical theorists Roland Barthes and Michel Foucault, who questioned the central importance we give to the artist. While no one doubts that it is the artist who makes the art work, the question remains as to what extent the artist is inventing the art work, or, in Barthes' famous dictum, how much she or he is employing the 'already written'. While we may naïvely believe that we can think original thoughts, or that a sculptor can make an > original (in the sense of conceptually different) sculpture, in reality the thought or sculpture is an assemblage of already existent images, ideas and values that are the true source of what we think or do.

The demotion of the artist has been echoed by a corresponding rise in the status accorded to the observer. This approach presents some dangerous challenges to the orthodoxies by forcing them to redefine the relationship of the art work with its context, most crucially in the ways in which the interpretation of that work depends upon the viewer. > Reception aesthetics, as it is known, assumes that much of what a picture 'means' is not exclusively the result of the artist's thoughts, but is equally a

construction of what we as > beholders believe it to mean. Under this dispensation, a writer or a critic 'is not the privileged interpreter of his own text' (David Carrier, *Principles of Art History Writing* (1991)). Taken to extremes, the belief that the viewer 'constructs' the art work afresh is profoundly anti-historical, because it robs the work of its historical context and clothes it instead with the anarchy of the viewer's interpretation. It is therefore important to recognize that we all have our own agendas and beliefs. This point becomes central when we consider that an audience (a collective noun) is always assumed to be homogeneous, that all those with 'taste' and intelligence will appreciate the same art works. But this idea of a canon fails to take into account different ideological and aesthetic points of view. For example, it is unlikely that the feminist Germaine Greer, who has written a celebrated book on women in art, *The Obstacle Race* (1979), would have the same view of the representation of women in art as Emperor Napoleon III, who had a particular liking for ample nudes.

Also associated with the loss of faith in the pivotal role of the artist has been the rise to prominence of the study of the structure of an art work as the key to its meaning. Central among this approach to art history is semiology, the study of signs. Signs are not restricted to 'high' art but may be as profitably studied in car stickers and soft-drink cans as in Velásquez. Far from being initially driven by the art work itself, the practitioners of semiotics have borrowed both their approach and their terminology from literary criticism, conscious, perhaps, that art history was lagging behind in methodologies appropriate to the expanding interests of the discipline.

But semiology should not be confused with formalism. Whereas in the latter the art work is independent of human intervention, semiology operates within the domain of the social. It originated in the field of linguistics, especially in the work of Ferdinand de Saussure, who argued that signs are grouped into systems that allow for the expression of meaning. Saussure was of course talking about language, but it is not hard to imagine how one could construct a similar system for visual signs. Furthermore, it is the relationship between signs that allows for the chains of meaning we 'read', whether the words on this page, or visual imagery. The comic book is, of course, a particularly clear example of a visual sign system most often, but not always, accompanied by a text. While it may be argued that most pictures do not have words attached (> Cubist paintings are an exception), most galleries do in fact provide a form of narrative in both labels and complementary verbal information, as well as in the 'signifying system' of the presentation – chronological, thematic, etc.

Thus semiotics shows us not that form in art is a question of shapes, significant or otherwise, but that representations always tend towards the construction of meaning via the system. Hence it is possible to see the proliferation of semiotics throughout the humanities and the social sciences, embracing signifying systems of everything, from codes of conduct to road signs. The difficulty remains, of course, in the question of what creates the significance of an art work. Can an art work be a collection of visual signifiers, as found in advertising or housepainting? Pillar boxes are red in England and yellow in France, for example, but that does not make these conventions aesthetically significant. In other words, what makes 'art' in this system? It is questions such as this that have led to a lessening of confidence in semiotics, although it remains, especially in the area of film and media studies, a very persuasive model. Most recently it has furthered interest in what is known as > post-structuralism, or more specifically > deconstruction, the critique of the certainty of the 'structures', such as sign systems, we have just been discussing.

Neither post-structuralism nor deconstruction is properly speaking a methodology, but rather a critical insight into the danger of placing too much emphasis on method. The question of what a given art work 'says' and how its meaning may be analysed, whether through signs, social context, value, originality, symbols or any other method we have discussed, is seen by post-structuralists as naïve. Deconstruction reminds us instead that we cannot adopt this godlike stance, which supposedly allows us to look from some outside position into the subject we pretend to be analysing. Once again this is a sign of a healthy refusal to settle for a single interpretation through the realization that such interpretations are a result of the forces of other pressures and analyses.

Yet there is one approach to art history that does claim to be more than just another 'ism'. > Feminism has unquestionably had more impact on art history in the last decade than any other approach. The number of publications increases year by year, with specialist reviews and journals, monographs on major women artists such as Berthe Morisot and Artemisia Gentileschi, conference papers and papers from universities and institutions of tertiary education. The speed of this growth reveals its perceived importance. It was only in 1982, for example, that Kleinbauer and Slavens' *Research Guide of the History of Western Art* discussed at length 'the field of art history' without, in all its 229 pages, once mentioning feminism.

An early and valuable consideration of the question came in 1971 from Linda Nochlin, one of the first art historians to adopt a feminist stance, in an article entitled 'Why Are There No Great Women Artists?' Her question is, of course, phrased to make us think about the concepts of 'great' art and 'great' artists. Her answer begins to sketch in a possible solution to this problem, suggesting there are no values that we can take for granted, including those of 'art' and 'artist':

> Art is not a free autonomous activity of a super-endowed individual, 'influenced' by previous artists and more vaguely and superficially by 'social forces', but rather . . . occurs in the social situation, is an integral element of social structure, and is mediated and determined by specific and definable social institutions, be they art academics, systems of patronage, mythologies of a divine creator and artist as he-man or social outcast.

To quote Nochlin again, art is 'a political ideology addressed to relations of power'. Feminist art history has been most challenging in its assault on the (male) bastions of received opinion, and in questioning accepted notions of gender, sexuality and power. Feminist art historians claim that the piecemeal study of the present structure of art history serves only to marginalize women. The canon is male. Against this, 'feminist art history reproblematizes and reconstitutes the central issue of how meaning is produced in form within the work of art' (Linda Nochlin, *The Politics of Vision* (1989)). This suggests that the feminist approach is valid across the board, whatever the subject-matter. For feminists it is a new way of looking at the material, and it underlies Nochlin's interest in 'the questions of sexuality, subject difference, and subordination inherent in the production of meaning in the pictorial discourse'.

Notions of artistic genius and the heroic artist persist, even if the artist has the psychological problems of van Gogh or the unsavoury character of Gauguin, and are structured into our very notion of the 'artist', as Margot and Rudolf Wittkower's study of the artistic temperament, *Born under Saturn* (1963), clearly shows. Feminists argue

11

that from this stems the marginalization of women's art, and the treatment of these genres in which women have traditionally been active, such as > still life, as minor art.

The question of the applied arts is central to feminist art history, since craft, which has long been another area of importance to women practitioners, has also been relegated by mainstream art history to the status of a 'minor' art. Feminists, however, focus on such crafts as weaving and embroidery, as well as ceramics and book illustration, as the means to discuss not only women practitioners, but also the canon that excludes practitioners in these areas – both female and male – from serious consideration. Against this, feminists have argued not for the aesthetic appreciation of craft as another branch of the fine arts, but for the acknowledgement that the whole subject constitutes a political issue. As Norma Broude has noted, even this distinction may be turned to the advantage of the male-dominated canon: 'Decorative art and decorative impulses . . . [have] acted as important liberating catalysts' for male artists, while women in the crafts were seen as doing 'women's work'. The same prejudice operates in the area of copies. Delacroix making a copy of a Rubens is treated with the respect accorded to one genius creating a dialogue with another, but when a woman copies another artist it is merely seen to confirm her essentially imitatative nature.

With the above approaches we return to the essential difficulty confronting the student of the humanities or the social sciences (and art history has been claimed by both): should the art historian adopt a particular stance in advance of confronting the object? Baudelaire believed that art criticism should be 'passionate, partial and political', and his criticism is a monument of lively perception and good sense. And clearly Linda Nochlin has gained great intellectual strength from focusing her studies through the grid of feminism, as she suggests in *The Politics of Vision*:

My commitment to feminism, both as theory and as politics, has provided me with a vantage point of Otherness, and that if one sees art history from the vantage point of the Other, politics necessarily informs the very construction of the subject; it cannot be construed as an additional element.

It is impossible to be completely objective; we are formed by the usually unspoken presuppositions of our time, culture and social complexion. But some historians believe that this should make us all the more anxious to treat the art works of the past in their own context, and to reconstruct the context as conscientiously as possible. This is not to say that much of what has been discussed above is not powerfully and passionately written, only that the process of deconstruction is always in danger of obscuring the actual object of art history, whether it is a painting, a sculpture, a Navaho sand painting or an African tribal mask.

What have the approaches discussed above taught us? They have all suggested that our assessment of an art work is conditioned by a thicket of prejudices and a network of signs, and that the viewer has much work to do in order to make an accurate 'reading'. This we should all be able to accept as no less than obvious. What is more problematical is the tendency to refuse any autonomy to the art work itself, thereby denying the usefulness of even trying to arrive at an assessment that is as objective as possible. When it is suggested that absolutely nothing about the art work is fixed, and that it is all – literally – in the eye and mind of the beholder, then we should beware. However, it is of course by dispute that we prove the vitality of the discipline, and this

can only be healthy for the future of art history. To conclude, we must try to determine just what that future might prove to be.

THE FUTURE OF THE DISCIPLINE

It would be complacent to offer an overly sanguine appraisal of the discipline's future role. Although most art historians are convinced – with good reason – that the reputation of Raphael will remain secure within the history of art, nevertheless an expanded definition of art history to include the semiology of the comic book, for example, is also needed. Art history must offer a broad and eclectic approach to the study of visual imagery, or risk being left behind by the images it pretends to analyse. The important point to bear in mind is that the discipline is dynamic; it is not monolithic. As our perception of the subject changes over time, so old ideas seem less convincing, and fresh ones take their place. The changes the discipline is at present witnessing, which to the traditionalist might at first seem destructive or profoundly destabilizing, are on the contrary a sign of vigour. Ultimately, the need for societies to revise their opinions about their own cultural heritage is the guarantee that the discipline has a future.

Because we cannot fully understand the meaning of the societies we inhabit without appreciating their cultures, a strong case may be made not merely for art history's relevance but, indeed, for its central place in late-twentieth-century society. Whether art history is defined in its traditional sense as encompassing a 'narrow' sphere of interest centred on the > fine arts, or more realistically as the central discipline in an expanding cultural climate embracing new forms of visual culture such as advertising, what is certain is that the world we inhabit is filled with visual imagery that is increasing at an exponential rate. Art history has never had a greater responsibility than to find an intellectual form of sufficient subtlety and breadth to meet this challenge.

It is a truism that our century has seen declining confidence in several of the (supposedly) eternal verities, from religion and ethics to social structure, from the nature of knowledge to the very scope of scholarship. It is this lessening of confidence that allows new relationships between the art historian and the art work to be suggested; but we should nevertheless be careful not to follow the argument that states there is no objective truth, that everything is personal, because this is surely a form of intellectual laziness. This approach is also against scholarship, because it denies the opportunity to build any kind of intellectual structure.

The polemics of the previous paragraph may suggest to you the strong likelihood of a backlash against such anti-scholarly promiscuity. That is, if we accept the pendulum theory of a swing one way, then the other, we may expect a future emphasis on the opposites of those practices and theories that characterize some, but certainly not all, of the approaches already discussed. Throwing caution to the winds, we predict the development of the following trends in art history over the next decade:

● A continuation of the broadening of the focus of art history, continuing the movement away from 'high' art towards further consideration of popular cultural forms. The evidence is already with us in the proliferation of studies devoted to photography, film and television within the framework of visual culture. As early as 1950 Jean Casson was writing that film fulfils the very function 'which the public ascribes to art, namely to

erect an image of the reality in which it lives' (quoted in Belting, *The End of the History of Art?*).

● The continued movement of feminist art history away from its early 'biological' slant towards increased emphasis on the institutional and ideological constructions of gender and power, allowing for a middle way between the equally untenable positions whereby feminist art history is viewed as a special case, or women artists are analysed by criteria applicable only to the male-dominated canon.

● The demotion of the discipline's current Eurocentric emphasis. This will continue apace, along with the development of histories of non-Western art that will go beyond the survey approach to reflect the complexities of a given culture. These studies will eschew using Western standards and Western notions as tools of analysis; they will develop instead methodologies and theoretic structures that are the result of a dialogue with the subject-matter.

THE LITERATURE OF THE DISCIPLINE

The bibliography we offer here is a brief one that reflects the arguments laid out above. It offers a representative selection of sources which those who wish to pursue the topic further may profitably consult. Nearly all the works listed contain extensive bibliographies.

But first of all it is important to know how to find the right book on a given subject without fruitlessly wandering up and down the aisles of libraries or bookshops. The answer is to familiarize oneself with indexes and bibliographies. For the former, the *Répertoire d'art et d'archéologie* (1972–), *Art Index* (1929–), or *Artbibliographies Modern* (1972–) provide the means of compiling a list of references to articles in magazines, reviews and journals. The next step is to get to know the library catalogues, many of which are now computerized, and other electronic means of searching – for example, *Art Index* is now available on CD-ROM. There are several books to guide students through the discipline of art history, such as Lois S. Jones's *Art Research: Methods and Resources. A Guide to Finding Art Information* (3rd edn 1990), and Etta Arntsen and Robert Rainwater's *Guide to the Literature of Art* (1980).

Libraries contain, as we all know, mainly books, not journals, although the student should realize the value of journals, which often present their material in an up-to-date and focused way. Books on art history may be broken down into the rather traditional > monograph, that is a study of one artist or art work; thematic studies, say of stained glass or Siennese > frescos; survey books dealing with the broad development of the arts; exhibition catalogues, which appear on the occasion of a temporary exhibition of the work of an artist or school; and gallery catalogues, which present the permanent collection of a museum.

Among the most useful kinds of book on art history are dictionaries and encyclopaedias. While we hope that this dictionary meets the needs of a small-format, budget-priced dictionary, encyclopaedias, such as the McGraw-Hill *Encyclopaedia of World Art* in 15 volumes, offer comprehensive articles on art, artists, styles and countries. In the near future Macmillan is expected to publish its multivolume *Dictionary of Art*, which will do much to update the encyclopaedia market. Other major biographical encyclopaedias include E. Bénézit's French-language *Dictionnaire critique et documentaire des peintres, sculpteurs, dessinateurs et graveurs*, of which several editions are available, and U. Thieme and F. Becker's *Künstler Lexicon*.

Finally, here is a tip for those who are unsure about how to consult art-historical sources for maximum profit. Although many books may be read from cover to cover with enjoyment, they are not novels. Often a book is best consulted only in part. It is a good idea to decide on several keywords for which one may search. In this way consultation of the index or chapter titles will often prove far more informative than ploughing through everything an author has to say about the works of Raphael when what one really wants is information on Raphael's frescos in the > Vatican. As this

introduction has made clear by now, art history is not a passive discipline, but must be engaged with actively, and that means reading selectively and with intelligence.

1. SURVEYS AND HANDBOOKS ON ART HISTORY

H. H. Arnason, *A History of Modern Art* (rev. edn 1985)

Kenneth Clark, *Civilisation: A Personal View* (1969)

E. H. Gombrich, *The Story of Art* (1950; many editions)

H. Honour and J. Fleming, *A World History of Art* (3rd edn 1991)

H. W. Janson, *History of Art: A Survey of the Major Visual Arts from the Dawn of History to the Present Day* (4th edn 1991)

2. INTRODUCTIONS TO THE DISCIPLINE OF ART HISTORY

Sylvan Barnet, *A Short Guide to Writing About Art* (3rd edn 1989)

Michael Baxandall, *Patterns of Intention: On the Historical Explanation of Pictures* (1985)

John Berger, *Ways of Seeing* (1972)

Hans-Berthold Busse, *Kunst und Wissenschaft: Untersuchungen zur Asthetik und Methodik der Kunstgeschichtswissenschaft* (1981)

David Carrier, *Artwriting* (1987)

E. H. Gombrich, *Art and Illusion: A Study in the Psychology of Pictorial Representation* (5th edn 1977)

E. H. Gombrich, *Reflections on the History of Art: Views and Reviews* (1987)

W. McAllister Johnson, *Art History: Its Use and Abuse* (1988)

W. Eugene Kleinbauer, *Research Guide to the History of Western Art* (1982)

Heinrich Lutzeler, *Kunstführung und Kunstwissenschaft: Systematische und entwicklungsgeschichtliche Darstellung und Dokumentation des Umgangs mit der bildenden Kunst*, 3 vols (1975)

Norbert Lynton et al., *Looking into Paintings* (1985)

Erwin Panofsky, *Aufsatze zu Grundfragen der Kunstwissenschaft* (2nd edn 1974)

Marcia Pointon, *History of Art: A Students' Handbook* (1980)

Donald Preziosi, *Rethinking Art History: Meditations on a Coy Science* (1989)

Mark Roskill, *What is Art History?* (2nd edn 1989)

Mark Roskill, *The Interpretation of Pictures* (1989)

Adolf Schmoll, *Epochengrenzen und Kontinuitat: Studien zur Kunstgeschichte* (1985)

Hans Sedlmayr, *Kunst und Wahrheit: zur Theorie und Methode der Kunstgeschichte* (1978)

3. THE HISTORY OF THE DISCIPLINE OF ART HISTORY

Paul Barolsky, *Why Mona Lisa Smiles and Other Tales by Vasari* (1991)

Hans Belting, 'Vasari and His Legacy: The History of Art as a Process?', in *The End of the History of Art?* (1987), pp. 67–94

Thomas S. R. Boase, *Giorgio Vasari: The Man and the Book* (1979)

Heinrich Dilly, *Kunstgeschichte als Institution* (1979)

Christie K. Fengler, *Lorenzo Ghiberti's Second Commentary: The Translation and Interpretation of a Fundamental Renaissance Treatise on Art* (1974)

John Gage, *Goethe on Art* (1980)

Evert F. van der Grinten, *Elements of Art Historiography in Medieval Texts: an Analytic Study* (1969)

Elizabeth K. Helsinger, *Ruskin and the Art of the Beholder* (1982)

Michael Podro, *The Critical Historians of Art* (1982)

Thomas Puttfarken, *Roger de Piles' Theory of Art* (1985)

Joshua C. Taylor, *Nineteenth-Century Theories of Art* (1987)

4. STYLE

Clive Bell, *Since Cézanne* (1922)

Paul Frankl, *Principles of Architectural Style: The Four Phases of Architectural Style, 1420–1900* (1968)

Clement Greenberg, *Art and Culture: Selected Essays* (1961)

Michael Greenhalgh and J. V. S. Megaw (eds.), *Art in Society: Studies in Style, Culture and Aesthetics* (1978)

David Summers, 'Form, Nineteenth-Century Metaphysics and the Problem of Art-Historical Description', *Critical Inquiry*, 15 (1989)

Heinrich Wölfflin, *Principles of Art History: The Problem of the Development of Style in Later Art* (1932)

Heinrich Wölfflin, *Renaissance and Baroque* (Eng. trans. 1964)

5. ICONOGRAPHY

Max Dvorak, *The History of Art as the History of Ideas* (Eng. trans. 1984)

N. Goodman, *Languages of Art: An Approach to a Theory of Symbols* (1976)

Michael A. Holly, *Panofsky and the Foundations of Art History* (1984)

W. J. T. Mitchell, *Iconology, Images, Text, Ideology* (1986)

Warren G. Moon, *Ancient Greek Art and Iconography* (1983)

Keith Moxley, 'Panofsky's Concept of Iconology and the Problem of Interpretation in the History of Art', *New Literary History*, 17 (Winter 1986)

Erwin Panofsky, *Idea: A Concept in Art Theory* (1968)

Erwin Panofsky, *Meaning in the Visual Arts: Papers In and On Art History* (1955)

Erwin Panofsky, *Problems in Titian, Mostly Iconographic* (1969)

Erwin Panofsky, *Studies in Iconology: Humanistic Themes in the Art of the Renaissance* (1939)

Robert I. Rothberg et al. (eds.), *Art and history: Images and Their Meaning* (1988)

6. ART AND SOCIETY

Frederick Antal, *Classicism and Romanticism with other Studies in Art History* (1966)

Stephen Bann, *The Clothing of Clio: A Study of the Representation of History in Nineteenth-Century Britain and France* (1984)

John Barrell, *The Dark Side of the Landscape: The Rural Poor in English Painting, 1730–1840* (1979)

John Barrell, *The Political Theory of Painting from Reynolds to Hazlitt: 'The Body of the Public'* (1986)

Michael Baxandall, *Painting and Experience in Fifteenth-Century Italy: A Primer in the Social History of Pictorial Style* (1972)

Hans Belting, *The Image and its Public: Form and Function of Early Passion Paintings* (1989)

T. J. Clark, *The Painting of Modern Life: Paris in the Art of Manet and his Followers* (1984)

Thomas E. Crow, *Painters and Public Life in Eighteenth-Century Paris* (1985)

Arnold Hauser, *The Philosophy of Art History* (1959)

John Onians, *Art and Thought in the Hellenistic Age: The Greek World-View 350–50 BC* (1979)

J. Wolff, *The Social Production of Art* (1981)

Richard Wollheim, *Painting as an Art* (1987)

7. THE NEW ART HISTORY

Hans Belting, *The End of the History of Art?* (1987)

Norman Bryson (ed.), *Calligram: Essays in New Art History from France* (1988)

Norman Bryson, *Vision and Painting: The Logic of the Gaze* (1983)

David Carroll (ed.), *The States of 'Theory': History, Art and Critical Discourse* (1990)

Herve Fischer, *L'histoire de l'art est terminée* (1981)

Griselda Pollock, 'Art, Artschool, Culture: Individualism after the Death of the Author', *Block* 11 (1985/6), pp. 8–18

A. L. Rees and Frances Borzello, *The New Art History* (1986)

8. PATRONAGE

Bruce Cole, *The Renaissance Artist at Work: From Pisano to Titian* (1983)

Francis Haskell, *Past and Present in Art and Taste: Selected Essays* (1987)

Francis Haskell, *Patrons and Painters: A Study in the Relations between Italian Art and Society in the Age of the Baroque* (2nd edn 1980)

Michael Levey, *Painting at Court* (1971)

Barbara I. Mitchell, *The Patron of Art in Giorgio Vasari's Lives* (1975)

Hugh Trevor-Roper, *Princes and Artists: Patronage and Ideology at Four Hapsburg Courts, 1517–1633* (1976)

T. B. L. Webster, *Potter and Patron in Classical Athens* (1972)

9. FEMINIST APPROACHES TO ART HISTORY

Rosemary Betterton (ed.), *Looking On: Images of Femininity in the Visual Arts and Media* (1987)

N. Broude and M. D. Garrard (eds.), *Feminism and Art History: Questioning the Litany* (1982)

Anthea Callen, *Women Artists of the Arts and Crafts Movement* (1979)

Whitney Chadwick, *Women, Art and Society* (1990)

G. Greer, *The Obstacle Race: The Fortunes of Women Painters and their Work* (1979)

Heide Gottner-Abendroth, *Die tanzende Gottin: Prinzipien einer matriarchalen Asthetik* (1985)

T. Gouma-Peterson and P. Mathews, 'The Feminist Critique of Art History', *Art Bulletin*, LXIX (Sept. 1987), pp. 326–57

A. S. Harris and L. Nochlin, *Women Artists 1550–1950* (1976)

T. B. Hess and E. C. Baker, *Art and Sexual Politics* (1971)

A. Kuhn, *The Power of the Image: Essays on Representation and Sexuality* (1985)

A. Kuhn, *Women's Pictures: Feminism and Cinema* (1982)

L. Mulvey, 'Visual Pleasure and Narrative Cinema', *Screen*, XVI (Autumn 1975), pp. 6–18.

Lynda Nead, *Myths of Sexuality: Representation of Women in Victorian Britain* (1988)

Linda Nochlin, *The Politics of Vision* (1989)

Linda Nochlin, *Women, Art and Power and other Essays* (1988)

R. Parker, *The Subversive Stitch: Embroidery and the Making of Femininity* (1984)

Rozsika Parker and Griselda Pollock, *Framing Feminism: Art and the Women's Movement, 1970–1985* (1987)

Rozsika Parker and Griselda Pollock, *Old Mistresses: Women, Art and Ideology* (1981)

C. Pettys, *Dictionary of Women Artists: An International Dictionary of Women Artists Born before 1900* (Boston, 1985)

Griselda Pollock, 'Women, Art and Ideology: Questions for Feminist Art Historians', *Woman's Art Journal* (Spring/Summer 1983)

Griselda Pollock, *Vision and Difference: Femininity, Feminism, and Histories of Art* (1988)

Arlene Raven et al., *Feminist Art Criticism: An Anthology* (1988)

10. SEMIOTICS

Roland Barthes, *Image–Music–Text* (Eng. trans. 1977)

Theresa Coletti, *Naming the Rose: Eco, Medieval Signs, and Modern Theory* (1988)

Achim Eschbach (ed.), *Bibliography of Semiotics, 1975–1985* (1986)

R. E. Innes (ed.), *Semiotics: An Introductory Anthology* (1985)

Christopher Norris, *Deconstruction, Theory and Practice* (rev. edn 1991)

Winfried Noth, *Handbook of Semiotics* (1990)

Donald Preziosi, *The Semiotics of the Built Environment: An Introduction to Architectural Analysis* (1979)

David E. Wellbery, *Lessing's 'Laokoön': Semiotics and Aesthetics in the Age of Reason* (1984)

11. CRITICISM

Stephen Bann, *The True Vine: On Visual Representation and the Western Tradition* (1989)

Norman Bryson (ed.), *Visual Theory: Painting and Interpretation* (1991)

Solomon Fishman, *The Interpretation of Art: Essays on the Art Criticism of John Ruskin, Walter Pater, Clive Bell, Roger Fry and Herbert Read* (1963)

Robert Hughes, *Nothing if not Critical* (1990)

Neil McWilliam, *A Bibliography of Salon Criticism in Paris from the Ancien Régime to the Restoration* (1991)

Christopher Parson, *A Bibliography of the Salon Criticism in Second Empire Paris* (1986)

Lionello Venturi, *The History of Art Criticism* (1964)

Carol M. Zemel, *The Formation of a Legend: van Gogh Criticism, 1890–1920* (1980)

A NOTE ON THE CONTENTS

A book of this length cannot be a comprehensive survey of everything of interest, worldwide, to an art historian. Shortage of space has led to the following focuses:

● The dictionary is largely about Western art (i.e. painting and sculpture) from Greek times to the present day; it does not pretend to give anything more than limited attention to architecture.

● Artists are only included when they have written on art, have been published, and have been influential in the development of their specialism. Architects have been omitted.

● The decorative arts are almost entirely excluded, being the subject of another volume in this series. Prints and printmaking are included, however, because they form an important part of our subject.

● Prominent art historians are included when their publications and ideas have contributed to the development of the discipline.

● Long survey-type entries of the arts of particular countries have been avoided, and references for further reading are sometimes longer than the text itself. For example, no thorough account of Egyptian art is given; instead, the entry concentrates on the significance of Egyptian art for that of the West. Similarly, for Greek and Roman art the entries attempt to summarize why and how their productions are influential in later centuries.

● Technical entries have been kept brief and have bibliographies enabling you to seek out further details for yourself. This has been done in order to allow space for longer entries on 'conceptual' matters.

● The necessarily restricted space given to important topics is compensated by a comparatively rich bibliography.

A NOTE ON REFERENCES

The scope of a useful bibliography for the art historian grows daily, so we have had to be selective. To help the process, we have *not* cited books in the following categories:

● 'How-to-do-it' books, for example dealing with sculpture, printmaking or mixing watercolours. There is a host of such volumes, with new ones every year, and most are as good as any other. Look in your local library or bookshop.

● Museum and gallery guides. We assume that all public museums have guides to their collections, and that many have cheap and/or expensive unillustrated or illustrated versions. Search through your library under the name of the museum or gallery. The only exceptions to this are where the work(s) cited contain substantial information about the history of the institution.

● Guide books to cities, churches and buildings. Once again, we assume that all 'art treasure' cities are well provided with literature. Some series document such material systematically: see below under *Buildings of England*, and TCI, for example.

● All the 'painting/sculpture of' books. Major artists are amply covered with illustrated books, often including catalogues of their works.

● Unless there is a particular point to the exercise, we do not cite complete catalogues of artists' works either, unless they include important introductory or critical material.

● Standard histories of art have also been omitted from the headwords, although they sometimes appear in the individual bibliographies because they are frequently the best modern treatments of a subject or area. *The Pelican History of Art*, for example, although not yet covering all countries or periods, should be taken as read, so to speak!

WHAT IS MORE . . .

● We have tried where possible to cite the latest edition, but have not indicated when and where a book is translated from another language.

● We have generally preferred the latest books on a particular topic, because they will contain references to earlier publications. Plenty of art-historical 'classics' have, however, been included.

A Note on References

• Where a book has more than one author, we have usually confined ourselves to citing the (alphabetically) first, as catalogued.

• Plenty of material in foreign languages has been included since our discipline is an international one and it would be both inaccurate and parochial to restrict ourselves to English-language works.

A–Z Section

A

ABBOZZO

(Italian: 'rough sketch', 'outline'). In painting the initial delineation or blocking-in of a > composition on the > canvas. In sculpture the reducing of the block to a rough form of the intended work.

ABORIGINAL ART

The art of the native peoples of Australia. These cultures have traditionally used the body, rock surfaces, bark, stone and wood as the > support for > pigments of natural ochre dyes, along with charcoal and kaolin, although much recent Aboriginal art has adopted > acrylic paint on > canvas. Although the notion of 'art', with its connotations of Western non-functionalism, is inappropriate, Aboriginal production, always bearing in mind the cultural and linguistic diversity of the different Aboriginal peoples, may be roughly divided into work on > artefacts; on rock walls (which often indicate identification of the artist with a site of cultural significance); and imagery that functions with patterns of ritual, such as the > iconography recording the 'Dreaming', the account of Aboriginal social and cultural relations and the history of their land.

• R. M. Berndt (ed.), *Australian Aboriginal Art: a Visual Perspective* (1982).

ABSTRACT EXPRESSIONISM

A term used to describe a heterogeneous group of painters working in the late 1940s and early 1950s, loosely synonymous with the 'New York School'. The name 'Abstract Expressionism' was first used in connection with > Kandinsky's abstract painting of the 1920s, and indicates the movement's interest in personal expression as opposed to the dominant geometric > abstraction descended from De > Stijl and > Constructivism. It is this alone that allows artists of widely divergent styles to be so grouped. They may, however, be subdivided into the lyrical abstraction, > Colour Field paintings of Barnett Newman, Ad Reinhardt, Mark Rothko and Robert Motherwell; the > all-over, drip paintings of Jackson Pollock, which the critic Harold Rosenberg called > Action painting; and the figurative > expressionism of Willem de Kooning and Hans Hofmann. The influential critic Clement > Greenberg coined the term 'American-style painting' to describe these trends. The movement quickly won acceptance and placed American art

on a forward footing, and the USA was henceforth able to dictate the terms of the Modernist debate. Fundamental to Abstract Expressionism is the attention it pays both to the planimetric qualities of the picture surface, and to the qualities of paint, whether applied gesturally (> gestural painting) or as Colour Field, which serve to draw the eye back to the fact of paint on > canvas.

● H. Rosenberg, 'The American Action Painters', *Art News* (December 1952); M. Tuchman (ed.), *The New York School: Abstract Expressionism in the 1940s and 1950s*, exhibition catalogue, Los Angeles County Museum of Art (1965); I. Sandler, *Abstract Expressionism: the Triumph of American Painting* (1970); C. Greenberg, 'Modernist Painting', *Art and Literature*, 4 (1965), reprinted in F. Frascina and C. Harrison, *Modern Art and Modernism: A Critical Anthology* (1982; 1986), pp. 5–10.

ABSTRACTION

The term has two main applications. The first describes non-representational painting, that is painting which does not refer to the visible world but only to its own intrinsic concerns. Examples of this kind of abstraction include > Suprematism, De > Stijl, > Abstract Expressionism, geometric abstraction and > Tachism. The second kind of abstraction is that which 'abstracts' its images from the visible world – a form of abstraction synonymous in popular opinion with modern art. While this second form remains within the parameters of > representational art, in general it desires to break with the pictorial conventions of > Renaissance art. Examples of this kind of abstraction include > Fauvism, > Cubism, > Expressionism and > Futurism.

● A. H. Barr, jr., *Cubism and Abstract Art* (1936); E. Lucie-Smith, *Movements in Art Since 1945* (1969; 1987); H. Osborne, *Abstraction and Artifice in Twentieth-Century Art* (1979).

ABSTRACTION-CRÉATION

A loose association of > abstract > artists founded in Paris in 1931. It organized group > exhibitions and published a journal, *Abstraction-Création*.

ACADEMIC ART

In the first instance, academic art refers to the art of the > academies. It may, however, also be used as a stylistic descriptor of the > genre of > history painting, that is painting which portrays in the > grand manner subjects drawn from classical antiquity or the Bible. In the 20th century it has come to mean, not entirely justly, technically accomplished but otherwise arid and outmoded > narrative painting.

Those who professed the style with most conviction, such as Sir Joshua > Reynolds in his *Discourses*, or J-A-D Ingres, frequently failed to translate the generalized rhetoric of their pronouncements into concrete particulars that students could assimilate. Behind academic painting lies the idea that the means must suit the end, and that important

painting (which academic art was by definition) demanded exceptional ability exercised with restraint and understanding.

● 'Académique', in *Dictionnaire de l'Académie des Beaux-Arts*, vol 1. (1855).

ACADEMIES OF ART

Towards the end of the 16th century, groups of > artists, dissatisfied with the veniality and artisanal aspects of the > guild system, joined together into academies of art that sought to promote the intellectual and creative aspects of artmaking over those of their craft-based predecessors. Their aim was to capitalize on the rising status of the artist as the exponent of a > liberal art. The first artists' academy (as opposed to the gatherings of > dilettanti, > antiquarians and > amateurs also called academies) was established in Florence in 1563 by the artist and historiographer Giorgio > Vasari; under the > patronage of Cosimo de > Medici and with Michelangelo at its head. Other cities soon followed the example of Florence. The Accademia di San Luca was founded in Rome in 1593 with Federico Zuccaro as its first president, although as with its predecessor, more attention was paid to questions of status than to the practical matters of artmaking. In France, the Académie Royale de Peinture et de Sculpture was founded in 1648 around the ambitious and politically astute Charles > Lebrun, who enlisted the royal support that was to make this academy the envy of Europe. In the 18th century academies were established in, among other cities, Berlin (1696), Bologna (1709), Dresden (1750) and London (1768).

The academies attempted wherever possible to distance their own work from that of the guilds. They pretended to despise the guilds as corrupt and self-seeking, seeing them as stifling enterprise, freedom of choice and the rational ordering of artmaking into precepts and rules open to the exercise of the intellect. As a counter, the academy schools taught their students > fine art, which meant, primarily, not the practice of painting or sculpture but the more theoretical aspects of > anatomy, history and geometry. Students were taught > drawing, but not painting, as the former was seen to be further removed from the manual application of > paint reminiscent of the guilds.

Under state control for the most part, the academies institutionalized art through competitions, exhibitions, lectures, discussions and treatises. The purpose of all this activity, which ultimately militated against the progress of the fine arts, was to show that painting and sculpture were worthy candidates for inclusion among the liberal arts. To the same end only > history painting was regarded as an appropriate > genre for the academic painter. Thus a circular justification, that > academic art needed an academy to defend its interests, while the academy would claim its *raison d'être* was to provide a fertile environment to train history painters, led academic painters into sterile and self-absorbed practices little suited to meeting the needs of a changing art environment.

By the 19th century the academies were regarded as anachronistic. Certainly they had no answer to the challenge of > Romanticism, which held that an artist had nothing to learn from rules. In the face of this heresy, the academies reacted by using whatever influence they had to oppose innovation. The result was that in the course of the 19th century they declined from a position of considerable respect (the 18th-century French academy welcomed almost all major contemporary painters) to a position a century

later where no significant artist deigned to accept nomination to an academy. In this climate, they were seen to be offering little more than a certain kind of technical training, with none of the theoretical or intellectual leadership by which they had set such store two centuries earlier.

● Lois M. Fink, *Academy: The Academic Tradition in American Art* (1978); Nikolaus Pevsner, *Academies of Art, Past and Present* (1940); Frances Yates, *The French Academies of the Sixteenth Century* (1947); Charlotte Yeldham, *Women Artists in Nineteenth-Century France and England: Their Art Education, Exhibition Opportunities and Membership of Exhibiting Societies and Academies* (1984).

ACADEMY FIGURE

A usually full-length study of a male or female > nude executed as an exercise by a student in an > academy or art school (> art education and training), hence the name. The exercise had particular currency from the 17th to the 19th centuries, when study of the nude was a prerequisite for the practice of > history painting, which most often demanded the deployment of one or several nude or near-nude figures in dramatic action, e.g. J.-L. David's *The Oath of the Horatii* (1784). Pedagogically, the academies saw in this exercise the dual advantages for the students of working directly from > nature (thereby avoiding the heresy of > Mannerism) while > copying a model most often given a pose reminiscent of a famous > antique > sculpture, thereby allowing imitation of both nature and the antique.

● 'Académie (Modèle)', in *Dictionnaire de l'Académie des Beaux-Arts*, vol. 1. (1858).

ACCADEMIA DI BELLI ARTI

The art collection of the city of Venice. It was founded in 1807 by Napoleonic decree. The basis of the collection derives, as its name suggests, from the venerable Accademia di Belli Arti (Academy of Fine Art), augmented by the collection of the Galleria dei Gessi and by revolutionary plunder. It is the pre-eminent collection of Venetian painting in the world.

ACRYLIC PAINT

Plastic paint used by artists since the 1940s, made by suspending the > pigment in a > vehicle of acrylic resin dispersed in either > turpentine or water (acrylic paint soluble in water is more accurately a polymer paint). Its properties permit a wide variety of techniques, from thin washes of great precision to a > painterly > impasto.

ACTION PAINTING

A term coined by the critic Harold Rosenberg in 1952. For Action painters the > canvas is the temporal and spatial arena on which to imprint, without any figurative or literal

reference, a record of the processes of its making. Action paintings have been made by means as various as drips or splashes, as in the work of Jackson Pollock; naked women covered in paint and dragged over a canvas, as by Yves Klein; or the broad > gestural brushstrokes of Willem de Kooning. This common interest in 'gesture' links Action painting with the wider concerns of > Abstract Expressionism, while the 'performances' of Klein anticipate the manifestations of German Aktionismus, > Performance art; > Body art and the > happenings of the 1960s and 1970s.

● H. Rosenberg, 'The American Action Painters', *Art News* (1952); I. Sandler, *Abstract Expressionism: The Triumph of American Painting* (1973); *Abstraction: Towards a New Art*, exhibition catalogue, Tate Gallery, London (1980).

ADDISON, JOSEPH

(1672–1719). English essayist. Addison opened up to English debate the question of aesthetic pleasure in essays such as 'On the Pleasures of the Imagination' (1712). He categorized aesthetic pleasures as > beauty, grandeur and novelty, and in doing so established the foundations of the notion of 'sensibility', which from the mid-century was to have an important influence on English > taste.

AERIAL PERSPECTIVE

Analogous to linear > perspective and used in conjunction with it, aerial perspective is a means of suggesting recession into depth in a painting. This illusion of recession is suggested through modulating colour and tone in imitation of the effects of the atmosphere on distant objects. Aerial perspective thus imitates, for example, the way distant objects fade to blue and appear to shimmer in the light. Notable practitioners include the > Early Netherlandish painters. > academic landscapists such as Claude Lorrain, the > Romantic Turner and the > Impressionists. Outside Europe, Chinese painting is remarkable for its use.

AESTHETICISM

The philosophy of 'art for art's sake', which holds that art needs no justification other than the pursuit of > beauty and should not be pressed to serve other ends. Historically, the idea reached its apogee in the 19th century in the writings of Mme de Staël, Victor Cousin and the > Symbolists in France; and Walter > Pater and Oscar Wilde in England. The idea was attacked as irresponsible by critics with a social conscience such as John > Ruskin, who went as far as the courts in his disagreement with the painter Whistler over the issue; William > Morris; and the novelist Tolstoy in *What is Art?* (1898). While most 20th-century critics, whatever their political persuasion, would concede that there is an 'aesthetic dimension', few would wish to argue that art is unaffected by non-aesthetic concerns.

AESTHETICS

The study of aesthetics attempts to define philosophically the concepts of > beauty and > taste. The term has been current since the 18th century, when it was introduced by A. G. Baumgarten, and the philosopher > Kant used it in this sense in his *Critique of Judgement* (1790), in which he argued that aesthetic appreciation reconciles the dualism of theory and practice in human nature, thereby leaving the way open to identify beauty as a profoundly subjective quality, and not necessarily inherent in the art work. This rigorous philosophy was undermined in the 19th century by > Aestheticism which trivialized the study of beauty into the doctrine of 'art for art's sake'. In the 20th century the term is widely and imprecisely used as a synonym for the domain of > fine art as opposed to the > decorative arts, or the study of art in isolation from social or political factors, although > Marxist philosophers have brought social relevance into the study of aesthetic worth.

● R. G. Collingwood, *The Principles of Art* (1938). H. Marcuse, *The Aesthetic Dimension* (Eng. trans. 1978); H. Osborne, *Aesthetics* (1972).

AKTIONISMUS *See* Performance art.

ALBERTI, LEON BATTISTA

(1404–72). Important as a learned theoretician with a passion for the > antique past, and a man whose projects were taken up by princes and popes. With interests in literature, music, art and architecture, he was a > Renaissance universal man, all the more significant because of his highly influential and extensive writings, several of them in Tuscan Italian, the new vernacular, rather than in the scholarly language of Latin. These include *Della Pittura* (1436) and *De Re Aedificatoria* (1452, published 1485), the first Renaissance work on architecture, as well as books on the family and other treatises. His concern with and knowledge of antiquity no doubt increased during his time as Papal Inspector of Monuments (1447–55), and he used this to develop several solutions as to how the Renaissance might use the > antique in its buildings, especially churches.

Although more of a gentleman architect than a sleeves-rolled-up professional, all his religious works offer models for the future. Thus the Tempio Malatestiano at Rimini, which he recased in 1450, plays variations on the theme of the triumphal arch and the aqueduct (not to mention the wished-for but unattempted dome), treated with a true feeling for the grandeur, scale and materials of antique buildings, and is more convincingly antique-looking than anything > Romanesque or by > Brunelleschi. Concerned also with the import of geometry through harmonic (> harmony) proportions, Alberti's architecture shows how the past can be adapted to serve the present.

● Vincenzo Fontana, *Artisti e Committenti Nella Roma del Quattrocento: Leon Battista Alberti e la Sua Opera Mediatrice* (1973); Martin B. Katz, *Leon Battista Alberti and the Humanist Theory of the Arts* (1978); Joan Kelly, *Leon Battista Alberti: Universal Man of the Early Renaissance* (1969).

ALLA PRIMA

(Italian: 'at first go'). A method of applying > oil paint directly on to the > support without proper > underpainting. The > Impressionists employed the technique to achieve the spontaneity they required of their paintings. The method is related to > wet into wet. The technique is known as 'direct painting' in English and *au premier coup* in French, but the Italian term is most common.

ALLEGORY

A device in > narrative painting in which an action is the vehicle for a covert meaning or interpretation. From this perspective, the 'real' meaning of a > Renaissance > nude is not sensual pleasure but Truth. The presentation of myth and fable in > history painting is an obvious example of the use of allegory, and is common throughout the history of narrative painting, from > mediaeval depictions of the seven deadly sins through to the representation of liberty as a semi-clad woman in > Delacroix's *Liberty Leading the People* (1830). Other allegories are more obscure and need a more complicated set of references to decode them. The representation of the story of Hercules at the crossroads is allegorical in that he must choose between the rocky path of Virtue and the broad plain of Vice, each indicated by an alluring woman. Allegory is not a > genre, or even a narrative, but relies on the beholder's ability to interpret devices such as the personification of abstract notions of good and evil as two women, or the use of a lily as a > symbol for purity. Artists have used a variety of texts and commentaries as aids to the representation of allegory in art. The Bible offers a wealth of parables, while Ovid's *Metamorphoses* has provided a fund of mythological and classical references. A cornerstone of much history painting, allegory survived with the narrative painting on which it depended until the advent of > Modernism.

● J. MacQueen, *Allegory*, The Critical Idiom Series, ed. J. D. Jump (1970); Ovid, *Metamorphoses*, trans. with intro. M. M. Innes (1955; 1983).

ALL-OVER PAINTING

A term applied to paintings such as Jackson Pollock's > Abstract Expressionist drip paintings, where paint is dripped or flung across the entire surface of the > canvas. The resulting painting has no traditional > compositional structure or even any indication of which way up the picture should be viewed.

ALTARPIECE

During the Middle Ages, church altars would have accommodated a statue group of the crucified Christ, or perhaps a Virgin and Child or a figure of the saint to whom the church was dedicated. In Italy, it was a development that gained popularity during the 14th century, when the painted altarpiece offered an opportunity for artists to paint large religious works, sometimes > polyptychs, which would be suitably visible,

depending on the importance of the altar. A structure situated behind the altar (often incorporating carved figures) is called a reredos. Since most churches had several chapels as well as a high altar (and some had chapels right down the aisles and around the east end, as with the > mediaeval pilgrimage-church layout), the altarpiece quickly became an important element in a painter's work. In the north and the Iberian peninsula, it was also common to have sculpted altarpieces, or a mixture of sculpture and painting. In England, Nottingham alabaster was sometimes used.

The altarpiece is one of the staples of post-mediaeval Western art history, a vogue that declined only in the 19th century, partly because of a yearning for simplicity. Following the > Reformation it has been perceived as a specifically Catholic form, as is seen from the furore following the placement of a > Rubens *Adoration* on the altar of Trinity College Chapel, Cambridge. *See also* Portable altar.

● Peter Humphrey and Martin Kemp (eds.), *The Altarpiece in the Renaissance* (1990); Barbara G. Lane, *The Altar and the Altarpiece: Sacramental Themes in Early Netherlandish Painting* (1984); H. W. van Os, *Sienese Altarpieces, 1215–1460: Form, Content, Function* (1990); Judith B. Sobre, *Behind the Altar Table: the Development of the Painted Retable in Spain, 1350–1550* (1989).

AMATEUR

There are two meanings to amateur, which can be applied to one who practises an art such as painting non-professionally, without thought of profit, and also to the > connoisseur, who is an 'amateur' in the French sense of the word, that is an informed devotee, a term current from the 17th century.

The practice of painting or > architecture (sculpture was for the most part too 'mechanical', with connotations of > craft and industry) as an amateur went hand in hand with an interest in the > liberal arts. Scholars such as > Goethe and > Ruskin made > drawings or > watercolours, often as a means of recording scenic impressions or > antique remains visited on a > Grand Tour. 'Amateur' also embraced those who risked ostracism should a social accomplishment like drawing transgress the bounds of amateurism and take the form of professional practice. as was the case, for example, with well-born women until the 20th century. More recently amateur has come to mean a person who occupies his or her leisure time by painting as a hobby. In such a context amateur often implies a lack of skill, as in 'amateurish'.

The other meaning of amateur – the non-practitioner who cultivates an informed interest in the artist – has been in use since the middle of the 18th century, superseding in part the term > dilettante. Many of these amateurs were passionate collectors (> collecting) of anything from antique > artefacts through to > cabinet paintings. Indeed, 'cabinet' is from the French *cabinet d'amateur*, meaning a small private collection contained in a private residence.

● F. Haskell, *Patrons and Painters: Art and Society in Baroque Italy* (1963; 1980).

AMERICAN-STYLE PAINTINGS *See* Abstract Expressionism.

AMPHORA

A large vase-shaped Greek ceramic vessel with two handles, used for the storage of foodstuffs or wine. The form varies. Some stand on their own base, others have a tapered base for storing in racks.

ANAMORPHOSIS

A picture in which the subject-matter appears to be grotesquely distorted, but which when seen from the correct viewpoint, or viewed in a mirror, appears correctly drawn. Sometimes an entire picture is drawn in anamorphosis, sometimes only part of it. Examples include the *Portrait of Edward* VI (1546; attributed to Cornelis Anthonisz), in which the medallion portrait of the sitter against a > naturalistic > landscape appears in proportion only when viewed from the side. Perhaps the most famous example of anamorphosis is Holbein the Younger's *The Ambassadors* (1533). In this, Holbein has painted in great detail a richly furnished interior with two standing figures. In the foreground he has painted a hugely elongated skull. The play between the ordinariness of the room and this > *memento mori* (reminder of death) is exacerbated by the discontinuity of the picture space – there is no spatial connection between the room and the skull. Presumably that connection exists only in the minds of the sitters, or of the > beholder.

● J. Baltrusaitis, *Anamorphoses, ou perspectives curieuses* (1955); E. H. Gombrich, *Art and Illusion* (1960).

ANATOMICAL STUDY

Given the emphasis in the Western tradition on the human body, especially the > nude, it is unsurprising that students in > academies were set to study anatomy, just as an engineer might study gears. Few artists (exceptions being Leonardo and Géricault, and then not wholly for artistic reasons) were interested in close anatomical study, and the regime was often confined to the early parts of a course, frequently by drawing or otherwise working from > antique sculptures (or parts thereof) rather than by examining corpses, which was not only difficult and frowned on by the Church, but could be dangerous (in 1688 the architect Perrault died from the after-effects of dissecting a putrefied camel at the > Louvre). Books and skeletons helped study, and in 1764–8 the sculptor Houdon produced in Rome a male figure with the skin stripped off (L' > *Écorché*), the better to study the disposition and actions of the muscles. This exists in many copies and versions.

● Bernard Schultz, *Art and Anatomy in Renaissance Italy* (1985).

ANGEL

In Christianity the lowest ranking of the heavenly spirits and with seraphs, cherubs and archangels the only ones regularly portrayed in art. Their > iconography as messengers

and supporters is both Jewish and > Assyrian; their manifest form in Christian art stems, like that of the cherub, whose form is another > Roman import (> putto), from the Roman figure of the winged Victory, with wings and flowing locks, and they are nearly always female, although in the Bible angels are clearly wingless and masculine (the paintings of Rembrandt, who studied the Bible closely, are an exception). As well as the messenger in the Annunciation, angels are much used in religious 'crowd scenes', their dress, physical beauty and often multicoloured wings adding to the glory of the Virgin Enthroned, or the Assumption of the Virgin.

● Lothar Heiser, Die Engel im Glauben der orthodoxie (1976); Peter L. Wilson, Angels (1988).

ANTAL, FREDERICK

(1887–1954). Marxist art historian. Born in Hungary and trained under Max Dvorak in Vienna, Antal worked in Berlin from 1922 until he moved to England in 1933. In reaction to the > formalism of > Wölfflin, which dominated European and especially German > art history of the 1920s, Antal stressed the importance of socio-economic factors in the development of > style. His major books include Florentine Painting and its Social Background (1948); Fuseli Studies (1956); Hogarth and his Place in European Art (1962), and a collection of essays, Classicism and Romanticism, with Other Studies in Art History (1966).

ANTIQUARIAN

In Momigliano's definition, a student of the past concerned to classify by category or type rather than by chronology – a type influential in the reform of historical methods in the 18th century: 'His preference for the original documents, his ingenuity in discovering forgeries, his skill in collecting and classifying the evidence and, above all, his unbounded love for learning are the antiquary's contributions to the "ethics" of the historian.' More generally, somebody interested in the whole range of ancient life and the objects that illustrate it, from > terracotta lamps through to statues and buildings.

● Stanley G. Mendyk, Speculum Britanniae: Regional Study, Antiquarianism and Science in Britain to 1700 (1989); Arnaldo Momigliano, 'Ancient History and the Antiquarian', Journal of the Warburg and Courtauld Institutes, XIII (1950), pp. 285–313; Arnaldo Momigliano, Studies in Historiography (1966); Stuart Piggott, Ruins in a Landscape: Essays in Antiquarianism (1976); Ancient Britons and the Antiquarian Imagination: Ideas from the Renaissance to the Regency (1989).

ANTIQUE

Although antiquities have been described as 'rubbish old enough to be precious', 'the antique' is a shorthand term for the whole package of > Greek, Hellenistic and > Roman art and > architecture from the 5th century BC to about the 4th century AD. The study of the antique was of increasing importance for both the nature and the development of European art from at least the time of Charlemagne, an importance confirmed by the Italian > Renaissance, whose very name implies a 'rebirth' of art under

the influence of ancient models. If painting, sculpture and architecture were all affected by the antique until the advent of > Modernism, this is not to imply that the tradition is now dead, for > Post-Modernism has seen to its resuscitation.

The focal place of the antique in Western art is echoed by the number of articles in this book touched by the concept. Its art works formed the very backbone of the > Classical tradition, and > academies were set up to do honour to that tradition. > Collecting regularly focused on its products, as did public > museums and galleries, both of which were fed in an almost systematic way by the young gentlemen who went on the > Grand Tour – a more elegant version of the > theft of art works. Interest in the phenomenon did not begin with the Renaissance, however: it formed the backbone of > Carolingian art, and is much in evidence in the famous > sketchbook of > Villard de Honnecourt.

Although the antique can be a tyranny, it has normally been an inspiration because of the emotional richness and stylistic variety of the exemplars it has provided, the exemplars themselves more poignant still because they reflect and perpetuate the grandeur and attainments of the > civilizations that gave birth to them.

● K. Borinski, *Die Antike in Poetik und Kunsttheorie vom Ausgang des klassischen Altertums bis auf Goethe und Wilhelm von Humboldt* (1914–24); Phyllis P. Bober, *Renaissance Artists and Antique Sculpture: a Handbook of Sources* (1986); Michael Greenhalgh, *The Classical Tradition in Art* (1978); *The Survival of Roman Antiquities in the Middle Ages* (1987); Erwin Panofsky, *Classical Mythology in Medieval Art* (1933).

APOLLINAIRE, GUILLAUME

(1880–1918). Influential French writer, poet and art critic. Beginning with interests in > Symbolism, he had by 1912 embraced > Modernism in his attempts to make structural experiments analogous to those of the > Cubist painters he so admired. With his word pictures (*calligrammes*) and abundant enthusiasms, notably for Cubist art, Apollinaire was one of the most articulate and visible publicists for the > avant-garde.

● Harry E. Buckley, *Guillaume Apollinaire as an Art Critic* (1981); Francis Steegmuller, *Apollinaire: Poet among Painters* (1863).

APOLLO BELVEDERE

A draped marble statue of the god Apollo in the act of releasing an arrow from his hunting bow. Displayed in the Vatican's Belvedere Court since the late 15th century, it has crystallized one tradition of ideal (> idealism) > beauty from Bernini to > Winckelmann, Anton Raffael Mengs to Canova. In other words, along with the > Belvedere Torso, one of the antiquities most influential in shaping post-Renaissance styles from the > Baroque through to > Neoclassicism.

● Hans H. Brummer, *The Statue Court in the Vatican Belvedere* (1970); Hedwig Kenner, *Der Apoll vom Belvedere* (1972).

APPLIED ART *See* Decorative art.

APPROPRIATION

Although the >copying of art works has a venerable history within the practice of >imitation, the late 20th century has seen the advent of a different attitude towards borrowing. The difference lies in the fact that whilst artists as diverse as Rubens and Ingres advocated imitation of older art as a route to originality, appropriation makes borrowing an end in itself. Contemporary artists such as Sherrie Levine, who has openly reproduced 1930s photographs by Edward Weston and Walker Evans, and Mike Bidlo, who has painted copies after Picasso, challenge the notion of >originality through an interrogation of the model's devices. Other artists with an interest in appropriation include Jeff Koons, Carlo Maria Mariani, David Salle and Julian Schnabel.

● P. Duro, 'Painting in Plato's Cave: Post-Modernism and Imitation', *Art Monthly Australia*, 34 (1990), pp. 13–15.

AQUATINT

Like >etching, aquatint relies on acid eating a plate, but can achieve more varied effects because it deals with tone rather than line. The ground used is porous (perhaps varnish and sugar), so that the acid bites the plate in a more or less mottled effect that can look like a >watercolour wash. Often used with etching to achieve both line and tone, as in the works of Goya.

● John R. Abbey, *Life in England in Aquatint and Lithography, 1770–1860. Architecture, Drawing-Books, Art collections, Magazines, Navy and Army, Panoramas, etc., from the Library of J. R. Abbey: A Bibliographical Catalogue* (1972).

ARCHAEOLOGY

The study of mankind through material remains. Archaeology is a parent of art history, all the more important now that dating and sequencing techniques (introduced as early as >Winckelmann) can provide essential evidence on which the art historian can balance arguments about >attribution. Although the discipline today sees itself as an exact science (and demands laboratories and funding to suit), its academic origins are similar to those of art history, especially in the realms of Classical archaeology, and some university departments are named accordingly.

Needless to say, then, the disciplines of art history and archaeology are especially intermingled in those periods for which records are sparse or missing, when evidence from the earth can help in dating, sequencing or reconstruction. What separates them is the greater amount of theory that modern archaeologists must perforce apply to make patterns and sense out of their material.

● E. Gary Stickel (ed.), *New Uses of Systems Theory in Archaeology* (1982); Glyn Daniel,

A Short History of Archaeology (1981); Glyn Daniel (ed.), *The Past Masters: Eleven Modern Pioneers of Archaeology* (1989); Ulrich Leute, *Archeometry: An Introduction to Physical Methods in Archaeology and the History of Art* (1987); Ian Longworth and John Cherry (eds.), *Archaeology in Britain since 1945: New Directions* (1986); Martin Robertson, *Between Archaeology and Art History*, inaugural lecture (1963).

ARCHAIC ART

Conventionally, the period and style of art preceding the > Classical period of Greek art in the age of Pericles, from the 7th to the mid-5th centuries BC. The period, under > Egyptian influence, showed a developing emphasis on the human figure, male and female, nude and clothed. *See* kouros; kore.

More generally, it can refer to any period preceding one which has remained a touchstone for later centuries.

● Jean Charbonneaux, *Archaic Greek Art 620–480 BC* (1971); Roland Hampe, *The Birth of Greek Art, from the Mycenaean to the Archaic Period* (1981).

ARCHAISM

The deliberate imitation of a past style, even > primitivism, and therefore the eschewing of the range of 'modern' styles currently practised. It is thus part of > revivalism. Archaism may refer back to a golden age for political, religious or just stylistic reasons, or for a mixture of these. Interest under the Emperor Augustus in pre-Classical and indeed Classical Greek art is one example, when it was used to achieve a super-purity of style that not only paralleled (and indeed proclaimed) some of the Emperor's political ideas by confirming his mastery over Greece, but also offered Romans a 'new' and pure art style – the neo-Attic – to go with their 'new' ruler. The *Altar of Augustan Peace*, for instance, owes much stylistically to the Parthenon frieze. The > Pre-Raphaelites were another example of archaism, with their implicit criticism of the bloated exaggerations of art since Raphael, and their declared desire for purity through looking to the > quattrocento for models. The > Nazarenes in Germany had similar aims, which were absorbed in the broad river of the > Gothic Revival.

ARCHITECT

The 'chief maker' of a building. A Greek term indicating control over builders, but which also has grandiloquent overtones (cf. 'the Divine Architect' for God) and which came into common use again only in the > Renaissance. If the term lapsed in the Middle Ages, the entity certainly existed, in > Villard de Honnecourt, for example. The task of the architect often extends beyond designing buildings, to town planning (i.e. the impact of a new building on its environment), interior design and the laying-out of parks.

Since the Greeks, architecture has been a learned profession, involving geometry and a whole range of knowledge, including engineering, as laid out in the text of > Vitruvius, who dedicated his book to Augustus. The architect may thus be both practitioner and

theoretician. The builders of the great cathedrals of the Middle Ages were certainly engineers, probably moving from site to site with their teams as the structures rose. We know very little about the status of the mediaeval architect, but the prestige of the Renaissance architect was high, as can be seen from the arrival of the gifted > amateur (> Alberti) – in other words, architecture was a worthy pastime for lords and gentlemen, witness the countless 18th-century British country houses designed by (or with the help of) their owners.

A feature peculiar to the Renaissance and > Baroque periods is the number of architects also skilled in the other arts; from Brunelleschi and Alberti to Michelangelo and Bernini. This could not last into the 19th century, when new materials and building methods effectively separated the architect from the engineer – a division that continues today.

● Spiro Kostof (ed.), *The Architect: Chapters in the History of the Profession* (1977); Louis F. Salzman, *Building in England Down to 1540: A Documentary History* (1967).

ARCHITECTONIC

A description for something that has the qualities of architecture, and frequently used to describe solid and proportional methods of painting construction. The landscapes of Cézanne and the later paintings of Poussin, for example, might be so called, because they seem partly inspired by the 'construction kit' forms of sphere, cube, etc.

ARCHITECTURE

By extension from 'architect', the art of designing grand buildings (a cathedral is architecture, but is a garage?). In the words of Frederick Kiesler, it is the art of making the superfluous necessary – inhabited sculpture, perhaps, which was Brancusi's definition. Not all > civilizations or groups therein have exerted themselves to pour money into splendid buildings, and recourse must be made to mind-sets and the social context as well as to finance to determine why Athens, for example, built big and enduringly but Sparta did not. According to Nietzsche (*The Twilight of the Idols*, 1889), 'in architecture, the pride of man, his triumph over gravitation, his will to form, assume a visible form. Architecture is a sort of oratory to power by means of forms.'

● John Fleming and Hugh Honour, *The Penguin Dictionary of Architecture* (1972); Nikolaus Pevsner, *A History of Building Types* (1976).

ARCHIVE

A collection of documents, traditionally hand- or typewritten (i.e. not usually printed books, except as ancillary), with a particular focus, which might be an individual, an institution, a city or a state. Archival investigation is the foundation of much basic research in many branches of historical study, enabling scholars to piece together policies and attitudes as well as events and chronologies. In many instances, the

documents provide the best key to accessing a particular period. For example, the archives in Florence are invaluable for > Renaissance art, as would be the Angevin archives in Naples, had not the retreating German Army deliberately set fire to them during the Second World War.

● Marilyn A. Lavin, *Biblioteca Vaticana: Seventeenth-Century Barberini Documents and Inventories of Art* (1975).

ARISTOTLE

(384–322 BC). Greek philosopher and polymath, student of Plato and instrumental in the development of > Neoplatonism, renowned lecturer on subjects from biology and politics to ethics, > aesthetics, theology and metaphysics, and originator of a veritable system (and terminology) of philosophy which remains highly influential. Thomas Aquinas's incorporation of important elements of Aristotle's philosophy into Christian theology was an important element in the further acceptance of > Classical philosophies during the > Renaissance – note the central place given to Plato and Aristotle in Raphael's *The School of Athens* (> Stanza della Segnatura, > Vatican, 1509–11). For Aristotle, as for Plato, art consists of the > imitation of nature; the art object actually possesses beauty, which is therefore not merely in the eye of the > beholder. Beauty can be measured objectively, therefore, and perhaps constructed as a result of measurement – a belief on which > academies of art were sometimes founded. Indeed, in his *Politics*, Aristotle counselled the teaching of > drawing, whereby a sense of beauty and aesthetic judgement might be inculcated. His love of ordering knowledge according to its nature and type (theoretical, practical, productive), and his collections of books and objects which he probably used to illustrate his lectures, make him an honorary founder of the > museum movement, as well as of the classifications of knowledge still current.

● L. Venturi, *History of Art Criticism* (several edns and trans.), chapter 1.

ARMATURE

The skeletal framework that provides the support for a sculpted clay or plaster figure.

ARMORY SHOW

Officially known as the International Exhibition of Modern Art, the Armory Show was an invitational > exhibition of modern art held in the 69th Regiment Armory, New York between 17 February and 15 March 1913. The aim was to bring before the American public > Modernist painting and thus rival the exhibitions of the more conservative > National Academy of Design. It was organized by a group of artists who called themselves the Association of American Painters and Sculptors, formed in 1911 under the presidency of the painter Arthur B. Davies (1862–1928), whose progressive tastes

original intention of presenting an exhibition exclusively of American art was expanded to include European Modernism.

The exhibition was ambitious in two ways. First, it brought together a large number of works, some 1,600; second, it aimed to establish the history of Modernism. The European section, about one-third of the exhibits, included works by Goya, Delacroix, Courbet, Rodin, as well as Redon, Braque, Picasso, Brancusi and Kandinsky. Thus the balance was tilted firmly in favour of French > Impressionism, > Post-Impressionism, > Fauvism and > Cubism. > Expressionism and > Futurism were almost completely ignored. The American section emphasized the younger > avant-garde, and included William Glackens' *Family Group* (1911) and John Sloan's *Sunday, Women Drying their Hair* (1912).

The reaction of critics and public was predictably hostile. Most saw in the exhibition an unwelcome invasion of difficult-to-understand European painting (this at a time when the USA feared the destabilizing effects of mass European immigration). Duchamp's *Nude Descending a Staircase* (1912) was singled out for particular abuse, and Matisse's work was likewise attacked. After New York the exhibition moved to Chicago and Boston, and was seen by a total of some 300,000 people. The importance of the Armory Show is that it exposed the conservative American art world to a coherent and vital form offering a viable alternative to > representational painting.

● M. B. Brown, *American Painting from the Armory Show to the Depression* (1955); B. B. Perlman, *The Immortal Eight: American Painting from Eakins to the Armory Show, 1870–1913* (1979); J. D. Prown, *American Painting from its Beginnings to the Armory Show* (1980); M. W. Brown, *The Story of the Armory Show* (2nd edn 1988); M. B. Green, *New York 1913: The Armory Show and the Paterson Strike Pageant* (1988).

ART AUTRE *See* Tachisme.

ART BRUT

The art of those, such as the mentally ill, whose work cannot be accommodated within established categories. It shares with > naïve art a lack of concern with pictorial or aesthetic conventions. After the Second World War Jean Dubuffet, who coined the term, began a collection later installed in the Château de Beaulieu in Lausanne.

● M. Thévoz, *Art Brut* (1976).

ART BULLETIN

Published since 1913 by the College Art Association of America, the AB is the foremost scholarly journal of art history (all periods and countries) published in the USA, and is noted for its lengthy, well-referenced papers.

ART DEALING

Before the advent of the professional dealer, trade in art works was mostly conducted amongst collectors, or through agents, who were often diplomats or practising artists seen by patrons as most qualified to pass an expert opinion. While an art trade had been a feature of 17th-century Dutch commerce, and art was of course sold to meet the demands of the > Grand Tourist in centres such as Paris or Rome, it was not until the 18th century that dealers such as Gersaint, who dealt in Watteau's paintings, became a feature of the art market – an indication that > collecting was broadening beyond the munificent but otherwise narrow confines of royal > patronage to embrace an aristocratic and bourgeois clientele. In the 19th century an increasingly intolerant > Salon in Paris controlled patronage, with undesirable consequences for progressive and independent artists. A few dealers emerged willing to support new art. The > avant-garde was promoted by dealers such as Durand-Ruel, who supported the > Impressionists, Vollard, who supported Cézanne and Matisse, and Kahnweiler, the dealer of Picasso and the > Cubists. While no one section of the art market can now be said to control the distribution of art, the art dealer has continued to play an important role in mediating between artists and the public.

● M. Gee, *Dealers, Critics and Collectors of Modern Painting: Aspects of the Parisian Art Market between 1910 and 1930* (1981); F. Haskell, *Patrons and Painters: Art and Society in Baroque Italy* (1963; 1986); N. Green, 'Dealing in Temperaments: Economic Transformation of the Artistic Field in France during the Second Half of the Nineteenth Century', *Art History*, 10 (1987); Ambroise Vollard, *Recollections of a Picture Dealer* (Eng. trans. 1978).

ART DECO

A style of > architecture and decoration, between the First and Second World Wars, that saw a revival in the 1960s and in Post-Modernism, especially in architecture. It is Modernist rather than > Historicist, and with a machine-like gloss instead of the naturalistic ornament of Art Nouveau, which it replaced. Since its gods were Modernism and industrialized production techniques, this is not surprising, even if its consequent preference for bold, simple and angular shapes lacks the sophistication of such movements as the > Bauhaus. Much of it hovers on the borders of > kitsch, and it may be questioned on both aesthetic and practical grounds whether the use of modern materials *ipso facto* aids good design.

● Patricia Bayer, .*Art Deco Source Book* (1988); J-P Bouillon, *Art Deco, 1903–1940* (1989); Alastair Duncan, *The Encyclopaedia of Art Deco* (1988).

ART EDUCATION AND TRAINING

The education and training of artists from antiquity onwards has evolved to meet the needs and expectations of artists on the one hand and society on the other. From ancient times through to the Middle Ages, instruction was provided by masters who

taught their apprentices the skills of their > craft through example. Emphasis was placed on practical instruction – know how rather than know why.

With the advent of the > Renaissance this practical instruction was complemented by a more liberal education based on the need for the artist to be able to represent episodes from the classics (> Classicism) and > mythology. In terms of pictorial development, the growing awareness of > perspective required at least some understanding of geometry and mathematics. The improved social status of the artist was a further incentive to widen the student's education. During the late 16th century in Italy, and then across Europe in the 17th century, art instruction became increasingly theoretical. In > academies such as the Accademia del Disegno founded by > Vasari in Florence in 1563 or the Académie Royale de Peinture et de Sculpture founded in Paris in 1648 great emphasis was placed on theoretical discussion and > drawing as the vehicle to translate the artist's inspiration into plastic form, most often mediated through reference to the > antique.

By the age of > Romanticism the view that art education consisted of repeating the formal solutions of the past was beginning to be questioned. Genius, the key concept of the age, was held to be antithetical to rules. Art, so the Romantics held, was not open to instruction but to the free play of the spirit. While > academic art instruction did not cease until well into the 20th century, by the middle of the 19th century education was seen as élitist, and in the crafts in particular there was a revision in favour of social relevance. Whereas the > Arts and Crafts Movement tried to halt the spread of industrial production, the Deutscher Werkbund, founded in Munich 1907, and the > Bauhaus, founded in 1919 in Weimar by Walter Gropius, were more typical in the way they embraced the new methods of production and tailored training accordingly.

Contemporary > fine arts courses have retained something of the teaching of the academies while at the same time embracing the notion of genius. More recently, new forms of visual communication such as > video and > computer-generated images have led to greater diversity. This new technology is challenging the simplistic and orthodox divisions between the fine and the > applied arts and has been partly responsible for an increased interest in the > theory of art, which now occupies an important place in many curricula alongside other academic subjects traditionally taught in art schools, such as > art history. *See also* Art Institutions and Prix de Rome.

● Nikolaus Pevsner, *Academies of Art Past and Present* (1940); Anthony Blunt, *Artistic Theory in Italy 1450–1600* (1940; 1989); A.W.A. Boschloo (ed.), *Academies of Art between Renaissance and Romanticism* (1989).

ARTEFACT

An 'object made with human skill' ('art' being taken in the sense of 'skill' or 'cunning'). The term seeks to be colourless and non-judgemental, thereby avoiding arguments about what is or is not 'art', and allowing us to evaluate woven baskets alongside the Sistine Ceiling. It is much used by anthropology for this very reason.

ARTE POVERA

Italian > Conceptual art movement. An exhibition of the same title was organized in

Turin in 1970. It aimed for expression outside the traditional areas of artistic worth by privileging the > happening on the one hand and a form of > Junk art on the other.

● G. Celant, *Arte Povera: Conceptual, Actual or Impossible Art?* (1969).

ART HISTORY

Established as an academic discipline in universities with Gustav Waagen's chair in Berlin in 1844. 'A "history of art" . . . transforms a notion of art nurtured in the works of art into the subject of a historical account, independent of and only reflected in the works' (Belting, *The End of the History of Art?*). The ramifications of the discipline past, present and future are discussed at length in the Introduction to this volume.

● W. McAllister Johnson, *Art history: Its Use and Abuse* (1988); Janet F. Masters, *Art history: A Study Guide* (2nd edn 1987); Wylie Sypher, *Art history: An Anthology of Modern Criticism* (1975).

ART HISTORY

The journal of the British Association of Art Historians, which first appeared in 1978 (index to the first ten years in the volume for 1989).

ART INDEX

Its full title describes its contents: *Art Index: A Quarterly Author and Subject Index to Publications in the Fields of Archaeology, Architecture, Art History, Arts and Crafts, City Planning, Fine Arts, Graphic Arts, Industrial Design, Interior Design, Landscape Design, Photography and Films and Related Subjects.* H. W. Wilson, New York, 1929 onwards.

ART INFORMEL *See* Tachisme.

ART INSTITUTIONS

While the term institution may be extended to include abstract structures such as art > criticism, here it refers to those bricks and mortar structures such as the École des > Beaux-Arts, although the two kinds of institution are not as distinct as they might first appear.

The institutionalization of art has always existed, whether under royal > patronage – the motivating force behind the building of the pyramids – or, as in > mediaeval Europe, under the tutelage of the > guilds. However, the rise of the > academies in Italy in the late 16th century and then in France – and eventually the rest of Europe – from the 18th century brought about a division between artists who were inside the institutions and those who were excluded. Associated most often with royal patronage,

academies extended their powers to > art education and > display, thereby seeming to gain a stranglehold over the entire art world. They further dictated the nature of art production by enforcing a value system based on > history painting and > academic handling of paint. Thus by the nineteenth century there existed a division between the academicians and the 'independents' that was both material and ideological. The later > avant-garde artists eventually united into an informal 'institution' in opposition to the official, State-sponsored bodies.

While present institutions are not regarded as by definition inimical to the production of art, such organizations as the > Arts Council, along with state-funded art education and exhibitions, do not permit the belief that their influence is in decline.

● Nikolaus Pevsner, *Academies of Art Past and Present* (1940); J. Laurent, A *propos de l'École des Beaux-Arts* (1987); C. Frayling, *The Royal College of Art* (1987).

ARTIST

The recognition of certain kinds of activity as 'artistic', and the practitioner of those activities as an artist, is historically a relatively recent development, beginning with the separation of painters, sculptors and architects from other > 'crafts' during the > Renaissance, a process that was confirmed as an article of faith in the 17th century with the founding of the > academies, and finally transformed into a doctrine by > Romanticism. It is clear, then, that the concept of the artist is intimately related to the separation of the > fine arts from the manual crafts and the subsequent infusion of notions of intellect, > creativity, > invention, emotion and inspiration. While there has never been a time when the work of artists has in any real sense been isolated from a ritual or social function, it has pleased Western societies to regard the separation as definitive, thereby creating the fanciful notion – and retrospectively applying it to cultures where such ideas are totally inappropriate – of the artist as misunderstood > genius.

● A. Hauser, *The Social History of Art* (1951); M. and R. Wittkower, *Born Under Saturn: The Character and Conduct of Artists* (1963); Vasari, *Lives of the Artists*, trans. G. Bull (1965; 1972).

ARTISTES FRANÇAIS, SALON DES *See* Salons.

ART NOUVEAU

Art history documents and studies a succession of 'new' arts, which are usually various forms of > revivalism. Art Nouveau was a European and North American style of decorative art and > architecture from the 1890s to the First World War, which relied on observed rather than formalistic plant forms, and swirling, tendril-derived patterns. These were applied to cutlery and lamps just as to walls and metro stations, or, indeed, to book and magazine illustrations, as in the periodical *Die Jugend*, founded in 1896, which gave the movement its German name of > Jugendstil. This naturalism perhaps stemmed from the work of William > Morris and the > Arts and Crafts Movement. Art

Nouveau as a movement was largely dead by the 1920s, killed by waves of postwar austerity and classicism, not to mention its own excessive tendrilizing and exaggerated naturalistic forms, although its frivolity lived on in > art deco. However, some of its practitioners, such as Charles Rennie Mackintosh and Henry van de Velde, designed restrained pieces whose simplicity chimed in well with industrial design, and achieved a classicism of its own.

● Richard Kempton, *Art Nouveau: An Annotated Bibliography* (1977); Nikolaus Pevsner, *Pioneers of Modern Design* (1960); Peter Selz and Mildred Constantine (eds.), *Art Nouveau: Art and Design at the Turn of the Century* (rev. edn 1975).

ARTS AND CRAFTS MOVEMENT

A rearguard movement occasioned by alarm at the deteriorating quality of design in mid-Victorian Britain, which sought to revive quality production by recourse to handmade techniques. Its worthy theorist was C. R. Ashbee, and William > Morris its most famous practitioner. Socialist convictions (in the manner of John > Ruskin) and ideals of communal living (like mediaeval craftsmen) had its followers fleeing the cities to live in the countryside, and they rejected the manifold > revivalisms that clearly helped to depress the quality of 19th-century > decorative art.

However, fighting against industrialization was the wrong approach (cf. the > Bauhaus, which swam with the flow), and their productions never reached the common man for whom they were intended, because handmaking (as any industrialist could have told them) was simply too expensive. Nevertheless, the movement had much influence in Germany, the Low Countries and the USA, and some of its design ideas were adapted to the machine age.

● Lionel Lambourne, *Utopian Craftsmen: The Arts and Crafts Movement from the Cotswolds to Chicago* (1980); Gillian Naylor, *The Arts and Crafts Movement: A Study of its Sources, Ideals and Influence on Design Theory* (1971); S. K. Tillyard, *The Impact of Modernism, 1900–1920: Early Modernism and the Arts and Crafts Movement in Edwardian England* (1988).

ART SCHOOLS *See* Art education and training.

ARTS COUNCIL OF GREAT BRITAIN

Formed in 1945, the Council is a body of 16 members formed to increase public awareness of and accessibility to > fine art, to improve the standard of art production, and to advise local and national government on arts policy.

ART TRAINING *See* Art education and training.

ARUNDEL, THOMAS HOWARD, 2nd EARL OF

(1586–1646). English patron, > antiquarian and > connoisseur. He was a significant > collector of antiquities and Classical sculpture and of Old Master paintings, including Holbein and > Dürer. He also commissioned paintings from his contemporaries > Rubens and van Dyck. Part of his collection of antiquities is now in the > Ashmolean Museum in Oxford.

ASH-CAN SCHOOL

When in 1907 the conservative > National Academy of Design in New York continued to refuse progressive work, eight young artists – Robert Henri, William Glackens, George Luks, Everett Shinn, John Sloan, Arthur B. Davies, Ernest Lawson and Maurice Prendergast – formed 'The Eight' and in 1908 organized an independent exhibition in the Macbeth Gallery in New York. This was the exhibition of the 'Ash-Can School', and was significant less for the art displayed than for its expression of a break with the academic values of the conservative art establishment. As its name suggests, the school was essentially > realist in outlook, focusing on scenes of everyday life.

● B. B. Perlman, *The Immortal Eight: American Painting from Eakins to the Armory Show, 1870–1913* (1979); D. Braider, *George Bellows and the Ash-can School of Painting* (1971).

ASHMOLEAN MUSEUM

In Oxford, England. Named after Elias Ashmole (1617–92), who presented his collection, much of it a > cabinet of curiosities, to the University in 1675.

● R. F. Ovenell, *The Ashmolean Museum, 1683–1894* (1986).

ASSEMBLAGE

A construction in three dimensions using materials most often overlooked by traditional sculpture, which relates it to > junk art. Early assemblages include > Dada works such as Duchamp's > ready-mades and Picasso's *Bull's Head* (1943), constructed from the handlebars and saddle of a bicycle. The term gained wide currency in the early 1960s following an > exhibition called The Art of Assemblage at the Museum of Modern Art in New York in 1961.

● W. G. Seitz (ed.), *The Art of Assemblage*, exhibition catalogue, Museum of Modern Art, New York (1961); A. Kaprow, *Assemblage, Environments and Happenings* (1966).

ASSYRIAN ART

Mesopotamian art from the 15th to the seventh centuries BC, notable for > bas-reliefs, carved > ivory, > bronze vessels and wall-paintings (which have not survived).

Stylistically, representation of hunting and >battle scenes show great powers of >composition, with finely sculpted bas-reliefs disposed >planimetrically. The figures are usually rather stiff and >perspective is not used.

● R. D. Barnett, *Assyrian Palace Reliefs and the Influence on the Sculptures of Babylonia and Persia* (1960); S. H. F. Lloyd, *The Art of the Ancient Near East* (1961); C. L. Woolley, *Mesopotamia and the Middle East* (1961); M. E. L. Mallowan, *Early Mesopotamia and Iran* (965).

ATELIER

French term for an artist's >workshop or studio. The French language does not have two words for an artist's workplace, as English does with 'workshop' and 'studio', *atelier* serving for both.

ATELIERS LIBRES

(French: literally, 'free studios', i.e. unofficial teaching >academies). In reaction to the increasingly conservative École des >Beaux-Arts, several independent >academies opened in the course of the 19th century. They included the Académie Suisse, where artists such as Courbet and later Cézanne came to study the model free of academic teaching; the Académie Julian, opened in 1860, which included among its professors the celebrated >academic artist Bouguereau and was also home to the >Nabis; the Académie Carrière (1898), noted for its liberal teaching methods, and which counted among its students the future >Fauves; and the Académie Ranson, which the painter Paul Ranson opened in 1908 to further his >Symbolist theories.

ATTRIBUTE

An object associated with a religious, mythical or historical figure, indicating a quality or fact about that person. Examples include keys for St Peter, a wheel for St Catherine, Vulcan's anvil and Cupid's bow. While these may be used >emblematically – St Catherine may be represented simply leaning against a wheel – the attribute can be used in a more complex way by taking the place of an actual depiction of its owner, as in St Mark being represented by a lion. In cases such as this the attribute behaves more like a >symbol. The study of attributes, symbols and >allegory in art is called >iconography.

● E. H. Gombrich, *Symbolic Images* (1972); Rudolf Pfleiderer, *Die Attribute der Heiligen: ein alphabetisches Nachschlagebuch zum Verstandnis kirchliche Kunstwerke* (1987).

ATTRIBUTION

The assigning of a work of art to a period, country, school or individual >*œuvre* following an analysis of its physical, stylistic (>style) and >iconographic features and

49

their comparison with those of other already developed groupings (preferably including signed and/or dated works). Although it appears to some that the effort to determine authorship places an undue emphasis on a biographical (read 'heroic') approach to the > artefact, this is only one of the elements of attribution, which must seek not just to group but also to distinguish an autograph work (i.e. done by the master) from those with varying degrees of masterly intervention, as well as those of his pupils, school or general influence.

A work may, therefore, be attributed according to various criteria. Documentary evidence such as a contract may appear conclusive, but tends in practice to confirm only that a given art work once existed, not that the work in question is the work documented. Most commonly, attribution employs the skills of > connoisseurship to compare stylistically a work of proven authorship with a doubtful work. There are certain conventions for expressing how close an art work is to the artist, school, etc. to which it has been attributed. A work 'attributed to', or even less 'ascribed to', implies the work is not by the artist, that is, it is not 'autograph' (a term not referring to the presence or otherwise of a signature, but meaning 'by the hand of the artist'). When a signature is present it is of course no guarantee that the work is by the artist so named. The only safe attribution is one where the work has a completely documented history from the time of its making, and the work under examination agrees in every particular with that documentary evidence.

A work designated as 'workshop of' is one executed under the control of the artist; 'school of' describes a contemporary follower but not of the artist's workshop; whilst 'circle of' suggests a rather less close connection to the artist than 'school of'. 'Follower' refers to an > imitator of the artist. None of these designations is synonymous with > 'copy'. The language of connoisseurship uses 'after' to classify all kinds of copies, from those that are intended to deceive to those that are not. There are acknowledged auction-house conventions that indicate the degree of certainty of the attribution. Only the presence of the full name and forenames of the artist implies authorship; initials only imply less certainty, and the surname alone means it is not by the artist. It follows, therefore, that the use of 'workshop of' or 'circle of' in an auction catalogue is tantamount to a statement that the work is very distant from the named artist. In these cases the old adage 'buyer beware' has an obvious application.

Although it necessarily proceeds by trial and error (i.e. by the acceptance or rejection of suggestion over time), attribution is an important skill for both the connoisseur and the art historian in their attempts to formulate defensible explanations for the development of art. *See* Studio.

● M. J. Friedländer, 'Artistic Quality: Original and Copy', *Burlington Magazine* (1941), pp. 143–8; A. Perrig, *Michelangelo's Drawings: The Science of Attribution* (1991).

AUTEUR THEORY

(French: 'author'). Critical theory of the 1960s that reacted against the construction of the > artist as a > genius (i.e. the unique individual to whom the originality and significance of an art work can be traced), to embrace the view that focusing on the artist impedes a fuller understanding of the art work. This separation of artist and art work was most trenchantly articulated by Roland Barthes in 'The Death of the Author'

(1977). Here 'death' does not mean the literal death of the artist, but rather that she or he has been usurped as the key to understanding the art work by the > beholder, who interacts with the art work to produce a meaning.

Michel Foucault replied to Barthes in an essay entitled 'What is an Author?' (1978). Unlike Barthes, Foucault believed criticism could not do without the 'author function' as a focus for criticism, although, like Barthes, he did not suppose that study of the artist is the same thing as study of the work an artist produces. Instead of seeking an explanation in the mind or life of the artist, Foucault argued that the artist is constrained within a web of cultural relations, and that this is the real 'subject' we must seek.

In terms of art practice, these ideas may be found in such divergent expressions of unease with the notion of genius as the > multiples of Andy Warhol or the lack of a focal animating authorial presence in group > happenings.

● R. Barthes, *Image–Music–Text* (1977); M. Foucault, *Language, Counter-Memory, Practice: Selected Essays and Interviews* (1977); J. G. Merquior, *Foucault* (1985); D. E. Pease, 'Author', in *Critical Terms for Literary Study*, ed. F. Lentricchia and T. McLaughlin (1990).

AUTHORSHIP *See* Attribution.

AUTOGRAPH *See* Attribution.

AUTOMATISM

The practice by which the artist allows the unconscious to manifest itself through chance or improvisation. It was central to > Surrealism and later influenced the > Abstract Expressionists, who saw their paintings as a working-out of a subjective state of mind. Typical practices of automatism included Max Ernst's > frottages and Picabia's ink-blot technique.

● *Max Ernst*, exhibition catalogue, Musé Nationale d'Art Moderne, Paris (1975); J. H. Matthews, *The Imagery of Surrealism* (1977).

AUTOMNE, SALON D' *See* Salons.

AVANT-GARDE

That section of any institution or movement (usually political or artistic) judged, usually by its adherents if by nobody else, to be ahead of the rest, in contradistinction to those who bring up the rear and are *retardataire*, or at least in favour of the status quo. 'The forward march of art becomes the responsibility of a cultural élite who feel entitled to define progress among themselves and who are nonetheless convinced that history will take up the rear' (Belting, *The End of the History of Art?*). The term is loaded with political

and social undertones. I am stable, reliable, and for the status quo; you are a left-wing avant-gardiste; he is a dangerously *retardataire* reactionary. It is a misconception that the right wing is never avant-garde; witness the nurturing in Italy of good, excellent and very bad > architecture under Fascism. The whole concept includes an element of alienation, of artists who feel themselves and their work to be outside current social norms. To this extent, it is a spin-off of > Romanticism.

The concept of an avant-garde in art is scarcely older than the 19th century, before which the ostensible aim of any artist who required commissions was to conform to expectations, a procedure that, in spite of contemporary beliefs to the contrary, stifled neither initiative nor innovation. The 19th century, however, much influenced by the Romantic concept of the struggling artist, the measure of whose quality depended on his being against the current trends or at the very least unappreciated by normal cognoscenti, developed the concept of the avant-garde not only to explain unappreciated innovation, but often to justify the left-wing political attitudes surfacing in art during the period.

As a result, it is difficult, although far from impossible, to view the development of 'modern art' as anything other than a battle between the eventually triumphant, brilliant and often left-wing avant-garde and the institutionalized, mediocre and *retardataire* Establishment. Although there is some truth in the artistic version of 'What Manchester does today, London does tomorrow' (e.g. the work of Cézanne, Manet, Monet versus the rest), such a black-and-white approach is facile, ignoring on the one hand the innovations of the traditionalists, and on the other the extent to which the avant-garde used tradition as a springboard.

● Hans Belting, *The End of the History of Art?* (1987); Edward Tims and Peter Collier (eds.), *Visions and Blueprints: Avant-garde Culture and Radical Politics in Early Twentieth-Century Europe* (1987); Renato Poggioli, *Theory of the Avant-garde* (1968); Robert C. Williams, *Artists in Revolution: Portraits of the Russian Avant-garde, 1905–1925* (1977).

AVIGNON, SCHOOL OF

A school of painting that flourished during the residency of the papal court at Avignon in the 14th century. The > patronage dispensed by the popes attracted a colony of artists to the city. *See* Papacy.

B

BAEDEKER

Karl Baedeker (1801–59) initiated a series of guidebooks to the countries and cities of Western Europe and the Mediterranean basin that are an early equivalent of the > TCI and the > *Buildings of England*. They were in part modelled upon those issued by the English publisher John Murray. Although of course outdated (in many cases even the street names have changed), Baedekers are invaluable for the picture they give of Europe before the great political and social changes occasioned by two world wars and various revolutions.

● *Baedeker's Handbook(s) for Travellers: a Bibliography of English Editions Published Prior to World War II* (1975).

BAMBOCCIANTI

Painters of (at first Italian) street and peasant scenes, named after the 17th-century > Dutch painter Pieter van Laer, whose deformed body gave him the nickname 'Il Bamboccio', little clumsy one. This type of > genre painting was very popular, as a walk round any country house will demonstrate.

BARBERINI

Prominent Tuscan princely family of the 16th and 17th centuries which had a large and often guiding impact on the development of the > Baroque. Maffeo Barberini (1568–1644) took the papal throne in 1623 as Pope Urban VIII and proceeded to express the new-found confidence of the Catholic Counter-Reformation in large building projects and by commissioning the best artists, Bernini foremost amongst them. Urban's appropriation of > bronze beams from the Pantheon to build Bernini's baldacchino in St Peter's (as well as to make cannon for Castel Sant'Angelo) occasioned the famous quip, 'What the Barbarians once did, the Barberini do now'. His nepotism was just as constructive. His nephew Francesco (1597–1679) was made a Cardinal, and he had Maderno, Borromini and Bernini build Palazzo Barberini (1625–33), with Pietro da Cortona painting the famous > *trompe-l'œil* ceiling to its gallery in 1640. He also formed a famous library and collection of antiquities.

● John B. Scott, *Images of Nepotism: The Painted Ceilings of Palazzo Barberini* (1991).

BARBIZON SCHOOL

A group of mid-19th-century French > landscape painters centred on the village of Barbizon on the edge of the Forest of Fontainebleu. Although none of them broke with the convention of exhibiting studio-executed > compositions, they made > *plein air* studies directly from nature. Their compositions did not follow the classicizing (> Salons) convention of providing a historical theme as the focus. This identified them as progressives and made their approach attractive to the younger generation of > Impressionists who came to Barbizon to paint outdoors while still students in Charles Gleyre's studio. The principal Barbizon artists were Diaz de la Peña, Théodore Rousseau and Charles-François Daubigny. Millet, although not a Barbizon School painter, lived in the area.

● Jean Bouret, *The Barbizon School and Nineteenth-Century French Landscape Painting* (1973).

BARGELLO

(Italian: 'prison', 'gaol'). As its name suggests, the Bargello, built in Florence in the 13th century as a private residence, was converted into a prison in 1574. In the 19th century it was restored and transformed into a museum. Its holdings of > Renaissance sculpture include such seminal works as Donatello's *David* (1432–40) and *St George* (1415–17) and Michelangelo's *Bacchus* (c.1496–7).

BARNES, DR ALBERT C.

(1872–1951). American collector whose fortune derived from pharmaceuticals. His > collection is principally of Old Masters and > Modernist painting, including Renoir, Cézanne, Matisse and Picasso. In 1922 he established the Barnes Foundation at Merion, Pennsylvania to house the collection and provide a centre for the study of the history of art, although the > museum was never open to the public during its benefactor's lifetime and has only restricted opening to this day.

BAROQUE

A term used to denote a period covering the 17th and much of the 18th centuries in Italy, as well as in Spain, Germany, Austria and, to some extent, France – that is, the period between > Mannerism and > Rococo.

The term is, however, more clearly concerned with style, and it first developed as a reaction to the contorted confusions of Mannerism, which seemed unable to convey any message because part of its appeal was precisely its jigsaw-like complexity and its closed nature. Baroque, on the other hand, promoted energetic simplification and, in the work of Caravaggio, for example, a return to some of the ideals of High > Renaissance > Classicism. But Baroque is best seen not in individual paintings but in whole ensembles, where the term implies grandeur, spatial complexity and an interest in the excesses of both decorative elaboration and of light and shade – in short, a sense

of theatre that often involves the manipulation of the spectator, whether the medium is painting, sculpture or > architecture. The 'ringmaster' artist must co-ordinate all the arts in order to achieve the desired impact, so that Baroque is frequently the union of the arts working together, as in Bernini's 'control' of the crossing of St Peter's, or his arrangement of the piazza outside.

Often considered a Catholic art form, this definition offers a partial explanation for the limited effect of the style in the Protestant parts of the Low Countries, in Britain, or in (Gallican) France, where the Baroque was often tempered by Classicism, as in the paintings of Poussin. The style had a long life, with notable revivals towards the end of the 19th century.

● Francis Haskell, *Patrons and Painters: A Study in the Relations Between Italian Art and Society in the Age of the Baroque* (1963); Margaret Lyttelton, *Baroque Architecture in Classical Antiquity* (1974); John R. Martin, *Baroque* (1977); Christian Norberg-Schulz, *Baroque Architecture* (1971); Rudolf Wittkower, *Gian Lorenzo Bernini, the Sculptor of the Roman Baroque* (3rd edn 1981); *Studies in the Italian Baroque* (1975).

BARR, A. H. Jr.

(1902–81). American > art historian and founding director of the > Museum of Modern Art, New York (1929–67). His contribution to the history of > Modernism was twofold: firstly, he established the museum as the pre-eminent collection of modern art in the world; and secondly, his interpretation of the development of Modernism, most in evidence in *Cubism and Modern Art* (1936), bordered on the prescriptive, as it not only charted the past but implied the agenda for the future of 20th-century art.

BATTLE PAINTING AND SCULPTURE

These form almost a > genre by themselves. Representations of battle go back further than the metopes of the Parthenon to the > Egyptians and > Assyrians, and in the ancient world were especially popular on > sarcophagi, tombstones, > triumphal arches and columns because of the way they could project the correct image of the victorious ruler or the heroic (or heroized) deceased. Similar images must have been depicted in paintings as well, although the famous *Darius fleeing Alexander* is now known only through a (decorator's) mosaic version from Pompeii (Museo Nazionale, Naples). It was little practised during the Middle Ages, but Uccello, Piero della Francesca and others repopularized the genre during the > quattrocento, no doubt after studying surviving > antique examples on sarcophagi and bas-reliefs (e.g. Column of Trajan, Rome), and also on > coins and > medals. The torch was passed to Titian and Rubens, both of whom were much inspired by copies of the battle paintings resulting from > Leonardo's and Michelangelo's > frescos in Palazzo Vecchio, Florence (long since destroyed through tracing, and then painted over).

The French Revolutionary and Napoleonic Wars occasioned a fine crop of battle pieces, not least among the Allies, for whom St Paul's Cathedral and Trafalgar Square are pantheons to the war dead. The Restoration continued the trend, and the Gallery of Battle at Versailles is but a continuation of the wartime decorations completed for Louis

XIV in the Salon de la Guerre in the same palace. The Napoleonic period sees some awkwardness in attempts to represent the true nature of warfare, which, being considerably more deadly than in ancient times, was no longer so heroic (whether it took place in modern dress, which looked strange, or nude, ditto). > Romanticism, fascinated by blood and sudden death, did not mind, and we find outbreaks of horror-painting (Gros, for example) instead of the usual mode of heroic conventionality. The First World War might be thought to have killed off the genre, but it survives intact to the present day, the many versions of *The Raising of the Flag on Iwo Jima* (modelled on Joe Rosenthal's famous 1945 photograph) bearing witness to this fact.

● Nina M. Athanassoglou-Kallymer, *French Images from the Greek War of Independence 1821– 1830: Art and Politics Under the Restoration* (1989); Denis Thomas, *Battle Art: Images of War* (1977).

BAUDELAIRE, CHARLES

(1821–67). The most influential French poet and critic of his age. Baudelaire held that timeless > beauty was an abstraction and notions of beauty differed from age to age. Thus for Baudelaire it followed that beauty should be sought in its individual expression and not, as the classicists advocated, in its general aspect. Refusing to make moral beauty a prerequisite for physical beauty, Baudelaire glorified the outcasts of contemporary society in the poems of *Les Fleurs du mal* and in art criticism such as his 'Salon of 1846', in which he called for resistance to the deadening effects of bourgeois culture. In his search for an artist to record modern life, he considered but rejected > Delacroix as too romantic and Courbet as too literal-minded (Baudelaire's hero needed imagination to see the sublime in the everyday). Baudelaire could have chosen Daumier or Manet, but with *Le Peintre de la Vie Moderne* (1863) he settled on a relatively unknown draughtsman, Constantin Guys, to represent his views. Baudelaire had tremendous influence on the > Symbolists but, unlike them, he sought to escape into society, not to shun it. More than any other artist or critic, Baudelaire posited the representation of contemporary life as central to the Modernist endeavour.

● C. Baudelaire, *The Painter of Modern Life and Other Essays*, ed. J. Mayne (1964); Jonathan Mayne (ed.), *Charles Baudelaire: Art in Paris, 1845–1862: Salons and Other Exhibitions* (1965; 1981); Walter Benjamin, *Charles Baudelaire, a Lyric Poet in the Era of High Capitalism* (Eng. trans. 1983); Gitta May, *Diderot et Baudelaire critiques d'art* (rev. edn 1967); Georges Poulet, *Baudelaire: the artist and his world* (1969).

BAUDRILLARD, JEAN

Contemporary French theorist who has had enormous influence on > Post-Modernist thought. His ideas on 'simulacra' challenge notions of > originality and authenticity. The modern environment of mass consumption, electronic imagery and the circularity of information means that we cannot maintain an objective 'reality' separate from our means of generating it; thus artists must find reality in representation. This has been

taken by some artists as an endorsement for a socially irresponsible form of self-reference in which images have meaning only within the discourse of art.

● J. Baudrillard, 'The Precession of Simulacra', in *Art and Text* (1983).

BAUHAUS

(German: 'building house'). German design school founded in 1919 in Weimar by Walter Gropius and closed by order of the Nazis in 1933. Gropius united a team of > avant-garde teachers that included > Kandinsky, Klee, Moholy-Nagy and Lyonel Feininger. Its artistic philosophy was influenced by William > Morris and the > Arts and Crafts Movement, and aimed to end the > fine art/ > craft division and integrate all the arts under > architecture (Gropius was an architect). Students undertook a six-month introductory course on > form, > colour, materials and techniques without any reference, as in traditional art training (> Art education and training), such as that of the École des > Beaux-Arts, to the example of the past. After this the students graduated to a workshop of their choice, such as > stained glass, ceramics, mural-painting (> fresco) or stage design.

In 1923 an exhibition was mounted to silence critics of the Bauhaus in Weimar. In spite of its success, the Bauhaus continued to be the target of political attacks, and in 1925 it moved to Dessau. With this move the emphasis on craft was replaced by a focus on > functionalism, while the expressionistic tendencies of Klee and Kandinsky characteristic of the early experiments in painting were succeeded by geometrical abstraction under the influence of Russian > Constructivism and the Neo-Plasticist doctrines of De > Stijl. The period was enormously fruitful, with many of the Bauhaus's best designs coming from these years, as well as a series of Bauhaus books including Klee's *Pedagogical Sketchbook* and Kandinsky's *Point and Line to Plane*.

In 1928, however, with political attacks once again renewed, Gropius resigned as director to be replaced by the Swiss architect Hannes Meyer, who had joined in 1927 as the first (tardily appointed) head of > architecture. Meyer left in 1930 and was replaced by a leading architect of > International Style, Mies van der Rohe, whose emphasis on architecture alienated some of the painters, so that Klee left in 1931. The Nazis continued to agitate for the School's closure, succeeding in 1932. For its last year the Bauhaus was in Berlin, until the Nazi government of 1933 forced its definitive closure in April of that year. Members of the Bauhaus spread its philosophy across the world, especially to the USA. Gropius became Professor of Architecture at Harvard University, while Moholy-Nagy founded a New Bauhaus in Chicago.

● H. Beyer et al., *Bauhaus* 1919–1928, exhibition catalogue, Museum of Modern Art (1938; 1955); G. Naylor, *The Bauhaus* (1968); H. M. Wingler (ed.), *The Bauhaus* (1969).

BEAUTY

Far more than the pleasing external appearance of beings and things. For Stendhal, beauty was the promise of goodness, for > Kant the very symbol of moral goodness; and as a Kurdish proverb says, if God didn't love beauties, he wouldn't have created

them. All three suggest the essence of beauty's place in art; namely that far from being just a transient ('skin-deep') effect of light, shade and chance, it is the manifestation of moral goodness, and is beloved of God. The artistic pursuit of beauty therefore ties appearance with essence and > form with idea, beauty being, according to Charles Kingsley, the very signature of God. Thus to create beauty is to worship God, and to admire it is to admire yet another manifestation of the glory of God.

This is not simply a Christian construction, however, and it has Plato (> Neoplatonism) as its most influential exponent. This conjunction of pagan and Christian was especially convenient for the cult of beauty promoted by the > Renaissance since it could be seen not simply as pagan opportunism, but as active worship of the Godhead. Thus Michelangelo's David, clearly modelled on pagan exemplars (e.g. at Pisa), is 'religious' not simply because of its Old Testament subject-matter.

● Albert Hofstadter and Richard Kuhns (eds.), Philosophies of Art and Beauty: Selected Readings in Aesthetics from Plato to Heidegger (1964); Valerie Steele, Fashion and Eroticism: Ideals of Feminine Beauty from the Victorian Era to the Jazz Age (1985).

BEAUX-ARTS

The phrase literally means > 'fine arts' in French, and in a French-speaking context is used to differentiate the arts of painting and sculpture from the > decorative arts or > crafts. There are two, related uses: 1. The École Nationale Supérieure des Beaux-Arts (Paris) is often shortened in speech to the 'Beaux-Arts'. Founded in 1793 but with origins dating back to the foundation of the French Academy in 1648, its training emphasized a gradualism based on a reworking of tradition. 2. The pedagogical aesthetic of the École engendered the 'Beaux-Arts Style', which manifested itself in painting, sculpture and > architecture. The style consisted of an > eclectic borrowing of motifs and subjects drawn from past styles, often, as in the case of architecture, incongruously married with the use of new industrial materials such as cast iron, for example in the work of Labrouste, architect of the Bibliothèque de Ste Geneviève (1838–50), and Jean-Louis-Charles Garnier, architect of the Paris Opéra. In the fine arts, major exponents of the style included the painter Henri Regnault and the sculptor Carpeaux, whose La Danse (1869) adorned the façade of the Opéra (the original is now in the > Musée d'Orsay).

● A. Boime, The Academy and French Painting in the Nineteenth Century (1971; 1986).

BEHOLDER

Until recently any demands or expectations held by the spectator or viewer were considered incidental to the consideration of art, preference being given to the artist's intention as the key to meaning. This attitude has recently been challenged, however, by those who argue that the construction of meaning is a two-way process, and that the role of the beholder in this process is pivotal. The approach has been adopted by several factions in recent > art history from reception theorists (> reception aesthetics) -

to feminists (>feminist art history), both of whom regard the social status, intellectual make-up, or gender of the beholder as central to the construction of meaning.

● M. Fried, *Absorption and Theatricality: Painting and the Beholder in the Age of Diderot* (1980); R. C. Holub, *Reception Theory: A Critical Introduction* (1984); G. Pollock, *Vision and Difference* (1988).

BELL, CLIVE

(1881–1964). Art >critic whose aesthetic theories were encompassed by the notion of 'significant form', by which he meant those qualities in an art work that distinguish it from other kinds of objects. Bell saw a painting as principally a flat surface covered with >colours and shapes: 'To appreciate a work of art we need bring with us nothing but a sense of form and colour and knowledge of three-dimensional space.' Bell found in Cézanne the most complete expression of this >formalism. Along with Roger >Fry, Bell was instrumental in introducing the work of the >Post-Impressionists to the British public. He was involved in the selection of works for the Second Post-Impressionist >Exhibition organized by Fry in 1912. He contributed to the study of art through his insistence that aesthetic enjoyment is a property of the form not of the content (subject-matter) of the art work. His major ideas are contained in the essays 'The Aesthetic Hypothesis' and 'The Debt to Cézanne' in *Art* (1914). Other publications include *Since Cézanne* (1922), *Civilization: An Essay* (1928) and *Victor Passmore* (1945).

● L. Venturi, *History of Art Criticism* (1936; 1964); W. G. Bywater Jr., *Clive Bell's Eye* (1975).

BELLORI, GIOVANNI PIETRO

(1615–96). Italian art theorist, >antiquarian and >collector. In emulation of >Vasari's account of the >Renaissance, he wrote on >Baroque art in *Vite de' pittori, scultori et architetti moderni* (The lives of modern painters, sculptors and architects, 1672). He was the leading 17th-century Italian advocate of >antique >beauty and his ideas were very influential on the development of >academic art theories, including those of the French >Academy, >Winckelmann and >Reynolds.

BELVEDERE TORSO

A late Hellenistic fragment signed by Apollonius, in the Belvedere Court of the >Vatican in >Renaissance times and now in the main body of the Vatican Museums. The muscular figure vied with the >*Laocoön* in the popularity and influence stakes, from Michelangelo (cf. the Sistine Ceiling) to the 19th century.

BENJAMIN, WALTER

(1892–1940). German cultural theorist whose essays and fragmentary studies on 19th-century Paris, the cinema and the theatre of his friend Brecht are perhaps the greatest

essays of cultural criticism in the 20th century. Always open to the importance of paradox and contradiction, Benjamin combined great originality of thought with unorthodoxy of opinion, which allowed him to profit from the > Marxist tradition of dialectical materialism tempered with great sensibility. Essays pertinent to visual culture include 'Charles Baudelaire: A Lyric Poet in the Era of High Capitalism' (1973), 'The Author as Producer' in *Understanding Brecht* (1966), and most importantly, the seminal essay 'The Work of Art in the Age of Mechanical Reproduction' in *Illuminations* (1968).

● T. Eagleton, *Walter Benjamin, or Towards a Revolutionary Criticism* (1981); R. Wolin, *Walter Benjamin: An Aesthetic of Redemption* (1982).

BERENSON, BERNARD

(1865–1959). Art historian. From 1887, when he went to Europe to study under > Morelli, he was a major figure in the systematization of Italian > Renaissance art through > attribution and > connoisseurship and 'B.B.'s Lists' of paintings he attributed to > artists. His villa near Florence, I Tatti, now part of Harvard University, remains as it was under Berenson, a study centre dedicated to the elucidation of Italian art.

For some Berenson's career offers an object lesson on what happens when connoisseurs get too close to dealers (> art dealing); for others, he is remembered as a potent force in the training of two generations of art historians. Although the clouds of hagiography are now parting, we shall know even more when his correspondence with > Duveen is revealed in the year 2005 and we can see just how the partnership between > art history and commerce actually functioned.

● Ernest Samuels, *Bernard Berenson: The Making of a Connoisseur* (1979); Colin Simpson, *The Partnership: The Secret Association of Bernard Berenson and Joseph Duveen* (1987).

BERGER, JOHN

(1926–). British art critic and writer. After working as a painter and teacher of painting, Berger contributed > Marxist criticism to the *New Statesman*. While Berger's Marxism has a humanist face, he contends that art must mirror social change. Thus, in *The Moment of Cubism and Other Essays* (1969) he argues for connections between revolutionary art and revolutionary politics. In other works, most notably the hugely successful *Ways of Seeing* (1972), based on a television series, Berger confronts such issues as the role of consumerism, the portrayal of women, and art and money in ways that are only now becoming part of art historical enquiry. Other examples of Berger's criticism include *Permanent Red: Essays in Seeing* (1960; 1979), *The Success and Failure of Picasso* (1965; 1980), *Art and Revolution* (1969), *The Look of Things: Essays* (1974), *About Looking* (1980) and *The White Bird* (1985).

● G. Dyer, *Ways of Telling: The Work of John Berger* (1986).

BIBLE

One of the main sources for the subject-matter of centuries of Western art, its importance relies on its contents being a lingua franca. Its > propaganda import and value for artists and the Church is clear, and perhaps 90 per cent of surviving art up to the later > Renaissance is based in some way upon it. The matter of the transmission of > iconographic themes from Early Christian illustrated Bibles through to the Middle Ages is complicated; the illuminated Bibles themselves are amongst the most splendid of artistic creations. The illustration of the text continued after the advent of printing, at first with > woodcut illustrations, which were sometimes hand-coloured.

The > Reformation threw its contents into even greater prominence, for Protestants of various kinds relied on it to the exclusion of those mechanisms provided by the Catholic Church. As Calvin exclaimed in 1534: 'My Mass, here it is! It's the Bible, and I don't want any other!' The market for Bible translations in the vulgar tongue was huge, and illustrated editions popular (Burgkmaier, Augsburg 1523; Holbein, Basle 1522 and 1523). They have remained so to this day, not necessarily accompanied by the texts, witness Gustave Doré (1866), Chagall and Rouault.

● Walter Cahn, *Romanesque Bible Illumination* (1982); George Henderson, *Studies in English Bible Illustration* (1985); Mordechai Omer, *Turner and the Bible* (1981); Ronald Paulson, *Book and Painting: Shakespeare, Milton and the Bible: Literary texts and the Emergence of English Painting* (1982).

BIEDERMEIER

The simple and homely furniture and decoration > style (and by extension, painting and sculpture styles) of Germany in the first half of the 19th century, comparable to its British early Victorian counterpart in its middle-class 'feel'. The name, based on a fictitious philistine, might translate as the 'Smith style'.

● George Himmelheber (ed.), *Kunst des Biedermeier, 1815–1835: Architektur, Malerei, Plastik, Kunsthandwerk, Musik, Dichtung und Mode* (1988); Geraldine Norman, *Biedermeier Painting, 1815–1848: Reality Observed in Genre, Portrait and Landscape* (1987)

BINDER

The agglutinant in > paint or > pastel that 'binds' the particles of the > pigment together and causes them to adhere to the > ground.

BIOGRAPHY *See* Monograph.

BIOMORPHISM

> Abstract form that echoes plant or animal life rather than the machine world. Thus the sculpture of Hans Arp, Henry Moore and Barbara Hepworth is biomorphic.

BLACK-FIGURE VASE PAINTINGS

The earlier of the two main methods of Greek vase painting, whereby the figures, applied to the clay as a thin reddish liquid, changed to black when fired. Details had to be added with incised lines (showing the clay colour through the black) or with added white or red. In a sense, the process is the reverse of > naturalistic. After *c*.530 BC, > red-figure painting took over.

● John D. Beazley, *Attic Black-figure Vase Painting* (reprinted 1978); John Boardman, *Athenian Black-figure Vases: A Handbook* (1974).

BLAKE, WILLIAM

(1757–1827). English > Romantic artist and poet, whose individualist and visionary spirit was the antithesis of that of Sir Joshua > Reynolds, whom he attacked in the marginalia of his own copy of the the second edition of the *Discourses* (1798). Blake took exception to Reynolds, of whom he noted, 'This Man was Hired to Depress Art', for advocating the > imitation of older art as the route to > originality, and worse, for denying the concept of native > genius. To this Blake retorted, 'The Man who says that Genius is not Born, but Taught – Is a Knave'.

● Morris Eaves, *William Blake's Theory of Art* (1982); Robert N. Essick, *The Visionary Hand: Essays for the Study of William Blake's Art and Aesthetics* (1973); 'Blake's Annotations of the Discourses' in Sir Joshua Reynolds, *Discourses on Art*, ed. R. R. Wark (1959; 1981).

BLAUE REITER, DER

('The Blue Rider'). In 1911 a number of painters, including Wassily > Kandinsky, Franz Marc and August Macke, seceded from the > Expressionist Neue Künstlervereinigung (NKV or New Artists' Association) after criticism of Kandinsky's > abstract tendencies. The name of the group derived from a cover illustration of a horse and rider by Kandinsky for an almanac (essays and graphic work) of the same name published in 1912, which also included the important essay by Kandinsky, 'On the Question of Form'. The almanac was the forum for the group's ideas about the correspondence between different art forms such as music, painting, dance and theatre. It also included examples of > folk and > naïve art, tribal and children's art. The name was also given to an exhibition at the Thannhauser Gallery in Munich, which subsequently toured Berlin, Cologne and Frankfurt and included works by Kandinsky, Marc, Macke, Heinrich Campendonck, Albert Block, Paul Klee, the composer Arnold Schoenberg, Robert Delaunay and Henri Rousseau. A much larger exhibition was staged in 1912 and also toured the German provinces. Although still exhibiting Expressionistic tendencies, the direction of the group (Kandinsky in particular) was towards non-objective (> abstraction) painting. The movement did not survive the deaths of Marc and Macke in the First World War, and the move of Kandinsky back to the Soviet Union and then his return, in 1921, to a teaching post in the Bauhaus.

● K. Lankheit (ed.), *The Blaue Reiter Almanac*, Eng. trans. H. Falkenstein (1974); H. K. Rothel, *The Blue Rider* (1971); P. Vergo, *The Blue Rider* (1977).

BLOCK BOOK

An early form of printed book in which each page was cut from a separate block (> woodcut), incorporating both text and illustrations. This labour-intensive form of reproduction lost popularity after the invention of movable-type printing.

BLOOMSBURY GROUP

A group of artists and writers influential in England in the early years of this century. Among the artist members were Vanessa Bell and Duncan Grant and the art critics Clive > Bell and Roger > Fry. It was in this context that Fry began his promotion of the > Post-Impressionists and Bell wrote many of his most influential essays (*Art*, 1914). The group was instrumental in forwarding the cause of English Modernism.

● I. G. Lumsden, *Bloomsbury Painters and their Circle* (1976); S. P. Rosenbaum (ed.), *The Bloomsbury Group* (1976).

BLUNT, ANTHONY

(1907–83). British art historian and spy for Soviet Russia, Director of the > Courtauld Institute, Surveyor of the King's (later Queen's) Pictures (1945–72), and author of studies on French and Italian art and > architecture largely of the 17th century, specializing in Poussin and later in the art and architecture of the Italian Baroque. As Director of the Courtauld Institute, he influenced the teaching and learning of > art history in postwar Britain. Unmasked as a Russian spy and relieved of his knighthood, he has been the subject of interesting speculation about whether paintings smuggled out of the Eastern bloc may have been used to pay him for his treachery. Evidently, art history can lead to an interesting career involving travel.

● Barrie Penrose and Simon Freeman, *Conspiracy of Silence: The Secret Life of Anthony Blunt* (1986).

BODY ART

In the 1960s and 1970s some artists began to use their own or occasionally other people's bodies as the vehicle for artistic expression. Related to > Happenings, > Conceptual art and > Performance art, it saw the body subjected to a variety of treatments, from the choreographed public performances of the gilded and besuited Gilbert and George to the self-mutilation of Gina Pane, who cut patterns into her skin with razor blades. Unlike Performance art, however, it was not interested in the participation or involvement of an audience. In place of an audience many of the body

artists, such as Vito Acconci, whose work included holding his breath and disfiguring his arm by friction, recorded the result on photographs, film or video. By involving the artist directly in the art work, Body art opposed the detached cerebralism of 1960s > Minimalism.

● J. Maisonneuve and M. Bruchon-Schweitzer, *Modèles du corps et psychologie esthétique* (1981).

BODY COLOUR

Opaque water-based paint produced by mixing > pigment with white. A true > watercolour of transparent colours may thus be heightened with body colour.

BOLOGNESE SCHOOL

An important centre for art in both the Middle Ages and the > Renaissance (e.g. Jacopo della Quercia, Michelangelo), the heyday of the Bolognese School was the later 16th century. Then, painters such as Pellegrino Tibaldi and especially the Carracci family developed a classicizing style of nobility and simplicity that flew in the face of current Mannerist trends. Their ideas were taught in the Accademia degli Incamminati – the > academy of 'those who have set out on the road', this being the road to good art. Tibaldi had brought his ideas from Rome, and the Carracci took them back there (notably in the Farnese Gallery, and in Sta Maria del Popolo and S. Luigi dei Francesi), guiding by their example the development of the 'liberated' Classicism of Caravaggio, Domenichino, Guido Reni and Guercino, which we describe as > Baroque.

● Anna M. F. Baraldi, *Pittura bolognese del '500* (1986); S. J. Freedberg, *Circa 1600: A Revolution of Style in Italian Painting* (1983).

BOOK OF HOURS

A prayer book for private use, essentially the services with variations. As an art object for rich individuals, especially during the 15th century, it was the carrier for some of the most sumptuous of all book > illumination, for example, the *Très Riches Heures du Duc de Berry*. Because the calendar was often illustrated, it gave artists the opportunity to display secular activities as well as religious ones in a recognizable contemporary setting – important elements in the construction of northern > naturalism as championed by artists such as Jan van Eyck, whose own art (like that of Mantegna, for example) was probably restricted to large-scale paintings, but included > miniatures as well.

● Janet Backhouse, *Books of hours* (1986); John Harthan, *Books of Hours and their Owners* (1977).

BORGHESE GALLERY

A collection of paintings and sculpture begun by Cardinal Scipione Borghese (1576–1633), the nephew of Pope Paul V and a > connoisseur influential in the art world of 17th-century Rome, notably as patron of the young Bernini. The arrangement of the works in the villa in which it is housed (and to which many > antique sculptures were added in the 18th century) remains much as the Cardinal ordained it, which is important for understanding the impact of Bernini's placing of his own works.

BOSSE, ABRAHAM

(1602–76). French engraver and > perspectivist who, as Professor of Perspective, became embroiled in a heated dispute with Charles Lebrun, director of the French > Academy, over the significance of 'rules' in art. While Lebrun reserved the right to 'correct' nature, including occular perception, as the need arose, Bosse was adamant that mathematically proven theories must prevail. The significance of this dispute reflects the course a 17th-century academy needed to chart between a liberal (> liberal arts) respect for rules and an avoidance of the mechanical aspects of > craft.

● A. Bosse, *Le peintre convert aux règles de son art*, ed. R.-A. Weigert (1964).

BOTTEGA

(Italian: 'shop'). The Italian designation for the > workshop or studio of the > artist. For practical reasons it was most often on the ground floor and perhaps open to the street.

BOZZETTO

(Italian: 'sketch', 'model'). A painted > sketch, or in sculpture a small-scale model for a larger work, for example a study in wax or clay for a > monumental > bronze.

BRAVURA

(Italian: 'bravery'). Although in Italian this also means skill, in critical language it carries the implication of forcefulness and daring. Thus Frans Hals is a bravura painter, showing the demonstrable skill and verve of a > painterly > artist, while Rubens may also be considered to possess the quality because of his dynamic > compositions.

BRITISH MUSEUM

Begun as an amalgam of private > collections, beginning with Sir Hans Sloane's, together with manuscripts from the Harley and Cotton collections, and opened in 1759 in cramped quarters. Signal collections were added over the years: the Classical vases of

William Hamilton (1772), the Townley Marbles (1805), the > Elgin Marbles (1816), and George III's books (1828). Important for the range and quality of its collections, for the scholarship of the publications of its staff, and for its active research programme, including the commissioning of travel and excavations, the BM's conservation standards are also world-class (and, unlike the J. Paul > Getty Museum, it does not sit over the San Andreas fault). In addition, the BM became a model for others to follow by offering the first large-scale collections open (at first by application and ticket) to the public in Western Europe and North America, thereby extending what was already a practice at large country houses.

As > architecture, the BM now offers not just the Greek Revival of Smirke's main building (1823–47), but also the more adventurously industrial iron construction of the famous Reading Room (1857). As a centre for scholarship, the BM, a copyright library, has accommodated scholars from > Marx to > Gombrich, although its functions have been transferred to the British Library, with a hotly debated fate for the Reading Room itself.

Its collections, as hinted above, are extensive, the Department of Prints and Drawings being especially useful for art historians, with extensive holdings by Dürer, Claude, Rembrandt, Rubens and Turner.

● J. Mordaunt Crook, *The British Museum* (1972); Edward Miller, *That Noble Cabinet*: A *History of the British Museum* (1973); David M. Wilson, *The British Museum: Purpose and Politics* (1989).

BRONZE

An alloy largely or exclusively of copper and tin, used since about 2000 BC. Because of its lower melting-point, it is easier to cast – using some kind of mould or supporting core – than copper, and also harder. Hence it was early recognized as an ideal material for sculpture: lighter than > marble, able to be duplicated, not to mention repaired, and sturdy enough to survive outdoors. Just as attractive to sculptors was the material's ability to take fine detail (best seen when working in the *cire-perdue* (> lost wax) method, and also to retain a beautiful > patina.

Casting was a specialized business, sometimes experimented with by the adventurous (such as Donatello), but often left to professionals, for example, bell-casters. Sculptures would usually be made around a core (apparently wooden in ancient Greece), and with small statuettes or even life-size pieces this might be left in place. Larger sculptures would have the core removed and then be given a skeleton ('armature') so that the metal could be cast suitably thin and therefore not cost too much. > Colossal statues, like their smaller fellows, would conveniently be cast in sections and then fitted together, perhaps with drapery or armour to conceal the joins. Bronzes could therefore be more adventurous than marble; better suited, for example, to large-scale equestrian statues, or to figures in energetic action with wide-flung limbs.

Such a luxurious > medium has always been popular, and statuettes especially so, not just amongst > collectors, but also with artists, for whom they provided portable models, as it were. Ghiberti, for example, probably had > antique statuettes in bronze and > terracotta to inspire his work on the > Gates of Paradise. > Renaissance collectors avidly sought not only the antique statuettes themselves, but also modern

versions and imitations inspired by the antique. Large-scale bronzes have suffered from changing fashions and especially from war, for their material is intrinsically precious and they are easily melted down.

● Suzanne Doeringer et al. (eds.), *Art and Technology: A Symposium on Classical Bronzes* (1970); Christian Hauser, *Art Foundry* (1974); Jennifer Montagu, *Bronzes* (1963); George Savage, *A Concise History of Bronzes* (1969).

BRÜCKE, DIE

('The Bridge'), formed in Dresden in 1905 by a group of young architectural students: Ernst Ludwig Kirchner, Fritz Bleyl, Erich Heckel and Karl Schmidt-Rottluff. The following year others, principally Max Pechstein and·Emil Nolde, were invited to join. In October 1906 the group held its first exhibition in Dresden. Another was organized in December 1906 and a travelling exhibition for 1907. In 1910 the group joined the Neue Sezession (New Secession), founded by Pechstein and others in Berlin, but later withdrew from the association to keep its independence. The last group exhibition occurred in 1912, and the group disbanded in 1913.

The group's name was meant to signal both the artists' sense of unity and their aim of being a link with, and catalyst for, the art of the future. Their art, highly > Expressionist, and for the most part > figurative, is often shocking and crude. Their greatest achievement lies in reviving the > woodcut, capitalizing on its expressive potential for strong discordant > colour and employing an aggressive line in which the carving into the block is left rough and textured.

● *Brücke 1905–1913: Eine Kunstlergemeinschaft des Expressionismus*, exhibition catalogue, Folkwang Museum, Essen (1958); *Painters of the Brücke*, exhibition catalogue, Tate Gallery (1964),

BRUNELLESCHI, FILIPPO

(1377–1446). Italian goldsmith, sculptor and architect, who in 1401–2 entered (and lost) the competition for a new set of doors for the Florence Cathedral baptistery. In 1402 he went to Rome, probably with Donatello, and this may have been when he picked up his taste for > architecture, which occupied him from *c.*1415. As well as building numerous churches in Florence and the Hospital of the Innocents there, his overwhelming achievement was the erection of a dome over Florence Cathedral; he began this in 1420, and the lantern was completed after his death. He was the subject of a biography of *c.*1485, perhaps by Manetti, which promoted him as one of the prime movers of > Renaissance architecture.

● Eugenio Battisti, *Brunelleschi: The Complete Work* (1981); Frank D. Prager, *Brunelleschi: Studies of his Technology and Inventions* (1970); H. Saalman (ed.), *Antonio Manetti: The Life of Brunelleschi* (1970).

BRUSH

Painter's tool for applying > paint to the picture surface, consisting of a bush of either animal hair or synthetic material attached by glue and a ferrule to a wooden handle. Various sizes and shapes of different kinds of hair permit a very wide degree of flexibility. Bristle (hog-hair) brushes are used for > oil painting, softer animal-hair brushes such as sable for > watercolour, and nylon brushes for > acrylic paints.

BUDDHIST ART

The representation of the Buddhist religion, perhaps the most widespread and influential artistic and architectural tradition in the East, following Buddha's death around 480 BC in India. Buddhism has affected deeply and permanently the artistic and architectural landscapes of Korea, China, Japan, Thailand and South-East Asia. Its impact on the West has been small; in the other direction, Buddhist sculpture in Gandhara (north-west India and Pakistan) has been deeply affected by > Greek art.

● Benjamin Rowland, *The Art and Architecture of India: Buddhist, Hindu, Jain* (3rd edn 1967); Dietrich Seckel, *The Art of Buddhism* (1964); Chikyo Yamamoto, *Introduction to Buddhist Art* (1990).

BUILDINGS OF ENGLAND

A series of guidebooks to the > architecture and non-movable furnishing of English secular and religious buildings, begun by Nikolaus > Pevsner in 1951 (with Cornwall), and still being revised and enlarged. Nobody with even a passing interest in English architecture can afford not to consult these invaluable, accurate, opinionated and sometimes quirky volumes.

● Bridget Cherry and John Newman (eds.), *The Best Buildings of England: An Anthology*(1986).

BURCKHARDT, JACOB

(1818–97). Swiss art historian, and a student of Ranke. He popularized the Italian > Renaissance with his discursive guidebook *Cicerone* (1855) and, especially, with *Die Kultur der Renaissance in Italien* (The Civilization of the Renaissance in Italy; 1860), which is less about art than about culture. Reflecting perhaps the preoccupations of the mercantile aristocracy of his own century, Burckhardt 'set the agenda' for how to look at the Renaissance, and almost invented the concept, beginning with an imaginative section on 'The State as a Work of Art'. He worked with the belief – convincingly voiced by > Hegel – that each age has a spirit, and that a careful description will reveal it. His most famous book is *Die Kultur der Renaissance in Italien*, a form of > *Geistesgeschichte* – cultural history – rather than art history.

● J. Burckhardt, *Letters* (1955); E. M. Janssen, *Jacob Burckhardt und die Renaissance* (1970).

BURIN

The pointed steel tool, with handle, used by the engraver (> engraving) to make grooves in the plate. It is pushed forward to give the necessary and often variable excavating depth and breadth.

BURKE, EDMUND

(1729–97). Statesman and politician who appears here for his A *Philosophical Enquiry into the Sublime and the Beautiful* (1757), influential in both England and, especially, in Germany (e.g. on > Kant, in his *Critique of Judgement* of 1790). He distinguished > beauty, which can be rationally perceived, from the sublime, which is an emotion invoked by the limitlessness and grandeur of wild and awesome scenery and natural phenomena such as storms. Burke's interests corresponded to a reaction against the cerebral niceties of the Classical > landscape in favour of a more emotional mode, hence his writing paralleled the vogue for the > picturesque, and set the tone for aspects of > Romanticism (cf. the work of Caspar David Friedrich or John Martin).

● Walter J. Hipple, *The Beautiful, the Sublime and the Picturesque in Eighteenth-Century British Aesthetic Theory* (1957); Alice P. Miller, *Edmund Burke and his world* (1979).

BURLINGTON, RICHARD BOYLE, EARL OF

(1694–1753). He made the > Grand Tour to Italy for the first time in 1714–15, but soon returned there enthused with > Palladianism and made a collection of drawings of the master's work (now in the RIBA), some of which he published in 1730. His work at Chiswick (*c*.1725), together with his > patronage of architects such as Campbell and designer-architects such as William Kent, secured Palladianism as a fashion in England from which Georgian architecture took its complexion. He inspired and funded the publication of William Kent's *Designs of Inigo Jones* (1727) and Robert Castell's *Villas of the Ancients* (largely concerned with gardens; 1728), and published his own Palladio drawings of Roman baths as *Fabbriche antiche* in 1730. In all, the very apotheosis of the British gentleman > amateur. By > connoisseurship, patronage, example and publication, he laid the foundations for a new Classicism in British > architecture and garden design and for the revival of the attainments of Inigo Jones himself. In short, Burlington is one of the axes in the history of > taste.

● James Lees-Milne, *Earls of Creation: Five Great Patrons of Eighteenth-Century Art* (1962).

BURLINGTON MAGAZINE

The Burlington magazine for Connoisseurs was founded in 1903, and is, with > Art History, one of the premier scholarly > journals in the subject.

BYZANTINE ART

The art of the Eastern Roman Empire centred on Constantinople from its establishment as a 'new' city by Constantine in AD 313, up to and even beyond its capture (and the rest of the Empire before it) by the Turks in 1453. Byzantine art is characterized by both the survival and reuse of strong > antique traditions, and by a hieratic attitude towards religious art. Byzantium was important to the West throughout the Middle Ages, not only as a source of works of art – chalices, manuscripts, silks – but also as almost a definition of > civilization itself during whole centuries when cultural values in the West were often in danger of complete collapse. Constantinople – Byzantium – was thus *the* exemplary city (civilization = 'citification') at a time when Rome was in ruins.

The impact of Byzantine art on the West was often through gifts or trading, but the trickle changed to a flood with the sack of the city in 1204 during the Fourth Crusade, when boatloads of > icons, manuscripts and other art works, largely religious, reached the West. That impact is now best seen in Venice, where the > architecture and decoration of St Mark's is Eastern. Another wave of art works, and scholars, came to Europe following the fall of the Byzantine Empire in 1453, occasioning an upsurge of interest in and knowledge of > Greek art and > culture.

● V. D. Van Aalst and K. N. Ciggaar (eds.), *Byzantium and the Low Countries in the Tenth Century: Aspects of Art and History in the Ottonian era* (1986); Andre Grabar, *Byzantium: Byzantine Art in the Middle Ages* (1966); Ernst Kitzinger, *The Art of Byzantium and the Mediaeval West: Selected Studies*, ed. W. E. Kleinbauer (1976); Kulaus Wessel and Marcell Restle (eds.), *Reallexikon zur Byzantinischen Kunst* (1966).

C

CABINET OF CURIOSITIES

The forerunner of the modern museum, albeit with an emphasis on typology rather than chronology, its German name of 'Wunderkammer' describes it well, for it housed wonders ranging from rare shells and coins to narwhal horns, coral carvings and what today we would call ethnographic materials. Probably since Roman times, if not earlier, gentlemen and princes have collected the strange and the curious, from mummified mermaids to (stuffed) two-headed calves. Cabinets were particularly popular in the > Renaissance. The > Ashmolean Museum in Oxford is one of the few remaining museums with such a cabinet as its original nucleus, although written descriptions and > catalogues are not rare. Antiquities and works of art could also be included, as well as fossils and other elements of natural history, but the first emphasis was on the strange and unnatural, and fakes were rife. *See also* museums and galleries.

● Oliver Impey and Arthur MacGregor (eds.), *The Origins of Museums: The Cabinet of Curiosities in Sixteenth- and Seventeenth-Century Europe* (1985); Arthur MacGregor (ed.), *Tradescant's Rarities: Essays on the Foundation of the Ashmolean Museum, 1683, with a Catalogue of the Surviving Early Collections* (1983); Julius von Schlosser, *Raccolte d'arte e di meraviglie del tardo Rinascimento* (German original 1908; Italian trans. 1974).

CABINET PAINTING

The term for a small > oil painting, most often of a > genre, > still life or > fête galante theme, and painted for a domestic or intimate environment. Thus paintings as different as Vermeer's *View of Delft* (> Mauritshuis, *c.*1660) and Fragonard's *The Swing* (> Wallace Collection, *c.*1766) are cabinet paintings. The name 'cabinet' derives from the French *cabinet d'amateur*, meaning the small private museum of a > connoisseur or > amateur.

CALLIGRAPHY

The art of handwriting. While calligraphy in the West has long been regarded as a > craft, in > Chinese and > Islamic cultures the status of the written word, textually integrated with the pictorial representation, cannot be so easily separated from the > fine arts. Even in Europe, mediaeval book > illumination did not distinguish so categorically text from illustration or embellishment. By the 16th century copybooks and the rise of printing had had the effect of unifying calligraphy around a few major scripts such as Gothic, Roman or Italic. The art of calligraphy spread across Europe from Italy,

often being incorporated into each state's attempts to homogenize diverse regional differences. Thus Colbert in 17th-century France dictated the style of script to be used by the administration, while the plainness of 'copperplate' English perhaps reflects a pragmatic need for an unambiguous presentation of commercial transactions. With the advent of typewriting in the late 19th century and more recently the word processor, calligraphy is now without a practical purpose, allowing for its renaissance as an art form worth pursuing in its own right.

● A. S. Osley (ed.), *Calligraphy and Palaeography* (1965).

CAMDEN TOWN GROUP

Formed in London in 1911, the group included Walter Sickert, Spencer Gore, Lucien Pissarro, Augustus John, Wyndham Lewis, Duncan Grant and Henry Lamb. The group had little aesthetic cohesion, other than a preference for empirical observation rather than Continental 'theorizing'. The group held exhibitions in 1911 and 1912, and in 1913 merged with the Cumberland Market Group and the Fitzroy Group to form the London Group. This larger association included Paul and John Nash and Vanessa Bell (associated with the > Bloomsbury Group). The new group exhibited in Brighton in 1913 as 'The Camden Town Group and Others', then under its own name from 1914. The London Group continued to exhibit after the Second World War, when it was a forum for artists attracted by the group's mildly progressive tendencies.

● W. Baron, *The Camden Town Group* (1969).

CAMERA LUCIDA

(Latin: 'light chamber'). The name is misleading, but was so called by analogy with the > camera obscura. Invented at the beginning of the 19th century, the camera lucida is a drawing aid consisting of a prism placed before the eye in such a way that the operator is able to trace the captured image on to a sheet of paper set below.

● John H. Hammond, *The Camera Lucida in Art and Science* (1987).

CAMERA OBSCURA

(Latin: 'dark chamber'). An aid to painting, it consists of a darkened box, or room into which the artist climbs, with a small aperture in one wall through which light from a well-lit scene enters, forming an inverted image on the wall opposite. Later, more sophisticated models added a lens to the aperture, increasing its affinity to the human eye or the photographic camera. Its strength as an aid to drawing resides in its ability to distil on to a flat surface the confused visual information that strikes the eye. It was much used by topographical and Dutch > still-life painters. Eminent practitioners include the Dutch > genre painter Vermeer in the 17th century and the > veduta painter Canaletto in the 18th century.

CANON

In art the term refers to works of a given artist, period or school accepted 'into the canon' as genuine (>attribution) by connoisseurs. When applied to an artist the term >*œuvre* may be used.

CANVAS

A woven fabric used as a >support for >oil or >acrylic painting. It is usually made of linen, cotton, jute or hemp. It is stretched over a wooden frame (>stretcher) and must be treated with >size and primed with a >ground before the paint is applied. It superseded the >panel as the principal support for painting in the 16th century, being lighter, more easily transportable and relatively easy to construct, as well as offering a larger format and more 'give' and variation in the surface texture.

CAPRICCIO

(Italian: 'caprice'). A composition of fantastic, bizarre or surreal subject-matter or a work of excessive imagination, such as Goya's aptly named series of nightmare visions, *Los Caprichos*. The capricci of Guardi and Canaletto show imaginative reconstructions of well-known monuments in impossible locations.

CARAVAGGISTI

Followers and imitators of Caravaggio (1571–1610), who set a model for extravagant >chiaroscuro and >realism that remained popular, especially in Southern Europe, throughout the 17th century. They did not form a >school as such, but his admirers nevertheless spread his manner to Naples, the Low Countries, France and Spain.

● Alfred Moir, *Caravaggio and his Copyists* (1976); Benedict Nicolson, *The International Caravaggesque Movement: Lists of Pictures by Caravaggio and his Followers Throughout Europe from 1590 to 1650* (1979).

CARICATURE

From the Italian for 'to load', a portrait where those features that specifically identify a person are exaggerated, although not necessarily maliciously. The notion is distinct from an interest in physiognomical types such as informed the work of >Leonardo. Mediaeval artists doodled likenesses in the margins of manuscripts, but true caricatures date from the later 16th century in Italy with Annibale Carracci, Domenichino and then Bernini. Caricature is a weapon in the armoury of the humorous >cartoon, well seen in the works of Hogarth and Rowlandson, as well as in Daumier's >lithographs for the weekly magazine called *La Caricature*.

● Werner Hofmann, *Caricature: From Leonardo to Picasso* (1957); Francis Kingender, *Hogarth*

and English Caricature (1944); Lionel Lambourne, *An Introduction to Caricature* (1983); Gerhard Langemeyer, *Mittel und Motive der Karikatur in funf Jahrhunderten: Bild als Waffe* (1985).

CAROLINGIAN ART

A term designating the art and > architecture of the reigns of Charlemagne (800–814) and his successors (Louis the Pious and his sons) until about 900. Thanks probably to the astuteness of Charlemagne himself, as well as his scholarly entourage, a clear programme for the renewal of art and architecture was established, relying partly on the attainments of > Byzantium, some of whose artists and works were imported, but more especially on the revival of the art of pagan and especially Early Christian Rome. This was reflected even in the regalia of kingship and empire. Basilican churches with a T-plan appeared, together with Roman sculptural forms, and Byzantine-influenced mosaics with pagan and Early Christian > iconography were welcomed. Roman-style > frescos were made, and although little direct evidence has survived for these, their existence can be proven by the > revivalism of sumptuous manuscript > illuminations, many of which used models influenced by Hellenistic art. This was not just a > court art but a national, even nationalistic one, the agenda being to revive the Roman Empire itself, with Charlemagne as the new Augustus, as his biographer Einhard's *Life*, modelled on the manner and contents of Suetonius, makes clear.

The first of a series of revivals or renaissances, Carolingian art is of crucial importance to the development of > Romanesque art and architecture, foreshadowing many of its characteristics.

● John Beckwith, *Early Mediaeval Art: Carolingian, Ottonian, Romanesque* (1964); K. J. Conant, *Carolingian and Romanesque Architecture, 800 to 1200* (1959); A. Grabar and K. Nordenfalk, *Early Mediaeval Painting from the Fourth to the Eleventh Centuries* (1957); Percy E. Schramm et al., *Denkmale der deutschen Koenige und Kaiser*, 2 vols (1962 and 1978).

CARTOON

1. Named after the paper from which it is made, the final, full-size design for a painting, which the artist will transfer to the final > support either by scribing the lines with a stylus, or by pricking through them; 2. A humorous drawing. We have early indications of their potential in the circle of the Carracci and their impromptu sketches of each other doing ordinary things. The > genre developed and prospered as a channel for social and political comment, and is common today.

● The eds. of the Foreign Policy Association, *A Cartoon History of United States' Foreign Policy, 1776–1976* (1975); David Kunzle, *A History of the Comic Strip* (1973); Robert Philippe, *Political Graphics: Art as a Weapon* (1982).

CARTOUCHE

Decorative escutcheon, usually ovoid or lozenge-shaped, left blank in the centre to

accommodate an inscription. In carving, the reduction of material such as > stone, > marble or wood into the desired shape, such as a sculpture or architectural ornament. It is the opposite of > modelling, where the process is additive, as with clay.

CARYATID

A female figure doing duty as a vertical architectural support, most famously in the pseudo-columns of the Erechtheum in Athens.

CASSIRER, ERNST

(1874–1945). German philosopher and author of important books on *Individual and Cosmos in the Renaissance* (1927) and the *Philosophy of Symbolic Forms* (1923–9). See also a collection of his essays and lectures in *Symbol, Myth and Culture* (1979). Inspired by 18th-century rationalist ideas, language, art, religion and science were for Cassirer symbolic forms used by man to build a new, ideal world. When first informed in 1920 of the unorthodox arrangement of books in the > Warburg Institute (philosophy next to astrology and magic, and art linked with literature and philosophy), he remarked: 'The library is dangerous. I shall either have to avoid it altogether or imprison myself here for years' – which he did.

● Silvia Ferretti, *Cassirer, Panofsky and Warburg: Symbol, Art, History* (1989); Seymour W. Itzkoff, *Ernst Cassirer: Philosopher of Culture* (1977).

CASSONE

A long, low chest in decorated wood given as a wedding present or containing a wedding dowry, and especially popular during the Italian > Renaissance. The Cinemascope-like shape would be painted with appropriate scenes from the > Bible or Classical mythology.

CASTING *See* Bronze.

CATALOGUE RAISONNÉ *See* Catalogues.

CATALOGUES

This form of documentation has become increasingly popular with art historians and the gallery-going public. There are three major kinds of catalogue. The first is the catalogue of an artist's > *œuvre*, often called a *catalogue raisonné*. This is a critical listing of the entire production of an artist, and it pays special attention to issues such as the measurement, title, medium, > provenance, exhibition history, condition, and literature

of the work. The *catalogue raisonné* is also particularly concerned with discriminating between > original, by-the-hand-of-the-artist works and > copies or > forgeries.

The second kind of catalogue is that of a museum's permanent collection. Most major museums have devoted considerable time and money in the form of curatorial expertise to the making of such catalogues. Those of the > National Gallery in London, for example Martin Davies' *The Earlier Italian Schools* (1961), are exemplary. Nothing is assumed or asserted without substantiating evidence. As such these catalogues promote a > connoisseurship that is both valuable and deeply conservative.

The third kind is the catalogue of the temporary exhibition. With the rapid increase in popularity of the temporary exhibition, catalogues have grown in importance. They are now thoroughly researched, well illustrated and reliable, often combining all the advantages of the catalogues discussed above with a critical perspective absent from the curatorial catalogue. These catalogues remain in the long term valuable works of reference, not least because it has become the norm to include good illustrations and to append a detailed bibliography.

● M. Pointon, *The History of Art: A Students' Handbook* (1980; 1989), esp. pp. 73–6.

CAVE PAINTING

Caves and other shelters hold some of the oldest art – drawings as well as paintings – in the world, and the phenomenon is worldwide, with a truly enormous number of examples. Research grows apace, hampered by difficulties in dating the actual art surface, except by stylistic comparisons or by examining the occupation levels in the cave. Popular subjects are the animal world and man's would-be domination over it by hunting and/or magic. Some of the art sites are too deep in mountainsides to have been conveniently habitable, hence the likelihood that many – Lascaux, for example – were decorated with some religious or ritualistic purpose.

Not all caves are natural, and not all cave art is prehistoric. Troglodytic living is still convenient and popular in those areas where the rock is easily worked, although social pressures (for example, at Matera in Southern Italy) are against it. Cappadocia has a plethora of frescoed rock churches from the > Byzantine period, as well as complete underground cities.

● L'Abbé Breuil, *Four Hundred Centuries of Cave Art* (1952); André Leroi-Gourhan, *The Dawn of European Art: An Introduction to Palaeolithic Cave Painting* (1982); Alexander Marshack, *The Roots of Civilization* (1972); Thomas G. E. Powell, *Prehistoric Art* (1966); Nancy K. Sandars, *Prehistoric Art in Europe* (2nd edn 1985); Ann Sieveking, *The Cave Artists* (1979); Klaus F. Wellman, *A Survey of North American Indian Rock Art* (1979).

CAYLUS, COMTE DE

(1692–1765). Well-travelled French > antiquarian with an interest in contemporary art and intimately involved with official French artistic life with the Academy (> academies) of Painting from 1731 and with the Academy of Inscriptions from 1742. His interest in the Classical past made him influential in the development of > Neoclassicism, partly

because of his support of artists working in this manner. His own > collecting led to the publication in seven quarto volumes of his heavily illustrated *Recueil d'antiquités égyptiennes, étrusques, grecques, romaines et gauloises* (1752–67), used as a sourcebook by practising artists. Caylus's work is important in the development of > archaeology as a strict discipline (rather than as mere treasure-hunting), and his ideas, work, publications and reputation much affected > Winckelmann in developing his own approach to the past.

CELLINI, BENVENUTO

(1500–71). Italian goldsmith and > Mannerist sculptor. He led a boisterous and interesting life, being involved with the papacy during the Sack of Rome, and eventually working for Francis I in Paris and Fontainebleau. His autobiography (many editions and translations, although not published until 1728), gives a stimulating picture of his own arrogance, of fights with courts over > patronage, and of the artistic life of the age, with heroic (if not wholly believable) accounts of the casting (in > bronze) of his *Perseus*, and of various narrow escapes.

CELTIC ART

The counterpoint, as it were, of the > Greek and > Roman traditions of European art, and first developed in France and Germany during the 5th century BC. Although Celtic art often used motifs from the classical world, its main concern was non-> figurative, depending on the dynamism and intricacy of pattern and line, and its ornamental motifs were frequently anthropomorphic, and/or mixed with vegetal and animal motifs from the Classical world. If the fanfares of Roman art subdued the voice of native traditions, when the Roman culture crumbled (3rd century AD onwards), Celtic forms came once more to the fore, reinforced by similarly > decorative art from the waves of invaders populating Europe during the Migration Period. The stronghold of these forms was Scandinavia, where Classical influence (except via trade) was slender.

The contribution of Celtic art to the fabric can be clearly seen in manuscript > illuminations (most famously in The Book of Kells) and in > Romanesque sculpture, especially of tympana and column capitals. The > Renaissance, with its cult of > antique > beauty, killed it, except for various fitful > revivals connected with local nationalisms.

- Vincent and R. Megaw, *Celtic Art from its Beginnings to The Book of Kells* (1989).

CENNINI, CENNINO

(c.1370–c.1440). Early > Renaissance Florentine painter. No paintings by Cennini survive, but he is celebrated as the author of the earliest Italian treatise on painting, *Il Libro dell' Arte*, written c.1390. The importance of this book resides in the fact that it records the practices and methods of the > mediaeval workshop while introducing the new ideas of the Renaissance. The treatise is encyclopaedic on craft processes such as 'How goat glue is made, and how it is tempered; and how many purposes it will serve', and 'How to

model on a panel with *gesso sottile*, and how to mount precious stones'. However, Chapter I also introduces ideas on the status of the > artist alien to the mediaeval mind: '[Painting] calls for imagination and skill of hand, in order to discover things not seen . . . and to fix them with the hand, presenting to plain sight what does not actually exist'. And: '[Painting] justly deserves to be enthroned . . . with poetry. The justice lies in this: that the poet . . . is free to compose and bind together, or not, as he pleases, according to his inclination. In the same way, the painter is given the freedom to compose . . . as he pleases, according to his imagination'. This comparison between the poet and the painter (> *ut pictura poesis*) was to become central to the Renaissance notion of the > artist and instrumental in the justification of the foundation of > academies of art.

● Cennino d'Andrea Cennini, *The Craftsman's Handbook*, trans. D. V. Thompson Jr. (1933; 1960).

CERCLE ET CARRÉ

('Circle and Square'). An artists' association with a journal of the same name founded by a group of > Constructivists in 1929 in Paris. It was superseded in 1931 by the > Abstraction-Création group.

CHALK

Drawing material shaped into a stick, used for drawings in which a soft, ambiguous line is desired. As well as the familiar white (limestone) chalk, there is sanguine, a red chalk made from red ochre, and black chalk, made from carbonaceous shale.

CHAMP DE MARS, SALON DU *See* Salons.

CHAMPFLEURY

(1828–89). Pseudonym of Jules Husson, novelist and critic. He was a member of the > Realist > school and an early supporter of Gustave Courbet.

CHARCOAL

A > drawing material made by charring sticks of wood such as willow or vine. The resulting > medium offers a soft, ambiguous line highly suitable for a broad treatment of the subject. It is used in establishing the composition of an > oil painting, where broad outlines and indications of mass are required. Charcoal smudges easily, and may be modified by rubbing. While these qualities were prized by colourists such as Tintoretto and Rembrandt, > academic thinking proscribed charcoal as open to abuse, allowing the painter to 'fudge' areas of the composition by exploiting the properties of the medium. It is not permanent without the use of a > fixative.

CHEF D'ŒUVRE *See* Masterpiece.

CHIAROSCURO

The term, which means 'bright-dark' in Italian, refers to the disposition of light and shade in a composition to give the effect of volume, mass or space. It is more commonly applied when a > painterly and dramatic use of tonal contrast is central to the representation of the action, and it is this meaning that Roger de > Piles gives chiaroscuro in his *Cours de Peinture* (1708). Artists remarkable for the use of chiaroscuro include Rembrandt and Caravaggio.

CHINESE ART

With origins reaching back more than 4,000 years and > artefacts ranging from armour through painting and ceramics to > architecture, and exhibiting mastery of many materials from > bronze to silk and paper, Chinese art covers an enormous chronological, technical and cultural span, influencing regions as distant as Europe, India and the Middle East. The use of bronze, which was worked with unsurpassed skill, was common in the Shang (1766–1122 BC) and Chou (1028–256 BC) periods, when it was fashioned into ceremonial vessels and domestic utensils. Sculpture of > stone, > marble and bronze was widely practised, and was a feature of funerary ornamentation, as in the tombs of the Han period (206 BC–AD 220).

Stylistically, > Buddhism, which arrived in China in the period of wars between the Han and the Sui (581–618) periods, introduced Indian > naturalism to the region's sculpture. In ceramics, the invention of porcelain during the T'ang period (618–906) revolutionized pottery manufacture and design. Reaching its apogee in the Ming period (1368–1644), porcelain exerted a tremendous influence on European ceramics – without, however, the Europeans ever succeeding in imitating true porcelain – and was the focus of European > chinoiserie in the 18th century. Painting, considered in China, as in the post-> Renaissance West, as an intellectual rather than a manual art, was dominated by > ink painting, which fuses the arts of representation and > calligraphy. Paintings were made on silk or paper, in ink and > watercolour, in the form of scrolls. This technique migrated to Japan, where the scrolls are known as > Yamato-e.

Central to Chinese art is the representation of landscape, rendered in a non-scientific form of > perspective that attempts to reconcile distance and foreground through the judicious use of devices such as meandering rivers. This tradition continued for centuries until in the 19th century it fell into an > academicism and sterility that was broken only when China was rudely confronted by the economic and cultural power of the West at the beginning of the 20th century. The influence of European movements such as > Cubism and > Surrealism was replaced after the Communist take-over in 1949 with the imposition of > Socialist Realism.

● W. Watson, *Style in the Arts of China* (1974); S. E. Lee, *A History of Far Eastern Art* (1964; 1973); M. Sullivan, *The Arts of China* (1967; 1978); J. Cahill, *Painting at the Shore: Chinese Painting of the Early and Middle Ming Dynasty 1358–1580* (1978); M. Loehr, *The Great Painters of China* (1980); J. Cahill, *The Distant Mountains: Chinese Painting of the Late Ming Dynasty*

1570–1644 (1982); *The Compelling Image: Nature and Style in Seventeenth-Century Chinese Painting* (1982).

CHINOISERIE

The term denotes the influence of > Chinese > fine and > decorative art on European taste, especially during the 18th century. With the opening of trade routes by world powers such as Great Britain and the Netherlands, Chinese ware became available in quantity for the first time. The vogue for Chinese design particularly influenced interior furnishings, ceramics, > architecture and landscape gardening. Chinoiserie properly refers not to Chinese > artefacts but to the products made by European manufacturers in emulation of the Chinese style, or by factories in the Far East that copied these European imitations.

● H. Honour, *Chinoiserie: The Vision of Cathay* (1961; 1973).

CHRISTIAN ART

Has been a main focus for artistic and architectural > patronage, productivity and development in the West from the 3rd century AD until well into the 19th century, when encroaching secularism born of the > Industrial Revolution and consumerism began to reduce its profile. Any historian of the Western art of those centuries is not adequately equipped without a knowledge of the > Bible, perhaps also of the > Book of Hours, and certainly of the > iconographical traditions and transformations involved in the representation of the holy story and also in the construction and furnishing of houses of God.

● André Grabar, *Early Christian Art: From the Rise of Christianity to the Death of Theodorius* (1968); David F. Martin, *Art and the Religious Experience: The 'Language' of the Sacred* (1972); *Reallexikon fuer Antike und Christentum. Sachwoerterbuch zur Auseinandersetzung des Christentums mit der antiken Welt* (1950); Gertrud Schiller, *Ikonographie der christlichen Kunst*, 4 vols (1966–80).

CHRISTIE'S

The first auction house to sell art, Christie, Manson & Woods began in London in 1766, and now has branches and interests worldwide.

CHURRIGUERESQUE

Named after the Spanish Churriguera family of > architects and sculptors, active in late 17th-century Salamanca, the style is an elaborated version of the > Baroque. Like many such terms, it was first one of abuse, implying extravagant, over-heavy and over-abundant architectural > ornament. Fine examples of the manner are to be seen at Santiago de Compostela, and in Mexico.

CIAM *See* International style

CINQUECENTO

The 'five hundreds'. The Italian conventional term for the art of the period 1500–99.

CIRE-PERDUE *See* Lost wax.

CIVILIZATION

Has been called the victory of persuasion over force (by Palmer-Wright), and the term refers to that amalgam of non-utilitarian activities which provide food for the mind and the soul and hence a receptive breeding-ground for the arts and their practitioners. It flourishes when a class wishes to dispose of surplus time, money, manpower or energy by providing an intellectual and physical environment that promotes > beauty and learning. As such, it is an élitist concept, for it can only thrive when labour is not the main pursuit of life. As Benjamin Disraeli noted in 1872: 'Increased means and increased leisure are the two civilizers of man'. The basic meaning of the word is bound up with the concept of living in cities, and its natural opposite is barbarism.

It is a term that can be hijacked to give a deeper meaning to 'art', as with Kenneth > Clark's television series thus entitled. In a sense, he laid claim to civilization by prizing its products and presenting himself as their epitome, leading the satirical magazine *Private Eye* to dub him Lord Clark of Civilization.

CLARK, KENNETH, LORD CLARK OF SALTWOOD

(1903–83). Independent scholar, working under > Berenson in Florence on > monographs on Italian art; Surveyor of the King's Pictures (1934–44); influential Director of the > National Gallery (1934–45), where he introduced a controversial picture-cleaning policy; and yet more influential Chairman (1954–7) of the Independent Television Authority. Clark also patronized contemporary art most astutely. His popularizing television series *Civilization* (1969) made him appear to his detractors as the logical – and Establishment – conclusion to the process itself, rather like > Vasari being the culmination of his own famous *Lives*. This mandarin of art was a sensitive > connoisseur, > collector and > art historian, and his two volumes of autobiography reveal him as a man of sense and humour.

● K. Clark, *Another Part of the Wood: A Self-Portrait* (1974); K. Clark, *The Other Half: A Self-Portrait* (1977); K. Clark, *Civilization: A Personal View* (1969); R. Margaret Slythe, *Kenneth Clark, Lord Clark of Saltwood: Bibliography* (1971).

CLASSICISM AND THE CLASSICAL TRADITION

'Classic' has several meanings, the best known being a work of literature that, in the words of Mark Twain, everyone wants to have read and no one wants to read – that is, a work of acknowledged and lasting excellence. This makes clear that Classicism is by no means restricted to art and > architecture, but expresses the continued prizing of the traditions, ideas and products of the ancients. The term 'Classical' may also refer to the art of ancient > Greece and thence > Rome, implying various qualities of these periods and creating a > 'canon' of procedures, tones and achievements from which subsequent generations might learn, often through the midwifery of the > academies.

Classicism refers to the traditions under which the art of the ancients was admired and imitated because, in > Winckelmann's words, the works of the Greeks 'reveal not only Nature in its greatest beauty, but something more than that; namely, certain ideal beauties of Nature which, as the old commentator of Plato teaches us, exist only in the intellect'. Classicism is thus an art of the intellect predicated on > antique example, not just in the practice of art, but in aesthetics as well, as the long popularity of the ideas of Plato (> Neoplatonism) and Aristotle indicates. What is more, morality – a particular world-view – is part of the package, also based on Greek and Roman examples. In later centuries the term was often used in opposition to > Romanticism: the former calm, generalized, moral, civic and cerebral, the latter personal and emotional, with stylistic qualities to match its spiritual ones.

> Imitating the productions of the past is not the same as > copying them. In Rodin's words, 'an art which has life does not reproduce the past, but continues it.' This is the best way of understanding an attitude to art that privileges traditions of art and > architecture going back to the Greeks, but which does so without copying them. In other words, the tradition is sufficiently rich to be the artistic equivalent of a Broad Church, welcoming a multitude of attitudes to and variations on the past. *See* also Antique.

● R. R. Bolgar, *The Classical Heritage and its Beneficiaries* (1963); Philip P. Fehl, *The Classical Monument: Reflections on the Connection between Morality and Art in Greek and Roman Sculpture* (1972); M. Greenhalgh, *The Classical Tradition in Art* (1978); B. Rowland, *The Classical Tradition in Western Art* (1963); Samuel H. Butcher, *Aristotle's Theory of Poetry and Fine Art* (1895).

CLAUDE GLASS

A smoked convex lens used for viewing landscapes, its name derives from the artist Claude Lorrain who reputedly used one. Its effect was twofold: firstly, its convex lens pulled a landscape together, producing a pleasing > repoussoir > composition; secondly, the glass darkened the scene, obliterating detail and rendering it in > chiaroscuro. Artists and writers on the > picturesque used the glass to see the landscape as they would wish to portray it.

CLOISONNISM

From the French *cloison*, a partition. A way of dividing up areas of flatly applied colour with an enclosing black outline. The style was developed by the > Pont-Aven painter Émile Bernard under the influence of Japanese > Ukiyo-e woodblock prints.

● S. Lövgren, *The Genesis of Modernism: Seurat, Gaugin, van Gogh and French Symbolism in the 1880s* (1959).

COBRA

An association of Danish, Belgian and Dutch > Expressionist painters, their name deriving from their countries' capital cities – Copenhagen, Brussels and Amsterdam. The original members of the group, which formed in Paris in 1948, were Asgar Jorn, Karel Appel and Cornelius Corneille. Later they were joined by Pierre Alechinsky and Jean Atlan. They aimed for a spontaneous and expressive painting free of the constraints of the intellect. In practice this meant using a highly > gestural technique and strong > colour. In some cases, such as Appel's *Portrait of Willem Sandberg* (1956), the paint is impacted on to the > canvas with particular violence. The group held exhibitions in Copenhagen (1948), Amsterdam (1949) and Liège (1951), but disbanded in 1951. In the USA, Cobra was closely linked with the aims of > Abstract Expressionism and > Action painting, although it retained a greater interest in figuration. Like > Art Informel and > Art Brut, Cobra's stance was against the dominant trend of Modernism towards geometric abstraction.

● *Cobra 1949–51*, exhibition catalogue, Stedelijk Museum, Amsterdam (1962); *Cobra*, exhibition catalogue, Boymans-van Beuningen Museum, Rotterdam (1966).

CODEX

A manuscript in book, as opposed to > scroll, format.

● Colin H. Roberts and T. C. Skeat, *The Birth of the Codex* (1983).

COINS

An important medium for art, although they are often neglected by art historians. They have frequently been used by canny rulers to convey their own views of themselves and their importance and deeds (> propaganda). Sometimes the art on coins is > 'original' (as in the stunning tetradrachms of Hellenistic Syracuse), and they are often invaluable to historians because they record works of art or > architecture either long since demolished or lost and otherwise known to us only through copies or smaller reproductions.

Invented in about the 7th century BC in the Eastern Mediterranean, coins are an important medium for the dissemination of artistic and political ideas not simply

because they are portable, but because they are made to exchange. They travel large distances, and can therefore be artistic 'seeds', so that the artistic horizons of the Celts, for example, could be widened by studying Roman coins, and those of the Vikings by Arabic ones. A characteristic of all coins up to the 20th century is that although rulers and coin-clippers often cheated (the former by debasing the metal, the latter by shaving off bits), the bullion value of the coin was its face value. This has both good and bad sides to it. The good side is that coins could be hoarded for generations: Roman pennies were still accepted currency in some parts of 19th-century France; nomadic jewellery where Seljuk and Hellenistic silver coins are mixed with modern ones is still worn; and such coins could often be used as models in later times. But the bad side is that coins could be melted down when times were hard.

Coins and > medals have long been sought by artists who recognized their utility as veritable galleries of portable art and > iconography (see, for example, many of the works of Titian or Michelangelo), and many educated gentlemen from the later Middle Ages onwards would own a coin > collection, usually Roman but sometimes Greek, which would be used not so much to study art as to acquaint its owner with the physiognomy of the great rulers of the past. Hoards of coins and other bullion buried in times of unrest are frequently found today, and stories of treasure trove abound from the Middle Ages onward. They are most likely to be discovered when rebuilding old houses or making the excavations for new ones, but many collectors probably got their material when it was turned up by the plough, or from the plundering of graves.

● Laura Breglia, *Roman Imperial Coins: Their Art and Technique* (1968); Thomas L. Donaldson, *Architectura Numismatica: Ancient Architecture on Greek and Roman Coins and Medals* (reprinted 1966); Friedrich Imhoof-Blumer, *Ancient Coins Illustrating Lost Masterpieces of Greek Art: A Numismatic Commentary on Pausanias* (rev. edn 1964).

COLLAGE

From the French *coller*, 'to gum'. As the French origins of the term imply, a collage is a surface to which paper, cloth or other material has been attached. The process came to prominence with the > Cubists, when Picasso and Braque began incorporating newspaper clippings and other non-art materials into their paintings with the intention of questioning not only the limits of > fine art but also the nature of representation. > Dada and > photomontage artists such as John Heartfield used collage to shift their work from the fine art to the political arena, while > Surrealists such as Max Ernst used it to bring unrelated imagery into disturbing juxtaposition, as in *Une Semaine de Bonté* (1934).

COLLECTING

Acquisitiveness has long embraced art works. Collections of torques, axeheads and the like were certainly made in the Bronze Age, but these were probably hoarded for their metal value, and some surely belonged to itinerant smiths. The first true art collections in the > Greek > Archaic period may have been in honour of the gods: most temples incorporated a treasury with perhaps a > bronze grille for safety and visibility, whilst

sanctuaries such as Delphi and Olympia boasted separate buildings, each dedicated by a city or state. Some of the suitably inscribed objects discovered there are in their > museums.

The Romans collected art on a grand scale, indulging their admiration for things Greek and Hellenistic to such an extent that collecting often shaded into plunder, whether as the result of military activity (Caesar in Greece) or a civic position (Verres in Sicily). Such collecting profoundly influenced > Roman art and > architecture, and consequently the whole of the post-mediaeval Western tradition.

Mediaeval church treasuries often incorporated works of art, and many cult statues or shrines were rich in Roman and Greek cameos. But we have no detailed knowledge of civilian collecting before the late 14th century, when, probably in imitation of the Romans, collecting became extremely fashionable. The > Medici, for example, collected not only > antique > coins and > medals, gold and silverware, jewellery and statues, but also imported contemporary porcelain and rugs from the East and commissioned artists to beautify their palaces. In this way the spin-off from collecting was the deeper education of contemporary artists: Michelangelo, for instance, studied in the Medici 'sculpture garden', which must have included antiquities.

Following the example of > Renaissance princes, the monarchs of Europe took collecting as a serious activity that reflected admirably on their prestige, and many of the great collections began in the 16th and 17th centuries. But none could ever be as prestigious as that of the papacy: the popes started early, they owned large tracts of Italy (the best soil for antiquities), had the political power to compel 'donations', and were backed by a court (the Curia) of *cognoscenti*. Above all, their own political prestige as successors to the Caesars offered a powerful reason for collecting.

Collecting is an important topic for art historians because it offers a mirror of how individuals and ages saw themselves, and also because the older objects collected frequently serve as models by which contemporary art develops. The very best collectors can be arbiters of > taste not just by commissioning new works, but also by owning coherent collections of older works of interest to contemporary artists for the refinement of their own > styles.

● Douglas Cooper, *Great Private Collections* (1963); Nicole Dacos, *Il tesoro di Lorenzo il Magnifico: repertorio delle gemme e dei vasi* (1980); Frank Herrmann, *The English as Collectors: A Documentary Chrestomathy* (1972); Niels von Holst, *Creators, Collectors and Connoisseurs: The Anatomy of Artistic Taste from Antiquity to the Present Day* (1967); Gerald Reitlinger, *The Economics of Taste*, 2 vols (reprinted 1982); Francis H. Taylor, *The Taste of Angels: A History of Art Collecting from Rameses to Napoleon* (1948); Frances Vivian, *Il console Smith mercante e collezionista* (1971); Gustav Friedrich Waagen, *Treasures of Art in Great Britain; Being an Account of the Chief Collections* . . ., 3 vols (1854).

COLOSSAL SCULPTURE

Conventionally, a figure more than twice life-size is called 'colossal'. The > Greeks and > Romans were fascinated by such large-scale works and produced them in > marble and > bronze, usually representing gods and heroes, and sometimes pieced together from various materials over an > armature. The > genre was adopted during the Middle Ages for architectural sculpture (which would have seemed insignificant if placed high

on a cathedral at only life-size); and > antique horizons reopened with a vengeance during the > Renaissance when the colossal manner was widely adopted. Indeed, as a stroll around Florence or Rome will indicate, it became a model as important for sculptural credibility as, perhaps, > fresco work was for a painter.

● Virginia Bush, *The Colossal Sculpture of the Cinquecento* (1976).

COLOUR

The effect of light rays of varying wavelengths on the nerves of the eye is perceived as colour. Thus a given colour reflects light within that band on the spectrum, absorbing all the rest and only allowing the eye to see that colour. Colours on the edge of the spectrum will show hues of the next colour within the predominant colour. Colours are ordered according to their position on a colour circle that opposes the > primaries (red, yellow, blue) and disposes the > secondary colours (orange, violet, green), with pairs of primaries in the intervening segments of the circle. Tertiary colours are the intermediate mixtures of primary and secondary colours. The perceptual and emotional values of colour have been studied by scientists and art historians, and although all artists are concerned with colour as a value in their work, some, such as the > Neo-Impressionists and the > Symbolists, have devoted considerable time to understanding its scientific or emotional bases – though it would be quite wrong to imply with more success than those who have not approached colour from this physiological perspective.

COLOUR FIELD PAINTING

A term used to describe > abstract painting of the 1950s and early 1960s that rejected the > gestural brushstroke and > calligraphic drip of the > Abstract Expressionists in favour of covering the surface of the > canvas with monochromatic > colour strains of varying intensity. This effected a non-tactile painting that flattened the picture space to the point where it became identical with the surface of the canvas, avoiding any sense of recession into depth. Instead of attempting to assemble pictorial components into a > composition, the Colour Field painters attempted to develop the totality of the entire picture surface. Leading exponents include Helen Frankenthaler, Ellsworth Kelly, Morris Louis, Ad Reinhardt, Kenneth Noland and Barnett Newman.

● H. Osborne, *Abstraction and Artifice in Twentieth-Century Art* (1979); *Abstraction: Towards a New Art*, exhibition catalogue, Tate Gallery (1980).

COLOUR THEORY

Any of several attempts to explain how > artists may successfully > imitate in > paint the hues of the natural world. Until the 19th century, this was usually done by trial and error, without necessarily any 'scientific' foundation. > Leonardo was an exception, believing that > 'perspective is the bridle and rudder of painting', and counting variability of > colour according to distance from the eye as part of this. But with the

growing interest in colours during the Industrial Revolution, induced partly by commercial requirements to manufacture > pigments developed, artificially, a more systematic experimentation seen in the work of > Delacroix and Constable (see also his other scientific interest in cloud studies), and later in the > Impressionists with their studies of light, and the > Neo-Impressionists with > pointillism.

● J. Gavel, *Colour: A Study of its Position in the Art Theory of the Quattro- and Cinquecento* (1979); K. T. A. Halbertsma, *A History of the Theory of Colour* (1949).

COMPLEMENTARY COLOUR

A colour that appears to be diametrically opposed to another colour, for example red and green or blue and orange. The optical vibration set up by these juxtapositions has been exploited by artists such as > Delacroix and more systematically by the > Neo-Impressionists and > Op artists.

COMPOSITION

One of the essential structuring elements in an art work, along with > proportion, > colour and > invention. Composition refers essentially to considerations of the > formal unity of the work, such as the arrangement of volume, mass and line, but it impinges on invention insofar that blame would be attached to the artist who compromised > decorum for the sake of composition.

COMPUTER ART AND GRAPHICS

Now there is no longer anything sacred about a paintbrush, and thanks to the development of > digital imaging, artists can use computers as tools for the production of art, and do so relatively cheaply and to increasing effect. While the work of art is on the computer screen, it is but a collection of points of light. Each point is controllable through software and various input devices (mouse, joystick, electronic pen), so that it can be infinitely modified, or through executing various computer-processing convolutions such as reverse, enlarge, make smaller, sharpen, blur, smear, change all colours, turn into line art, and so on. The image may be printed out at any stage, either as a computer bit-map or on some systems as a video signal, and its development further continued while copies of the 'printing stage' images are stored on computer or video disks.

Such flexibility is exciting and useful in the graphic arts, but tends to be held back by the high cost and relatively low quality of suitable output devices. Presumably we shall soon see wholly electronic exhibitions, where the viewer sits at the monitor and accesses art works, electronic versions of which may reside on computers anywhere in the world, across a network.

● Tosiyasu L. Kunii (ed.), *Computer Graphics: Visual Technology and Art: Proceedings of Computer Graphics Tokyo '85* (1985); Herbert W. Franke, *Computer Graphics; Computer Art* (2nd rev. and

enlarged edn 1985); Caron Ward and Rhonda O'Meara (eds.), *Towards a New Aesthetic: Exploring Computer-aided Art and Design* (1990).

CONCEIT

In literary criticism, a far-fetched metaphor. In art it may be the use of a seemingly inappropriate compositional figure, or the choice of a > medium that has little in common with the thing represented. Thus Bernini in his sculpture of the *Ecstasy of St Teresa* (1645–52) employs > marble for the diaphanous draperies of the saint, demanding that the > beholder acknowledges the wit of this perverse alliance.

CONCEPTUAL ART

A loose umbrella term that gained currency in the 1960s to describe a variety of art forms which placed emphasis not on the physical presence of the art work but on its 'conceptual' meaning. In practice this threw up a huge variety of activities, from > Performance and > Body art through to > Minimalism. Much of this work is directed at exploring the conventional limits of art through the deployment of a range of anti-art practices. Conceptual art is often abstruse, uninterested for the most part in audience comprehension, and designed to inspire indifference. The intention is that experimenting with unorthodox art forms will turn attention away from questions of > representation and mimesis (> imitation) towards the reality of the work's conceptual framework, but whether this happens in practice is a moot question.

● U. Meyer, *Conceptual Art* (1972).

CONCRETE ART

A term describing non- > figurative, non- > representational 20th-century > abstraction. The De > Stijl artist van Doesburg gave the term its present meaning when he issued a manifesto of the same name in 1930. After 1936 a series of exhibitions were organized in Switzerland under the name Konkrete Kunst. Following the Second World War the term was widely used to designate artists who worked within a > Constructivist or a geometrically abstract approach to the construction of > form.

● *Konkrete Kunst: 50 Jahre Entwicklung*, exhibition catalogue, Kunstgesellschaft, Zurich (1960).

CONNOISSEURSHIP

From the old French *connaisseur*, meaning 'expert'. There is a strong element of art appreciation in the work of the connoisseur, and connoisseurship is inseparable from the notions of quality and authenticity that properly form part of the appraisal of art works.

The appreciation of art works for their intrinsic qualities (aesthetic value) rather than for a functional or devotional purpose (cult value) has led to their being considered in a different way. By the > Renaissance it was commonplace to value art works for the skill they exhibited rather than for the materials used. The underlying shift, then, was from art work to > artist, and it follows that the connoisseur's interest in > fine art is an interest in the skills and practices used. From the 16th to the 18th centuries, connoisseurship implied both discrimination and knowledge, not much different, in fact, from the skills of the 18th-century > amateur (which then meant 'enthusiast'). It has been argued that although the connoisseur will always be something of an amateur, an amateur will not necessarily be a connoisseur. The 18th-century connoisseur made the same kind of value judgements common in, but not synonymous with, those of > criticism, the difference lying in the connoisseur's specialized knowledge of the subject, without the subjective and perhaps excessive enthusiasms of the amateur or the impersonal pronouncements of the critic.

A second meaning of connoisseurship, closer to today's understanding, is that of the art expert able to distinguish between the authentic and non-authentic, for example between an > original and a > copy. This implies that an authentic art work demonstrates qualities or – and this is not the same thing – quality that an > imitation cannot. Consequently, some art works are called 'authentic', meaning they are considered to be original works by a given artist, while others are called copies. This is a narrow definition of the work of the connoisseur, but one which has had great impact on the study of > art history and > museology, where collections have long been valued for the integrity, that is, authenticity, of their holdings. In this limited sense connoisseurship goes little beyond > attribution or establishing the > provenance of an art work.

Today the meaning of connoisseurship retains at least an element of the critical/ aesthetic interests of earlier centuries. And although it is not correct to imply, as one might with 'art expert', an element of commerce and the valuation, rather than evaluation, of art works, limiting connoisseurship to the narrow confines of authentication has proved a regrettable restriction. While in the past connoisseurship provided many of the parameters still regarded as the norms of > art history, the continued uncritical application of such notions today does little to advance the study of the history of art.

● David A. Brown, *Berenson and the Connoisseurship of Italian Painting*, exhibition handbook, National Gallery of Art, Washington (1979); M. J. Friedländer, *On Art and Connoisseurship* (1942).

CONSERVATION

The conservation of art works has become increasingly specialized in response to the escalating value of art and the demands of an increasing number of exhibitions and displays of art works not designed for such public access. Ideally, conservation is a preventative strategy to avoid degradation and in this may be differentiated, although not absolutely, since the two are complementary, from > restoration, which implies the damage is already present.

Conservation aims to ensure that an art work is held in a physical environment, and

physical state, that does not threaten its existence or expose it to degradation. Thus, a controlled environment such as a museum will provide appropriate levels of lighting and humidity while also guarding against pollution and human accident. Such measures are rarely likely to be sufficient, however, as decay is inherent in physical objects no matter how well housed. The work of the conservator therefore includes preventative or remedial treatments for art works, such as the impregnation of paper > supports with pesticides and anti-fungal agents, and the stabilizing of fugitive or fragile > pigments or support.

While most conservation techniques aim to be as unintrusive as possible, there will sometimes be conflict between the demands of preservation and the expectations of the public. Old Master drawings, for example, are rarely seen to advantage exhibited behind glass in low levels of light, but the nature of the art work requires that just such precautions be taken. More problematic, perhaps, are those cases where the material appearance of the work is altered as a result of the demands of conservation.

● H. J. Plenderleith, *The Conservation of Antiquities and Works of Art* (1956); P. Vergo (ed.), *The New Museology* (1989); Jane Fawcett (ed.), *The Future of the Past: Attitudes to Conservation 1174–1974* (1976).

CONSTRUCTIVISM

To some extent, Constructivism opposed the contemporary movement of > Expressionism through its promotion of the reasoned deployment of the principles of 'pure' art. Its advocates articulated dimension not in terms of mass but volume in space. In this sense it is the sculptural equivalent of > Suprematism or the > Cubist > assemblages of Picasso. With its origins in revolutionary Russia, Constructivism's early exponents championed it as a socially relevant art, as exemplified in Tatlin's *Monument to the Third International* (1919–20), but the Revolution soon turned against > abstraction in favour of > Socialist Realism, disillusioning many of its principal exponents and sympathizers, including Naum Gabo, Antoine Pevsner, > Kandinsky, El Lissitzky and Moholy-Nagy, and forcing them to flee Russia. This emigration had the effect of spreading the principles of Constructivism to Europe.

● S. Bann (ed.), *The Tradition of Constructivism* (1974); J. M. Nash, *Cubism, Futurism and Constructivism* (1974).

CONTÉ CRAYON

A hard, > pastel-like crayon invented by the eponymous scientist in 18th-century France.

CONTENT *See* Meaning in art.

CONTINUOUS REPRESENTATION

Where several incidents from the same story-line are shown together in one 'picture'. The order in which the incidents are read might depend on how the artist has the

viewer follow the composition, on the spectator's knowledge of the events, or even on differential scaling of the figures. Roman sarcophagi and historical narrative reliefs use the technique, as does much >mediaeval and >Quattrocento art, for example Ghiberti's Gates of Paradise. The technique highlights one of the problems with 'stationary' art in that, unlike film, temporal sequencing can be awkward to arrange. This is one of the ways in which art was recognized as being different from poetry: >*ut pictura poesis*.

CONTRAPPOSTO

(Italian: 'set against'). Developed by the >Greeks of the >Classical period, this is a device for posing the (usually) male body in a sinuous balance. One leg is vertical and even column-like, whilst the other leg trails; the torso must therefore be placed over the 'column' leg in order to balance the body, with the opposing hip thrust out. This gives a pleasing 'S' curve to the body, and makes it interesting because the posture contains the suggestion of forward movement. Much employed by the >Romans, the stance reappeared in the >Renaissance, and became a mainstay of bodily contortion under >Mannerism.

CONVERSATION PIECE

A small-format group >portrait in >oils in which the protagonists are shown engaged in conversation, usually indoors but occasionally in a >pastoral setting. Executed in a realistic and detailed manner, these paintings were particularly popular in 18th-century Britain.

COPTIC ART

The art of Christian Egypt, most important between the 5th and 8th centuries. Coptic art was initially influenced by the art of Syria and Persia, and later by Christian Spain, Greek Orthodoxy and maritime republics such as Venice. These influences were fused and in turn may have influenced >Romanesque >architecture, >Islamic art, post-Imperial Italy, the Christian kingdoms of East Africa and even Christian Ireland. Typical products of Coptic art include wall-paintings and >icons, ceramics, metalwork, stone and >ivory carvings and textiles. Its hallmarks are a strong use of >colour, schematization of design, a tendency towards geometric pattern-making and a certain naïvety with regard to >naturalistic representation.

● J. D. Cooney, *Late Egyptian and Coptic Art* (1953); J. Beckwith, *Coptic Sculpture* 300–1300 (1963); K. Wessel, *Coptic Art* (1965).

COPY

A non-fraudulent manual >imitation of a work of art produced by a third party. The copy is not a version or >replica, which properly refers to a copy of the >original made by the artist or under his or her control. Neither is it the product of a mechanical

duplication, such as a > reproduction, and nor is it identical with a fake or > forgery, where the intention is to deceive.

Multiplication of a prototype has been a motivating force in the creation of copies since antiquity. The excellence of > Greek sculpture was admired by the > Romans, who invented little but perfected mechanical means of copying that allowed for the duplication of the chosen > original; many Greek sculptures, such as the > Laocoön, are known today through their Roman copies. > Mediaeval > guild practice encouraged the repetition of workshop formulas and successful prototypes rather than the > invention of new artistic solutions. Mediaeval artists were interested less in notions of originality in the design or execution of an art work than in the use of genuine (authentic) materials of the first quality.

With the > Renaissance, the growth of a more conscious desire to rival antiquity meant that artists measured themselves against past art, at the same time as acknowledging that antiquity embodied near-perfect solutions to the representation of human form. Michelangelo won prestige with imitations of > antiques that were taken for originals. However, artists soon became careful to show that their copies were works created in the spirit of homage or for the purposes of study, as the public began to demand a sense of individuality hitherto not part of the artistic persona (> artist). The need to differentiate between original and copy led to the rise of > connoisseurship, often erroneously regarded as synonymous with the work of the > art historian.

Copying therefore became a means for artists to study the art of the past. Painters as markedly original as Rubens advocated the emulation of antiquity. With the rise of the > academies in the 17th century, a system of values that antiquity was thought to best embody were taught primarily through the study and execution of copies. Sir Joshua > Reynolds in his *Discourses* professed the doctrine that upheld imitation for the purposes of instruction as being far removed from the mere slavish copying of appearances. Instead, the aim was to re-create the conditions of the making of the original – even if in practice this tended to mean literally copying the models prescribed by the academies.

By the 19th century, art training (> art education and training) had become rigidly linked to the doctrine of the imitation of past art, thereby engendering in students the dangerous belief that the past had accomplished everything and little remained to be done. But with the advent of > Modernism artists ceased to regard copying as an essential part of training. The copy made for the purposes of study was superseded by the interpretative copy, for example Francis Bacon's *Portrait of Pope Innocent X* (1953) or Picasso's reworkings of compositions after Manet or Velásquez, which challenge the originals by refusing to regard them as authoritative.

Nevertheless, the copy is not absent from contemporary art practice. > Pop art challenged notions of originality in works such as Warhol's prints of the *Mona Lisa*. Today > Post-Modern interest in intertextuality – where rigid notions of original/copy, or indeed authentic/inauthentic, have ceased to have meaning – is restructuring fundamental notions of what constitutes the domain of art.

● W. Benjamin, 'The Work of Art in the Age of Mechanical Reproduction', *Illuminations* (1973); Sir Joshua Reynolds, *Discourses on Art*, ed. R. Wark (1975); J. M. Muller, 'Rubens' Theory and Practice of the Imitation of Art', *Art Bulletin*, LXIV (1982); P. Duro, 'Copyists in the Louvre in the Middle Decades of the Nineteenth Century', *Gazette des Beaux-Arts*, CXI (1988).

COPYRIGHT

Although the law varies from country to country, the copyright of a photograph or slide of a work of art usually resides with the person or body who paid for the work to be photographed. This is *not* necessarily the same as the owner of the work itself, and is certainly not the same as the purchaser of a copy-slide, who is specifically prevented from publishing it without the permission of the copyright holder. Copyright can lapse after time – usually 50 years – and is intended to protect intellectual property, operating with books as well as images.

● Charles Gibbs-Smith, *Copyright Law Concerning Works of Art, Photographs and the Written Word* (2nd rev. edn. 1974).

COSMATI

> School of marble-cutters, mosaicists and sculptors in 13th-century Rome, named after the principal family involved, the Cosmas. 'Cosmati work' refers to the coloured inlays of stone or glass in which the school specialized.

COUNTER-REFORMATION

The revival in confidence of the Catholic Church, following the traumatic changes of the > Reformation. For art, the period (roughly 1560–1648) saw a greater emphasis on > propaganda in the service of religion, a new style of triumphantly Catholic > architecture, and a tightening of attitudes amongst the clergy as to what was permissible in art. Veronese, for example, found himself in trouble with the Inquisition with his *Last Supper* (Accademia, Venice, 1573) and defended what were considered unseemly details by proclaiming his right 'to decorate the picture as I saw fit'. The matter was defused by changing the title of the painting to *The Feast in the House of Levi*. One important consequence of the Counter-Reformation was the development in the 17th century of an avowedly Protestant > icongraphy for religious works, clearly seen in the work of Rembrandt.

● A. W. A. Boschloo, *Annibale Carracci in Bologna: Visible Reality in Art After the Council of Trent* (1974); Paul D. Hilbrich, *The Aesthetic of the Counter-Reformation and Religious Painting and Music in Bologna, 1565–1615* (1972).

COURT ART

In many societies, it has been customary for rulers not only to maintain friends at court, but also to employ workmen and craftsmen to attend to matters ranging from the maintenance of the building fabric through the making of furniture, arms and armour to weaving and silversmithing. Poets and authors would be retained to write, musicians to play, and artists to paint and sculpt as required. Small courts – such as Urbino or Rimini during the > Renaissance – might employ workers casually as required, or in

small numbers; large courts – such as that of Louis XIV at the > Louvre, Versailles and other locations – would employ hundreds. Indeed, for the French court, with its hosts of palaces, such extensive needs meant that the processes were industrialized, with veritable factories set up to service the continuing demands. Under > Lebrun, this also meant the adoption – and imposition? – of a regular 'state style'.

Large courts also needed international connections to service their requirements, and these were filled by ambassadors or trade contacts. The court of the > Medici in the 15th century acquired porcelain from the East, whilst the Grand Duchy of Tuscany accumulated a startling collection of hand-knotted carpets and rugs. The papal court had Raphael make designs for > tapestries for the Sistine Chapel, and these were then sent to Flanders to be woven.

Courts would not necessarily use local talent only, however, but would make offers and receive requests from far afield. Charles I of England sought foreign artists to bolster his court's international prestige, just as in the previous century the French King Francis I had imported Italians (Primaticcio, Serlio) to make his palace of Fontainebleau as up to date as possible. European artists even travelled to Asia. Since most artists could not afford to wait for a summons, they wrote, the best-known such letter being Leonardo's request to the Duke of Milan, from which it is evident that being an > 'artist' came low on the list of accomplishments attractive enough to make the Duke hire him, which he did in 1482. Travel might be necessary to have post and pension confirmed, > Dürer, for example, had to go to the Netherlands in July 1520 to have Charles V reconfirm his position as court painter to his predecessor, the Emperor Maximilian.

In the context of so many craftsmen, poets, scholars and musicians, an artist's work would be various, and not necessarily restricted to apparently 'high' art. Velásquez painted not only the monarch and his family along with suitable canvases recording Spain's greatness, but also their dwarfs and buffoons, whom he treated with sensitivity and humanitarian grandeur.

• Michael Levey, *Painting at Court* (1971); Kathleen Morand, *Claus Sluter: Artist at the Court of Burgundy* (1972); Leonardo Olschki, *Guillaume Boucher: A French Artist at the Court of the Khans* (1946).

COURTAULD INSTITUTE OF ART

London. The first centre for the study of > art history in England was endowed in 1931 by Sir Samuel Courtauld (1876–1947), a > collector of > Impressionist and > Post-Impressionist works in particular, which he presented to the University of London in 1932 and which hang in the Courtauld Galleries along with bequests by Roger > Fry, Lord Lee of Fareham, Count Antoine Seilern and Sir Robert Witt. The Institute has also benefited from Sir Robert Witt's bequest of his library of > reproductions of paintings and drawings, an important and developing reference tool. Once housed in separate locations (the Institute in the Adam house in Portman Square, the Galleries next to the > Warburg Institute), both are now under the fine roof of Somerset House on the Strand. Together with the Warburg Institute, the Courtauld has published since 1937 the *Journal of the Warburg and Courtauld Institutes* (> journals). Other publications include collections of illustrations from their photo collections and a checklist of painters, *c*.1200–1976, represented in the Witt Library (1978).

CRAFT

Traditionally, craft has been seen as hand labour devoid of intellectual content. Thus the 17th-century founders of the French Académie Royale de Peinture et de Sculpture denigrated > guild > artists as 'craftsmen', lacking > invention and learning. In the 19th century several groups, including the > Arts and Crafts Movement, attempted to bridge the gap between industry and > fine art through the promotion of handcrafts, but these Utopian schemes failed in the face of economic necessity. More recently craft has been rehabilitated by women artists (> feminist art) who see its subservient position to fine art mirroring their own equally unjust social and political subjection.

CRAQUELURE

A painting is composed of several layers of > support, > paint and > varnishes, which expand and contract, but not to the same extent and not necessarily together. Because of these continuing tensions, a painting of any age will develop a reticulum of cracks. Some artists (most > quattrocento Italians) avoided excesses by careful preparation; others, perhaps through experimentation with new combinations of materials (Reynolds's use of bitumen, for example) encouraged miniature crevasses. Craquelure is one·sign of the age of a painting, and therefore of its authenticity. Its reproduction is a target for > forgers, the sloppy ones simply painting it on, the better ones (Jan van Meegeren, for instance) sometimes 'cooking' their > canvas in an oven and then rubbing genuine old dirt into the cracks.

CRAYON

A drawing material shaped into stick form, such as > pastel. The > pigment is bound (> binder) with oil, wax or gum. Crayons produce a soft line highly suitable for suggestive effects, and for this reason they were regarded as an unsuitable > medium by the > academies, who taught the advantages of precision through line.

CREATIVITY

From a post- > Romantic perspective, creativity is the essence of artistic activity, but historically its antagonism to concepts such as > imitation is much less clear-cut. In part this is due to its conflation in Romantic notions of art with > invention and > originality. Creativity was regarded by the > academies as the principal attribute separating the intellectual > fine arts from the imitative and mechanical > crafts. In this sense, however, it would be more historically accurate to speak of the quality of 'invention'.

CRITICISM

For Coleridge, Flaubert and a host of others, it was failed historians, biographers, poets and the rest who became critics and thus parasitical and pedantic detractors. That such opinions are still common demonstrates both the enduring sensitivity of the executor to

the critic, and also the key position held by the critic in modern times in determining something of the public success of a work.

At its worst, art criticism can destroy artists or elevate those 'required' by the market; at its best, it is a disinterested activity that attempts to assess art works according to notional scales of quality and attainment. The problem with all critical activities is that they rely on changing patterns of > taste, so that fashion must always play its part in any consideration. The notion of some eternal scale of measurement by which an art work can be judged has long been discredited.

The best criticism is interactive, being a dialogue between the works and the human intelligence. A good critic, according to Anatole France, is one who tells the story of his mind's adventures among the masterpieces, whereas for Delacroix, the painting itself was the bridge connecting the painter's mind with that of the viewer.

Is criticism the task of the art historian? Yes, to the extent that any historian needs some of the techniques of the > connoisseur, especially an eye for quality and attainment.

● Quentin Bell, The Art Critic and the Art Historian (1973); Frank P. Chambers, The History of Taste: An Account of the Revolutions of Art Criticism and Theory in Europe (1932); Joseph Darracott, Art Criticism: A User's Guide (1991); Wylie Sypher, Art History: An Anthology of Modern Criticism (1975); Daniel T. O'Hara, The Romance of Interpretation: Visionary Criticism from Pater to de Man (1985).

CROCE, BENEDETTO

(1866–1952). Italian critic and aesthetician, as well as sometime Minister of Education, who proclaimed good art to be the intuiting of emotion (Aesthetic, 1902). Influential as the founder of the periodical La Critica, as well as for his studies of > Hegel, > Marx and > Renaissance art, Croce's theories had an important impact on the works of Carritt and Collingwood.

● M. E. Moss, Benedetto Croce Reconsidered: Truth and Error in Theories of Art, Literature and History (1987); G. N. G. Orsini, Benedetto Croce: Philosopher of Art and Literary Critic (1961).

CROSS-HATCHING

The use of close parallel lines on a > drawing or > engraving to indicate tone or shading. Hatching is when one set of lines is used, cross-hatching when a second set of lines is inscribed across the first.

CUBISM

An early 20th-century movement led by Pablo Picasso and Georges Braque. The origins of Cubism may be traced to Les Demoiselles d'Avignon of 1907, when Picasso began to construct picture space through the use of angular planes and surfaces, inspired by the late paintings of Cézanne and African tribal sculpture. The following year, in November

1908, the critic Louis Vauxcelles coined the name 'Cubism' in a review in *Gil Blas* of the paintings of Braque, who constructed form as a series of interlocking planes.

Cubism aimed to restructure representation through a redefinition of > realism, to show the solid reality of objects, not merely their appearance. In its first phase, known as 'Analytical' Cubism (1908–12), it abandoned the conventions of > Renaissance pictorial space in favour of a multi-viewpoint exploration of the motif that would show objects disposed in a shallow picture space from many different angles, articulated through overlapping and interlocking planes that would respect the > planimetric nature of the picture surface.

In its second, or 'Synthetic' stage, Cubism moved away from the representation of the object in nature to focus on the material nature of the object in relation to other objects/materials. Synthetic Cubism emphasized its non-illusionistic agenda through the inclusion of 'real' elements, such as fragments of wallpaper, journals or photographs ('papier collé'). Thus in *Still Life on a Table* (1913), Braque included a strip of newspaper in his painting, the primary 'meaning' of which is the fact it is a newspaper, but which by extension 'represents' a newspaper in a painting and also provides a structuring device within the picture space.

The importance of Cubism resides in its potential to construct an art work that no longer holds up nature as the ultimate appeal, but in which the relationship between the constituent parts is central to its meaning. In this way, Cubism confirmed the general direction of > Modernism from Manet onwards, and anticipated the development of > abstraction and > Greenberg's ideas on 'pure' painting.

● A. H. Barr Jr. (ed.), *Cubism and Abstract Art*, exhibition catalogue, Museum of Modern Art, New York (1936); J. Golding, *Cubism: A History and an Analysis 1907–1914* (1959, rev. edn 1968); J. M. Nash, *Cubism, Futurism and Constructivism* (1974); C. Green, *Cubism and its Enemies* (1987); Mark Roskill, *The Interpretation of Cubism* (1985).

CULTURE

The knowledge, beliefs, traditions and collective memory of a society, made manifest through all its activities; or, for Henry van Dyke, the habit of being pleased with the best and knowing why. The former definition is country-based and is fertile ground for nationalistic theories espoused by such philosophers as > Hegel, whilst the latter emphasizes the notion of quality. The term is a loaded one, and difficult for art historians to use except as a synonym for > civilization, although anthropologists, for example, would disagree with this usage.

● E. H. Gombrich, *In Search of Cultural History* (1969); Raymond Williams, *Culture* (1981).

CURATORSHIP

The job of the curator is to care for art works. It can involve a range of tasks from > conservation to research on > provenance and art-historical context, and includes such topics as acquisition, law (> copyright), insurance matters, the preparation, transport and staging of exhibitions, as well as the design of suitable storage and

display conditions. Nowadays this rarely takes place in private homes, but more usually in museums and galleries, and its aim is to explicate the art work for the public (> catalogues), to present it in some philosophical or sociological context (gallery tours, education programmes), and to ensure that it survives unharmed for future generations. The preferred balance between the various elements in this range of duties is often hotly discussed, as fashions in what might be called 'the public interface' develop and change.

● Susan M. Pearce, *Archaeological Curatorship* (1990); John M. A. Thompson et al. (eds.), *Manual of Curatorship*: *A Guide to Museum Practice* (1984).

D

DADA

An international anti-art movement that flourished between 1916 and 1923. It began in Zurich during the war years with the collaboration of a group of artists seeking refuge from the First World War, and included the Romanian poet Tristan Tzara, the French artist Hans Arp and the German writer Hugo Ball. In 1916 Ball founded the Cabaret Voltaire, where Dada 'manifestations' took place, and this was backed up by the publication of manifestos, pamphlets and magazines, whose anarchic graphics later became very influential in > avant-garde circles. In 1917 Dada spread to the rest of Europe and beyond. Tzara and Ball opened the Galerie Dada in Zurich, Francis Picabia published the periodical 391 in Barcelona, and Duchamp the magazines *The Blind Man* and *Wrong-Wrong* in New York. After the war Dada became influential in Germany around Kurt Schwitters, Hans Arp and Max Ernst, and in Paris it was animated by Andr.

The name 'Dada', reputedly selected at random from a dictionary and meaning 'hobby-horse' or 'gee-gee' in French, was adopted to symbolize the anti-rational, anarchic and anti-traditionalist stance of its members. The Dadaists printed nonsense poetry set in a random selection of typefaces and exhibited > found objects, such as Duchamp's *Fountain* of 1917 (a urinal inscribed with the name R. Mutt) and his bicycle wheel mounted on a stool. These tactics of shock and unreason challenged accepted values in art – such as the cult of > beauty – that the group regarded as hypocritical or false and out of keeping with a militaristic and industrial Europe.

After 1919 Dada's nihilistic principles were moderated through the gradual institutionalization of their work – Dada was incorporated into the Paris Salon des Indépendants in 1920 – and through juxtaposition replacing the shock of disjunction as an aesthetic principle, which, after 1923, fed into > Surrealism. In the politically and economically unstable Germany of the 1920s Dada was influential in the social comment of > Neue Sachlichkeit artists such as George Grosz, Otto Dix and John Heartfield.

● W. Rubin, *Dada and Surrealist Art* (1969); D. Ades, *Dada and Surrealism Reviewed* (1978); D. Ades et al., *In the Mind's Eye: Dada and Surrealism*, ed. T. A. R. Neff (1985).

DANUBE SCHOOL

A term given to various painters working in the Danube valley in the 16th century, especially Altsdorfer, Cranach the Elder and Huber. They were never a coherent > school, although all displayed an interest in the romantic possibilities of > landscape painting.

● *Prints and Drawings of the Danube School: An Exhibition of South German and Austrian Graphic*

Art *of* 1500 *to* 1560, catalogue, New Haven (1969); Patricia Rose, *Wolf Huber Studies: Aspects of Renaissance Thought and Practice in Danube School Painting* (1977).

DATABASE

A collection or 'bank' of data of uniform characteristics, usually stored in and capable of being manipulated by a computer. In > art history, databases might cover the work of one artist, or of one > school or city, and be capable of being searched with such questions as 'Give me all works by artist A painted between dates B and C and now to be found in museums in cities D, E and F.' Because myriad works of art may need to be studied in the course of any research project, databases are of increasing relevance to our discipline, especially now that > computer graphics and > videodisks mean that text data about works of art can be accompanied by representations of related images. On some systems, it may be possible to display simultaneously multiple images on one monitor, and also to resize them. To make efficient use of databases scattered around the world, accessibility over a high-speed computer network is more than desirable, and probably the main condition under which all such projects will be conducted in the future.

● Cuadra/Elsevier (pubs.), *Directory of On-line Databases* (yearly updated issues from 1979); Michael Greenhalgh, 'Databases for Art Historians: Problems and Possibilities', in *History and Computing*, ed. Peter Dunlop and Deian Hopkins (1987), pp. 156–67; Ian Lancashire and Willard McCarty (eds.), *The Humanities Computing Yearbook* (1988 onwards).

DEALERS *See* Art dealing.

DECADENCE

The 'falling-off' from a particular set of standards or cultural attainments. It can never be an objective judgement but always an emotional one, although it does not necessarily imply disapproval. Usually the term is not applied solely or even mainly to style, but also encompasses the context in which works of art are produced, that is, the behaviour and morals of the artists and their society. The relationship between the abandoned standards and the ensuing decadence is symbiotic, in that the latter is impossible without full consciousness of the standards being undermined; decadence thus relies heavily for its impact on the very standards it affects to despise.

Although it is possible to imagine a decadent style without having recourse to the social or artistic context (cf. > Berenson's censure of the Constantinian figures on the Arch of Constantine), the perception of decadence is usually bound up with the story-line of a work of art, since – at least in the last two centuries – it is more fully a literary and cultural phenomenon than a purely artistic one. And it is a phenomenon that is eagerly and consciously sought by its practitioners, who enjoy an unseemly and designedly shocking wallow in the perverted, over-sensuous, strange and exotic pools of human sensibility.

● Linda C. Dowling, *Aestheticism and Decadence: A Selective Annotated Bibliography* (1977); Richard Gilman, *Decadence: The Strange Life of an Epithet* (1979); B. Berenson, *The Arch of Constantine or, The Decline of Form* (1954).

DECONSTRUCTION

Originating as a critique of > structuralist linguistics, deconstruction seeks to under-
stand the limits of language as a relational system of differences, or, in the words of the
instigator of the movement, Jacques Derrida, of *différance*. By this neologism Derrida
means both 'difference' and 'to defer', that is to recognize the gap between intention
and content, or content and reading. More recently Derrida himself wrote on the limits
of representation in *The Truth in Painting* (1987). The notion of *différance* has been taken
up with enthusiasm by some artists, and particularly architects, who seek to disrupt
expectations while indulging in the play of difference – which often seems to amount to
little more than the use of the unexpected, or downright inappropriate.

The movement has enormous potential to liberate our expectations of the art work,
allowing its entry into a wider, > semiological universe of signs and meaning, but has
yet to produce meaningful art, with the notable exception of > feminist deconstructions
of received notions of gender, sexuality and power, as in Cindy Sherman's photographic
self-portraits.

● D. C. Wood, 'An Introduction to Derrida', *Radical Philosophy*, 21 (1979); J. D. Culler, *On
Deconstruction: Theory and Criticism after Structuralism* (1982); J. Derrida, *The Truth in Painting*,
trans. G. Bennington and I. McLeod (1987),

DECORATIVE ART

Furniture and furnishings in all media: glass, > tapestry, > enamel, wallpaper, precious
metals, pottery, porcelain and wood. As a result of the survival of earlier prejudices, the
decorative arts have rarely been taught in > art history courses, which implicitly
separate them from the > 'fine' arts of painting, sculpture and > architecture.
Thankfully, this situation is now changing, as the discipline broadens its remit to match
those of other historical studies. The high/low division stems partly from the
development of the > academies, when 'fine' artists sought to distance themselves from
craftsmen by separating the academic and therefore cerebral from the decorative and
therefore manual, although to many > mediaeval artists, and indeed to many
> Renaissance artists – Donatello and Benvenuto Cellini, for example – there was
simply no such division. Nevertheless, the division was reinforced by Renaissance and
academic notions of > genius, and 19th-century movements such as the > Arts and
Crafts did little to bridge the divide.

One of the important characteristics of the decorative arts, as with > parks and
gardens, is the readiness with which they accept foreign influence and fashions, and
hence tell the art historian, whether investigating > court art or > collecting, more
about the temper of an age than can be learned from a painting.

● E. H. Gombrich, *The Sense of Order: A Study in the Psychology of Decorative Art* (1979);
Madeleine Jarry, *Chinoiserie: Chinese Influence on European Decorative Art in the Seventeenth and
Eighteenth Centuries* (1981); Dan Klein, *Decorative Art 1880–1980* (1986).

DECORUM

A requirement in > Classical aesthetics that an art work in whatever > medium be appropriate in > style and expression, not only internally, but also to its context. Decorum would therefore require a painting of heroic subject-matter to be treated seriously, in an elevated tone; conversely, to represent peasants as nobles would have been a breach of the proprieties. Such ideas found favour in the > academies, but after their decline a sense of what was fitting sometimes no longer made sense. Daumier, for example, could get a laugh out of portraying King Agamemnon with a paunch and Helen of Troy as a middle-aged woman out strolling, arms linked, like his own 19th-century French bourgeois audience. By using expectations of decorum as the lynchpin of his comedy, he demonstrated the decline of the very idea.

● Philip P. Fehl, *Decorum and Wit: The Poetry of Venetian Painting. Essays in the History of the Classical Tradition* (1991).

DEGENERATE ART

(*Entartete Kunst*). The name given by the Nazis to any art that did not meet their requirements for an authentically 'German' art, i.e. > naturalistic, > academy-inspired representations of the Aryan peoples. In Fascist > propaganda degenerate art was perpetrated by, or sympathetic to, the 'Judo-Bolshevist' tendency, and was therefore a target for official action. In 1937 an exhibition called 'Entartete Kunst' was held in Munich and other provincial centres, and included works by leading Modernists confiscated from German museums. Alongside work by Nolde, Chagall, > Kandinsky and Matisse, and by implication identical with it, were works by the insane.

● B. Hinz, *Art in the Third Reich* (1980); F. Roh, *Entartete Kunst: Kunstbarbarei im Dritten Reich* (1962); S. Barron (ed.), *Degenerate Art: The Fate of the Avant-Garde in Nazi Germany*, exhibition catalogue (1991).

DEL.

From the Latin *delineavit*, meaning 'he drew it'. When included in the margin of an > engraving, the term indicates the name of the artist who made the > original > drawing from which the engraving was made. Thus 'Lebrun *del.*' means Lebrun was the artist.

DELACROIX, EUGÈNE

(1798–1863). French > Romantic painter, one of the great artists of the 19th century and a distinguished and perceptive writer on art. During two very different periods of his career he kept a journal in which he discussed his theory of art and recorded his impressions of both contemporary and past art. He was also a prolific letter writer and published essays on artists with whom he felt an affinity, such as Michelangelo and, especially, Rubens.

● P. Burty (ed.), *Lettres d'Eugène Delacroix* (1878); R. Escholier, *Delacroix: peintre, graveur, écrivain*, 3 vols (1926–9); Eugène Delacroix, *Journal*, ed. A. Joubin, 3 vols (1960).

DERRIDA, JACQUES *See* Deconstruction

DESIGN

In > Renaissance art theory, design, or > *disegno* in Italian, referred to what in English would be considered as > drawing, with the added connotation of > composition. In modern parlance, however, design refers to the planning and pre-production stage of the manufacture of a functional or useful > artefact. Design will therefore take into account such criteria as intended purpose, technical limitations, quality, durability, aesthetic appeal and marketability. For much of the 19th century, when this understanding of design developed, the design of industrially produced artefacts was seen as inimical to quality and good taste, a view held by the > Arts and Crafts Movement in particular. In the 20th century this thinking was reversed by design schools such as the > Bauhaus, which attempted to improve the quality of industrial design. However, the antagonism of design, as applied essentially to the planning of functional artefacts, to > fine art, where considerations of function are not appropriate, is still held to be an issue.

● Nikolaus Pevsner, *Pioneers of Modern Design* (1960).

DESTRUCTION OF ART WORKS

Art works disappear through casual disregard, personal enmity, *raison d'état*, and as an incidental by-product of war and pollution.

Because no century has ever regarded every art work from the past as *ipso facto* worthy of preservation, casual disregard has probably been the most powerful, though slow-working, weapon in their destruction. By the same token, preservation of art works (> conservation) has depended upon finding a use for them so that they are relevant to the current state of affairs. In > architecture, > Roman > amphitheatres survived not because gladiatorial combats were continued in the Middle Ages, but because these structures made excellent housing and/or fortresses. On the other hand, many > antique buildings were allowed to decay because no use could be found for them, or because they were in an unsuitable location, such as the palaces on the Palatine in Rome, which could not be fed with running water in the Middle Ages. In sculpture, the equestrian statue of Marcus Aurelius survived because it was mistakenly thought to represent Charlemagne, the first Christian emperor. In periods thirsty for useful metals, many such large > bronze pieces disappeared. In painting, frescos could remain viable for centuries, as long as the supporting wall did not suffer damp or earthquakes. > Coins could survive as curiosities, but usually bullion needs would eventually see them melted down. The same fate awaited Louis XIV's surely vulgar suite of silver furniture. > Marble sculpture does not decay, and there are plenty of antique sites where earthquakes or vandals simply knocked statues to the ground, where they awaited their discoverers. Unfortunately, however, building work needs mortar, mortar needs lime, and marble statues in handy sizes provided fuel for the limekilns at those sites where the population was expanding, which is why so many more works have survived in Turkey and North Africa than in France or Italy.

Given the part played by > propaganda in the meaning and importance of many art works, it follows that their destruction would sometimes be required as a matter of state, whether civil or religious. Christian churches under > Islam were stripped of their frescos or mosaics, or, more often, whitewashed over. Offending sculptures had their faces hammered, and perhaps their arms and hands as well, in order to prevent active malevolence. Similarly, the Christians overturned and hammered Roman cult statues, just as the Romans replaced with their own works the cult objects of the peoples they conquered.

Destruction of art works by war has sometimes been the price exacted by the victor, but this has usually been confined to looting rather than the demolition of buildings, although the pulling-down of defensive walls and castle keeps was often practised. Looting, for art historians, can be productive, because it broadcasts art: > theft of art works. Complete destruction by war is a specifically 20th-century curse, and during the Second World War, aerial bombardment and the resulting firestorms were particularly effective in creating large-scale wreckage. Important, movable art works were rarely affected, usually being removed to mines or natural caves well out of the target zones, but architecture and > decorative art suffered enormously. Whole tracts of London were wiped out during the Blitz, including several Wren churches and many historical buildings in the City of London, and the Allies visited such devastation on Germany that the record of buildings damaged and destroyed runs to many thousands.

Aerial pollution of any consequence is a sign of our century, for the waste products of the internal combustion engine produce acids that eat away at stone and marble and, in the most severe cases, undermine sculpted surfaces into a pox of scabs and dust. Cleaning may brighten buildings (as in André Malraux's work in Paris), and perhaps the slight destruction of their surface is not too serious, but with sculpture such cleaning is impossible without first stopping the rot and resecuring the surface. The problem is especially serious in Rome and Athens, and in the former it has been suggested that all monuments be encased in a controlled atmosphere before everything is destroyed.

● Hartwig Beseler, *Kriegsschicksale: Deutscher Architektur: Verluste-Schaden-Wiederaufbau: eine Dokumentation für das Gebiet der Bundesrepublik Deutschland*, 2 vols (1988); Charles De Jaeger, *The Linz File: Hitler's Plunder of Europe's Art* (1981); Ministry of Works, *War and Archaeology in Britain: The Excavation of Ancient Sites and the Preservation of Historic Buildings* (1949); John Phillips, *The Reformation of Images: Destruction of Art in England, 1535–1660* (1973); Wilhelm Treue, *Art Plunder: The Fate of Works of Art in War, Revolution and Peace* (1960).

DEUTSCHER WERKBUND

An association founded in Munich in 1907 in order to improve the standard of industrial production. It promoted design for the machine instead of opposing it, and advocated the principle of mass production. The philosophy of the Werkbund was influential on Walter Gropius, who later founded the > Bauhaus.

● L. Burkhardt (ed.), *The Werkbund: Studies in the History and Ideology of the Deutscher Werkbund, 1907–1933* (1980).

DEVICE *See* Emblem.

DIDEROT, DENIS

(1713–84). Enlightenment > critic and philosopher. Diderot's writings on art are included mainly in the celebrated *Encyclopédie*, of which he was chief editor from 1751 to 1772, and in his reviews of the > Salons (1759–81). His views were materialist, and he believed the ability to appreciate > beauty was not innate, but acquired through learning. Opposing the > idealist and classicizing tendencies of 17th-century French > aesthetics, he praised the work of the > genre painter Chardin and the popular moralizing in the paintings of Greuze.

● Else M. Bukdahl, *Diderot, critique d'art* (1982); J. Seznec, 'Diderot and Historical Painting' in *Aspects of the Eighteenth Century*, ed. E. R. Wassermann (1967).

DIGITAL IMAGING

In an effort to make images (the art historian's stock-in-trade) more easily available, work is proceeding with making art images computer-readable by converting them into digital information. Once in this form, they can be controlled and manipulated by a computer, thereby allowing several to be brought up together on a computer screen (a computerized light table), or sent across the world over computer networks. Once such transmission is fast and easily accomplished, the next step will be to hold > databases of text and images in one location (or in sections in collections of locations) so that they are accessible from anywhere in the world. Thus the art historian will be able to have an 'electronic library' available to the local computer monitor, and the actual location of the stored data and images will not matter.

It is sometimes assumed that computers are 'intelligent', in the sense that they can be trained to 'read' images, and certainly a TV camera linked to a computer and a robot can deal with simple castings on a production line, and thereby help automate construction. But the use of 'computer intelligence' to analyse the contents of an electronic image, let alone to distinguish between two images on grounds of > style or > iconography, is certainly decades away, and will even then be so expensive and laborious to program that reliance on the > connoisseurship of the human eye and brain will be with us for a long time yet.

DILETTANTI

Founded in 1732 by wealthy young men who had undertaken the > Grand Tour, the Society of Dilettanti sponsored the study of the > fine arts, especially of antiquity. They financed publication of illustrated volumes on antiquities and presented several > collections to the nation, notably those of Sir William Hamilton, Charles Townley and Richard Payne Knight.

● L. Cust, *History of the Society of Dilettanti* (1914).

DILTHEY, WILHELM

(1833–1911). German philosopher and historian of ideas, who considered that manifestations of > culture were not open to the laws of causality (as were the social sciences) but could only be evaluated through the examination of society's attitudes towards them, the attitudes themselves being the product of historical circumstance. It being therefore impossible to know the past, Dilthey argued that the only solution would be to ask the nature of the central issues a given culture was engaged with, rather than study shifts in social relations, economics or > style.

● M. Ermarth, *Wilhelm Dilthey: The Critique of Historical Reason* (1978).

DILUENT

A liquid, usually a solvent, which may be used to dilute or thin a solution. Thus > turpentine is a diluent for > oil paint.

DIORAMA

Developed by Daguerre in the 1820s, a diorama is a scenic painting that, through the use of > perspective and lighting effects, gives a life-like impression of climatic conditions or times of the day. The most common form of the diorama today is the natural history displays of museums, where a 'stage' has been set with vegetation, stuffed animals and naturalistic lighting.

DIPTYCH

The name given to two panels of wood or > ivory hinged together like a book and displaying related scenes. The origin of the idea is the > antique waxed writing-tablet, the writing surfaces of which closed together for protection. The first example of the device in the visual arts of the West is the consular diptych. These celebratory ivory panels were sent throughout the Empire by Roman consuls of the 4th century and after, and displayed in fame-enhancing poses and settings.

In mediaeval and later art, the diptych sometimes appeared with portraits of a man and his wife, perhaps with > emblems on the external faces. But the device is best known through the 15th-century Flemish example, when hinged pairs of paintings on wood were used for private devotion, and often showed a portrait of the owner on one panel and a holy scene on the other. It is not unusual to find triptychs, where the central panel has the main scene (usually religious) and the side panels subsidiary scenes or donor portraits.

● Jane B. Friedman, *An Iconological Examination of the Half-length Devotional Portrait Diptych in the Netherlands 1460–1530* (1977); R. Delbrüch, *Die Consulardiptychen* (1926–9).

DISEGNO

For the Italians a general term for all the visual arts, but specifically a term focusing on > 'drawing', by which is meant the very structure of a painting. In the 17th century, it was frequently opposed to *colore*, with Poussin seen as an upholder of *disegno*, and > Rubens of *colore* (> Poussinistes vs. Rubensistes). The rationale was provided by the artistic league tables of Roger de > Piles and if it seems to us strange even to try to separate drawing from > colour, the > Renaissance and its > academies did not find it so. Michelangelo saw a substantial gulf between his own art and that of Titian partly for this reason, and the Poussin/Rubens polarity underlined the existence of two distinct artistic traditions.

● Dennis Mahon, *Studies in Seicento Art and Theory* (1971); Zygmunt Wazbinski, L'*Accademia medicea del disegno a Firenze nel Cinquecento: idea e istituzione* (1987).

DISPLAY OF ARTWORKS

Although today the exhibition of art works is assumed to involve their presentation in a public forum, this was not always the case. Some devotional objects were seen rarely, if at all, and then only as part of religious ritual. By the Renaissance, works collected by > amateurs into > cabinets of curiosities and the private > collections of the nobility or royalty were not public in the modern sense of the word, but open to very restricted audiences. With the break-up of many private collections towards the end of the 18th century and the removal of their art works to the new national and later civic museums of art open to the public, the question of display became important. Today public museums have to reconcile the often conflicting demands of > conservation and display.

Most museums aim to be as unintrusive as possible, but it is inevitable that there will at times be conflict between the demands of conservation and security and the expectations of the public. Old Master drawings, for example, are rarely seen to advantage exhibited behind glass in low levels of light, but the preservation of the art work requires that such precautions be taken. Today galleries go to inordinate lengths to balance their obligations towards both the art work and the public, paying attention to issues such as lighting, labelling, colour schemes and seating in order to make their role in the enjoyment of the artwork as unobtrusive as possible.

● B. O'Doherty, *Inside the White Cube: The Ideology of the Gallery Space* (1986); P. Vergo, *The New Museology* (1989).

DIVISIONISM *See* Pointillism.

DONOR

Large numbers of works of art and > architecture are the result of the calculated generosity of a private donor, rather than being provided by the Church, state or city. The practice goes back at least to > Greek times, and was a means of increasing personal and family prestige. Where works of art or architecture are dedicated to a

deity, they are said to be votive, that is works demonstrating devotion. Herodes Atticus, although perhaps principally devoted to his own prestige, paid for buildings and fountains throughout the Greek world, notably in Athens; > Roman emperors dedicated and even paid for temples, such as Augustus's Temple of Mars Ultor, following the Civil War against Mark Antony. During the Middle Ages, the rich rushed to donate land to the Church, as well as to build chapels and dedicate altars, silver and manuscripts so that their eternal souls might be prayed for in perpetuity. Each chapel would be decorated, often sumptuously, for the public prestige of the donor was in the balance. As a result, many of the great chapels of the > Renaissance, for example, were decorated by the very best artists: Giotto in the Bardi Chapel, Masaccio in the Brancacci Chapel (both in Florence), Raphael in the Chigi Chapel and Bernini in the Cornaro Chapel (both in Rome).

Art works might also be donated by individuals or institutions to stand in public places. Statues of Roman dignitaries were erected through the piety of relations, and were so described on the podium. Greek and Hellenistic statues of athletes were erected by the organizers of the games, or the athletes' patrons, to beautify the approaches to the stadia; in the same context, states would fill small buildings with gifts to the God of the games. These treasuries are still to be seen at Delphi and Olympia. The various > guilds of Florence competed amongst themselves by commissioning artists to fill niches on the exterior of Orsanmichele.

For many > mediaeval and Renaissance > patrons of the arts, especially outside Italy, their generosity in donating works to religious institutions did not therefore include anonymity, and in the West during the 14th century a practice developed whereby they had their artists record them in the works they made, partly as an act of piety and partly, perhaps, as the result of socially conscious arrogance, for they surely elevated their own status through associating themselves with religious figures. The representation of donor and recipient together is, however, a much older idea: Greek heroes or Roman emperors often hobnobbed with the gods on terms of apparent equality. Christian usage of disparity in size was adopted from pagan art, and is frequently seen in donor portraits in the East, such as the examples in Hagia Sophia and in the Martorana in Palermo.

In both these cases, and in some Western works of art, for example many > Early Netherlandish paintings, the donor kneels in the same space and even at the same scale as the holy figures, so that a saint might present him, her or them to the Virgin and Child. Frequently, however, donors are separated from the holy figures in another panel of a > diptych or > polyptych, and are often smaller in scale in order to indicate their lesser importance.

● S.G. Moulton, *Titian and the Evolution of Donor Portraiture in Venice* (1981).

DRAWING

A composition of line and shade, usually on paper and executed in > pencil, pen, > charcoal, > chalk or a similar > graphic > medium. Drawings have traditionally been used as the preparatory stage of picture-making in the form of a > sketch and when transferring the composition to > canvas, > panel or wall. As a medium in its own right drawing came to be appreciated when the working drawings of > Renaissance artists

began to be valued for the insights they offered into an artist's powers of > invention. In 17th-century > academic theory drawing was valued over painting as the literal transposition of the idea, as distinct from the 'mechanical' work of grinding and applying > colour, which recalled the artisanal approach of the > guilds. From this stemmed the belief of the superiority of line over colour (> Poussinistes vs. Rubensistes), an unjustified assertion that assumed the colourists neglected drawing. While many artists made drawings, including > Rubens, Rembrandt, Fragonard and Turner, for others such as Ingres it was the touchstone of art. Two of Ingres' favourite aphorisms were: 'Drawing is the probity of art', and 'I can teach you painting in a week, but drawing takes a lifetime'. In the 20th century, drawing has been liberated from this subservient role to find expression in the work of such consummate artists as Rodin, Matisse and, more recently, Hockney.

● Charles de Tolnay, *History and Technique of Old Master Drawings* (reprinted 1972); Francis Ames-Lewis, *Drawings in Early Renaissance Italy* (1981); Susan Lambert, *Reading Drawings: An Introduction to Looking at Drawings* (1984).

DRAWING-FRAME

An aid to the accurate > copying of a figure in > perspective. It consists of a rectangular wooden frame with a grid of wires stretching horizontally and vertically across its diameter. The frame is placed between the artist and the subject at such a distance from the artist that it corresponds to the surface intended to receive the drawing. The picture surface is then divided into squares matching those of the drawing-frame, leaving the artist with the simple task of transferring the resulting measurements to the drawing. Such a device is illustrated in Albrecht Dürer's *Underweyssung der Messung* (Treatise on Measurement) (1525).

DRIP PAINTING *See* Action painting.

DRYING OILS

Any vegetable oil, such as linseed, walnut or poppyseed, which oxidizes into a hard film and is thus employed as a > varnish or as a > vehicle in > paint.

DRYPOINT

A reproductive technique associated with > etching, where the plate is directly scratched with a sharp point, instead of being bitten by acid. Used by etchers (for example Rembrandt) to add light and delicate touches of detail or shading to their plates, which could not be accomplished easily using the less controllable acid. When used alone, drypoint is notable for the burr of metal shavings cast up by the steel point, which produces velvety effects in those few impressions (usually no more than 50) that can be pulled before the burr is destroyed under the pressure of the printing process.

DURAND-RUEL, PAUL

(1831–1922). French picture dealer (> art dealing) best known for his support of the > Impressionists, after he met Monet and Pissarro in England when all three were refugees from the Franco-Prussian War of 1870–1. During the 1870s his support seemed futile, but from the 1880s wider public interest in the movement saw his investment return huge profits. In 1886 there was enough interest for him to organize an exhibition of Impressionist painting, and to open an office in New York, the success of which directly contributed to the founding of America's unparalleled collections of Impressionists.

DURANTY, EDMOND

(1833–80). French novelist and art critic. He was an advocate of > Realism and an early supporter of the > Impressionists. His novella Le Peintre Louis Martin perfectly captures the tensions between the > avant-garde and the Establishment in mid-19th-century Paris.

● Edmond Duranty, 'Le Peintre Louis Martin', in Le Pays des Arts (1881).

DÜRER, ALBRECHT

(1471–1528). Seminal not just as the pre-eminent painter of the German > Renaissance, but also because of his attachment to the relatively new art of printing via > prints and associated religious texts, and because of his writings. Indeed, his printmaking and print-publishing activities were extensive and his large series of the Great Passions, the Apocalypse and the Life of the Virgin were published as books. By his own example, he opened up German art to Italian influences, and espoused many of the characteristics of the Italian Renaissance, ideas as well as > forms.

Whilst he promoted his artistic ideas and styles by publishing his prints, his attitude to art was also theoretical and systematic in true Renaissance fashion: he published his Treatise on Measurement in 1525, and his Four Books on Human Proportion appeared posthumously in 1528. He sometimes acted as his own publisher and after his death his wife continued the battle against > forgeries and > imitations of the famous AD monogram. The very foundation of the German > School of art rested not just on his example, but on his theoretical writings, which were studied as handbooks of art. Through him, Northern art would adopt > academic practices similar to those south of the Aps.

● Albrecht Dürer, Schriftlicher Nachlass, 3 vols (1956–69); Erwin Panofsky, The Life and Art of Albrecht Dürer (1955).

DUTCH ART

Before the 17th century, the history of Dutch art was based first on the strong artistic traditions of the Duchy of Burgundy, a branch of which occupied the southern

Netherlands, with art production concentrated on Bruges and Ghent, and then on > Renaissance forms of art imported from Italy and the Germany of > Dürer. The heyday of Dutch art was the 17th century, when Holland's international influence and prestige depended on her overseas trade, her navy and her high political profile.

The flavour of her art reflected the largely bourgeois structure of her society, her predominant Protestantism and her mercantilism, not to mention her patriotism: Subjects preferred included > landscape and city scenes, domestic life, > portraits and > marine scenes; religious stories would often be interpreted within familiar land- and cityscapes. Conversely, Renaissance traditions of 'high' art found little favour. Given that the Dutch Republic was Britain's main competitor for command of the seas and hence of prosperity through overseas trade, it is not surprising that many aspects of Dutch art found echoes in that of its rival, especially in the 18th century.

● Svetlana Alpers, *The Art of Describing: Dutch Art in the Seventeenth Century* (1983); Erik Larsen, *Calvinistic Economy and Seventeenth-Century Dutch Art* (1979); Jakob Rosenberg et al., *Dutch Art and Architecture: 1600 to 1800* (3rd ed. 1977).

DUVEEN, SIR JOSEPH

(1869–1939). An > art dealer who elevated dealing from mere trade to an art in itself by convincing some of the great magnates of the USA to buy (largely) Italian > Renaissance art for prestige and pleasure – but not yet for investment, although very large sums changed hands. In the process Duveen was instrumental in denuding the British Isles and Continental Europe of many first-class paintings, which now, thanks to the USA's generous tax concessions, hang on the walls of that country's public galleries. He paid a little back by endowing the Duveen Galleries in the > British Museum.

Bernard > Berenson facilitated the process of this continental rearrangement of art > collections by signing certificates of authenticity that reassured the (largely artless) Duveen buyers that they were getting what was said on the labels – labels often originated by Berenson's own > connoisseurship.

● Samuel N. Behrman, *Duveen* (1972); Colin Simpson, *The Partnership: The Secret Association of Bernard Berenson and Joseph Duveen* (1987).

E

EARLY NETHERLANDISH PAINTING

A school of painting, principally 15th century, straddling the borders of present-day Belgium, Northern France and the Southern Netherlands. The school reached an early peak in the work of the Master of Flémalle, and especialy Jan van Eyck, whose unsurpassed mastery of the new technique of > oil painting is evident in *Giovanni Arnolfini and his Wife* (1434), the > medium allowing him an astonishing degree of control but with a fluidity quiet alien to the prevailing > tempera painting. Stylistically, the school showed a strong interest in using > naturalism in the service of > symbolic meaning; thus in *Arnolfini*, for example, the representation of fruit is not simply a naturalistic *tour de force* but also a reference to the biblical story of Eden, and so on. Other major exponents of the school include Petrus Christus, Rogier van der Weyden and Hugo van der Goes.

● E. Panofsky, *Early Netherlandish Painting* (1953); M. J. Friedländer, *Early Netherlandish Painting from van Eyck to Breugel* (1956).

EARTH ART. *See* Land Art.

EASEL

A wooden stand designed to support the painting in a near-verticle position during execution. WIth the rise of the transportable > oil painting on > canvas, known as the > easel-painting, during the 16th century, the easel became increasingly important. While the adjustable tripod came to be the most common form, much larger structures were needed to accommodate the monumental canvases of > history painters. A light collapsible easel was developed in the 19th century to cater for > *plein air* painters whose main requirements was lightness for ease of transportation.

EASEL-PAINTING

The term refers to any painting, although usually executed in > oils on > canvas, small enough to be accommodated on a standard > easel.

ÉBAUCHE

(French: 'sketch'). In > oil painting, the preliminary blocking-in of the underpainting.

ECLECTICISM

The blending of influences from various sources to form a new > style or approach. Eclecticism was highlighted by > Vasari as a characteristic of Raphael's art, although in truth the concept goes back to antiquity. To the extent that most artists develop their own style from an amalgam of influences, then most art is eclectic; but the term is properly used only of a conscious and indeed synthetic combination of influences: for example, Tintoretto's intention to combine the > *disegno* of Michelangelo with the > colour of Titian. If the term is sometimes misleadingly used of the Carracci and their followers, and targeted as the very opposite of > originality, it is correctly applied to the host of 19th-century artists concerned with various forms of > revivalism.

● Albert Boime, *Thomas Couture and the Eclectic Vision* (1980); Klaus Dohmer, *In welchem Style sollen wir bauen?: Architeckturtheorie zwischen Klassizismus und Jugendstil* (1976); Mark Girouard, *Sweetness and Light: The Queen Anne Movement, 1860–1980* (1977).

ÉCORCHÉ FIGURE

(French: 'flayed'). A study of a human or animal figure without skin, revealing the musculature, used for teaching or scientific purposes. > Leonardo's studies of humans and Stubbs's of horses are notable examples.

EDITION

For books, especially illustrated ones likely to be collected because they contain the work of significant artists, the concept of an edition is important, it being the total number of copies printed at one time without changes being made (there may be several separate impressions of the same edition, but this rarely affects artists' illustrated books). In much 20th-century work, editions are usually small (i.e. 'limited editions'), and the likelihood of there being subsequent editions equally so. With earlier illustrated books, however, the question is more complicated because there was a trade in the plates of illustrations, which were were often reworked, so that determining the exact relationship between an artist and an illustration can be difficult.

In the 19th century, the practice developed of publishing sets of prints with no or very little text, and these may also be said to appear in editions. Important series were produced by Hogarth, Goya and Picasso. *See* Print.

> Sebastian Carter, *The Book Becomes: The Making of a Fine Edition* (1984).

EGYPTIAN ART

With traditions stretching back to the 4th millennium BC, Egyptian art is the parent of all European artistic traditions, producing exemplars in > fresco painting, bas-relief, three-dimensional sculpture and > architecture which were imitated by both contemporary and later > civilizations. Egyptian art popularized forms and ideas that could be applied

elsewhere, from the monumental (sometimes > colossal) statue to the temple complex, and from elaborate grave goods and mausoleums to commemorative art. Thus the > Greeks probably developed the standing human figure and the forms of their temples from Egyptian examples, and the > Romans (especially after the conquest of Egypt) found Egyptian monumentality sufficiently attractive to furnish their cities with imported obelisks and statues, and to develop their own pseudo-Egyptian styles.

● Heinrich Schafer, *Principles of Egyptian Art* (1974); William S. Smith, *The Art and Architecture of Ancient Egypt* (1958).

EGYPTIAN REVIVAL

What the > Renaissance knew of Egypt, and their interest in > hieroglyphs, was mostly picked up from Roman sources, and a comprehensive knowledge of Egyptian art invaded Western Europe only after Napoleon's Egyptian expedition of 1798, when he took scholars with him. Thus D. V. Denon's *Voyage dans la haute et dans la basse Égypte* (1802) offered many designs to imitate, far more than Piranesi's *Diverse maniere di adornare i cammini* (1769), which was not based on firsthand knowledge. However, it was the *Description de l'Égypte*, the researches of Napoleon's scholars in nine folio volumes, which fascinated Europe and laid the foundations not only for scholarly excavation there, but also for the Eygptian Revival itself.

This was largely in the > decorative arts, not least because of the grip the Greek and Roman revivals had on all > architecture except for the funereal, as may be seen from Boullée's designs or from any 19th-century cemetery. In some cases, as with the collector Thomas Hope, the Egyptian style was adopted to complement Egyptian antiquities, collected in increasing numbers as the century wore on.

● J. Baltrusaitis, *La Quête d'Isis: Essai sur la Légende d'un Mythe* (1985); Peter A. Clayton, *The Rediscovery of Ancient Egypt: Artists and Travellers in the Nineteenth Century* (1982); J.-M. Humbert, *L'Egyptomanie dans l'Art Occidental* (1989).

EIGHT, THE. *See* Ash-can School.

ELGIN MARBLES

Sections of the pedimental statues, frieze and metopes of the Parthenon collected by Lord Elgin in 1801–3 with the permission of the Turks and eventually sold by him to the British government in 1816, but only after a Royal Commission (a document of much interest in the history of > taste) had adjudicated on their artistic worth. The Earl hoped that the works might help in the perpetual struggle to improve the level of artistic taste in Britain, but by the time they were on open view neoclassicism was waning, and it was only minor artists such as Westmacott and B. R. Haydon who were interested in using them. Stylistically, they introduced Europe to > Greek art of the > Classical period, whereas until then (and in spite of the theorizing of > Winckelmann) the majority of prized antiquities had been Hellenistic or > Roman.

Today, the Elgin Marbles continue as the focus of arguments about the return of artistic property 'liberated' (in this case from the Turks) in less happy times. Should

such works be returned to their correct context (in this case a museum on the Acropolis in Athens), and if so where should that be, and under what conditions should such returns cease? Since a nation's heritage is presumably made up of things begged, bought, borrowed and stolen, disentangling the 'correct' ownership of works such as the Elgin Marbles from considerations of the present owner's heritage could prove impossible. Perhaps a working principle could be made in which 'heritage', which would be allowed to remain in its present home, would be defined as anything that has been in place for more than a century, whereas > theft of art works in the past 100 years or so would require action. This would affect trophies won principally by Britain and North America and later by countries such as Switzerland and Japan from more impoverished parts of the world, including Italy, Greece and North Africa. The question is, how might what has now become part of a nation's heritage be protected against such restitution?

● John Boardman, *The Parthenon and its Sculptures* (1985); Christopher Hitchens (ed.), *The Elgin Marbles: Should They Be Returned to Greece?* (1987); William St Clair, *Lord Elgin and the Marbles* (1983).

EMBLEM

A design with a hidden meaning. Emblems derive from the > Renaissance popularity of > Egyptian > hieroglyphs, which were supposed to contain hidden mysteries. A key work was Francesco Colonna's *Hypnerotomachia Polifili* (1499), which contained many newly invented emblems. Andrea Alciati's *Emblematum liber* (1531), the first of many true emblem books, provided both designs and an explanation and led to a veritable vogue for such hidden communications in the 16th and 17th centuries, when it became almost a literary and artistic > genre. The rationale behind an emblem (i.e. the source of the explanation or the design) could be either Christian or pagan, and religious emblems appeared in religious paintings just as personal devices were often included in > portraits, > coins and > medals.

If such delight in the concealment of meaning seems obscurantist – the best example of this is Dürer's print entitled *Melencolia I*, about which a very long book has been written in an attempt at elucidation – the explanation is that meaning cannot always reside on the surface of things, but in their essence. Art historians must be aware of the emblem if they are fully to elucidate broad swathes of art from the Renaissance until the end of the 18th century, when the fashion died.

● Peter M. Daly (ed.) *The English Emblem and the Continental Tradition* (1988); Peter M. Daly (ed.), *The European Emblem: Towards an Index Emblematicus* (1980); Henry Green, *Andrea Alciati and his Books of Emblems: A Biographical and Bibliographical Study* (1966); Arthur Henkel and Albrecht Schoene, *Emblemata: Handbuch zur Sinnbildkunst des XVI und VII Jahrhunderts* (rev. edn. 1976).

EMPIRE STYLE

A style in furniture and the > decorative arts begun by the architects Percier and Fontaine for Napoleon, and reliant upon knowledge of the clean and simple lines of > Classical furniture derived from study of the excavations at Pompeii and

Herculaneum, and also from the vogue for > Egyptian art. The latter was appropriate, given Napoleon's conquest of that country and his role in the popularization of Egyptian art (> Egyptian Revival).

● David Irwin (ed.), *Joseph Beunat: Empire Style Designs and Ornaments: A Reprint of Recueil des dessins d'ornaments d'architecture, 1813* (1974); M. Fleischmann, *In the Neoclassic Style: Empire, Biedermeier and the Contemporary Home* (1988).

EMULSION

The suspension of one liquid in another usually incompatible one, for example oil in water. This is achieved through the agency of an an emulsifier, which coats the drops of oil to prevent them from coalescing. The egg used in > tempera painting contains the natural emulsifiers albumen and lecithin.

ENAMEL

In > fine art a glossy > paint that dries to a hard, smooth surface, not unlike the glazes applied to ceramics. In the > decorative arts enamel is a vitreous glaze used in the decoration of ceramics, jewellery or similar small objects such as cigarette boxes and mirror frames. The technique enjoyed a vogue with > Art nouveau.

ENCARNADO

(Spanish: 'flesh-coloured'). A term used to describe the representation of flesh on polychromed Spanish wooden sculpture.

ENCYCLOPÉDIE

The *Encyclopédie: ou, Dictionnaire raisonné des sciences, des arts et des metiers* (35 volumes, published between 1751 and 1776) was the greatest publishing enterprise of the 18th century, and was popular Europe-wide, in both the original and in excerpts and translations. It is a landmark in the production of illustrated encyclopaedias. Not only was it the most complete and highly illustrated encyclopaedia to date, but its stance (from its prime mover and editor, Denis > Diderot) was that of the > Enlightenment. For the visual arts, it provides valuable descriptive and illustrative information on techniques, as well as summaries of attitudes towards the perennial artistic matters of > academies, the > antique, and so on. Selected texts are available in many editions and translations, for example edited by A. Soboul and published by Éditions Sociales, Paris, from 1962.

● Robert Darnton, *The Business of Enlightenment: A Publishing History of the Encycolpédie, 1775–1800* (1979); John Lough, *Essays on the Encyclopédie of Diderot and D'Alembert* (1968); Amy C. Simowitz, *Theory of Art in the Encyclopédie* (1983).

ENGRAVING

This entry is limited to the strict definition of engraving, that is, the > intaglio process resulting from lines incised in a plate or block. See > etching and > lithography for the other main techniques, and > print for the importance of these media in the art world.

Employing a technique used since the mid-15th century, a sharp needle or > burin ploughs lines of varying widths and depths into a plate, usually made of copper. > Ink is forced into the furrows, the surface wiped clean (it should print white), and the plate pressed against a sheet of dampened paper so that the ink is transferred to it. The finished effect depends on the subtlety and intricacy of the lines, as well as the skill in inking and wiping the plate. Such plates are very robust, and will take a large number of impressions without noticeable wear; because of this, engravings were used interleaved in books in large numbers, although they could not be printed at the same time as type, since the latter is a relief process and requires much less pressure to print well.

Because of the slowness and difficulty of the technique, which must conjure bulk, highlights and shadows from a set of lines, line engraving was usually the preserve of professionals, who from the 16th until the end of the 19th century used the technique to make > reproductions of paintings and > drawings. Because lines were their only means of expression, engravers developed a set of analogues for shadows, textures and highlights from criss-crossed and 'bellied' lines in an attempt to build up > form and depth. Other than artists' drawings, reproductive engravings were, for better or worse, the main channels for the dissemination of knowledge about works of art until the advent of machine-reproducible photographic methods.

● Arthur M. Hind, A *History of Engraving and Etching from the Fifteenth Century to the Year 1914* (3rd rev. edn 1963); Anne Lyles and Diana Perkins, *Colour into Line: Turner and the Art of Engraving*, exhibition catalogue, Tate Gallery, London (1989).

ENLIGHTENMENT

A philosophical movement of the 18th century, beginning in France but then spreading throughout Europe, celebrating reason and the perfectibility of man over his passions and the environment. The Enlightenment's champions – such as Montesquieu, > Diderot and Voltaire – were liberal, pro-science, anti-superstition and anti-institutionalized religion, and all believed the state to be the proper vehicle for the improvement of the human condition. To the extent that they bothered about the > quarrel of the ancients and moderns, they were firmly on the side of progress. Those who subscribed to these ideals or mind-set constitute the roll of honour of 18th-century thought and writing, from > Pope, Gibbon, Adam Smith, Hume, Benjamin Franklin and Thomas Jefferson to > Kant, > Lessing and Herder.

Along with the > Industrial Revolution, from which it obtained much inspiration and ammunition, the Enlightenment occasioned the most fundamental changes in the mind-set of the largest number of people since the institution of the Church. Profoundly influential for all the arts, it was a motor for both the American and the French Revolutions. Like the architects of these, its philosophers, movers and shakers, realizing the power of art, viewed it primarily as a tool for the improvement of the moral and

social condition of mankind – see, for example, Diderot's support of the moralizing paintings of Greuze, for which he provided what amounted to prescriptions.

• Joseph Burke, *The Iconography of the Enlightenment in English Art* (1970); A. Nivelle, *Kunst und Dichtungstheorien zwischen Aufklärung und Klassik* (1971).

ESTE

Lords of Ferrara until 1598 (thereafter of Modena and Reggio), and > patrons of artists including Alberti, Pisanello, Jacopo Bellini and Cosimo Tura. **Isabella d'Este** (daughter of **Ercole** I) married Francesco Gonzaga of Mantua, and bought paintings by Mantegna, Perugino and Correggio for her > *studiolo*. > Collecting clearly ran in the family, for her brother **Alfonso** patronized Bellini and Titian, and in the 17th century, **Francesco I** commissioned portraits from Bernini and Velásquez. Many of their best pictures were sold to Augustus III of Poland at Dresden in 1744.

• Clifford M. Brown, *Isabella d'Este and Lorenzo da Pavia: Documents for the History of Art and Culture in Renaissance Mantua* (1982); Charles M. Rosenberg, *Art in Ferrara During the Reign of Borso d'Este* (1450–1471): A *Study in Court Patronage* (1974).

ETCHING

This entry is rstricted to the strict definition of etching. See > engraving, > drypoint and > lithography for the other main techniques, and > print for the importance of these media techniques, and > print for the importance of these media (> medium) in the art world.

Etching relies on acid biting into a plate where required, and on the use of resin to protect areas where this should not happen. A copper or zinc plate is covered with resin, and the artist then draws on it with a needle, exposing a series of lines that can then be bitten in the acid bath. Whereas an engraved line requires firm precision to guide the sharp point of the > burin over the slippery copper, the etching needle moves easily over the resin, making this a much easier and less calculated technique, almost equivalent to > drawing and consequently much practised by artists, who can simply 'draw' into the resin. This is one reason why etching is not a technique for > reproducing the work of others. Another is that engraved lines are clear and precise, because the channels have sharp sides ploughed out by the burin; etching, on the other hand, produces lines with uneven and even wobbly sides, because the exact characteristics of the etched line depend on the metal into which the acid eats. Etching, then, is favoured for original compositions, best seen in the work of Rembrandt, who would rework his plates time and again.

Biting the plate goes in stages, and is open to experimentation. Impressions of the plate are taken every so often to see how deeply the acid has bitten into the exposed lines. Subtle effects can be obtained by encouraging differential biting, that is by 'stopping out' with resin those lines judged sufficiently bitten, and then concentrating on the others. The plate is then covered with > ink and the surfaces, which are to print white, wiped clean. The ink is transferred to the paper under the pressure of the

printing press. Very fine lines and delicate effects are possible, but because of the printing process, delicacies quickly wear off the plate after only a few impressions, necessitating re-cutting.

● Ernest S. Lumsden, The Art of Etching: A Complete and Fully Illustrated Description of Etching, Drypoint, Soft-ground Etching, Aquatint and Their Allied Arts, Together with Technical Notes upon Their Own Work by Many of the Leading Etchers of the Present Time (reprinted 1962).

ETRUSCAN ART

The Culture of central Italy (Etruria = Tuscany) from the 8th century BC until > Roman absorption following its conquest in the 1st century BC. The Etruscans were especially notable as engineers, > bronze-casters, metalworkers and builders of monumental tombs; their culture, of complex influences, especially prized > Classical > Greek work, which is why some of the best Greek vases (> Etruscan vases) have been found on Italian soil. It is believed that the Romans developed their taste for art from their various conquests, especially from Greece and the Etruscans. Thereafter Etruscan art had no apparent influence until the > Renaissance, when > Leonardo and Michelangelo may have known something of it. Its main revival was in the 18th century, when it was part of the general movement of > Neoclassicism towards pre-Roman sources.

● Otto Brendel, Etruscan Art (1978); A. Neppi Modona, A Guide to Etruscan Antiquities (rev. edn 1968); Nigel J. Spivey, Etruscan Italy (1990).

ETRUSCAN VASES

In the 18th and 19th centuries, > Greek vases unearthed in Tuscany and believed by some to be > Etruscan. They were popular collectors' items, and Sir William Hamilton (husband of Emma) formed two large > collections while British plenipotentiary at Naples. Now in the > British Museum, illustrations of the first collection were luxuriously published by P. F. H. d'Hancarville in 1766–7 in four folio volumes, and illustrations of both collections continued to appear in cheaper > editions well into the 19th century. They sometimes appeared without colour, and the simple linear designs of the vases certainly encouraged > Flaxman to purify and 'linearize' his > style into two dimensions (and into low > relief for his funerary plaques). In his illustrated editions of their works, he treated Dante and Homer in a similar fashion, and this was quickly taken up in France by David and his followers. The manner hit Europe at a time when her artists were tiring of the extravagant three-dimensional and > illusionist qualities of > Renaissance and > Baroque forms, and were, through excavations at > Pompeii and Herculaneum, turning yet again to the > antique for inspiration.

● Brian Fothergill, Sir William Hamilton, Envoy Extraordinary (1969).

EUSTON ROAD SCHOOL

A school of painting and > drawing situated on Euston Road, London, from 1937 to 1939. It was antagonistic to > abstraction and favoured > naturalistic painting. Leading

119

members included Graham Bell, William Coldstream, Lawrence Gowing and Victor Pasmore.

EXHIBITION CATALOGUES. *See* Catalogues.

EXHIBITION

Exhibitions proper – as opposed to work offered for sale in fairs such as Saint-Germain in Paris or as part of a religious festival where artists provided the visual imagery – were a result of the rise in the status of the artist from artisan to practitioner of a liberal (> liberal arts) profession. As such, artists came to be expected to exhibit their work as a professional body, as anticipated in the founding statutes of the French > Academy in 1648. Although the first > Salon dates from 1667, they were infrequent until 1737, but thereafter were held annually or biannually. These exhibitions, although open to the public and > critics, were the preserve of the academicians. In the 19th Century, however, the Salon was opened to all artists, and admission was by jury.

Abuses and favouritism prevailed and independent artists began to stay away, or hold rival exhibitions, such as Courbet's independent show in 1855 at the very gates of the official Exposition universelle. More evidence of discontent with the Salon was shown by Salon des > Refusés, authorized by Emperor Napoleon III in 1863, and the Impressionist exhibitions between 1874 and 1886. By then, however, dealers (> art dealing) were providing another link between artist and public, while other exhibition venues, confusingly also called 'salons', such as the Salon des Indépendants, proliferated. By the end of the 19th century dealers were increasingly organizing one-person and group shows, for example > Durand-Ruel's New York exhibition of > Impressionist painting in 1886. This is an early example of a practice that in the 20th century has become the norm. Today established artists are represented by galleries (> museums and galleries) who exhibit their work on a regular basis. The 20th century has also seen many artists' groups, from the > Blaue Reiter to > Cobra, formed for, amongst other things, the purposes of exhibition.

● T. E. Crow, *Painters and Public Life in Eighteenth-Century Paris* (1985; 1986); Ian Dunlop, *The Shock of the New: Seven Historic Exhibitions of Modern Art* (1972); Elizabeth Holt, *The Triumph of Art for the Public, 1785–1848: The Emerging Role of Exhibitions and Critics* (1983); Georg F. Koch, *Die Kunstausstellung. Ihre Geschichte von den Aufaengen bis zum Ausgang des 18 Jahrhunderts* (1967).

EXPRESSION

The art of showing the emotions, the mind and the soul by means of facial and bodily movements, expression was recognized as a lynchpin of any art involving a > naturalistic account of human beings from > Alberti's *Della Pittura* (1436) onwards. In a famous retort reported by > Vasari about the preparation of his *Last Supper*, Leonardo made the same point: expression is the only means allowing artists to communicate that which is inside. In the theatre of the Greeks and Romans, expression was

formalized by the use of masks, whilst in the 17th century, with its emphasis on the academic and cerebral, attempts were made to systematize expression for the artist, so that it might be taught in the > academies. Charles > Lebrun's treatise *Méthode pour apprendre à dessiner les passions* . . . (1698), and the subject of his lectures to students at the Académie, was but the formalization of the lessons he learned through studying the art of Poussin. The same ideas prospered in the 18th century, bolstered by the study of physiognomy (considered a science), which seeks to determine character from appearance; see, for example, Lavater's *Physiognomical Bible* (1772).

● Guy Sircello, *Mind and Art: An Essay on the Varieties of Expression* (1972).

EXPRESSIONISM

An early 20th-century movement which came to prominence during the First World War in reaction to the > naturalism of > Impressionism and its followers. Although movements such as > Fauvism may clearly be called (and indeed were considered) Expressionist, it is now applied to the art of Germany and Austria and their satellites from the beginning of the century up to the seizure of power by the Nazis, who suppressed it as Communistic > 'decadence'.

Expressionism sought to express pictorially the > artist's state of mind, religious or social convictions in images that in the roughness of their execution and simplicity of line and plane broke with the conventions of > academic art in favour of a frame of reference influenced by > naïve and > folk art. Following the lead of earlier artists who had employed an 'expressionistic' manner (the small 'e' denotes the approach not the movement), such as Gauguin, van Gogh and Edvard Munch, Der > Brücke (The Bridge), formed in Dresden in 1905, carried Expressionism to extremes in violent and aggressive > compositions. From 1911, the > Blaue Reiter (Blue Rider) group held > exhibitions in Munich and Berlin and evolved a more structured and, in the case of > Kandinsky, more theoretically informed art out of Expressionism.

After the First World War, Expressionism influenced the essentially > realistic > Neue Sachlichkeit artists. Expressionism was also an early influence on the > Bauhaus via Kandinsky and Klee, who began to emphasize the > abstract qualities in their work, and in its merging of abstract form and expressive > Gestural painting, on post-Second World War > Abstract Expressionism.

● F. Whitford, *Expressionism* (1970); J. Willet, *Expressionism* (1970); *Art and Politics in the Weimar Republic: The New Sobreity 1917–1933* (1978); S. Barron, *German Expressionism 1915– 1925: The Second Generation*, exhibition catalogue, Los Angeles County Museum of Art (1988).

EX-VOTO

(Latin 'from a vow'). A painting or > artefact donated to a shrine as a votive offering of thanks to God, either for a prayer granted or in the hopes of divine intervention.

F

FAÇADISM

Shorthand for a type of > style, or equally a reproach directed at architects whose interest in > architecture seems limited to the construction of façades, and who neglect to provide any coherence between the façade and what lies behind. All stage scenery designers would gladly plead guilty to this crime, which has come to prominence recently with the expansion of > Post-Modernism, a style whose detractors claim is largely restricted to cardboard-like façades, many imitated from book illustrations, or misunderstood or abbreviated from the works of dead and better architects. The description is frequently accurate, since Post-Modernism often erects façades that stand well clear of what lies behind (like stage sets), and which bear an unclear structural relationship (if any at all) to the rest of the building. It is also poignantly appropriate in those instances where façades have been preserved for town-planning proprieties when the building layout behind no longer serves any useful purpose, as exemplified by the 20th-century Robert Adam Riverside scheme in Richmond, London.

In a more general sense, façadism is the propensity for designing architecture like stage sets, a characteristic which Richard Brilliant identifies in > Roman architecture: 'The creation of the stunning façade as an architectural motif, the awesome, grandiose scale of buildings set an impressive stage for the presentation of great actors and weighty assertions.'

FACTURE

(French: 'handling'). The way in which a work of art is constructed, or the techniques and means employed in its execution. More specifically, the way brushmarks remain visible in the > impasto or > bravura application of oil paint.

FARNESE

A dynasty of > patrons, from Cardinal **Alessandro Farnese** (1468–1549; Pope Paul III from 1534) to his great-great-grandson Cardinal **Odoardo** (1573–1626). The former began the Farnese Palace in 1517, employing Antonio da Sangallo the Younger and Michelangelo in its execution. Pope Paul's grandson (known as his 'nephew'), also called **Alessadro** (1520–89), commissioned the building of the church of Il Gesù and encouraged > Vasari to write his *Lives*. Odoardo Farnese commissioned Annibale and Agostino > Carracci to decorate (1597 onwards) the Palace's > Farnese Gallery, one of

the landmarks of early > Baroque. Not least, the family were > collectors of large quantities of > antique statuary, which in the 18th century found their way to the Bourbons of Naples and are now to be seen in the National Museum there.

FARNESE GALLERY

Cardinal Odoardo > Farnese (1573–1626) brought Annibale > Carracci to Rome in 1595 to decorate with > frescos a small room (the Camerino) in the Farnese Palace. Two years later, he commissioned him to decorate the larger Gallery with scenes from the Loves of the Gods, which, assisted by his brother Agostino, he did in an > illusionistic > style that owed nothing to the contemporary style of > Mannerism. Annibale's sources were the High > Renaissance with Raphael's > Vatican > Stanze and Michelangelo's Sistine Ceiling, although the Farnese Gallery is distinct from them in its fleshy warmth and playful sexuality. Together, the three works were considered the main monuments of art in Rome for students to study, which they did until the French Revolution, since the clarity of Annibale's manner and his 'correcting' or 'updating' of his sources (which led to his reputation for > eclecticism) made his work admirable teaching material for > academies.

● John R. Martin, *The Farnese Gallery* (1968); Iris Marzik, *Das Bildprogramm der Galleria Farnese in Rome* (1986).

FARNESE HERCULES

One of the best-known and most drawn and > imitated > colossal statues. A > Roman version of a 4th-century BC type, it was once in the > Farnese Collection, but is now in the National Museum in Naples.

FAUVISM

From the French *fauve*, meaning 'wild beast'. Fauvism originated at the very end of the 19th century when, in emulation of van Gogh and particularly Gauguin, > Matisse began to exploit the expressive potential of > colour in pictures such as *Luxembourg Gardens* (1899). The term 'Fauve' was coined by Louis Vauxcelles in 1905 to describe the work of a group of painters in the circle of Matisse, including Rouault, Derain, Vlaminck and Marquet, who exhibited at the > Salon d'Automne in Paris that year. The Fauves used colour not as the > Impressionists had done, to transcribe the 'reality' of surface appearance, but to fix the expressionistic (> expression; Expressionism) properties of brilliant colour used as a structuring device. Thus Matisse in *Green Stripe* (*Madame Matisse*) (1905) used olive-green to project his wife's nose and brow away from the warm flesh tones of her cheeks without recourse to orthodox devices of modelling or delineation. The brushstrokes, broadly applied across the picture surface, serve to draw further attention to the non-recessional nature of the implied picture space.

By 1909 the movement had broken up, revealing artists who had little in common other than an interest in the anti- > academic and anti-impressionistic use of colour.

The Fauvists' interest in the >formal concerns of balance and harmony was influential on >Kandinsky and the >Blaue Reiter and on later manifestations of colourism in general.

● B. Denvir, *Fauvism and Expressionism* (1975); J. Elderfield, *The Wild Beasts: Fauvism and its Affinities* (1976); M. Giry, *Fauvism: Origins and Development*, trans. H. Harrison (1982).

FEDERAL ART PROJECT

US government support scheme from 1935 to 1943, which under the auspices of the Works Progress Administration (WPA) employed artists during the Depression. The initiative, which involved projects such as the decoration of public buildings and other community works, formed part of President Roosevelt's 'New Deal'.

● F.V. O'Connor (ed.), *Art for the Millions: Essays from the 1930s by Artists and Administrators of the WPA Federal Art Project* (1973).

FÉLIBIEN DES AVAUX, ANDRÉ

(1619–95). French theorist and writer, friend and biographer of Poussin, he was >historiographer in the French >Academy and supported the >Poussinistes in their dispute with the Rubenistes. He is best remembered for his *Entretiens sur les vies et sur les ouvrages des plus excellens peintres anciens et modernes* (Conversations on the Lives and Work of Outstanding Ancient and Modern Painters) (1666–88).

FEMINIST ART

Although women have been active in the arts for centuries, it is only much more recently that women artists, from the >Impressionist Berthe Morisot to 20th-century artists such as >Colour Field painter Helen Frankenthaler, >Op art painter Bridget Riley and >figurative sculptor Barbara Hepworth, have achieved a measure of recognition. The work of these women is not feminist in the sense that neither its >form nor its content engages with the question of the situation of women in society. However, feminist art practice questions such attitudes, arguing that every aspect of institutional art is biased in favour of men, from >art education to membership of >academies, and not least in the discipline of >art history (*see also* Feminist art history).

In this environment feminist artists have attacked such cosy assumptions as the supposed superiority of >fine art over >craft (to marginalize craft is to marginalize women, who have a strong tradition in the area). The setting-up of women's co-operatives (co-operation itself is seen as a feminist practice) has allowed women to bypass male prejudice through an 'alternative' structure of workshops, >exhibitions and >journals that have fostered the creation of an authentically feminist art. A notable early example is the work of the 1970s' collective led by Judy Chicago. *The Dinner Party* is a table setting for 39 guests, each setting commemorating a celebrated woman. More recent strategies adopted by feminist artists have questioned the construction of the artistic identify in relation to gender, and can be seen in Barbara Kruger's

billboards, which acknowledge advertising space as gendered space, and Cindy Sherman's photographic self-portraits, which explore the identities foisted on women by the media. Feminist art practice has shifted the agenda away from the rarefied concerns of > Modernism to embrace issues such as emotional space, rights, violence, politics and the environment.

● G. Greer, *The Obstacle Race* (1979); R. Parker and G. Pollock, *Old Mistresses: Women, Art and Ideology* (1981); R. Parker and G. Pollock, *Framing Feminism: Art and the Women's Movement 1970–85* (1987); N. Broude and M. Garrard, *Feminism and Art History* (1982); K. Linker, *Difference: On Representation and Sexuality* (1985).

FEMINIST ART HISTORY

The recognition that women artists have a history as long and complex as that of men has come late to > art history, which as a discipline stands accused of marginalizing their work in favour of a male-defined > canon of artistic greatness. Since the 1970s, the work of women artists past and present has come to occupy an increasingly important place in art history through the efforts of > feminist art historians, often despite the passive resistance of male colleagues. The study of women artists has brought to light many artists who have been marginalized by orthodox art history, such as Rosa Bonheur, Berthe Morisot and Käthe Kollwitz.

However, the rehabilitation of reputations only would not carry the study of women's art production further than the > revisionist agenda of modifying the canon to embrace a small number of biographies (> monographs) of women artists. Feminist art history is much broader, seeing the work of both men and women artists as a legitimate subject of study, and, more importantly, drawing on notions of power, discourse and ideology to study the motivations of art history. This approach had revealed hitherto overlooked areas of research, such as the representation of women, the gendered 'gaze', institutional bias, sexuality and > patronage. It has also led many feminist art historians to argue that feminism is not simply another 'ism,' like > Marxism or > structuralism, but, because it challenges the whole basis of art history through its critique of male-defined parameters, is an altogether new discipline.

For example, the notions of > genius and greatness are so constructed that only a male artist can fulfil them. This leads feminists to conclude that only the overthrow of the canon and its replacement with a broader one encompassing > craft (a traditional strength of women artists and designers) as well as > fine art will allow women to gain the recognition they deserve. However, this view is incompatible with the revisionist approach mentioned above, and has created a debate within the feminist movement over the best strategies needed to gain women their place in art history. A very selective list of feminist art historians includes Norma Broude, Deborah Cherry, Lucy Lippard, Eunice Lipton, Linda Nochlin, Rozika Parker, Griselda Pollock, Ann Sutherland Harris and Lisa Tickner.

● Norma Broude and Mary D. Garrard (eds.) *Feminism and Art History: Questioning the Litany* (1982); Heide Gottner-Abendroth, *Die tanzende Gottin: Prinzipien einer matriarchalen Asthetik* (1985); T. Gouma-Peterson and P. Mathews, 'The Feminist Critique of Art History', *Art Bulletin*, 39.3 (1987), pp. 326–57; Linda Nochlin, *Women, Art and Power and Other Essays*

(1988); Griselda Pollock, *Vision and Difference: Femininity, Feminism, and Histories of Art* (1988); E. Tufts, *American Women Artists, Past and Present: A Selected Bibliographical Guide* (1984); C. Pettys, *Dictionary of Women Artists* (1985).

FESTSCHRIFT

Scholars in all disciplines will frequently band together to write or publish papers in honour of one of their colleagues or teachers and to celebrate his or her work by associating themselves with it. The resultant volume, called a festschrift, may, therefore, have a theme which the honoured recipient will enjoy, or may be divided into a whole series of areas in which the recipient has published work. Festschriften often contain a patchwork of short papers on unusual themes, sometimes spanning vast ranges of time and space. There are publications summarizing festschriften in various areas, and excerpting organizations such as > RILA also notice them.

● *Guide to Festschrifter* New York Public Library (1977); Paul O. Rave, *Kunstgeschichte in Festschriften* (1962); B.W. Lincoln, *Festschriften in Art History 1960–1975* (1988).

FÊTE CHAMPÊTRE

(French: 'Outdoor feast'). A > pastoral painting of figures feasting, dancing or making love in an > idealized landscape, often to the accompaniment of music. A celebrated example is the *Concert Champêtre*, now usually ascribed to Titian, in the > Louvre.

FÊTE GALANTE

(French: 'courtship party'). A term coined by the French > Academy to describe Watteau's reception piece for membership of the Academy, *The Pilgrimage to the Island of Cythera* (1717), a painting representing a masquerade on the theme of love.

FIGURATIVE ART

A > representational painting in which figures or objects are portrayed as they might appear in nature, or as they appear to an artist who wishes to execute a painting with commonly understood external references. Although as a term representational painting is generally to be preferred to figurative art, the latter retains currency as specifically identifying an artist's concern with the human figure. Thus Francis Bacon and Henry Moore are figurative artists.

FIN DE SIÈCLE

(French: 'end of the century'). A > style in the arts and > design of the period 1880–1900, typically expressing a jaded and > decadent spirit exemplified in the > graphic

work of Aubrey Beardsley and to some extent present in the organic mutations redolent of death and decay in > Art Nouveau, although this last movement had an equally strong commitment to an assertive > expressionism.

FINE ART

Painting, sculpture and > architecture were not considered by the ancients to be amongst the > liberal arts, although they were distinguished from mere craftsmanship (> crafts). A similar confusion existed in the Middle Ages, and the 'intellectualization' of the arts – that is, their promotion to 'fine' rather than 'applied' (> decorative arts) – was sanctified by theorists of the > Renaissance from > Alberti and > Leonardo to > Vasari, and stamped with the approval of the > academies.

FITZWILLIAM MUSEUM

Founded in Cambridge in 1816 from the private > collection of the eponymous 7th Viscount, the original collections show the horizons of 18th-century > tastes, with good collections of > Renaissance Paintings and Rembrandt > prints. The building by Basevi and Cockerell (finished by E. M. Barry in 1875) is a good example of > revivalism.

FIXATIVE

A resinous > binder suspended in a volatile solvent, sprayed over > chalk, > charcoal or > pastel > drawings to protect them from rubbing.

FLAXMAN, JOHN

(1755–1826). Sculptor who worked for the Wedgwood pottery concern, and who was in Italy from 1787 to 1795. He appears here because of his illustrations to the *Iliad* and the *Odyssey* (1793), Aeschylus (1795) and Dante (1802), and also because of his lectures as Professor of Sculpture at the > Royal Academy. His illustrations (perhaps influenced in part by pottery work) were in an outline style largely derived from > Greek vases (> Etruscan vases). This flat, linear, avowedly non > Renaissance approach belonged to the late 18th-century desire to start art afresh from > antique principles – hence the popularity of vase designs. Flaxman's illustrations found Europe-wide fame, and were much imitated by artists, not least the mature David.

● David G. Irwin, *John Flaxman 1755–1826: Sculptor, Illustrator, Designer* (1979); Sarah Symmons, *Flaxman and Europe: The Outline Illustrations and Their Influence* (1984).

FLORENTINE SCHOOL

The focus of innovation in painting and sculpture from Cimabue in the 13th century to

Ghiberti, Donatello and Masaccio in the 15th and Michelangelo in the 16th, Florence was rich in > collectors and commissioners of art, and her productions set parameters important for High > Renaissance art in Rome and later throughout Europe.

● Bernard Berenson, *Italian Pictures of the Renaissance: A List of the Principal Artists and Their Works with an Index of Places: Florentine School*, 2 vols (1963).

FOCILLON, HENRI

(1881–1943). French art historian and Professor of Art History at the Sorbonne, Paris. Although his interests were wide-ranging, including the study of > Buddhist, > Japanese and > graphic art (his father was an > engraver), he focused on > mediaeval art in *Art des sculptures romans* (The Art of > Romanesque Sculptors) (1931) and *Art d'Occident* (Art of the West) (1938). With his *Vie des formes* (The Life of Forms in Art) (1934), these books expound his view that understanding the technical possibilities of an age is a prerequisite to understanding its art.

FOLK ART

A term used to describe art and > artefacts made within the parameters of rural > craft industries by artisans with little or no interest in emulating > fine art production. Thus woodwork, fabrics and pottery decorated with the traditional designs of a region, reflecting the interests and tastes of that community, are typical folk art products. It is a characteristic of folk art that it remains largely uninfluenced by fine art movements (there is no > Baroque period of folk art, for example), but finds its continuity in the self-sufficient craft practices of rural communities.

FONTAINEBLEAU, SCHOOL OF

A term applied to > artists of the French court of Francis I at the Château of Fontainebleau in the 16th century. In the absence of French artists able to work on the scale required, many of its members were Italians, for example Francesco Primaticcio, Giovanni Battista Rosso and Niccolò dell' Abbate. The > school's subject-matter was dominated by the mythological, as in *Diana the Huntress* (Louvre, *c.*1550) by an unknown artist, and by > idealized panoramic > landscapes. Stylistically, it is characterized by its strong, highly decorative panels set into surrounds of > stucco ornamentation, which were tailored to the expectations of elegance and refinement of the school's courtly > patrons, and articulated within the langauge of > Mannerism. Principal among the works of the school is the Gallery of Francis I by Rosso and the Gallery of Henry II by Primaticcio. The style spread through > etchings made after these designs. The ornamental stucco 'strapwork' (resembling interwoven leather straps), for example, migrated to Flanders and thence to England, where it became a popular motif in Tudor and Jacobean decoration.

● Henri Zerner, *The School of Fontainebleau: Etchings and Engravings* (1969).

FOREGROUND

That part of a painting which seems closest to the > beholder. Most usually it is identical with the > picture plane, but artists have presented objects that appear to project out into the beholder's space, as with the tombstone in Caravaggio's *Entombment* c.1604).

FORESHORTENING

The rendering of the true dimensions of an object presented in a painting as diminished through > perspective. Examples in art abound from the time of the > Renaissance, but a signal example is that of the fallen soldier in the > foreground of Uccello's *Battle of San Romano* (c.1455).

FORGERY

A > copy of another work of art passed off by the forger or by a third party as an > original work by the artist imitated. A forgery (or fake, the law makes no distinction) may therefore be distinguished from the various forms of the copy – for example studies after the art of the past, emulations and > replicas – by this intention to deceive, usually, but not always, for reasons of profit. > Vasari recounts the story of the young Michelangelo making a > marble Cupid and then artificially ageing it in order to convince a > collector of its > antique origin. Although his patron Lorenzo de > Medici remarked that in passing it off as an antique Michelangelo would get far more money for it, a mercenary motive seems to have been less important than his pretension to rival the sculptors of antiquity.

A forgery may be perpetrated by imitating the > style of an artist or period, or by counterfeiting the materials typical of that period, either through reusing old materials or ageing modern ones. In practice, forgery most often involves employing both deceptions at once. Having obtained or made materials similar to the object to be imitated, the artist then takes care to imitate the appearance of the work being copied, or reassembles characteristic passages into one new work. This form of copying, known as > pastiche, has the advantage for the forger of allowing the forgery to fit into an artist's > œuvre without duplicating any one work. A further sophistication is when the forger makes a work sufficiently unlike the artist copied that it tempts the historian to construct a 'new' style for the artist, thereby suggesting a plausible > attribution and legitimizing the forgery.

Passing off a work as being by another, inevitably more famous, hand, has long been the stock-in-trade of unscrupulous dealers (> art dealing). However, > amateurs and > art historians alike have often allowed enthusiasm for their chosen artists to sway their judgement. Van Meegeren's rather poor forgeries of Vermeer made around the time of the Second World War could only have convinced an art historian desperate to expand Vermeer's slender *œuvre*.

Artists themselves have attempted to control the proliferation of forgeries of their work. Albrecht > Dürer instigated court action to prohibit the fraudulent use of his > monogram and the unauthorized copying of his work. Claude Lorrain kept a studio

book, the *Liber Veritatis*, in which he recorded all his > compositions and their locations. Likewise, the art market and > museums, both with vested interests in protecting their reputations for unimpeachable integrity, attempt to distinguish originals from copies. This is done in one of two ways, either with the aid of science through laboratory tests, X-rays and chemical analysis, or through > connoisseurship, that is, the ability of an art expert to assess the authenticity of a work from the handling, style or, more vaguely, from the 'feel' for the quality of a work. Until quite recently, the approach of the connoisseur has been confounded in the public's mind with that of the > art historian.

Aesthetically there are several problems with the notion of forgery. It contrasts the 'genuine' or authentic work too strongly with its 'fraudulent' imitation. The effect of attributing positive qualities to an original, only to contrast it with the negative values – lack of quality, skill, conviction – of the imitation is a normative one, which adds little to the understanding of either imitation or model. In fact the inferiority of the copy is not intrinsic but implied on the basis of this binary opposition.

● M. J. Friedländer, *On Art and Connoisseurship* (1942); Otto Kurz, *Fakes*. A *Handbook for Collectors and Students* (1948); H. Tietze, *Genuine and False: Copies, Imitations and Forgeries* (1948); *Forgeries and Deceptive Copies*, exhibition catalogue, British Museum (1961); A. Lessing, 'What is Wrong with a Forgery?', *Journal of Aesthetics and Art Criticism*, 23 (1964), pp. 461–71; G. Vasari, *Lives of the Artists*, trans. G. Bull (1965; 1972); 'Copies répliques, faux', *Revue de l'art*, 21 (1973); 'Fakes and Forgeries', exhibition catalogue, Minneapolis Institute of the Arts (1973).

FORM

That part of a painting, sculpture or > artefact that may be described purely through the configuration of line, mass, volume and > colour. In practice, it is almost impossible to separate form from content, even in works that appear rigorously > abstract. Form is best considered as a constituent part of an art work that needs to be considered in relation to a work's > iconography, social and historical (> historicism) context.

FORMALISM

An approach to the appreciation and evaluation of an art work based on the exclusive consideration of the qualities of line, > colour, mass or volume that the work exhibits. The strengths of the approach reside in its ability to confront the art work without recourse to non-figural qualities. Thus, for example, we might say that > Leonardo's *Last Supper* is a > planimetric > composition articulated through a linear rather than a > painterly > handling, offering a typically > Renaissance solution to the problem of the > representation of a crowded interior. What this analysis does not give us is the religious significance of the subject-matter, any indication of the critical fortunes of the painting, its social context, > aesthetic appeal or the nature of the > symbolism.

Formalism however, was particularly useful when, at the beginning of the 20th century, > art history was searching for a critical framework that offered the scope to analyse all visual > artefacts, irrespective of their time and place of making. The art historian > Wölfflin was particularly instrumental in developing this approach in books

such as *Principles of Art History* (1915). Other notable practitioners have included Roger >Fry and Clive >Bell, who promoted >Post-Impressionism on largerly formalist grounds, and towards the middle of the 20th century, Clement Greenberg, who used a formalist critique to argue for the superiority of >Modernism over the >narrative painters of 19th century.

● C. Bell, *Art* (1914); R. Fry, *Cézanne* (1927); C. Greenberg *Art and Culture: Critical Essays* (1961)

FOUND OBJECT

(From the French *objet trouvé*). An object without >fine art connotations displayed as art, for example the >Dada artist Duchamp's >ready-made *Bottle Rack* (1914), or Picasso's *Bull's Head* (1943), constructed from bicycle handlebars and saddle. The importance of the found object is to question accepted definitions of what constitutes the art object. In this it was the intellectual ancestor of >Conceptual art.

● C. Kellerer, *Objet Trouve und Surrealismus. Zur Psychologie der Modernen Kunst* (1968).

FRANKFURT SCHOOL

Otherwise known as the Institute of Social Research of the University of Frankfurt, founded in 1923. In 1933 the Institute was forced into exile in the USA by the Nazis, but it returned to Germany in 1949. The importance of the school for >art history is that its >Marxism has had a massive impact on the study of the social sciences and >humanities. Broadly speaking, the school places great importance on the transformative powers of the Marxist 'superstructure' (the cultural domain), thereby giving art much greater power than either economic liberal or hard-line Communists allowed. Members of the school of interest to art history include Theodor Adorno, Herbert Marcuse and Walter >Benjamin.

FRESCO

A method of painting walls using powdered >pigments mixed with water and applied to fresh (hence 'fresco') lime plaster. The water and its pigments bind with the plaster, so that the fresco becomes part of the wall, and will last as long as it does. In use since at least the Minoan period, plenty of frescos survived from >Roman antiquity. Apart from durability, its advantages are cheapness (most walls have to be plastered anyway), the ease with which it can be plastered over and another fresco laid on top, and the scope it gives to artists to decorate large walls.

Its difficulties are several. Speed of work and sureness of hand are required since once the paint is applied the only way to get rid of it is to take off that portion of plaster. It was for this reason that the >Renaissance considered fresco work the demonstration *par excellence* of artistic ability. The colour range tends to be limited, and both the water medium and the whiteness of the plaster can lead to washy tones,

making bold designs desirable. Careful preparation is necessary. The wall (ceiling or vault) must be > squared up and the original > design sized up to it; this disappears once the final plaster layer (the *intonaco*) is applied – another way of sorting the men from the boys. Such fresco is called true fresco – *buon fresco*– to distinguish it from the often-used but inferior technique of painting on to dry plaster (*al secco*), using > tempera or > size, which tend to peel off.

Techniques first developed in the later 18th century mean that frescos can be detached from walls for reasons good (repairing the wall behind) or bad (Napoleon's desire to carry Raphael's frescos in the > Stanza della Segnatura back to Paris). The older the building the more useful this is, for there may be several layers of fresco to be peeled off, like the layers of skin an an onion. What is more, by removing the *intonaco*, the lower level (the *arricciato*) is revealed. This will retain the artist's original full-size > sketches, some of which are much more freely executed than the paintings on top.

> Leonardo attempted to discover something with more body, arguably by re-inventing ancient encaustic – wax-based – techniques. The fresco became less common in the 18th century, with Giovanni Battista Tiepolo being one of the last great Italian painters to make us of it. Knowledge of the operations used by such artists died by the 19th century, in spite of efforts by the > Nazarenes and > Pre-Raphaelites to revive the fresco as a viable artistic > medium.

● Eve Borsook, *The Mural Painters of Tuscany: From Cimabue to Andrea del Sarto* (2nd edn 1980); A. Caiger-Smith, *English Medieval Mural Paintings* (1963); *The Great Age of Fresco, Giotto to Pontormo: An Exhibition of Mural Paintings and Monumental Drawings*, Metropolitan Museum of Art (1968); Marilyn A. Lavin, *The Place of Narrative: Mural Decoration in Italian Churches, 431–1600* (1990).

FREUD, SIGMUND

(1856–1939). Austrian psychiatrist and pioneer of psychoanalysis. His major interests were in neurosis, sexuality, childhood, dreams and the unconscious. His principal writings include *The Interpretation of Dreams* (1900), *The Psychopathology of Everyday Life* (1904), *Totem and Taboo* (1913), *Beyond the Pleasure Principal* (1920) and *Civilisation and its Discontents* (1930). Freud's work, with its breadth and originality has touched art history as it has every other dicipline, and Freud himself wrote a study of > Leonardo. Increasingly, those who apply > psychoanalytic theories to > art history regard the language used to describe psychological states to be just as important as understanding the states themselves.

● P. Ricoeur, *Freud and Philosophy* (1970); S. Kofman, *The Childhood of Art: an Interpretation of Freud's Aesthetics* (1988).

FRIEDLAENDER, WALTER

(1873–1966). Teacher of > Panofsky at the University of Friebourg, but expelled by the Nazis in 1933, whereupon he emigrated to New York, and became professor at the university there. Works include *David to Delacroix* (1952) and *Mannerism and Anti-Mannerism in Italian Painting* (1957).

FRIEDLÄNDER, MAX J.

(1867–1958). German > art historian and Wilhelm von Bode's successor as Director of the Berlin Gemäldegalerie. His scholarly monument is the 14 volumes of *Die altniederländische Malerei* (> Early Netherlandish Painting) (1924–37).

FROTTAGE

(French: 'rubbing'). A technique whereby random marks on paper suggest to the > artist the beginnings of a > composition. Max Ernst invented the technique in 1925 when he inadvertently transferred the grain of some floorboards to a sheet of paper. The technique was in favour with the > Surrealists because of its ability to facilitate exploration of the subconscious.

● J. H. Matthews, *The Imagery of Surrealism* (1977); D. Ades, *Dada and Surrealism Revisited* (1978).

FRY, ROGER

(1866–1934). English critic, director of the > Metropolitan Museum of Art, New York, 1906–10 and co-founder and later editor of the > *Burlington Magazine*. He was an enthusiast for modern French painting and promoted the > Post-Impressionists in England through exhibitions at the Grafton Galleries in 1910 and 1912. His books include an edition of > Reynold's *Discourses* (1905), *Cézanne* (1927), and collections of essays and lectures such as *Vision and Design* (1920) and *Transformations* (1926). Fry was associated with the > Bloomsbury Group and in 1913 founded the > Omega Workshops to promote good > design. His > criticism was > formalist and placed great weight on the 'purity' and 'plasticity' of form.

● F. Spalding, *Roger Fry* (1980).

FUNCTIONALISM

The notion that to create an > artefact that serves the purpose for which it is made is to create a thing of > beauty. The idea, which is present in the writings of Plato (> Neoplatonism) and > Aristotle, engaged 18th-century writers on > aesthetics, but by then a distinction tended to be drawn between fitness for the purpose being a component of beauty, and fitness being the sole criterion of beauty. In its modern sense it makes a connection between function and > form, as in the oft-repeated aphorism coined by the American > Modernist > architect Louis Sullivan in his *Kindergarten Chats* (1901): 'Form follows Function'. For Modernists such as Sullivan the beauty of a structure was revealed through the logical way in which it expressed the inherent qualities of the materials used and the purpose for which it had been designed. In this sense a skyscraper and an > Abstract Expressionist painting may both be said to be 'functional' or 'expressive'. Functionalism played a crucial guiding role in the > Bauhaus

but has more recently been questioned, particularly in the Modernist confusion of functionalism and brutalism. There is, after all, no reason why a highly decorated > Art Nouveau teapot should not pour tea as well as one embodying a rigorously austere machine aesthetic. > Post-Modernism has reacted against functionalism by reintroducing decoration, whimsy, > colour and a sense of play, without losing the advances made by the application of functionalist principles.

● Peter Blake, Form Follows Fiasco: Why Modern Architecture Hasn't Worked (1977); Dennis Sharp, The Rationalists: Theory and Design in the Modern Movement (1978); Tom Wolfe, From Bauhaus to Our House (1981).

FUNERARY ART

Belief in an afterlife similar to this one, and thus usually involving the same body, has been a powerful impulse since prehistoric times. it has occasioned not only imposing works of > architecture, such as huge mounds and funerary temples or chapels to house the dead (perhaps containing several generations of the same family), but also funerary > reliefs and statues to tell of their appearance and deeds. If the body is to live again in another world, it will presumably need what it had in this world, so burials with clothes, jewellery, arms and armour, domestic utensils, cosmetics, furniture, vases and implements and the rest were common.

Indeed, without funerary art in all its bewildering variety, our knowledge of the past would be proportionately less the further we go back in time. > Archaeology is almost unthinkable without tombs to investigate.

In fact, many of the great set pieces of > art history are funerary in origin, from the Pyramids and the great mortuary temples along the Nile, to Old St Peter's in > Rome, all the cemetery churches of the Via Appia, the Brancacci and > Medici chapels, les Invalides in Paris, and much of the best sculpture of Bernini, > Flaxman and Canova. In a sense, funerary art is a branch of artistic > propaganda, and its most conspicuous monuments can be used to convey ideas not just of solidity and aesthetic quality, but also and much more importantly, of continuity of power.

It is also conceivable that funerary requirements prompted the development of > portrait sculpture. Certainly, the rebirth of life-size sculpture in the Middle Ages is seen early in such monuments, and this concern for portraiture is confirmed in an identical (but not > antique-influenced) context in the Italian > Renaissance.

There is also one other very important element of funerary art, analagous to the temporary > triumphal arch, namely the temporary architecture and sculpture required for a lying-in-state. The furnishing of these ceremonies occupied the best artists, as can be seen from numerous > prints showing constructions such as *chapelles ardentes*, allegorical set pieces in bas-relief, or the round that the 'finished' monuments sometimes mimicked.

● Bernard Andreae, Studien zur romischen Grabkunst (1963); Nigel Llewellyn, The Art of Death: Visual Culture in the English Death Ritual c. 1500–c. 1800 (1991); Charles Murray, Rebirth and Afterlife: A Study of the Transmutation of Some Pagan Imagery in Early Christian Funerary Art (1981).

FUTURISM

Italian art movement founded in 1909 by the poet Marinetti to promote – in manifestos and noisy self-pubicity – a rupture with the prevailing > academicism of Italian art in favour of modernity, technology, speed and the power of the machine. An exhibition was held in Milan in 1911, which toured throughout Europe during 1912. As the idea of movement was inherent in all their aims, the Futurists developed the concept of 'dynamism', the representation of humanity or machines in action, as in Boccioni's *Unique Forms of Continuity in Space* (1913), a sculpture that shows a > bronze figure striding forward, whose limbs transform, and are transformed by, space, or Balla's *Dynamism of a Dog on a Leash* (1912), which shows a dog whose legs blur, cartoon-like, imitating the forward momentum of its owner. The Futurists were also interested in 'simultaneity', a > Cubist-like representation of multiple viewpoints but with the addition of movement, as in Carrà's *Simultaneity, Woman on a Balcony* (1912–13). Stylistically, they borrowed elements of divisionism (> pointillism) from the > Neo-Impressionists and overlapping planes from the Cubists. They in turn influenced the Russian > Constructivists, the > Blaue Reiter, the > Vorticists and > Dada. The principal members of the group were Giacomo Balla, Umberto Boccioni, Carlo Carrà, Luigi Russolo and Gino Severini.

● Anne d'Harnoncourt, *Futurism and the International Avant-garde: Essays* (1980); Filippo T. Marinetti, *Selected Writings* (1972); Marianne W. Martin, *Futurist Art and Theory*, 1909–1915 (1978).

G

GALLERY *See* Museums and galleries.

GARDENS *See* Parks and gardens.

GATES OF PARADISE

The name given to > Ghiberti's second set of > bronze doors to the Florence Baptistery ever since Michelangelo said they were fit to be the gates of Paradise itself.

GAZETTE DE BEAUX-ARTS

Begun in 1859, this has long been the premier French > journal in the discipline, joined in 1970 by *La Revue de l'Art*.

GEISTESGESCHICHTE

(German: 'spirit/mind history'). The history of ideas can frequently be fruitful for > art historians since a full appreciation of an art work is often inseparable from an understanding of the ideas common at its birth and usually so very different from our own mind-set. The German terminology is often used because the discipline is largely a German invention, promoted by scholars such as von Ranke, > Dilthey and Mannheim.

● Max Dvorak, *The History of Art as the History of Ideas* (1984).

GENIUS

Although the idea of the > artist as untrammelled genius may be traced back to the Renaissance and even antiquity, the concept flowered in the age of Romanticism, when the artist was seen as an untutored (that is, unspoilt) child of > nature imbued with a particularly sensitive and emotional personality that allowed the individual to express fundamental truths about the human condition. This was a reversal of the previously dominant interpretation of the role of the artist. Whereas a classicizing (> Classicism and the Classical tradition) artist was judged by his or her ability to translate the lessons of antiquity into a contemporary context, the Romantic genius needed no such

constricting guidelines, finding the full weight of significance within individual experience. Sir Joshua > Reynolds in his *Discourses* (1769–1790) argued against this position, stating that the artist who taught himself had a fool for a teacher, but an enraged > Blake denied Reynolds's position and saw in the concept of genius the very definition of the artist. Much more recently, the idea of genius has taken a battering from the exponents of the > auteur theory, who deny that any individual can enjoy the degree of autonomy that the upholders of the genius theory attribute to their subject.

● R. and M. Wittkower, *Born Under Saturn: The Character and Conduct of Artists* (1963).

GENRE PAINTING

A term used for paintings depicting scenes of daily life, animals or > still life. Although these themes have long been represented in art, they were generally incorporated into the major genres (in the broader sense of the term, meaning a particular branch or category of art or literature) of religious, > history and > portrait painting. Genre painting first became important in its own right in 17th-century Holland, where it met the desire of the middle class for a > representational painting that reflected their secular, commercial, pragmatic lives. Prominent among Dutch genre painters are de Hooch, Metsu, Vermeer and Steen.

In the 18th century genre painting found a major representative in France in Chardin, whose still lifes and interiors are among the finest of their kind, imbued as they are with a reverent attention to the quotidian that transcends mere representation. Nineteenth-century genre painting formed a significant minority at > exhibitions such as the Paris > Salon, but without commensurate critical attention. With the advent of > Impressionism, however, the belief that an 'important' painting required an 'important' subject was challenged and defeated, with the result that artists such as Cézanne were able to find the full range of > aesthetic and intellectual possibilities within very simple still-life motifs, a concern with > form rather than content being a hallmark of > Modernism. The 20th century has witnessed the collapse of the hierarchy of genres (> genres, hierarchy of), which saw genre painting allocated a lowly position.

● Svetlana Alpers, *The Art of Describing: Dutch Art in the Seventeenth Century* (1983); Phillip Conisbee, *Chardin* (1986).

GENRES, HIERARCHY OF

The term refers not to > genre painting but to the various genres (from the French *genre*, meaning 'type, category') of painting. The notion that some art works are automatically more important than others because of their subject-matter is alien to our thinking, but until at least the middle of the 19th century this idea had real force. The > academies, who practised an elevated form of painting in the > Grand Manner, classified painting in this way, beginning at the bottom with > still life (inanimate objects), moving through animals to > genre (peopled, but only by peasants) and > landscape to > portraits (for the most part of sitters of some social standing) and from there to religious and > history painting. These last two were 'naturally' the most important categories

because they encompassed all other genres. While the genre painter could only paint one kind of scene, the history painter was also a landscape/genre/still-life painter, since all these skills were needed to represent the dramatic narrative of history.

This system militated against genre painters such as Chardin, who found himself fulsomely praised by the critic > Diderot but denied access to comparison with history painters, while Greuze, who failed to enter the French Academy as a history painter, was awarded the dubious privilege of being received as a genre painter.

GESSO

A mixture of chalk or plaster of Paris and rabbit-skin or parchment glue applied as a smooth white > ground in > tempera > panel painting. On > picture frames and other decorative mouldings it may be modelled, when it is known as *gesso rilievo*. Gesso is applied in several coats. The first coat is known as *gesso grosso* (coarse gesso) and the final coats as *gesso sotile* (fine gesso). The surface is sanded down at each stage.

GESTALT

(German: 'form, figure, shape'). The term adopted by a school of psychology promoting the idea that a work of art or literature is much more than the sum of its parts, and that the properties perceived in it are not necessarily derived from the individual elements. For > art historians, gestalt psychology suggests a special focus on the > formal qualities of a work, but also that emotional qualities actually exist in a work and are not simply imposed upon it by the empathetic response of the > beholder. See the works of Rudolph Arnheim for examples of this approach.

● Rudolph Arnheim. 'Gestalt and Art', *Journal of Aesthetics and Art Criticism*, 2 (1943), pp. 71–5; Rudolf Arnheim, 'A Plea for Visual Thinking', *Critical Inquiry*, 6 (Spring 1980), pp. 489–97; Anton Ehrenzweig, *The Hidden Order of Art: A Study in the Psychology of Artistic Imagination* (1967); Hans Sedlmayr, *Die Architektur Borrominis* (1930); Barry Smith (ed.), *Foundations of Gestalt Theory* (1988).

GESTURAL PAINTING

The application of > paint in such a way that the artist's expressive or 'gestural' brushwork is emphasized. Gestural or > painterly execution is a feature of the work of Tintoretto and Rubens (> Poussinistes vs. Rubenistes) and > Expressionist artists such as van Gogh. In the 20th century gestural painting was an important component of > Abstract Expressionism's reaction to the machine-like paintings of the geometric > abstractionists. Gestural painting returned to prominence in the 1980s in the work of the > Neo-Expressionists, for example Baselitz and Immendorff.

GETTY, J. PAUL

(1892–1976). American oil baron, >collector and philanthropist, whose museum opened at Malibu in 1954 with a new one opening in a re-created Roman villa nearby in 1974. Getty endowed the museum more than adequately through a trust; when he died that trust became the best-endowed non-public entity in the art-historical world, setting up the Getty Center for the History of Art and the Humanities in 1983, and a system of grants and fellowships to match. American critics have sometimes maintained that 'the Getty' has simply taken up the slack produced by a decrease in the funding of the National Endowment for the Humanities; foreign critics mumble about a lavishly funded extension of cultural imperialism; but the whole community can benefit from Getty projects, some of which involve basic research aids such as computerized >databases and bibliographies, or from the work of their Conservation Institute. J. Paul Getty Jr. (1932–), preferring England to the USA, rebalanced the financial ship just a little by giving $50,000,000 to the >National Gallery in 1985.

● Elizabeth Bakewell, *Object, Image and Inquiry: The Art Historian at Work. Report on a Collaborative Study by the Getty Art History Information Program* (AHIP) *and the Institute for Research in Information and Scholarship* (IRIS), Brown University (1988).

GHIBERTI, LORENZO

(1378–1455). Goldsmith, painter, sculptor of the >Gates of Paradise and author of the unfinished *Commentaries*, which is not only his autobiography, but also includes an account of >antique art and a set of notes on the artists of the previous century. He used Pliny for the antique section, but the autobiographical one is the first by an artist that has survived. With this work, Ghiberti demonstrates the antique roots of >humanism and explains the stylistic thrust of his own work (he collected antiquities). It is also one of the models used by >Vasari for his approach to writing the history of artists.

● Christie K. Fengler, *Lorenzo Ghiberti's Second Commentary: The Translation and Interpretation of a Fundamental Renaissance Treatise on Art* (1974); Richard Krautheimer, *Lorenzo Ghiberti* (1970); Beate Nagel, *Lorenzo Ghiberti und die Malerei der Renaissance* (1987).

GILDING

The application of metal (usually gold) leaf to a painting, >picture frame, manuscript >illumination or decorative moulding. In gilding, the gold is beaten until it is very thin, then laid on to a >gesso >ground. Normally the effect is enriched by coating the ground with red bole, which alters the colour of the translucent gold. The leaf is then burnished to impart a brilliance to the surface. It was much used in picture-making in >mediaeval and >Renaissance >workshops, when the frame was considered an integral part of the art work, worth the craftsman's labour, and gold was used for parts of the painted surface, such as haloes, thrones or the background generally. Although it became increasingly fashionable to replace the effects of gilding on the picture surface

by using paint, thereby marginalizing gilding to the setting, it remained *de rigueur* for frames until the modern period, when artists began to exhibit work in painted or plain frames, or with no frames at all.

GIOTTESCHI

So powerful was Giotto's contribution to art that in the 14th century many artists continued to work in his manner, including Taddeo Gaddi and the Master of St Cecilia – so many, in fact, that we lack names for them, hence the usefulness of the term.

● Max Imdahl, *Giotto: Arenafresken, Ikonographie, Ikonologie, Ikonik* (1980).

GLASGOW SCHOOL

An association of artists active towards the end of the 19th century in Glasgow, in opposition to the London-based > New English Art Club. The style of the group owed much to the influence of French > naturalism. Prominent members included Sir James Guthrie and Sir John Lavery. There was a second, later Glasgow School belonging to the Art Nouveau movement. Its most important member was the architect Charles Rennie Mackintosh.

● *The Glasgow Boys*, exhibition catalogue, Scottish Arts Council (1968).

GLAZE

In > oil painting, a transparent coating of > paint over an area of > colour, used with a view to modifying the underlying colour. Glazing (which might be in multiple layers) offers the painter in oils a richness, depth and subtlety unattainable in > tempera or > fresco, where modulation of the basic colour is difficult and/or fugitive.

GOBELINS

French > tapestry factory in Paris, state-run since the 17th century as part of Colbert's centralization of French industry. Its full title is the Manufacture royale des meubles de la Couronne and, as its name suggests, it made not only tapestries but other kinds of furnishings too. Its importance resides primarily in the quality of the designers who worked there. Charles > Lebrun, director of the > Academy of Painting and Sculpture, was its first director; and the academicians Jean-Baptiste Oudry and François Boucher were directors between 1734 and 1755 and 1755 and 1770 respectively. It enjoyed acknowledged technical mastery of the > medium and the orders it received were executed for royal residences such as Versailles. Its position as the foremost tapestry factory of Europe lasted throughout the 18th century, and production continues to this day.

● *Charles Le Brun: Premier Directeur de la Manufacture Royale*, exhibition catalogue, Musée des Gobelins (1962).

GOETHE, JOHANN WOLFGANG VON

(1749–1832). German poet, novelist and critic. At first he championed > Gothic art, which he associated, in typically > Romantic vein, with the expression of > 'nature' as opposed to the 'reason' of > Neoclassicism. His first visit to Italy in 1786–8 resulted in enthusiasm for > Classicism. His writing on art includes *Italian Journey* and a study of > colour theory, whilst his celebrated novel, *The Sorrows of Young Werther* (1774), is virtually a manifesto of the Romantic movement.

● J. Gage (ed.), *Goethe on Art* (1980).

GOLDEN SECTION (also GOLDEN MEAN)

A system of proportion that establishes a harmonic ratio between two unequal parts of a painting. If a line or rectangle (such as the surface of a painting) is divided in such a way that the ratio of the smaller area is to the larger as the larger is to the whole, then the resulting division is known as the Golden Section. It may be expressed as 5:8, so 8:13. Its most obvious application, used in countless > compositions, is in establishing the horizon line of a > landscape, but many more applications exist. The division may be a vertical one, and often a stand of trees in a landscape may be observed to be bisected by the Golden Section. The system was known to Euclid, who defined it in Book 6 of the *Elements*, and it was studied in the > Renaissance by the mathematician Luca Pacioli in *Divina Proportione* (1509), with illustrations by > Leonardo. It may be observed with ease in the > ideal landscapes of Claude or Richard Wilson, and provides the underlying pictorial structure in many of Monet's paintings, which appear superficially to be direct transpositions of > nature.

● H. E. Huntley, *The Divine Proportion: A Study in Mathematical Beauty* (1970); John White, *The Birth and Rebirth of Pictorial Space* (3rd edn 1987).

GOMBRICH, SIR ERNST HANS JOSEF

(1909–). Austrian > art historian. He trained in Vienna and settled in England in 1936, where he has been associated with the > Warburg Institute as Director of the Institute and Professor of the History of the Classical Tradition from 1959 to 1976. Gombrich has held many other visiting professorships, including Slade Professor at both Oxford (1950–3) and Cambridge (1961–3), and Andrew D. White Professor-at-large at Cornell (1970–77). Gombrich's reputation rests on the breadth of learning he has brought to bear on > symbolism and > iconography in the art of the > Renaissance as well as on his studies on the > psychology of perception in books such as *Art and Illusion* (1960). His best-known book, *The Story of Art*, which has gone through many editions in several languages since publication in 1950, demonstrates how Gombrich is able to distil a massive amount of erudition into a compact and readable narrative. His other work includes the collections of essays *Meditation on a Hobby-Horse* (1963) and *Norm and Form: Studies in the Art of the Renaissance* (1966) and *The Sense of Order: A Study in the Psychology of Decorative Art* (1979).

GONCOURT, EDMOND DE (1822–96) and **JULES DE** (1830–70)

French critics and authors of a frequently salacious *Journal* that reveals much about the private lives of contemporary artists. They were prominent in the > revival of > taste for the > Rococo, wrote on Japanese art, and championed the work of the > cartoonist Gavarni. Their novel *Manette Salomon* (1867) provides many insights into the attitudes, working methods and social relations of French painters in the middle decades of the 19th century.

● Anita Brookner, *The Genius of the Future: Studies in French Art Criticism: Diderot, Stendhal, Baudelaire, Zola, the Brothers Goncourt, Huysmans* (1971); Pierre Sabatier, *L'esthétique des Goncourts* (reprinted 1970).

GOTHIC ART AND ARCHITECTURE

The art of (principally) northern Europe from the 12th to the 16th centuries. The term originated as one of abuse (cf. Goths and Vandals), and tends to designate a period rather than a > style, but in spite of this, is too useful to abandon. Generally, Gothic art and > architecture succeeded in those areas little influenced by > Roman styles, whilst the > Romanesque continued to flourish where > antique exemplars were thick on the ground; thus there is little Gothic in Provence or Italy. In many regions, however, Gothic style was viewed as the adventurous, technically exciting successor to Romanesque.

In architecture Gothic is characterized by experiments concentrating on reducing the proportion of the structure needed for the supporting 'skeleton', this height and lightness of construction offering pointed arches, large vault spans and window areas (encouraging > stained glass), with the need for compensating buttressing on the outside to hold everything up.

Monumental (> colossal) sculpture, revived with Romanesque architecture, was of continuing importance in the Gothic period. However, in this context, as with manuscript > illumination, painting, > ivories and the rest, the stylistic boundaries are blurred. Stylization, linearity and an increasing sweetness culminated by the later 14th century in > International Gothic.

● Alain Erlande-Brandenburg, *Gothic Art* (1989); Andrew Martindale, *Gothic Art* (1967); Erwin Panofsky, *Gothic Architecture and Scholasticism* (1957).

GOTHIC REVIVAL

The rebirth of interest in the > mediaeval past, especially its > architecture, but also its > decorative arts. Beginning in 18th-century Britain, but also widespread in Germany and later in North America, its earlier manifestations had the decorated appearance of the > Rococo seen through historicizing spectacles, and the resultant filigree of the Revival's early phase is often called 'Gothick' to distinguish it from later, more 'archaeological' imitations and re-creations.

The movement is the most important of all revivals (> revivalism) because the most long-lived. It was caught up with a growing interest in history, particularly in the national past. The church-building of the 19th century, borne on waves of > historicist

piety, turned more to the native Gothic past for models than to > Classicism, partly, no doubt, because the current > taste was for decoration rather than plainness, and partly because the spikiness of some Gothic harmonized with the Rococo-like qualities of Gothick. The large number of Gothic churches surviving into the 18th century from what was the greatest spurt of church-building in Europe doubtless influenced the Revival, but several of the qualities of Gothic – its decorated, asymmetrical, organic, emotional, Northern, rather than Greek or Roman, basis – also offered a counterpoint to the prevailing Classicism. The Houses of Parliament in London reflect this dilemma: clearly Gothic, there is nevertheless a Classical severity and balance to their elevations.

In a broader context, the Revival was an early episode of > Romanticism, of the reaction of the North against the South, of the spirit against the flesh, and of the intricate and vegetative against > antique-based > formalism. Arguments in favour of Gothic (in Germany as in France and Britain) would often emphasize its 'home-grown' character (visible in plenty of monuments of earlier ages) against the dry imports of the Classical South.

● Paul Frankl, *The Gothic: Literary Sources and Interpretations Through Eight Centuries* (1960); Georg Germann, *Gothic Revival in Europe and Britain: Sources, Influences and Ideas* (1972); Michael J. McCarthy, *The Origins of the Gothic Revival* (1987).

GOUACHE

Opaque > watercolour, also known as > body colour. Unlike watercolour, where brilliance is achieved by allowing the whiteness of the paper to reflect light through the translucent > paint, in gouache > chalk is added to the > pigment to render it opaque. Brighter tones are achieved by admixing with white, so that light reflects off the surface of the paint, rather than off the paper, as in watercolour.

GRAFFITO

(Italian: 'scratched'). In painting, scratching a design through a surface (wet plaster) of one > colour to reveal another, so that the scratched lines stand out. A popular Italian method of decoration. More generally, 'a white wall is the fool's paper', say the French. And yet whilst a modern-day Byron might not be thanked for scratching his name on a column of the temple at Cape Sounion, historians of all shades must be grateful for the human urge to write 'illegally' since the results not only tell us who was where (what artists, for example, studied the Golden House of Nero during the > Renaissance), but also give an insight into unofficial reactions to everything from sex and politicians to religion.

They are also very useful for dating, as well as for epigraphic, purposes as can be seen from a study of those underneath the present St Peter's in Rome. Most graffiti are fugitive, but given the invention of the spray-can, some municipalities have given in to what appears to be the inevitable and set aside walls and subway trains for graffito artists. In a sense this undermines the whole subversive political point of the graffito, whether its subject-matter is political or not.

● Margherita Guarducci, *I graffiti sotto la confessione di San Pietro in Vaticano* (1958); Mabel Lang (ed.), *Graffiti in the Athenian Agora* (1974); Marc Rohan, *Paris '68: Graffiti, Posters,*

Newspapers and Poems of the Events of May 1968 (1988); Gunther and Christel Thiem, *Toskanische Fassaden-Dekoration in Sgraffito und Fresco, 14 bis 17 Jahrhundert* (1964).

GRAND MANNER

An elevated and often affected > style of painting, rather appropriate, in fact, to the pretensions of the self-important > academicians who employed it. It was seen as the natural vehicle for the lofty themes of > history painting, in which the particular and individual were subordinated to the general effect.

● D.A. Rosenthal, *La Grande Maniere: Historical and Religious Painting in France, 1780–1800*, exhibition catalogue (1987).

GRAND PRIX D'ARCHITECTURE *See* Prix de Rome.

GRAND PRIX DE PEINTURE *See* Prix de Rome.

GRAND TOUR

A more or less extensive tour of the Continent, usually with Rome as the point of furthest travel, undertaken by young English aristocrats who wished to perfect their languages, view the splendours of Rome firsthand, and receive the polish bestowed by foreign travel. Many collected art works and antiquities for their family estates, thereby spreading the > taste for Italianate > culture. The practice was at its height during the 18th century and was enthusiastically taken up by Continental Europe and North America. > Goethe's *Italian Journey* is a classic account. With the development of > Neoclassicism and the easing of restrictions further East, some travellers, especially members of the Society of > Dilettanti and the Society of > Antiquaries, ventured to Greece, Asia Minor, the Middle East and North Africa, extending Europe's intellectual horizons and also the scope of > collections at home, notably with the > Elgin Marbles.

● D. Constantine, *Early Greek Travellers and the Hellenic Ideal* (1984); Robert Eisner, *Travellers to an Antique Land: The History and Literature of Travel to Greece* (1991); J. W. Goethe, *Italian Journey 1786–1788* (Eng. trans. 1970); Christopher Hibbert, *The Grand Tour* (1969); R. S. Pine-Coffin, *Bibliography of British and American Travel in Italy to 1860* (1974); Hugh Tregaskis, *Beyond the Grand Tour: the Levant Lunatics* (1979); Jeremy Black, *The British and the Grand Tour* (1985).

GRAPHIC ART

Most commonly refers to the various kinds of > fine art > printmaking, while 'graphics' refers to the layout of books and other publications. In the first category, where printmaking is a form of artistic expression, many artists, from > Dürer and Rembrandt

through to Goya and Manet, have made prints, but in most cases printing has been subservient to their careers as painters. In the second category, some artists in the present century have made 'artists' books', that is, highly priced limited- > edition publications, commissioned by dealers (> art dealing) such as > Vollard and > Kahnweiler.

GREAT EXHIBITION

Although far from the first such > exhibition, the 'Great Exhibition of the Works of Industry of all Nations, 1851' (to give it its full title) in the Crystal Palace Hyde Park confirmed and popularized a fashion that still continues – one might call it the grandparent of today's blockbusters – but it also had the more serious purpose of stimulating good > design, and through that of supporting the manufacturing industry on which the prosperity of the British economy depended. The venture was popular (over six million visitors) and profitable, the excess being used to purchase plots in South Kensington for > museums and colleges, including the > Victoria and Albert Museum.

For the > art historian, apart from confirming Britain's pre-eminent place in 19th-century mercantilism, the Great Exhibition is interesting for three reasons: 1. Paxton's use of an iron frame and acres of glass makes the Crystal Palace an important marker in new materials and construction methods in > architecture, since it was almost prefabricated; 2. the display of machine-made art underlined the Victorian dilemma (recognized long before William > Morris) about how the machine should be used to bring art to the masses, good art, that is, not > kitsch; 3. many of the exhibits formed the 'trousseau' for the Victoria and Albert Museum.

● Charles R. Fay, *Palace of Industry, 1851: A Study of the Great Exhibition and its Fruits* (1851); *Great Exhibition: Official Descriptive and Illustrated Catalogue of the Great Exhibition of the Works of Industry of all Nations, 1851* (1851); Paul Greenhalgh, *Ephemeral Vistas: A History of the Expositions Universelles, Great Exhibitions and World's Fairs, 1851–1939* (1988).

GREEK ART

Conventionally divided into four periods (Geometric, > Archaic, > Classical, Hellenistic), Greek art stretches from the 11th century BC to the time of Augustus. Its importance in painting and sculpture lies in its representations of the > ideal > beauty of gods, heroes and humans. > Architecture, reviving perhaps in the 8th century BC, used post and lintel construction at first in wood, later in limestone and then widely in > marble to erect buildings that impressed by the beauty of their > form and exquisite materials, rather than (until the Hellenistic period) by their overbearing scale or structural adventurousness. > Bronze was the preferred material for sculpture (except architectural sculpture), but we know of the important works only through the marble copies of the Romans. The Greek contribution to town planning (both the regimented grid and the scenographic varieties) was also influential.

Relatively little Greek sculpture or architecture has come down to us, but we know about them because the Hellenistic Greeks and later the Romans bought the whole package, as it were, of Greek > culture. Their reactions to Greek art and architecture formed the launching pad for the > Classical tradition.

• Bernard Ashmole, *Architect and Sculptor in Classical Greece* (1972); John Boardman, *Greek Sculpture. The Archaic Period*. A *Handbook* (1985); *Pre-Classical: From Crete to Archaic Greece* (1967); J. J. Pollitt, *The Ancient View of Greek Art: Criticism, History and Terminology* (1974); Martin Robertson, A *History of Greek Art*, 2 vols (1975); A *Shorter History of Greek Art* (1981); *Greek Painting* (1978).

GREEK REVIVAL

Although > Winckelmann thought he knew about > Greek art, he really knew about > Roman > copies. In > architecture, however, > drawings and > engravings of Greek buildings of the > Classical period were available in increasing quantities from the 1760s, and > Etruscan vases introduced the Western public to 'chaste' outline styles. If the Greek Revival was but one of several outbreaks of > revivalism in the 18th century, it nevertheless fitted in well not only with the urge for increased simplification in painting and architecture, competing with 'Roman' styles by the 1790s (cf. the career of Jacques-Louis David), but also with the greater possibilities for travel further East and with an 'archaeological' interest in modelling modern work on ancient sources. In architecture, the movement produced in England a few monumental but sublimely bare country houses, various gazebos and some churches, being much more popular in America. However, the > taste for things Roman was too deep to be totally dislodged, except by geniuses such as Sir John > Soane. Examples of this reluctance include the struggle to get the > Elgin Marbles accepted as Greek art worthy of purchase by the nation, and the frequent restriction of the Greek style to the > decorative arts, such as dress and furniture styles, wallpaper and clocks. *See* Grand Tour.

• Roger G. Kennedy, *Greek Revival America* (1989); Dora Wiebenson, *Architectural Theory and Practice from Alberti to Ledoux* (1982).

GREENBERG, CLEMENT

(b.1909). American art critic. Greenberg's importance in the history of > Modernism rests on essays such as 'Modernist Painting' (1965), in which he identified the hallmarks of Modernism as a technique that draws attention to itself, a rejection of the imitation of literature (> *ut pictura poesis*) and above all a respect for the two-dimensional nature of the picture surface, in Greenberg's phrase, 'the ineluctable flatness of the support'. Art possessing these qualities he termed 'pure', while art ignoring these tenets was irrelevant to the development of Modernism and could safely be dismissed. Historically, the significance of Greenberg's criticism is that it established > Abstract Expressionism as an international movement by showing that the tendency towards 'pure' painting was traceable from Manet through Cézanne and Cubism to Mondrian and so to Pollock and Rothko.

Critically Greenberg's brand of > formalism has had enormous influence on the way we think about Modernism, but it should be noted that it is not without a strong subjective bias or a certain amount of intellectual error. For example, he claimed that in modern art one sees the fact of a painting before one engages with what the painting is about (the story), which he judged to be the 'best way' of looking at art: This is a value judgement without any intellectual or historical credibility. Furthermore, in making

Abstract Expressionism the inheritor of 19th-century moves towards 'flatness', he ignored the fact that he had traced the development of flatness from the present back to its supposed source, but then reversed the story to suggest a conscious striving towards flatness. The philosopher Sir Karl Popper has attacked this kind of thinking as > historicism.

Today, while his work still provides a fruitful perspective on Modernism, it is no longer the only viewpoint, not least because > revisionist historians point out that too much art, especially > figurative painting, is left out of account.

● C. Greenberg, *Art and Culture* (1961); K. Popper, *The Poverty of Historicism* (1957; 1974); F. Frascina and C. Harrison (eds.), *Modern Art and Modernism: A Critical Anthology* (1986); F. Frascina (ed.), *Pollock and After* (1985).

GRISAILLE

(From the French *gris*, meaning 'grey'). A painting, often a preparatory > underpainting or > sketch done, as its name suggests, exclusively in tones of grey. It is used on decorative cycles to imitate sculpture and architectural ornament and similar > *trompe-l'œil* effects.

GROTESQUE

A > style of fantastic decoration named after the Italian word for 'cave' because it derived from Roman mural and vault decorations (known as *grotte*), which, by the time of the > Renaissance, it was usually necessary to tunnel underground in order to find, as with the Golden House of Nero underneath the Baths of Titus in Rome. The manner is deliberately make-believe and anti-reality; its repertoire of devices includes tendrils and other floral ornaments, sphinxes, strange beasts, candelabra, small framed paintings and snippets of > architecture, all against a plain-coloured background. Interior designers (ancient, Renaissance and later) loved the style because it was suitably > antique in origin, whimsical and playful (even erotic), and capable of fitting any required expanse because it has no single subject-matter and hence no central focus.

● Wolfgang J. Kayser, *The Grotesque in Art and Literature* (1981); Thomas Wright, *A History of Caricature and Grotesque in Literature and Art* (1865; reprinted).

GROUND

The surface to which > paint is applied, or the preparation of that surface for painting. To render a > canvas suitable for an > oil painting, a ground of oil and > pigment is used to make the fabric less absorbent (size). For > panel painting, > gesso is used. The > colour used for the ground affects the final tonality of the painting, a fact which can be exploited by staining the ground before laying on the paint. In the case of > portrait painting, a deep-red ground gives life to flesh tones.

GUILD

Before the rise of > academies of art in the late 16th century, artmaking was controlled by guilds, such as the Communauté des Maîtres Peintres et Sculpteurs de Paris formed in 1391. The statutes of the guilds, many of which date back to the 13th century, took pains to define and quantify the work of members, especially in establishing the line of demarcation between the various trades of, for example, gilder, painter and wood-carver. Placed under the > patronage of Saint Luke (many guilds were known as 'academies' of Saint Luke), they acted as professional associations, overseeing the execution of commissions, verifying the quality of the work and the materials used, imposing fines, arbitrating in disputes involving members, and exempting the > artist from some forms of taxation and military service.

The guild > artist (master) employed qualified assistants (journeymen) and employed and trained apprentices. The apprentice joined a > workshop in his early teens, and after training for between five and ten years (six to seven years was the norm) was received into the guild on presentation and acceptance of a > masterpiece. After a period often spent travelling from workshop to workshop as a journeyman, the artist was free to set up his own workshop. The guilds were familial, providing a social infrastructure, as well as financial relief when necessary, for members and their dependants. Many guild artists intermarried; it was common for a good apprentice to marry the daughter of the studio head and eventually inherit the workshop.

The guild workshop was a place of routine and formulae. Once initiated into the community, the artist was sworn to secrecy and to protect the guild's interests against all comers. Each member of the workshop knew his role, from the apprentice who ground colours and ran errands to the journeyman assistant who lacked none of the skill of the studio head to the master who co-ordinated his team. By the 17th century this structure was less able to respond to the newer aspirations of artists who sought to break free from what they saw as a > craft practice in favour of voicing an artistic philosophy that > academies seemed better able to articulate.

● J. Guiifrey, 'Histoire de l'Académie de Saint-Luc', *Archives de l'Art Francais*, IX (1915); F. Antal, *Florentine Painting and its Social Background* (1948); M. Baxandall, *Painting and Experience in Fifteenth-Century Italy* (1972; 1976).

GULBENKIAN, CALOUSTE

(1869–1955). One of the great > collectors of this century, 'Mister Five Per Cent' (the profits from his trading in oil) was especially interested in French painting, sculpture and the > decorative arts, as well as in the ceramics and carpets that reflected his Armenian origins. The Gulbenkian Foundation in Lisbon houses his collections, but the story of why they did not come to England is an intriguing one.

● Nubar S. Gulbenkian, *Pantaraxia: Autobiography* (1965); José de A. Perdigao, *Calouste Gulbenkian, Collector* (1969).

H

HAMILTON, GAVIN

(1723–98). Scottish painter and > archaeologist. From *c*.1755, when he went to Rome, he was one of the midwives of the > Greek Revival because of his promotion of Poussin, his own paintings on Homeric subjects (he was the first to use such 'wild' texts for paintings), his excavations and the models they provided, and because of his friendship with Mengs and > Winckelmann.

HANDLING

The effects produced by the way in which each individual > artist manipulates his > medium (> paint, clay, > pencil, etc.). It is so personal as to constitute an artistic > signature, and thus often allows the works of different artists from the same > school or period to be distinguished.

HAPPENING

In the 1960s happenings – multi-media events animated by artists such as the composer John Cage, Claes Oldenburg and Allan Kaprow – emphasized the spontaneous and transient elements in performance while manipulating performers, props and audience in ways designed to break down barriers between them. A happening was neither an art exhibit nor a theatrical event but the site of an experiment in perception and as such is linked to > Conceptual art. As part of the > Pop phenomenon, happenings championed the development of art forms away from the traditions of > fine art and the > exhibition space. They were sited in parking-lots, factories or the street, and involved materials with no fine art association, such as rubber tyres, water, fat, ice-cubes, and in the case of Joseph Beuys, live and dead animals. Through its emphasis on transient effects and its challenge to notions of the permanence of art and aesthetic values, the happening became one of the most visible forms of artistic experience of the 1960s.

● M. Kirby, *Happenings: An Illustrated Anthology* (1965); A. Kaprow, *Assemblage, Environments and Happenings* (1966); F. Popper, *Art Action and Participation* (1975).

HARD EDGE PAINTING

An aspect of geometric abstraction that in the 1960s reacted to the > gestural and > painterly canvases of the > Abstract Expressionists. The > style emphasized

149

geometric, rectilinear > compositions that respected the 'flatness' of the picture surface. Rendered with a sharp, 'hard' edge, the machine-like application of > colour likewise emphasized the impersonality of the canvas and the artist's desire to avoid the autobiographical or subjective references inherent in > Expressionism. Major practitioners of the movement include Ellsworth Kelly, Kenneth Noland and Al Held.

HARMONY

The 19th century, scientific in bent, sought rules (rather than just relying on the eye) by which > colours in art might be combined to produce harmonious results. Chevreuil's *Principles of Harmony and Contrast of Colours* (1839; Eng. trans. 1872) was the first of many attempts, none of which succeeded in demonstrating that assessment of harmony was anything but empirical.

HATCHING

The use of closely set parallel lines by which an > artist is able to indicate tone and shade in a > drawing. The technique is most evident in > engraving and in a linear drawing > style. *See* Cross-hatching.

HEGEL, GEORG WILHELM FRIEDRICH

(1770–1831). German philosopher and professor whose books and reconstructed lectures have provided ideas crucial in 19th- and 20th-century thought, not only for his vision of the state (for Karl > Marx) and interest in social democracy, but also for his belief that every age has its characterizing spirit (> *Geistesgeschichte*), his conviction that these can be known by the human reason, and his exposition of Christian doctrine as an expression of philosophical truth. His work is a veritable synthesis of knowledge, and a new theory of history. He believed art, like politics, to be cyclical and progressive, but this was not based on the working-out of a naturalistic theme and biological analogy as it was for > Vasari. Thus his famous dialectic of thesis–antithesis–synthesis, married to the progression of the human spirit, took a world view of art – a decided innovation – seeing its history in three stages, namely the > symbolic (Oriental), the > Classical (> Greek and > Roman) and the romantic, the last being the proper province of modern art, inspired by Christian and Germanic traditions.

Hegel's belief in the spirit of the age has been both fruitful and dangerous for > art historians: 'A nation's religion, its laws, its ethical life, the state of its knowledge, its arts, its judiciary . . . all are extremely closely connected' (*Realisation of Spirit in History*, 1830). It has been fruitful because it broadens the consideration of art to encompass that of > culture, but dangerous because of the implication that art may be 'explained' by reference to other contemporary elements of > civilization, which will perforce share characteristics.

● E. H. Gombrich, *In Search of Cultural History* (1969); G. W. F. Hegel, *Lectures on the Philosophy of World History* (1975); Jack Kaminsky, *Hegel on Art: An Interpretation of Hegel's Aesthetics* (1962).

HEIDELBERG SCHOOL

Australian school of > *plein air* painters who worked in Heidelberg, Victoria, in the 1880s. An > exhibition, the '9 × 5 Impressions', was held at Buxton's Galleries in Melbourne in 1889. The group, which may be considered the first white Australian > school of painting, included Roberts, Streeton, McCubbin and Conder.

● B. Smith, *Australian Painting 1788–1960* (revised T. Smith, 1991); J. Clark and B. Whitelaw (eds.), *Golden Summers* (1986).

HELLENISTIC ART *See* Greek art.

HERMITAGE

Museum in St Petersburg. This is one of several museums that began as palaces (cf. Versailles and the Residenzmuseum in Munich), and which consequently houses a variety of worldwide > collections, some from Russian rulers, some from the aristocracy and some the result of > archaeological discoveries. Catherine the Great formed the basic collection, buying widely at auctions. Opened to the public in 1852, the collections are especially strong in > Impressionism and the École de Paris.

● Mikhail I. Artamonov, *Treasures from Scythian Tombs in the Hermitage Museum, Leningrad* (1969); *Catherine the Great: Treasures of Imperial Russia from the State Hermitage Museum, Leningrad* (1991).

HIEROGLYPHS

'Secret writing' using pictograms supplemented by phonetics, hieroglyphs are decorative in their own right and were used by the > Egyptians to record deeds and events. Horapollo, writing in the 5th century AD, gave usually fantastic or > allegorical explanations for them, influencing the hieroglyphic vogue of the > Renaissance and the craze for > emblems. The context was the belief that Egypt was the parent and the source of all knowledge, and that much of this was mystically locked in hieroglyphs, unread until Champollion's decipherment of the Rosetta Stone in 1822–4.

● Erik Iverson, *The Myth of Egypt and its Hieroglyphs* (1961); Norma J. Katan, *Hieroglyphs: The Writing of Ancient Egypt* (rev. edn 1985).

HISTORICISM

The term has two diametrically opposed meanings. The original use of the term sees a given historical epoch as unique and unrepeatable and therefore to be understood only through its own concerns. In opposition to this, the philosopher Karl Popper meant by historicism the application of quasi-scientific world-views, such as Marxism, to historical

development with the aim not only of explaining the past, but also of offering a perspective on the present and a blueprint for the future. More recently, another strain, called 'New Historicism', has been developed which rejects both these positions to focus on the 'intertextuality' of historical > artefacts (the way > guild practice, for example, may be read into > mediaeval > panel painting and vice versa).

● K. Popper, *The Poverty of Historicism* (1957; 1974); G. Stedman Jones, 'History: The Poverty of Empiricism' in *Ideology in the Social Sciences*, ed. R. Blackburn (1972); H. Aram Veeser, *The New Historicism* (1989).

HISTORIOGRAPHY

In the > fine arts, the study of the history of > art history. The study of historiography implies an awareness on the part of historians that the various approaches to the discipline influence the outcome of their researches. Historiography therefore necessarily studies > methodology, while rejecting the now unfashionable 'transparent' histories of earlier generations of historians.

● M. Podro, *The Critical Historians of Art* (1982; 1989).

HISTORY PAINTING

The term describes a > genre of painting in which scenes taken principally from the > Bible, mythology and > Classical literature are treated in an elevated and morally edifying way. The historical genre, which stylistically is associated with, but not identical to, the > Grand Manner, was the preferred genre of > academic artists, who regarded it as the highest expression of art. Notable practitioners of history painting include Poussin, Charles > Lebrun, Benjamin West and David.

HOGARTH, WILLIAM

(1697–1764). > Engraver and painter, and robust satirist of contemporary > taste and morals, from > academicism to prison practice. *The Analysis of Beauty* (1753) is a rare work of theory from an Englishman, not to mention an English artist, but Hogarth believed practitioners should know more about such topics than mere > dilettanti. In it, he introduces his serpentine 'line of beauty and grace' as an important element in the construction of > beauty, and he exemplifies this in some of his own painting.

● Frederick Antal, *Hogarth and his Place in European Art* (1962); Ronald Paulson, *Hogarth: His Life, Art and Times* (1971).

HUDSON RIVER SCHOOL

A > school of 19th-century North American > landscape painters who recorded the unspoilt Eastern seaboard immediately before its disappearance under European

settlement. Thomas Cole was the principal painter and founder of this first American school and was largely responsible for imbuing the rugged landscapes along the Hudson River with European notions of the > sublime, rendered in a part > topographical, part > Romantic mode. Asher B. Durand and William Cullen Bryant were also prominent members of the school.

● M. Baigell, A *History of American Painting* (1971).

HUMANISM

Although often used as shorthand to describe the period of the > quattrocento and > cinquecento in Italy, it refers more precisely to the intellectual mind-set of that period, with its rejection of scholastic theology and philosophy in favour of interests and horizons derived from the > antique. By studying rediscovered antique texts ('the classics') and thence the mind of the ancients, humanists set the tone and provided the context for the reuse of ancient art reforms by > artists and > architects. More generally, humanism refers to any philosophy that favours studying the deeds of mankind rather than those of the Godhead.

● Andre Chastel, *The Age of Humanism: Europe 1480–1530* (1963); Kenneth Clark, *The Art of Humanism* (1983); Ernesto Grassi, *Renaissance Humanism: Studies in Philosophy and Poetics* (1988); Albert Rabil (ed.), *Renaissance Humanism: Foundations, Forms, and Legacy* (1988); Roberto Weiss, *The Renaissance Discovery of Classical Antiquity* (1969).

HYPERREALISM *See* Photorealism.

I

ICON

(Greek: 'image'). A portrait from the Greek Orthodox world, of Christ or a saint, popular from perhaps the 6th century on panels, manuscripts or > frescos, and still produced today, often in traditional > styles. The idea is much older, deriving from the representation of pagan rulers; Christian images were frequent in churches by about the 5th century AD, together with > mosaics. Icons were used for contemplation, veneration (sometimes, perhaps, overenthusiastically: > iconoclasm) and instruction, as well as for decoration. They were produced in very large numbers, often in styles that apparently changed little over the centuries, and their influence on > revivals in Western art in the Middle Ages, and on the development of religious > panel painting, was extensive.

● Kurt Weitzmann, *The Icon: Holy Images from the Sixth to the Fourteenth Century* (1978).

ICONCLASS

A logical system for the classification of art works (especially those in the Western > Classical and Christian traditions) by means of their subject-matter or > iconography, and devised by Henry van der Waal in 1944 whilst in a concentration camp. It has been completed and edited by L. D. Couprie and R. H. Fuchs. The system, published under the auspices of the Royal Netherlands Academy of Arts and Sciences in Amsterdam, exists as published manuals (7 vols, 1974–81), a bibliography (7 vols, 1973–83), and an alphabetical index. It is a necessary 'key' for unlocking the > Marburger Index, and the process has been made easier by the publication in 1990 of an Iconclass Browser on CD-ROM.

ICONOCLASM

Strictly, a view of religion that deplores the representation of holy faces and therefore seeks to destroy them for reasons other than 'pure' vandalism. The basis of this belief is that the practice is impious, firstly because it seeks to represent that which is a hidden mystery, namely the splendour of God and the saints (although this revelatory possibility was precisely one of the reasons advanced by the iconodules for their veneration); and secondly because of the dangers of the simplistically minded worshipping the > icons themselves rather than venerating the persons they merely represent.

In 8th-century > Byzantium, the iconoclasts sought to abolish such imagery, and

although the iconodules promoted their use, unfortunately for art they lost the dispute. > Art history thereby lost very large quantities of evidence for the earlier development of Christian art in the East as works of art were enthusiastically hammered, painted over or otherwise destroyed.

Religions other than Christianity have been iconoclastic in their religious art: > Islam (there are some early exceptions) is an example, and perhaps assimilated the arguments from Byzantium, or indeed from Judaism, where the practice extended to names as well as images. In Constantinople, for instance, the Islamic conquerors completed what their iconoclastic Christian forebears had begun. Christian sects continued to be liable to fits of iconoclasm in their search for religious correctness. Large quantities of art were destroyed during the Wars of Religion, and following the English Civil War.

Much more loosely, iconoclasm is an attitude to the past that aims both to undermine preconceptions and to pull down old idols with the (sometimes) constructive aim of replacing them with something better. Parker and Pollock's 1981 book provocatively entitled *Old Mistresses: Women, Art and Ideology* is a good example of the procedure. As Oliver Wendell Holmes wrote in 1872: 'Rough work – iconoclasm. But the only way to get at the truth.'

● Phyllis M. Crew, *Calvinist Preaching and Iconoclasm in the Netherlands*, 1544–1569 (1973); David Freedberg, *Iconoclasm and Painting in the Revolt of the Netherlands*, 1566–1609 (1988).

ICONOGRAPHY

The study of subject-matter in art. The iconographer employs knowledge of > symbolic imagery to interpret art works. The > art historian Erwin > Panofsky was a pioneer of this > methodology and the leading exponent of iconographical studies. In his own words, iconography is 'that branch of the history of art which concerns itself with the subject-matter or meaning of works of art, as opposed to their form'. The approach is therefore in direct contrast to the > formalism of > Wölfflin. A painting in which a woman is placed next to a spiked wheel is a representation of St Catherine, martyred on such a wheel and whose > attribute it is. Most often the study of iconography is much more complicated, requiring an extensive knowledge of the related > culture and intellectual climate before analysis can take place; for example, Panofsky's study of van Eyck's *Giovanni Arnolfini and his Wife* (1434) in his *Early Netherlandish Painting* (1953).

Panofsky established an important distinction between iconography and iconology. In *Studies in Iconology* (1939) he defined iconography as the study of subject-matter and iconology as the study of meaning. His classic example of this difference is that of the man who raises his hat as a polite gesture. While the action itself is straightforward, its meaning derives from the practice of > mediaeval knights removing their helmets to express peaceful intent. As Panofsky states: 'To understand [the] significance of the gentleman's actions I must not only be familiar with the practical world of objects and events, but also with the more-than-practical world of customs and cultural traditions peculiar to a certain civilization'. Thus the action has two meanings, primary or apparent and secondary or conventional. The latter points towards hidden meaning in an art work.

Other eminent exponents of an iconographic approach include Émile > Mâle, Aby > Warburg and Rudolf > Wittkower.

● W. J. T. Mitchell, Iconology: Image, Text, Ideology (1986); E. Panofsky, Early Netherlandish Painting, 2 vols (1953); Studies in Iconology (1939; 1962); Meaning in the Visual Arts (1970; 1987); M. Podro, The Critical Historians of Art (1982; 1989).

IDEALISM

A stance, originally > antique but much promoted during the > Renaissance (for example by > Alberti), which maintains that art should be an uplifting experience for the observer, and that consequently the > artist should represent not exactly the natural world as seen, but should improve upon it by deliberately choosing the best elements in it. The philosophical justification for this (and for the originating philosopher the very argument against art itself) came from Plato's Theory of Ideas, in which he argued that the 'forms we see in this world are but imperfect versions of the true forms of the mind or of heaven. The artist is therefore the person who makes these ideal forms flesh, as > Bellori said in his lectures to the Academy of St Luke in 1664 (published in his Lives, 1672). In this context, the pursuit of > beauty by the artist is, in > Neoplatonic terms, nothing but the veneration of the Godhead, who is visible in all creation, an argument that should be considered before believing that the use during the > Renaissance of originally pagan subject-matter – seen as a criterion of beauty – was in any way impious.

The practice of idealism by artists was bound up with the > Classical tradition, for it was taught in the > academies, and was the key reason for the continuing influence of antique art and for the development of > Neoclassicism.

● Piotr Hoffman, The Anatomy of Idealism: Passivity and Activity in Kant, Hegel, and Marx (1982); Erwin Panofsky, Idea: A Concept in Art Theory (2nd edn 1975).

IDEAL LANDSCAPE

A > style of > landscape such as that practised by Claude, and a sub-> genre of both landscape and > history painting. An ideal landscape is a > composition loosely based on > nature and dotted with > classical ruins used as a setting for a biblical or historical theme, such as Claude's Landscape with the Father of Psyche Sacrificing to Apollo (1660–70). Its attraction for academic theorists, who held landscape to be an unimportant rung in the hierarchy of genres (> genres, hierarchy of) was that it artfully combined landscape and history painting, thereby legitimizing the former. It is synonymous with the term 'historical landscape', which received official recognition in the French > Academy when a > Prix de Rome was established for the genre in 1817.

● A. Boime, The Academy and French Painting in the Nineteenth Century (1971); P. Grunchec, Les Concours des Prix de Rome 1797–1863 (1986).

ILLUMINATION

From the Latin *illuminare* meaning 'to adorn', this rhetorical term serves to describe the decoration of ´ parchment and vellum (and from the 14th century some paper) manuscripts with initials, margin illustrations and part- and whole-page pictures. Although some manuscripts (such as the Utrecht Psalter) had > drawings only, the great majority were painted in > tempera > colours, the most sumptuous receiving gold ornament as well. Illuminated manuscripts were a mainstream art form from Early Christian times through to the invention of printing, which reduced the need for such work, although some early printed books also received illumination, perhaps partly to convince people (especially rich > patrons) that this newfangled invention could be suitably up-market.

Illumination was by its very nature labour-intensive and expensive, and thus tended to employ the best artists of the age. For the > art historian, this work often serves to represent an age when other forms of painting and sculpture (from small-scale to monumental) were either absent or have subsequently all but disappeared, such as the earlier centuries of the Middle Ages.

● Giulia Bologna, *Illuminated Manuscripts: The Book Before Gutenberg* (1988); John P. Harthan, *An Introduction to Illuminated Manuscripts* (1983).

ILLUSIONISM

Art thrives on illusion when it attempts to convince us that what is factitious is real: a > landscape on a wall is indeed a real landscape; the figures in the dome of a church are really part of a vision of Heaven itself vouchsafed to the viewer; a portrait actually breathes; or the fly that the apprentice painter paints on his master's work, and which the latter tries to brush away is real; or the bunch of grapes so lifelike that a bird tries to eat them. Such > *trompe-l'œil* work began early, and continues today.

In a sense the > artist is a magician, who when he or she 'imitates nature', conjures up a whole new world with many of the features of the 'real' one. Works of art have often been the subject of miraculous claims, such as wooden Black Madonnas on Thrones of Wisdom who cry, or walk round their church, or cure infertility, or statues that come to life which direct Don Giovanni to Hell. Then there is the *Mona Lisa*, said to be so lifelike that she could be seen to breathe, and figures of the crucified Christ that drip real blood. During much of the earlier Middle Ages, > antique statues were regarded with awe, and because they could not (or did not desire to) make similar creations, they were considered magical, that is almost superhuman. There are many > mediaeval stories of such statues, the best being the (fictitious) set in the Capitol, each representing a Province, which turned and pointed when sedition was in the air.

The belief that statues are sometimes more than the illusion of human beings has a long history, going back to the story of Pygmalion, who made a statue and fell in love with her. Conjuring three dimensions from painted plaster on a flat wall goes back at least to the first century BC (and probably to Hellenistic (> Greek) art). In some cases there is only a hint of man's hand, as in the wicker fence that separates us from the garden with its trees and birds in the Garden Room of the Villa of Livia (wife of the Emperor Augustus) from Prima Porta (now in the Museo Nazionale delle Terme, Rome).

At certain periods Roman *cognoscenti* demanded complete architectural frameworks, with false doors (sometimes half-open to reveal painted servants), peacocks on balconies, and yet more ranks of >architecture beyond. A similar illusionism, which may derive (statues and all) from late Hellenistic fountain architecture, is also found in >mosaic, as in the Great Mosque in Damascus, converted from the church of St John.

Painted illusionism was ignored by the Middle Ages, although they must have seen examples of it in the remains of Roman villas. The >Renaissance took it up with a vengeance, Mantegna being the foremost early practitioner in Padua and Mantua, and the first since antiquity to practice >*sotto in su*. Such works depend on a correct >perspective delineation of architecture and figures (as well, sometimes, as the atmosphere itself) to make them convincing.

Illusionism was particularly popular during the >Baroque, a movement that sought (especially in its religious art) a complex emotional experience depending on the fusion of the arts. Occasionally used by the somewhat staid French (Coypel, >Lebrun, >Delacroix), it was used little in England (Thornhill is an exception) but was especially popular during the 18th century in the Catholic areas of Northen Europe, where Baroque intensity lightened to the more playful and whimsical >Rococo.

If full-blown illusionism is nowadays out of fashion even in religious contexts, it survives in private secular locations amongst those who wish to enliven and appear to extend the small size of modern rooms.

● Marie L. d'O. Mastai, *Illusion in Art: Trompe-l'Oeil, a History of Pictorial Illusionism* (1976); Sven Sandstrom, *Levels of Unreality: Studies in Structure and Construction in Italian Mural Painting During the Renaissance* (1963).

IMAGERY

A picture in the mind of a quality perceived in >nature, or such an effect when produced by a poetic trope. In the visual arts (unlike literature), the means of creating imagery is identical with the images themselves, so in art appreciation imagery refers principally not to metaphors or similar tropes, but to the choice of images represented. However, schools such as the >Symbolists or the >Early Netherlandish painters, who used recurring >symbols to represent abstract ideas (that is, they used visual metaphors), may properly be discussed in terms of imagery.

IMAGINATION

Imagination in art was valued by critics from the >Renaissance onwards, but the faculty was especially prized by >Romanticism, which saw it as the central attribute of the artistic persona. Imagination as the expression of individual >creativity may be opposed to >naturalism, which aims to record the appearance of things without interposing the >artist between the subject and its representation.

● R. Scruton, *Art and Imagination: A Study in the Philosophy of Mind* (1982).

IMITATION

The concept of imitation in art stretches back to antiquity and few terms in art theory have been more misunderstood. The concept has been out of favour since > Romanticism wrongly equated imitation with > copying and made it the hallmark of lack of > originality. While the Latin term 'imitatio' is associated with the Greek 'mimesis', in art theory it tends to mean not just the copying of > nature but the emulation of the best of an existing > canon of art works, and was so discussed in Quintilian's *De Institutione Oratoria*. It was never a question of slavishly copying older art, but of creating a dialogue with the best of the past. While imitation was a live issue throughout the Middle Ages, it was from the > Renaissance onwards that it became central to many theories of art, and was institutionalized by the > academies, which needed to reconcile a belief in rules and precedent with a sense of invention that they claimed was absent from the > craft-dominated > guilds.

Thus the doctrine of the copying of great > artists of the past began, at first with profit, but later it became ossified into a mindless veneration of the past that dominated training (> art education and training) throughout the student's apprentice-ship, making it difficult for all but the strongest wills to emancipate themselves from its influence. Those, like Rubens, who did, gained great profit from studying older art, but those who remained under its yoke were drained of originality. Since the Romantics' veneration of originality as an essential rather than a learned quality, imitation in the 20th century has become associated with parody and > pastiche, and as such forms an important aspect of > Post-Modernism. *See also* Eclecticism and Ut *Pictura Poesis*.

• J. M. Muller, 'Rubens' Theory and Practice of Imitation in Art', *Art Bulletin* (1982).

IMP.

(Latin: *impressit*, meaning 'he printed it'). When it follows a name included in the marginalia of a > print, e.g. Smith imp., it means Smith printed the plate.

IMPASTO

A term used to describe opaque > oil or > acrylic paint applied in thick, heavy strokes either with a brush or palette knife. An > academic dictum was 'Brush in shadows thinly and impasto highlights'. Exponents of the technique include Rembrandt and Tintoretto, and in the 20th century Willem de Kooning and Frank Auerbach.

IMPRESSIONISM

A mid- to late-19th-century French > school of painters who combined subjects drawn from modern life with direct observation of the motif in > nature; as such Impressionism may be regarded as an aspect of > naturalism. In the 1850s, Courbet, and from the early 1860s, Manet, responding to > Baudelaire's call for modernity in art, brought the representation of contemporary life to the public's attention. But

Impressionism originated in the studio of the > academic painter Charles Gleyre, who trained four of the future Impressionists, Monet, Sisley, Renoir and Bazille. Monet, who had been influenced by the > *plein air* > landscapist Boudin, formed the nucleus of the group, which also attracted Berthe Morisot, Pissarro, Cézanne, Degas and, briefly, Manet. In 1874 they held their first group > exhibition in the studio of the photographer Nadar, where Monet's painting *Impression: Sunrise* (1872) attracted the attention of the satirist Louis Leroy, who baptized the group the 'Impressionists'. Seven more shows were held up to 1886.

Impressionism was radical in at least three ways. Firstly, it broke with the authority of the > Salon, preferring to exhibit independently. Secondly, its seeming indifference to subject-matter removed one of the major props of the 19th-century theory of > aesthetic value (historical subjects (> history painting) were deemed more important than > genre themes). Thirdly, its close observation of > nature and the effect of light cut through academic practice and rendered obsolete much > art education based on academic 'know-how' and respect for the past.

From 1869 Monet, followed by Renoir, developed a series of seminal studies of La Grenouillière, near Paris. In these works two formerly discreet stages of painting – the > sketch and the execution of the finished > canvas – were fused. Painting at least part of the time on the spot, Monet sacrificed > studio finish for the advantages of loosely handled > paint, which meant primarily the ability to retain in one canvas the elements of 'preparation' most often lost in the execution of the finished painting. Unsurprisingly, Impressionism was accused of making mere sketches, not art works, but this was missing the point. Impressionism broke with academic practice in order to present the viewer with a spontaneous interpretation of the world, unclouded by the application of academic formulas. In fact, Impressionist paintings were not for the most part the result of one sitting and were often reworked. But through the use of broken brushstrokes, high-keyed > colour, thick opaque > impastos and little preparatory painting, the pictures retained the freshness of studies.

By breaking with the formulas of academic art practice, subject-based > Salon painting and the tyranny of official exhibitions, the Impressionists created a climate for the rapid advance of > Modernism. In its exploration of the potential for painting to capture the effects of light and for the > medium, the paint itself, to become the painting (rather than merely the means to depict the subject), Impressionism may be counted among the most revolutionary art movements of the modern period.

● J. Rewald, *The History of Impressionism* (1946); T. J. Clark, *The Painting of Modern Life: Paris in the Art of Manet and his Followers* (1985); R. L. Herbert, *Impressionism: Art, Leisure and Parisian Society* (1988).

IMPRIMATURA

A > glaze of > colour applied over a preparatory > drawing on an > oil painting, both to reduce the absorbency of the > ground and as a means of establishing a tonal median.

INC.

(Latin: *incidit*, meaning 'he cut it'.) When the term follows a name – e.g. Jones inc. – on a > print, it means Jones engraved it.

INDEPENDENT GROUP

A group of British artists in London in the early 1950s who formed the nucleus of the early English > Pop movement. They included the critic Lawrence Alloway and the artists Richard Hamilton and Edouardo Paolozzi.

INDUSTRIAL REVOLUTION

In the 18th century, new manufacturing production methods, the use of new materials, and the development of labour-saving inventions and machinery brought about changes whose impact on Western Europe was more profound than even the French Revolution, and, arguably, longer-lasting. These changes had an indirect but subtly important effect on the art of the late 18th and early 19th centuries because industrialization influenced the way people thought about art and > design as well as about literature and religion. This had substantial long-term consequences for the contentious matter of the relationship between art and industry – a matter tackled in various ways by the > Great Exhibition, William > Morris and the > Bauhaus. If a minor result of the new manufacturing was the production of new > pigments for artists, more important ones included the changes made to the countryside by behemoth machines, the continuing move to the towns, and the consequent expansion of city-living. This led to equivocal stances taken by > landscape artists, and, eventually, to a new, urbanized market for art, which, during the course of the 19th century, moved decidedly down-market.

The traditional subject-matters for art were transformed and new topics appeared: landscape painting offered different perspectives (which Barrell has taught us to read); and the depiction of society at work and play (leisure was a new idea for many) grew. Meanwhile, the status of the 'unique' art work tottered before the need to cater, by means of the > print, the illustrated newspaper and > photography, to a much larger and ever more educated and discerning proportion of the population – one not overimpressed by traditional art forms or by the power structures they represented. Movements such as the > Arts and Crafts sought to reintroduce handiwork (and often a mediaevalizing style to go with it), but were doomed to failure because they could not compete economically in mass markets.

● Christopher Harvie et al., *Industrialization and Culture*, 1830–1914 (1970); Francis D. Klingender, *Art and the Industrial Revolution* (rev. edn 1972).

INFLUENCE

From the Latin 'to flow', 'to run into'. Influence affects everyone in the acquisition of all kinds of ideas, not simply artistic ones. The notion of absolute > originality is usually a

nonsense and, were it always to exist, would undermine any attempt to construct a meaningful continuous narrative about how and why art changes.

Indeed, influence is the very stuff of one variety of > art history, much of which involves assessing the impact of an art work or event upon others in the same or a later period. In some instances this is clear, because a few works are enormously influential, sometimes for centuries: it is easy to follow the 'audit trail' of Michelangelo's Sistine Ceiling, for example, or of > Leonardo's *Last Supper*. Claims have been made for ways of doing this in a systematic manner (> Morelli).

In less documented places and periods, influence must be a hook used to crochet anonymous and/or undated works into a defensible string of cause and effect. This requires both the > connoisseurship of a Morelli and a sensitivity to the various local and broader traditions involved; but it is a fragile skill, susceptible to being blown down by the cold wind of new discoveries or excavations, especially when the 'continuous narrative' is thin and halting.

Sometimes of help in grouping works and ideas, but essentially dangerous, is the concept of > *Zeitgeist*, which suggests that all products of a particular age and place share characteristics, for they must all be affected by 'the spirit of the age'. We are making the same assumptions when we swallow too readily books entitled *The Age of Reason* or *The Age of Baroque*. The danger lies in accepting the easy answer of 'one does it, they all do it', which gainsays the richness and diversity of any age. *See also* Copy and Imitation.

● Margarete Bieber, *Ancient Copies: Contributions to the History of Greek and Roman Art* (1977); Egbert Haverkamp-Begemann, *Creative Copies: Interpretative Drawings from Michelangelo to Picasso* (1988); Goran Hermenen, *Influence in Art and Literature* (1975).

INHABITED SCROLL

A type of running decoration of foliage with figures human and even animal. First used by the > Romans, it deserves mentioning because of its popularity in > mediaeval and > Renaissance art, for example in the > mosaic apse of S. Clemente, Rome (12th century), or in the margin of many a Renaissance manuscript.

INK

For writing or > drawing, ink made of lamp black was used by the > Chinese and > Egyptians in the 3rd millennium BC. In China and Japan the fluid has been used in a whole tradition of brush painting with transparent washes.

● Hiroshi Kanazawa, *Japanese Ink Painting: Early Zen Masterpieces* (1979).

INK PAINTING *See* > Chinese art.

INSCRIPTIONS

The > Greeks were inveterate commissioners of inscriptions, but the size and beauty of > Roman lapidary lettering began a monumental tradition that has continued to the present day.

Since antiquity, > patrons and artists have not been able to forbear telling the spectator more than is deducible from the > iconography of the art work they have commissioned or made, or from the monument they have erected. In some circumstances, such as a statue or bust, an inscription is not only conventional but necessary, otherwise knowledge of identity would soon be lost. In other inscriptions, especially on > architecture, the commissioner will take the opportunity to increase his fame by ensuring that it will last, via an inscription, as long as the building itself. In antiquity these were usually cut into > marble in letter forms of great beauty, which were to form models for the better > Renaissance printing presses. Such inscriptions, which survive in great numbers from > classical Greece onwards, can be invaluable in dating buildings and their restorations (e.g. the Pantheon, Rome), in naming patrons (Library of Celsus, Ephesus), or in recording family details on a funerary stele.

Although inscriptions were not rare, especially during the later Middle Ages, they came into their own again with the Renaissance, when patrons imitated > antique practice by using majestic and large-scale lapidary capital letters similar to those on the base of the Column of Trajan. Two examples would be the > frieze inscription on the façade of > Alberti's Tempio Malatestiano at Rimini, or the inscription on the frieze of the two main storeys of the courtyard of the Ducal Palace at Urbino.

Inscriptions on works of art may praise the patron, but they are especially valuable when they tell us something about the artist that we could not otherwise know. They may even offer self-praise, as with Buscheto's on the façade of Pisa Cathedral, comparing himself with Daedalus, or Nicola Pisano's inscription (1260) on his pulpit in the Baptistery of Pisa Cathedral.

Nor have inscriptions been restricted to architecture and sculpture. In painting, the label is common in > portraits, and > *trompe l'œil* 'stone' inscriptions are not rare. Jan van Eyck's apparent testimony to his presence at the betrothal of Giovanni Arnolfini (*The Arnolfini Wedding*) is amongst the most contentious, although the inscription on the Ghent > altarpiece runs it close.

● Dario A. Covi, *The Inscription in Fifteenth-Century Florentine Painting* (1958); Stanley Morison, *Politics and Script: Aspects of Authority and Freedom in the development of Graeco-Latin Script from the Sixth Century* BC *to the Twentieth Century* AD. (1972); John H. Sparrow, *Visible Words: A Study of Inscriptions in and as Books and Works of Art* (1969).

INSTALLATION ART

Installation art has flourished since the 1970s. An installation is a site-specific art work, created for a gallery or outdoor location. Instead of the site being simply a neutral backdrop to the exhibition of individual art objects, as in a traditional hanging, the ensemble of elements that make up the installation are arranged so as to interact with the site chosen and provide the > beholder with the sensation of physically entering an

art space. Practitioners of the > genre include Joseph Beuys, Christian Boltanski, Hans Haacke and Donald Lipski.

INSTITUTE OF CONTEMPORARY ARTS

Founded in London by Roland Penrose and Herbert Read in 1947, the ICA stages > exhibitions, lectures, films etc. in order to promote contemporary art.

INTAGLIO PRINTING

The term used for a design that does not stand in > relief, but is hollowed out of the surface of the object. Two examples would be engraved seal stones, which reproduce the design in relief when the stone, usually set in a ring, is stamped into hot wax, and > inscriptions, for example on gravestones, where the letters are incised not just because it is easier, but also so that the words and designs will remain legible despite the elements. The most common intaglio process is > engraving, where the excavated channels hold the > ink and transfer it to the > paper.

● Walter Strauss, *The Intaglio Prints of Albrecht Dürer: Engravings, Etchings and Drypoints* (rev. edn 1977).

INTERNATIONAL GOTHIC

The final strains of > Gothic, with a new interest in the details of > nature and a range of courtly and high-flown subject-matters to appeal to the interests of contemporary upper-class sophisticates, this style was popular enough from the later 14th century to cross the boundaries between France, Burgundy, Germany and Italy. It was practised by artists such as Gentile da Fabriano, Pisanello, Melchior Broederlam, and the Brothers Limburg. It influenced painting, sculpture and > illumination, for example the *Très Riches Heures du Duc de Berry* by the Limburg brothers (*c*.1411, Chantilly), with its presentation of a perfect world, highly coloured and detailed in its landscapes, clothes and > architecture.

However, the fact that the flowering of International Gothic in the early 15th century was so very different from the > antique-derived > nature-based > naturalism of artists such as Masaccio and Donatello only emphasized its preciosity and other-worldliness. It died as the forward-looking courts and > patrons of Italy took up the new > Classicism based on the antique and looked at nature through antique spectacles, finding the world outside the window insufficient for their needs.

● Liana Castelfranchi Vegas, *International Gothic Art in Italy* (1968); *The International Style: The Arts in Europe around* 1400, exhibition catalogue, Walters Art Gallery, Baltimore (1962).

INTERNATIONAL STYLE OR INTERNATIONAL MODERN

The name given by Philip Johnson and Henry-Russell Hitchcock to their book about the modern style in > architecture, which appeared in 1932 and has been influential ever since. In many ways this style was a 'deviation from the ancient and Classical manner' (Dr Johnson's definition of > Modernism), and also a reaction against what was considered to be the mindless > revivalism of the past century. Johnson and Hitchcock recognized that Modernism did not obey national boundaries, partly because architects could get together to solve the social problems of contemporary architecture, as they did in CIAM, the Congrès International d'Architecture Moderne, founded in 1928.

Buildings in this style share many of the following characteristics: simple cubic forms, including flat roofs, generally in an interlocking pattern; plain colours and airy interiors, often graced by specially designed furniture made from non-traditional materials; a lack of applied decoration; cantilevered concrete floors, allowing outside walls to be reduced and replaced by glass curtain walling; an interest in prefabricated construction; and a special focus on 'social' housing such as blocks of flats and low-cost projects. Concrete also allowed windows, balconies and the rest to jut out without support, leading Leo Mishkin to describe tower blocks using such methods as giant refrigerators with the ice-boxes half out.

● Arthur Drexler, *The Architecture of Richard Neutra: From International Style to California Modern* (1982); Richard Pommer, *Weissenhof 1927 and the Modern Movement in Architecture* (1991).

INV.

(Latin: *invenit*, meaning 'he designed it'). A term often found in the margin of a > print to indicate the > artist of the > original design or painting.

INVENTION

Originally the term was part of > classical rhetoric, and was so discussed by Quintilian in his *De Institutione Oratoria*. The importance of invention in the > fine arts can be seen the > Renaissance analogy between art and poetry (> *ut pictura poesis*), in which invention played a central role in separating fine art – an exercise in intellect – from the mechanical > copying of the applied (> decorative) arts. Although invention was a key concept in the social and intellectual emancipation of the > artist during the Renaissance, it later degenerated into an > academic preference for conception over execution, with disastrous consequences for > history painting.

ISLAMIC ART

Religious in character, Islamic art shuns > naturalism – seen as presumptuously god-like – in favour of abstract pattern-making. When > nature is made use of, for example the foliage in an arabesque, it is a highly stylized representation in which the natural element is subordinate to the overall geometry of the decorative scheme. Islamic art has

little or none of the Western preoccupation with narrative; instead the entire surface is covered with decoration that in Western art would be pierced to allow for representation of a story. In this way it is able to achieve to a remarkable degree the symmetry and mathematical > abstraction that are conducive to the contemplation of the word of God; indeed the incorporation of > inscriptions from the Koran is common. From its beginnings in the Umayyad period (660–750) – in which its > eclectic origins, with elements of Hellenistic, > Coptic and Persian art, may be discerned – the influence of Islamic art followed the spread of the Islamic Empire from the Mediterranean basin to the south of Spain, Africa, the Balkans and as far as Indonesia, engendering a huge variety of art forms and > styles.

● P. E. Kühnel, *Islamic Art and Architecture* (1966).

ITALIAN ART

From at least the 3rd century BC until the end of the 18th century, the peninsula of Italy was with few lapses the most important art-generating centre in the Western world: when Charlemagne (> Carolingian art) built at Aachen, his inspiration was Italian; churches built in Provence were > Romanesque because of Roman suzerainty over the region. The emergence of > Gothic style was the first exception to Italian 'artistic rule', but the prestige of the > Renaissance in courts outside Italy, together with the Europe-wide reach of the > papacy, anchored the peninsula's fame until other courts began to think they might do better.

Until that time, the first step was to import or try to import Italian artists (Francis I in France; Charles I in England), the second to send local artists to Italy to be educated. The French and Dutch went there in great numbers from the mid-16th century, and > Dürer had assimilated some aspects of Venetian art even earlier. The third step was to develop a local > style from Italian inspiration, as happened in the France of Louis XIV or in the Spain of Velásquez. Italian art proved too pompous (and too Catholic) for the British and the Dutch of the 17th and 18th centuries, who developed their own traditions almost untouched by Italian > idealism.

Italy and Rome remained prestigious during the 18th century thanks to the > Grand Tour, but this was also a factor in Italy's decline, for its point was the assimilation of Italian ideas (and the purchase of Italian art works) to use back home. The political decline of the papacy, the continuing fragmentation of the Italian states and the rising military and economic prestige of the North all helped to re-evaluate Italian art downwards in comparison with the exciting developments further north, despite the > academies, the various > grands prix and the > revivals of > Neoclassicism. With few exceptions, Italian art was prestigious for its past, not its present, and new art was being produced further north.

● Robert Enggass, *Italy and Spain, 1600–1750: Sources and Documents* (1970); Irma B. Jaffe, *The Italian Presence in American Art, 1760–1860* (1989); Lytton A. Sells, *The Paradise of Travellers: The Italian Influence on Englishmen in the Seventeenth Century* (1964); Heinrich Wölfflin, *The Art of the Italian Renaissance: A Handbook for Students and Travellers* (Eng. trans. 1963).

IVORIES

Objects for ritual, domestic and decorative use have been made of bone since prehistoric times, since bone is readily available in large quantities, is sufficiently hard to make even needles, is white or creamy-white, and takes detail well. Ivory, from the tusks of the elephant, has the same qualities together with the cachet of being a luxury item, traded at high cost from as early as the second millennium BC, and avidly used by Persians as well as > Greeks.

Because of the cost and quality of ivory, as well as the restricted dimensions of tusks, it has been used for small works, especially statuettes, jewel or cosmetic caskets and tablets of various kinds. During the Middle Ages, it was especially popular for statuettes of the Virgin and Child and for portable > altars. > Islam, being closer to the areas of production and trade, captured part of the market, and caskets of ivory, sometimes with > classical > friezes of putti and/or vine scrolls, found a ready market in > mediaeval Southern Europe.

The ancient Greeks began the practice of using ivory in small plaques to 'plate' wooden furniture, the best-known Christian counterpart being the 'Chair of St Peter' in St Peter's, an ivory chair of the 9th century encased in a shrine by Bernini. It was also used for the late-antique Consular > Diptychs, two panels of ivory with scenes displaying the power of the Consul, which were sent throughout the Empire from the 5th century AD, and which much later were sometimes taken into church treasuries and even used for calendars.

Ivory-carving was at its height during the Middle Ages in East and West, with some influence from the former to the latter. It survived as a luxury item during the northern > Renaissance, especially in Germany.

● Robert P. Bergman, *The Salerno Ivories: Ars Sacra from Mediaeval Amalfi* (1980); Vinod P. Dwivedi, *Indian Ivories: A Survey of Indian Ivory and Bone Carvings from the Earliest to Modern Times* (1976); Adolf Goldschmidt, *Die Elfenbeinskulpturen aus der Zeit der karolingischen und saechsischen Kaisern*, VIII–XI *Jahrhundert*, 4 vols (1914–26).

J

JAPONISME or (French) JAPONAISERIE

A term used to describe the influence and > imitation of Japanese arts and crafts in the West following the opening up of that country in the 1850s. In the > decorative arts, its influence was similar – in kind if not in extent – to the > chinoiserie craze of the previous century. In painting and allied arts, Japanese systems of > design, well known in the West through imported > prints, offered artists of the later 19th century (Degas, Manet, Toulouse-Lautrec) a way of 'balancing' works through masses of > colour and a robust linearity, both of which were radically different from traditional 'renaissance' methods.

● Gabriel P. Weisberg, *Japonisme: An Annotated Bibliography* (1990); Siegfried Wichmann, *Japonisme: The Japanese Influence on Western Art since 1858* (1981).

JEWISH ART

Because the > Bible and, specifically, the Ten Commandments, forbids images, Jewish art from the Middle Ages onwards has consisted, with few exceptions, of aniconic, decorative motifs. In the ancient world, it swung pendulum-like between representation (> frescos at Dura Europos, 3rd century AD) and > iconoclasm, influenced by and influencing the Moslems. By the same token, synagogues are rarely lavishly decorated. Nevertheless, there are plenty of Jewish artists who work iconically (Soutine, Chagall, Modigliani, Epstein), as well as much Jewish > iconography in Christian art. However, the circumstances under which most Jews usually lived perhaps militated against the formation of > schools of art, to the extent that it is arguable whether there is in fact such an entity as 'Jewish art' – as opposed to art done by and for Jews – since the majority of their productions can easily be related to gentile practices of the same period and country.

● Cecil Roth, *Jewish Art: An Illustrated History* (1961).

JOURNALS AND PERIODICALS

An important element in the literature on art is the short study written for publication in journals and periodicals that appear at more or less regular intervals. They may be roughly divided into those which focus on issues of interest to the art trade and > connoisseurship, such as *Apollo* and *The Connoisseur*; those offering an orthodox

approach to > art history, for example *The Burlington Magazine* and the *Gazette des Beaux Arts*; those dealing with contemporary art, such as *Artscribe* and *Flash Art*; those offering newer approaches to art history, such as *October* and the *Oxford Art Journal*; those with a multidiscipline approach, such as *Word and Image* or *Representations*; and lastly, journals of professional associations, including *Art History* (the journal of the Association of Art Historians, UK); the *Bulletin de la Société de l'Histoire de l'Art Français*, and *Art Bulletin* (College Art Association, USA).

There are two main advantages to consulting journals. Firstly, they provide concise and focused information on a particular topic, and secondly, their articles tend to be written by historians who will only later publish the material in book form. Given the long lead time for books, this is a considerable advantage. Material in journals and periodicals is more difficult to access than that contained in > monographs, and an index such as > *Art Index* should be consulted.

● M. Pointon, *The History of Art: A Student's Handbook* (1980; 1989) esp. pp. 79–80.

JUGENDSTIL

The name derived from the periodical *Die Jugend*, founded in Munich in 1896, and refers to the German equivalent of > Art Nouveau, with which it is stylistically identical.

JUNK ART

A movement of the 1950s and 1960s that used industrial junk, urban debris and the detritus of the consumer society as the raw material for art. In both its examination of the accepted limits of > fine art practice and its use of junk it is related to Braque and Picasso's Synthetic > Cubist > collages and the > found objects of the > Dadaists and the > Arte Povera group. Thus the sculptor César assembled synthetic sculptures made from car bodies crushed in a hydraulic press into grotesque building blocks. *See* Assemblage.

● *César*, exhibition catalogue, Boymans van Beuningen Museum, Rotterdam (1976).

K

KAHNWEILER, DANIEL-HENRI

(1884–1976). German > art dealer, publisher and writer. Kahnweiler moved to Paris and opened a gallery in 1907 in which he promoted the work of the > Fauves and the > Cubists. He was Picasso's dealer and was painted by the artist during his Cubist period.

KANDINSKY, WASSILY

(1866–1944). Russian artist and writer on art, Kandinsky was in the forefront of the development of > abstraction. He was a leading member of the > Blaue Reiter group from 1911 and taught at the > Bauhaus from 1922 to 1933. His writings on art include *Concerning the Spiritual in Art* (1912). He was particularly interested in the expressive use of > colour and in the relationship between painting and music.

● K. C. Lindsay and P. Vergo (eds.), *Kandinsky: Complete Writings on Art* (1982).

KANO SCHOOL

A > school of Japanese painting from the 15th to the 19th centuries that enjoyed official approval. The > style typically exhibits a strong use of > colour and line and a marked tendency to decoration. Leading artists include Masanobu, Eitoku, Sansetsu and Tsunenobu.

KANT, IMMANUEL

(1724–1804). German philosopher whose *Critique of Judgement* (1970) is a landmark in the theory of > beauty and the foundation for many subsequent writings on > aesthetics. According to Kant beauty is not measurable by scientific methods, let alone the result of a complex set of rules, but can only be appreciated by the feelings, aesthetic pleasure – which he called 'disinterested satisfaction' – being a union of various kinds of opposites, including reason and imagination, the particular and the general. This anti-rational stance places him with the > Romantics, rather than the rationalists.

● Salin Kemal, *Kant and Fine Art: An Essay on Kant and the Philosophy of Fine Art and Culture* (1986); Michael Podro, *The Manifold Perception: Theories of Art from Kant to Hildebrand* (1972).

KELMSCOTT PRESS

Founded in 1890 by William > Morris, this private press was intended to re-create what Morris believed to be the inherent craftsmanship of pre-mechanized printing, to which end he designed his own typefaces in a pseudo- > Gothic manner (or mannerism?). An example is his 1896 edition of Chaucer, with illustrations by Burne-Jones. As with all his other ventures, the results proved to be too expensive for the ordinary people he sought to reach and inspire, but the press was influential for a host of private presses in England and abroad.

● Arthur R. Dufty, *Kelmscott: An Illustrated Guide* (1969); William S. Peterson, *The Kelmscott Press: A History of William Morris's Typographical Adventure* (1989).

KINETIC ART

'Kinetics' is the study of the relationship between moving bodies, and the term Kinetic Art is thus used to describe both three-dimensional mobiles and constructions that operate in a predetermined or random way, driven by motor or by natural energy such as wind, and > Op art paintings, which use optical illusions to cause the picture surface to appear to move. Examples of the former are the mobiles of Alexander Calder and the powered constructions of Jean Tinguely, while Victor Vasarely's geometric > abstractions exemplify the latter. Other artists who have experimented with Kinetic art include Marcel Duchamp and Pol Bury.

● S. Bann et al., *Four Essays on Kinetic Art* (1966); F. Popper, *Origins and Evolution of Kinetic Art* (1968); *Kinetics*, (exhibition catalogue, Arts Council of Great Britain (1970).

KITSCH

Apparently a word current in Munich in 1870, from *verkitschen*, 'to make money'. Kitsch is art without aesthetic value, designed to appeal to the lowest common denominator because couched in plebeian terms, and therefore likely to sell. Distinguishing it from 'good' art can be difficult since perhaps the matter rests upon the artist's intention and/or judgement, which brings up questions of > revivalism and high camp. A photograph of cabbage-patch dolls posed as in > Leonardo's *Last Supper* (yes, it does exist) is undoubtedly kitsch, as is the *Mona Lisa* on a teatowel. Kitsch follows > taste, and does not set it, so its products are always 'safe' (in their exploitation of accepted icons) and recognizable. High styles, when wrongly used, perhaps also constitute kitsch – but is a French château re-created in North America art or kitsch?

● Matei Calinescu, *Five Faces of Modernity: Modernism, Avant-garde, Decadence, Kitsch, Postmodernism* (1987); Aleska Celebonovic, *Peinture kitsch ou realisme bourgeois: l'art pompier dans le monde* (1974); Gillo Dorfles, *Kitsch: The World of Bad Taste* (1969).

KORE

(Greek: 'maiden'). A female marble statue, usually draped and walking, from the > Greek Archaic period. The name indicates the indecision amongst early scholars about whether the figure represents a human being or a goddess.

● Gisela M. Richter, *Korai: Archaic Greek Maidens. A Study of the Development of the Kore Type in Greek Sculpture* (1968).

KOUROS

(Greek 'young man'). A male > marble statue, usually naked and walking, from the > Greek Archaic period. The name indicates indecision about whether the figure represents a human being, a hero or a god.

KRATER

A type of large > Greek pot, usually of an inverted bell shape, used for mixing wine and water. Like other Greek vessels, it was often decorated with scenes of daily life or mythology. *See* black-figure vase painting; red-figure vase painting.

KRESS, SAMUEL H.

(1863–1955). American businessman who established the Samuel H. Kress Foundation in 1929 with very broad philanthropic aims. The foundation was active in the restoration of buildings in war-ravaged Europe following the Second World War, and Kress's own interests in > Renaissance art led to his large donation to the National Gallery of Art in Washington.

KUNSTHISTORISCHES MUSEUM

Opened as a public gallery in Vienna in 1781 – well before the > Louvre – its paintings, sculptures and > decorative arts were formed from > collections made since the 16th century by the Habsburgs, who ensured the prestige and collectability of the masters of the > Renaissance and > Baroque, especially Titian, Giorgione, Veronese and Rubens.

KUNSTKAMMER *See* Cabinet of curiosities.

L

LAND ART

A movement of the 1960s related to > Conceptual art and against the urban sophistication of > Minimalism. Land Art was an attempt to broaden the accepted boundaries of sculpture, making the environment not simply the context but the material for the work itself. Thus Robert Smithson constructed a 500-metre *Spiral Jetty* in the Great Salt Lake and Walter de Maria inscribed two white lines in the Nevada Desert in *Mile Long Drawing*.

LANDSCAPE PAINTING

Landscapes are present, often in very > stylized or > idealized forms, in the backgrounds of many paintings of the > Renaissance and earlier, although in China (> Chinese art) the > genre began much earlier. As a genre in its own right, worthy of a painter's attention, pure landscape painting in Europe cannot be traced back much earlier than the 16th century, specifically to Altdorfer's *Landscape with a Footbridge* (c.1520), which differed from its predecessors in having > nature as its only subject-matter. However, critical reaction was opposed to the genre until the end of the 19th century (> genres, hierarchy of). Although landscape was important for > pastoral painters such as Giorgione, the > narrative and > genre painting of Bruegel and the > fête galante reveries of Watteau, none of these may be said to embody the landscape tradition.

The development of landscape was an essentially northern phenomenon, dominated by Germany in the 16th, the Netherlands in the 17th and Britain in the 18th and early 19th centuries. The 19th century saw the movement away from > studio painting (often including > sketching direct from nature) to > *plein air* painting in the > Barbizon School. In the later 19th century the > Impressionists succeeded in winning acceptance for landscape as a genre worthy of critical attention. The ideal landscapes of Claude in the 17th century are properly speaking a variant on > history painting (known as historical or > ideal landscape), but both the > Picturesque movement of the later 18th century and > Romantic painting placed the representation of landscape at the centre of their philosophy. Within > Modernism, landscape has played a significant role from the formal analysis of Cézanne to the > Fauves, > Expressionism and > Surrealism.

● J. Barrell, *The Dark Side of the Landscape: The Rural Poor in English Painting, 1730–1840* (1980); J. Rewald, *The History of Impressionism* (1949); K. Clark, *Landscape into Art* (1949); M. Sullivan, *The Birth of Landscape Painting in China* (1962); W. Stechow, *Dutch Landscape Painting of the Seventeenth Century* (1966).

LAOCOÖN

A > marble statue group of the Trojan priest of Apollo and his two sons being crushed by snakes, as told in the Aeneid (II, 264–95). The group dates from the 1st century BC, and is the work of the Rhodian artists Agesandros, Polydoros and Athenodorus in the Hellenistic tradition (> Greek art). Found in the Golden House of Nero in 1506 and placed in the > Vatican Belvedere, the work was of crucial importance for Michelangelo (cf. his St Matthew) and a whole string of his contemporaries, and has remained one of the most famous antiquities to this day. Part of its interest derives from it being one of the works mentioned by Pliny, which gives it a pedigree of sorts.

The work has triggered many expositions, two of which are very important. In 1755, > Winckelmann wrote about the group in his Gedanken, seeing it as typical of Greek heroism and exemplifying the 'noble simplicity and calm grandeur' of Greek art – surely a prime example of wishful thinking. In 1766, > Lessing quite rightly contradicted Winckelmann in his Laokoon and used the group as the focus for his discussion of the permissible limits of painting and poetry.

• Margarete Bieber, Laocoön: the Influence of the Group since its Rediscovery (rev. and enlarged edn 1967).

LAY FIGURE

A jointed wooden model of the human figure, anything from tabletop to life-size, and much used from the Renaissance onwards. The figure can be made to adopt any pose. > History painters used them to work out the general disposition of a > composition without having to recourse to live models, while > portrait painters draped them in the costume desired by the subject, thus avoiding many tedious sittintgs.

LEBRUN, CHARLES

(1619–90). French painter and art theorist. He studied in Italy from 1642 to 1646, and was instrumental in founding the Académie Royale de Peinture et de Sculpture (> academies of art) in 1648. He was First Painter to the King from 1664, Inspector General of Louis XIV's collections (including the > Gobelins and furniture factories) from 1663, and Rector of the Academy from 1668. Because of his Academy lectures (including a famous one on the expression of the emotions), as well as his other positions in the art world of Louis XIV, it is not surprising that Lebrun was no less than the arbiter of > taste for the King's Grand Siècle. Far more than just a painter, he saw to palace decoration, furniture and taste in general, and stamped his own modified > Baroque > style on French art at the same time as his Academy taught students to follow a similar path.

• June Hargrove, The French Academy: Classicism and its Antagonists (1990).

LEONARDO DA VINCI

(1452–1519). Italian painter, sculptor, architect, naturalist and technologist, who appears here because of his diaries and notes on art. In sculpture, nothing survives that is definitely by his hand, but his > influence is broad; in > architecture, his designs for > ideal churches and his supposed help to Bramante in Milan paid dividends with Bramante's Roman works; in painting, his crystallization of various geometrical grouping schemes was built upon by Michelangelo and especially by Raphael; and his use of > chiaroscuro launched the whole technique, best exemplified by Andrea del Sarto and Correggio and much later by Caravaggio.

He believed in art as an intellectual discipline – that is, as far more than a mere > craft. Important themes in Leonardo's achievements, and all reflected and sometimes explained in his notes and drawings, are the status he accorded to technological invention (his gigantic horse for Milan; a new type of > fresco for his Battle of Anghiari in the Palazzo Vecchio, Florence); to close examination of the natural world (he was interested in > landscape painting, as well as in anatomy and dissection); and to writing copious illustrated notes. Perhaps he intended to formalize his diverse knowledge in one or more handbooks, but, as so often in his life, he never got round to it, always being distracted by something more urgent.

The unrigorous and, more importantly, unsystematic, even chaotic, nature of Leonardo's studies (he was never a scholar in the > Renaissance understanding of the term) is one of his charms, and it did not prevent his many manuscripts fertilizing the study of art theory, as seen in the Treatise on Painting put together after his death.

● Martin Kemp, Leonardo da Vinci: The Marvellous Works of Nature and Man (1981); Leonardo: The Madrid Codices (1974); Martin Kemp (ed.), Leonardo on Painting: An Anthology of Writings, with a Selection of Documents Relating to his Career as an Artist (1989); Carlo Pedretti, Leonardo: A Study in Chronology and Style (1973).

LESSING, GOTTHOLD EPHRAIM

(1729–81). German dramatist and aesthetician, his distinguished literary criticism, especially in his celebrated essay, Laokoon (1766), challenged the dominance of French > Classicism and > Winckelmann's > idealism over German thought and championed a more subjective and expressive aesthetic that was to influence the proto- > Romantics of the later 18th century. His importance for the history of art lies primarily in his consideration in the Laocoön of the limits of poetry and painting (> ut pictura poesis) and of the nature of > imitation in art. According to Lessing, each art should employ the means proper to that art: painting will fail unless it addresses concerns proper to its form, rather than those suitable for other art forms, such as poetry. This way of thinking freed painting from too great a reliance on literature and allowed it to seek justification on its own terms and not those of an art form alien to it.

● G. E. Lessing, Laokoon, ed. W. A. Steel (1930; 1959); David E. Wellbery, Lessing's 'Laokoon': Semiotics and Aesthetics in the Age of Reason (1984).

LEXICON ICONOGRAPHICUM MYTHOLOGIAE CLASSICAE

(LIMC). A profusely illustrated and referenced dictionary of > classical mythology, with texts in English, French, Italian and German, written by teams of international scholars and published in Zurich (Artemis/Verlag) in parts since 1981.

LIBERAL ARTS

A > Greek tradition (crystallized by the 2nd century BC) that considered a particular group of subjects suitable for citizens to study, usually grammar, rhetoric, logic, geometry, arithmetic, astronomy and music. Martianus Capella (5th century AD) separated the first three from the last four and these became the trivium and quadrivium of > mediaeval university courses. In mediaeval and > Renaissance art, the liberal arts were represented by women holding their respective attributes. Painting, sculpture and > architecture were not included, because they were considered practical rather than cerebral, and were therefore accorded a lower station. Artists during the Renaissance (cf. > Leonardo's *Treatise on Painting*, for example) worked against this tradition, carefully elevating painting, sculpture and architecture to the status of work of the mind, equal to the liberal arts, and fit, therefore, to be taught in > academies rather than > guilds.

● Paul Abelson, *The Seven Liberal Arts: A Study in Mediaeval Culture* (1965).

LIBER STUDIORUM

A book of original > landscape > etchings (with much > mezzotint), begun by J. M. W. Turner in 1807 (date of the prospectus for the book), the idea directly inspired by Earlom's > engraved version (1777) of Claude's > *Liber Veritatis*. One hundred plates were projected, 70 were published, and a further 20 partly prepared.

● Alexander Finberg, J. M. W. *Turner's 'Liber Studiorum': With a Catalogue Raisonné* (1988); Gerald Wilkinson, *Turner on Landscape: the 'Liber Studiorum'* (1982).

LIBERTY STYLE

Another name for > Art Nouveau, which in Italy was called Stile Liberty – an indication of how the London department store's stylistic decisions could influence fashions abroad.

● Liberty & Co., *The Liberty Style* (1979).

LIBER VERITATIS

A book of > sketches after his own paintings kept by Claude Lorrain when he discovered that his paintings were so popular they were being > imitated and > forged.

Now in the >British Museum, it is thus an indication of the Europe-wide popularity of the mixture of >Classical and >pastoral >styles he promoted.

● Michael Kitson, *Claude Lorrain, 'Liber Veritatis'* (1978).

LIFE DRAWING

The practice of drawing from a live model, most often posed >nude, was current in antiquity, then fell into disuse, to be revived as a dogma by the >academies, for whom it became a cornerstone in the artist's education and the principal skill required for the depiction of figures in dramatic action in >history painting. In academic thinking, however, the model provided no more than a reference and was never to be copied slavishly, but rather idealized by the artist through reference to the >antique.

● G. Eisler, *From Naked to Nude: Life Drawing in the 20th Century* (1977); *Strictly Academic: Life Drawing in the 19th Century*, exhibition catalogue, State University NY, Binghampton (1974).

LIMITED EDITION

A term used to indicate that the number of copies made of a book or >print is limited by any of several factors, the most common being the desire to lavish special attention on the product, and by so doing to increase the product's value in the eyes of the market-place. 'Limited-edition mania' is analagous to 'first-edition mania' and can be just as pointless.

LIMNER

The >mediaeval name for a manuscript >illuminator, and an archaic term for a painter. It was later used to describe English >portrait >miniaturists such as Nicholas Hilliard, who wrote a treatise entitled *The Arte of Limning*. In colonial North America limner refers to self-trained, often unknown, portrait painters.

LINEAR PERSPECTIVE *See* >Perspective.

LINE ENGRAVING *See* >Engraving.

LINE vs. COLOUR *See* >Poussinistes vs. Rubenistes.

LINOCUT

A block-printing technique, similar to a > woodcut, developed at the beginning of the 20th century. A piece of thick linoleum is glued to a wooden block, carved in > relief and then inked and printed. While it has found popularity in art education and with amateur printmakers due to the relative ease with which the block is worked, it has also been used to effect by artists such as > Matisse and Picasso to produce broadly conceived, bold > designs.

LINSEED OIL

A flax-seed oil, which, when mixed with > turpentine, is the most common > medium in > oil painting.

LITHOGRAPHY

'Drawing on stone' was discovered by Aloys Senefelder in 1798, and he took out exclusive privileges for the process in Bavaria in 1799. The image is drawn with a waxy > crayon on a flat stone, and the process (which is planographic, in contradistinction to > relief or > intaglio printing) relies on the ink being attracted and adhering to the lines thus drawn and avoiding the non-drawn areas. Heavy pressure is not required to transfer the image to the paper, and the fine-grained stone can be scraped and used time and again. Lithography provides a method much closer to actual > drawing than > etching, so has naturally attracted artists as an 'art' > medium in its own right. Single-ink is the easiest, but colour printing is also possible, as is the imitation of a > watercolour wash, so the process can also be used for reproductive work.

Its popularity, which continues today, is due not only to artists such as Goya and Géricault, but also to the great popularizers such as Daumier, with his political and social > cartoons, and Toulouse-Lautrec, with his multicoloured > posters.

● Beatrice Farwell, *The Charged Image: French Lithographic Caricature*, 1816–1848, exhibition, Santa Barbara, California (1989); Beatrice Farwell, *French Popular Lithographic Imagery, 1815–1870* (1981); Domenico Porzio, *Lithography: Two Hundred Years of Art, History and Technique* (1983).

LOCAL COLOUR

The actual > colour of an object in neutral light, as opposed to the value it imparts when affected by a juxtaposed > complementary colour, atmospheric conditions or the use of a particular form of representation, such as the > academic > palette or > Impressionism.

LONDON GROUP *See* Camden Town Group.

LOST-WAX CASTING

The French term is *cire-perdue*. A technique employed in the Mediterranean since at least Archaic > Greek times, and long before that by the > Chinese. Casting can be a > copying process, often used to transfer a work in one > medium into another. Although it is possible to take a mould of an existing > bronze, which has the advantage of not damaging the > original, there is the disadvantage that the surface > modelling cannot fully be reproduced. Lost-wax casting entails making the sculpture in wax, supported by some central core or armature. The wax makes very fine modelling possible, faithfully taking every hint of the artist's hand. The finished work is bundled up in a fine plaster package, suitably adorned with vent-holes, and heated. The wax escapes, leaving a negative impression on the plaster. Molten bronze is then poured in to take the place of the wax and faithfully adopt all its surface features. The technique is, as it were, a mirror image of moulding. The quality is excellent, but the original wax model is perforce destroyed in the process.

● Christine Fox, *Asante Brass Casting: Lost-Wax Casting of Gold Weights, Ritual Vessels and Sculptures, with Handmade Equipment* (1988); Axel Michaels, *The Making of a Statue: Lost-Wax Casting in Nepal* (1988).

LOUVRE

Situated in Paris. Named after the adjacent zoo in which the French kings kept breeding wolves, the Louvre was built as a fortress in *c.*1190, was remodelled (several times) into a palace, and eventually became a museum, first opened to the public as the French national > collection in 1793. It contains the art collections of the monarchs of France begun by Francis I in the 16th century, and it housed the material plundered by Napoleon during his rape of Europe and > Egypt. It extended its collections through private gifts and, from the 19th century, through the sponsoring of > archaeological digs – just like the > British Museum. Its architectural history is complex, but an important landmark is Bernini's trip to Paris in 1665, when he made arrogantly Italian designs for the east façade, as an antidote to which Claude Perrault and colleagues designed an alternative classical façade (begun 1667), thereby confirming not only French nationalism and a degree of insouciance to (foreign) > Baroque, but also French architectural > Classicism as well, echoes of which are all over the country, but most conspicuously in the 18th-century palaces fronting the Place de la Concorde.

● Christine Aulanier, *Histoire du Palais et du Musée du Louvre*, 11 vols (1947–68); Yveline Cantarel-Besson, *La naissance du musée du Louvre: la politique muséologique sous la Révolution d'après les archives des musées nationaux* (1981); Cecil Gould, *Trophy of Conquest: The Musée Napoleon and the Creation of the Louvre* (1965).

LYRICAL ABSTRACTION. *See* > Tachisme.

M

MACCHIAIOLI

(From the Italian *macchia*, meaning 'speck' or 'patch'). A group of Italian painters of the 1850s who broke away from > academic art and were interested in > naturalism and a concomitant freer handling of > paint. The group has obvious parallels with the > Barbizon School and > Impressionism; two of its leading members were Boldini and Fattori.

MACHINE AESTHETIC

A term describing the 20th-century love affair with the efficiency and gloss of machinery, which concentrated on the representation of speed, mechanical efficiency through streamlining, and of reproducibility. This heady mixture was hymned by > Futurism, but is best seen in > architecture and interior design, surviving into our day in the high-tech > style of the > Pompidou Centre.

● Reyner Banham, *Theory and Design in the First Machine Age* (1962); Richard Cork, *Vorticism and Abstract Art in the First Machine Age* (1976); Edwin M. Fry, *Art in a Machine Age: A Critique of Contemporary Life through the Medium of Architecture* (1969); Nikolaus Pevsner, *The Sources of Modern Architecture and Design* (1968).

MAESTÀ

(Italian: 'majesty'). A painted representation of the Virgin and Child seated in majesty and surrounded by saints and > angels. It was especially popular in the 13th and 14th centuries. Duccio's *Maestà* (completed 1311) in the museum of Siena Cathedral is an example.

● Marina Warner, *Alone of All Her Sex: The Myth and the Cult of the Virgin Mary* (1976).

MAGIC REALISM

A term current from the 1920s to describe paintings executed in a highly > realistic manner but in which the subject-matter, as in > Surrealism, disrupts a > naturalistic reading.

MAHLSTICK (MAULSTICK)

A stick, padded at one end (for resting on the > canvas), against which the painter can steady his or her brush hand. First known in the 16th century, and used when painting in > oils.

MÂLE, ÉMILE

(1862–1954). French art historian principally concerned with religious > iconography from the 12th century to the > Reformation and after. Influential also as Professor of the History of Art at the Sorbonne (from 1912) and as Director of the École Française in Rome (1923–37).

● Émile Mâle, L'*art religieux de la fin du seizième siècle, du dix-septième siècle et du XVIIIe siècle: étude sur l'iconographie après le Concile de Trente, Italie, France, Espagne, Flandres* (2nd edn 1951); Émile Mâle, *The Gothic Image: Religious Art in France of the Thirteenth Century* (1972).

MANDER, KAREL VAN

(1548–1606). Netherlandish painter and writer on art, he founded the Haarlem > Academy with Hendrick Goltzius and Cornelius van Haarlem, and gave in Het *Schilder Boeck* (The Book of Painters) both a theory of art and artistic biographies in the manner of > Vasari and Pliny.

● Walter S. Melion, *Shaping the Netherlandish Canon: Karel van Mander's 'Schilder Boeck'* (1991); Karel van Mander, *Dutch and Flemish Painters* (trans. of Het *Schilder Boeck*) (1969).

MANDORLA

(Italian: 'almond'). An almond-shaped area of heavenly light used in religious art to frame the resurrected Christ or the Virgin Mary (unlike the halo, which surrounds the head only).

● George Ferguson, *Signs and Symbols in Christian Art* (1961).

MANNER

From the Italian *maniera*, as popularized by > Vasari, meaning 'style' or 'stylishness'. It has two uses: firstly, to indicate any > style, for all > artists must have at least one, without comment as to its nature; and secondly, to draw attention to 'mannerisms', such as the exaggeration of certain characteristics, or affectation – that is super-structural additions and ornamentations rather than elements essential to the telling of the story. See > Mannerism for a fuller discussion of the implications.

MANNERISM

With a capital 'M', the term designates generally the art of the post-High
> Renaissance period of the 16th century (*c.*1520–1600), and specifically productions in
a particular > style. Whether this phenomenon was a logical continuation of
> Classicism or a reaction against it depends on one's point of view. From *maniera*, the
Italian for 'style' or 'stylishness', the term usually means art in which lavish attention is
paid to stylization, that is to the superficialities of appearance rather than to the
profundities of meaning.

A Mannerist work will be anti- > naturalistic (elongated figures, strange > colours),
intricate in > composition, in love with exotic postures and > perspective, and
frequently have a heightened, mystical and insistent emotional temperature – stylishness
taken to extremes, and often depicting fantastic and bizarre subjects. Its crossword-like
complexity and cleverness made it suitable as > court art across Europe, whilst its
frequent > imitation and exaggeration of High Renaissance themes and > forms made it
easily recognizable. It shrivelled before the exuberant naturalism of the late 16th
century, as seen in the > Bolognese School and Caravaggio, and the straightforward-
ness of the > Baroque.

With a small 'm', 'mannerism' or 'mannered' refers to the deliberate exaggeration of
any aspect of art: the flaunting of stylishness for its own sake, rather than the use of
style as a vehicle for meaning. As such, any art can be mannered, and the term usually
implies a mechanical aping of someone else's stylistic characteristics without necessarily
understanding the reasons behind them.

● Walter Friedlaender, *Mannerism and Anti-Mannerism in Italian Painting* (1957); John K.
Shearman, *Mannerism* (1973); Richard Studing, *Mannerism in Art, Literature and Music: A
Bibliography* (1979); Georg Weise, II *Manierismo: bilancio critico del problema stilistico e culturale*
(1971).

MAQUETTE

A small model, most often done in clay or wax, made by a sculptor to test out a
> composition. It is analogous to the > sketch in painting.

MARBLE

Metamorphosed limestone, marble occurs in many varieties, some single colour, others
striated. Characteristics can include large or small crystals; no apparent 'grain'; opacity,
translucency and luminosity in varying degrees; the ability to take a polish that
'deepens' the surface effect, to stand slicing into thin veneers or excavating into large
blocks, and, very importantly, the ability to withstand ordinary atmospheric conditions
(but not the products of combustion: > destruction of art works) and retain its surface
detailing.

Marble has been prized since the second millennium BC for small-scale sculpture,
then increasingly for larger pieces. Since Hellenistic (> Greek art) times the colour
ranges and luminosity of the stone have made it a luxury furnishing material for floors,

walls and columns and thus an indication of quality and luxury, so much so that in centuries when quarries were closed (for example, much of the Middle Ages), make-and-mend and reuse of existing veneers, sarcophagi, etc. was rife. In Greek and > Roman times, it was not unusual to find entire buildings (and their associated sculptures) made out of marble, the Parthenon being a prime example. Not all countries have marble (the UK has none), but fine marbles are to be found in Italy, Greece, Asia Minor and North Africa, although having a suitable local marble has not prevented other kinds from being imported: whilst the > Classical Greeks were content with nearby supplies, the Romans had a vigorous import trade, especially with North Africa and Asia Minor.

The characteristics of marble have made it the primary material for sculpture from antiquity through to the > Renaissance and into the 19th century. If it cannot usually mimic flesh tones, it can approximate to the luminosity and 'depth' of skin, especially when tinted. The different colours available allow multicolour statues to be pieced together: white marble for the head and other flesh parts, with perhaps grey and black for the clothes. Few other materials possess the same beauty, which can be revealed through detailing and polishing, and the possibility of quarrying very large blocks adds scale to the list of its attributes.

● Raniero Gnoli, *Marmora Romana* (1971); Luciana Mannoni, *Marble: The History of a Culture* (1985); *Marble: art-historical and Scientific Perspectives on Ancient Sculpture*, J. Paul Getty Museum (1990); Leonard R. Rogers, *Sculpture* (1969); Rudolf Wittkower, *Sculpture: Processes and Principles* (1977).

MARBURGER INDEX

An inventory of art in Germany. The listing has been acquired by over 250 libraries and institutes since 1976, and now consists of over one million photographs available on microfiche. The project uses the > ICONCLASS method of categorization, and to the computerization of the text data is currently being added that of the images themselves. *See* Database; Computer art and graphics.

● Lutz Heusinger, *Marburger Index: Inventory of Art in Germany: Users' Manual* (2nd edn 1985).

MARINE PAINTING

One of the earliest of all frescos (from Akrotiri, Santorini, second millennium BC) probably represents a naval battle, and sea scenes are common all around the Mediterranean, and naturally so, given that the sea was a highway as well as a battleground. During the Middle Ages and the > Renaissance, most of the important battles (Lepanto was an exception) were fought on land, and marine painting came to the fore only with the rising hegemony of the Low Countries and Britain over the control of Atlantic and Eastern trade, when it could provide a visible exultation of a country's political power and commercial glory. Curiously, neither the Portuguese nor the Spanish, who between them had the world carved up in the 16th century, showed much interest in the genre. Marine painting also went hand in hand with the representation of

landscape, being part of the non- > academic representation of the outside world that flourished in the North (but not in the South).

● Denys Brook-Hart, *British Nineteenth-Century Marine Painting* (1974); George S. Keyes, *Mirror of Empire: Dutch Marine Art of the Seventeenth Century* (1990).

MAROUFLAGE

A term for gluing a > canvas on to a panel or a wall, or for strengthening it by lining it with another stiff backing canvas.

MARX, KARL

(1818–83). German political philosopher and revolutionary, founder of the > Marxist tradition of social science, best described as 'historical materialism'. His views in the cultural sphere are contained in the idea that expressions of > culture are governed by social relations determined by the mechanisms of production. While his approach has been criticized by Karl Popper as > historicist, his work is likely to remain important for those art historians who believe art is best understood as an expression of the society that created it.

● Perry Anderson, *In the Tracks of Historical Materialism* (1984); Nelson Cary and Lawrence Grossberg (eds.), *Marxism and the Interpretation of Culture* (1988); Nicos Hadjinicolaou, *Art History and Class Struggle* (Eng. trans. 1978).

MARXIST ART HISTORY

Marx's central belief in his theory of history, otherwise known as 'historical materialism', is most clearly expressed in his preface to *A Contribution to a Critique of Political Economy* (1859). This states: 'The mode of production in material life determines the general character of the social, political and spiritual processes of life.' Marx's > methodology has been adopted by many historians of many political persuasions, and has been applied in many ways, not all of them compatible. However, most subscribe, at least to some degree, to the metaphor of an economic base onto which is built a superstructure (the realm of cultural production). The question of the degree to which the base influences the superstructure has created most of the disputes within Marxism. Prominent Marxist critics and historians include Frederick > Antal, Arnold Hauser, Meyer Shapiro, John > Berger and T. J. Clark, although there are many more who employ at least elements of Marxism in their work. To a large extent the 'social history of art' is synonymous with Marxist art history.

● Hilton Kramer, 'T. J. Clark and the Marxist Critique of Modern Painting', *The New Criterion* (March 1985), pp. 1–8; D. McLellan, *Karl Marx: His Life and Thought* (1973); Griselda Pollock, 'Vision, Voice and Power: Feminist Art History and Marxism', *Block*, 6 (1982), pp. 2–20; A. Rifkin, 'Marx's Clarkism', *Art History* (Dec. 1985), pp. 488–95; Allan

Wallach, 'Marxism and Art History' in *The Left Academy*, ed. B. Ollmann and E. Vernoff, vol. 2 (1984), pp. 25–53.

MASTER OF . . .

> Art history works better when we know which artist executed a particular work, but this is only possible when it is signed, or when some other documentary evidence (contracts, contemporary biographies) is available. This leaves large numbers of anonymous art works that are grouped together as being by the same hand on stylistic grounds, or because they exhibit other similar characteristics. These will then be > 'attributed' to a Master, and named after the title of a famous work allotted to him (Master of St Cecilia), or after his supposed birthplace (Master of Flémalle).

● M. H. van Dantzig, *Pictology. An Analytical Method for Attribution and Evaluation of Pictures* (1973).

MASTERPIECE

Historically, a masterpiece was the work a craftsman presented to a > guild in order to achieve the position of master. It was therefore a practical examination of competence. The practice was adopted by most > academies, such as the English > Royal Academy and the French Académie Royale de Peinture et de Sculpture, and has resulted in > collections of considerable interest. Today the term is loosely applied to indicate works of great importance, or to the best work of an individual > artist.

● Walter Cahn, *Masterpieces: Chapters on the History of an Idea* (1979); A. Fontaine, *Les Collections de l'Académie Royale de Peinture et de Sculpture* (1930).

MATISSE, HENRI

(1869–1954). French > Modernist painter. Matisse championed > Abstraction from the early years of the 20th century, first in his work in the > Fauve movement and later in his highly decorative > compositions. He wrote little on art but encapsulated much of his thinking in 'Notes of a Painter', published in *La Grande Revue* (1908), and in an introduction to a guide to the Chapel of the Rosary at Vence, which he had decorated (1951).

● R. Benjamin, *Matisse's 'Notes of a Painter': Criticism, Theory and Context, 1891–1908* (1987).

MAURITSHUIS

The Dutch royal > collections, opened to the public in 1820 in The Hague in a palace built for Prince John Maurice of Nassau – hence the name. Unsurprisingly, it houses the best collection of 17th-century Dutch art, including works by Vermeer and Rembrandt.

MEANING IN ART

The consideration of the meaning of an art work requires appraisal not only of the subject-matter but also of the material properties intrinsic to the work, such as line, > colour, material and technique, as well as less concrete qualities such as the intention of the > artist, the historical context of the work and not least the way it is interpreted by the > beholder. The way in which each of these properties is appraised, and the relative values attached to them, will alter the perceived 'meaning' in each case. For example, a social > art historian may well stress the economic, social or political context, while emphasis on the subject-matter will concern the > iconographer, and > form a > formalist art historian such as > Wölfflin. Recently attacks on the idea that it is possible to reconstruct what an artist or society 'intended' by an art work (> auteur theory) has turned attention to the role of the beholder in the construction of meaning, an approach known as > reception aesthetics.

MEDALS

Conventionally, a > coin of substantial size that has some commemorative function and is not intended as currency. We know that Augustus had medals produced and distributed amongst his friends, and many large pieces have survived from the Roman Empire which appear to be medals, although we lack exact knowledge of how they were used. Here, as in so many other areas, the > Renaissance aped > Roman antiquity and took to striking medals on a large scale, usually for prestige, for commemorative purposes, or to distribute as keepsakes. The medals of Pisanello are best known. Often, medals provide vital information otherwise unavailable: Matteo dei Pasti's foundation medal for the Tempio Malatestiano at Rimini shows the building with the (unbuilt) dome, while Caradossa's foundation medal for St Peter's probably shows it as Bramante intended it to be.

Highly centralized institutions have taken particularly enthusiastically to issuing medals. It would be foolish to study the papacy's attitudes to art without studying the large numbers of medals they have issued; and Louis XIV founded the Académie des Inscriptions et Belles Lettres partly to look after the striking of suitable medals. They are still struck today to commemorate special events such as the Olympic Games, as parts of scientific and literary prizes, or for artistic competitions.

● Joseph Addison, *Dialogues upon the Usefulness of Ancient Medals* (1726; 1976); George F. Hill, *A Corpus of Italian Medals of the Renaissance before Cellini* (reprinted 1984); John Kent, *Two Thousand Years of British Coins and Medals* (1978).

MEDIAEVAL ART

The art and > architecture of the period – the 'middle age' – between the fall of the Roman Empire and the rise of the Italian > Renaissance. As such, the term is colourless and imprecise, since the Roman Empire continued after the transfer of the capital to Constantinople in AD 313 (the conventional beginning of > Byzantine art), and the

Renaissance was brewing long before the famous competition for the Baptistery doors to Florence Cathedral in 1401.

● Robert G. Calkins, *Monuments of Medieval Art* (1979); Caecilia Davis-Weyer, *Early Medieval Art, 300–1150: Sources and Documents* (1986); Georges Duby, *History of Medieval Art, 980–1440*, (rev. edn 1986); Ernst Kitzinger, *The Art of Byzantium and the Medieval West: Selected Studies* (1976); Walter F. Oakeshott, *Classical Influence in Medieval Art* (1959); George Zarnecki, *Art of the Medieval World: Architecture, Sculpture, Painting, the Sacred Arts* (1975).

MEDICI

Florentine banking family, the de facto arbiters of Florentine politics in much of the 15th century, and subsequently Dukes of Florence and (from 1569) of Tuscany. Important for their > connoisseurship and > collecting and their > patronage of > artists and > architects, little of > Renaissance Florence is unconnected with them. For example, **Cosimo** (1389–1464) built the Palazzo Medici-Riccardi, **Piero** (1416–69) commissioned Benozzo Gozzoli's > frescos for the chapel there, **Lorenzo** (called 'the Magnificent', 1449–92) was the first patron of Michelangelo, and **Lorenzo di Pierfrancesco** (1463–1503) was the principal patron of Botticelli. **Giovanni** (1475–1521) ascended the papal throne (1514) as Leo X, and **Giulio** (1478–1534) as Clement VII, events that extended Medici prestige and commissioning power to the Rome of the High Renaissance and its aftermath.

● Janet Cox-Rearick, *Dynasty and Destiny in Medici Art* (1984); *The Twilight of the Medici: Late Baroque Art in Florence, 1670–1743*, exhibition catalogue, Detroit Institute of Arts (1974); Edward L. Goldberg, *After Vasari: History, Art and Patronage in Late Medici Florence* (1988).

MEDIUM

In its widest sense the medium is the form selected by the > artist for a given work, such as painting or sculpture. It also refers to the material used, such as > oil paint. A more technical designation refers to the solution added to the > paint to enhance its properties, which in the case of oil paint would be a mixture of damar, stand oil or > turpentine.

MEMENTO MORI

(Latin: 'remember you must die'). In art any representation of mortality, such as a skull or a grave. They are most often present in > still-life and religious painting. A celebrated example is the skull shown in > anamorphic projection in Holbein's *The Ambassadors* (1533).

MÉRIMÉE, PROSPER

(1803–70). French author and senator, and Inspector of Historical Monuments from 1831. In this capacity he was influential in the restoration and preservation of the French patrimony. See Viollet-le-Duc.

● Elizabeth Morel, Prosper Mérimée: l'amour des pierres (1988).

MERZ

A > collage or > relief of randomly collected junk associated with the > Dada artist Kurt Schwitters, who invented this meaningless word by chance when making a collage (it was the result of cutting the letters 'merz' out of a newspaper clipping of the word 'Commerzbank'). It was also the title of a Dada magazine Schwitters edited from 1923 to 1932.

METAPHYSICAL PAINTING

(In Italian Pittura Metafisica). A > style of painting centred on the Italian artist Giorgio de Chirico in which both subject-matter and representation are characterized by a sense of unreality, for example enigmatic figures fleeing across urban environments constructed in illogical > perspective, as in de Chirico's The Melancholy and Mystery of the Street (1914). Other practitioners of the > genre include Carlo Carrà.

● M. Carrà, Metaphysical Art (Eng. trans. 1971).

METHODOLOGY

The recognition that the study of > art history is not a value-free, 'transparent' activity unencumbered by ideological expectations or intellectual implications has grown with an interest in the application of approaches such as > formalism, > iconography, > Marxist art history and > semiology to the discipline. More recently, methodology has transcended this role to examine the aims of the discipline itself – whether, for example, art history is a > humanistic discipline or a social science. It has recently become fashionable to demonstrate familiarity with a variety of art > theories that purportedly clarify the methodological issues in play but in some cases seem only to obfuscate the object of study under a tide of rhetorical analysis.

● N. Kampen, Feminism and Methodology: Dynamics of Change in the History of Art and Architecture (1983).

METROPOLITAN MUSEUM OF ART

New York. Founded in 1870, the Met built up its enormous > collections from some prestigious private collections (for example those of Cesnola, Pierpoint Morgan,

Rockefeller). It opened its present HQ on Central Park in 1880, and in 1938 opened the Cloisters (for > mediaeval art and > architecture) in Fort Tryon Park.

● Leo Lerman, *The Museum: One Hundred Years and the Metropolitan Museum of Art* (1969); Calvin Tomkins, *Merchants and Masterpieces: The Story of the Metropolitan Museum of Art* (rev. edn 1989).

MEZZOTINT

Most > print techniques (such as > engraving and > etching) use lines to delineate objects and for shading. Mezzotint ('half-tone') deals in light and shade more satisfactorily. Using a toothed tool called a 'rocker', the entire copper plate is covered by a mesh of fine dots, or 'burr', which if inked would print a rich black. The design is produced by scraping away the burr, so that a half-scraped area will print greyish, and a completely polished area dazzling white. The technique, invented in the mid-17th century, was particularly popular in the 18th century (as in reproductions of the > portraits of > Reynolds and Gainsborough, or the horse portraits of Charles Townley Stubbs) because of its great tonal range and rich, velvety blacks. It is no use for long runs, because the burr soon fails and the rich blacks with it.

● Carol Wax, *The Mezzotint: History and Technique* (1990).

MICROFICHE

A postcard-sized piece of film carrying a large number of miniaturized images, which may be read using a magnifying reader or even printed out on to paper. In > art history, the technology is an answer to the high costs of shorts runs of very specialized books (put a fiche with miniatures of illustrations in a pocket in the back instead), and also for national surveys of art works that accumulate very large quantities of images, for example the > Marburger Index. It is the result of the need to keep up-to-date library catalogues, since computer-generated fiches are obviously more convenient than printing the material in volumes. The fiche is also useful for republishing rare books or collections of > exhibition > catalogues, two examples of which are listed below. A fiche is foolproof, long-lasting, and needs only simple technology to read, but it will probably die in terms of art history now that the > videodisk and > digital imaging can do the same jobs better and are also random-access. In libraries, too, on-line computer-based catalogues, often networked, are becoming the rule.

● Amongst the works published on microfiche are: *Futurism: Art Exhibition Catalogues on Microfiche* (1982); *Medieval Art: Art Exhibition Catalogues on Microfiche* (1975).

MIMESIS *See* Imitation.

MINIATURE

From the Latin *minium*, the red lead used to emphasize capital letters in > illuminated manuscripts, the word in its strict meaning has nothing to do with size, but in the 17th century was confused with 'minute'. Originally the term described paintings or > drawings, usually in handwritten books, and generally illustrating the accompanying story. Popular during the Middle Ages, especially for prayer-books, > Books of Hours and > bibles, the > genre declined somewhat with the introduction of the printing-press, but survived as small-scale paintings (nowadays known as miniatures, but then called > limnings) from the > Renaissance onwards, for example in the wistful locket portraits of young men and women in the Elizabethan period in England.

● John Murdoch et al., *The English Miniature* (1981); Roy C. Strong, *The English Renaissance Miniature* (1983).

MINIMALISM

A movement that rose to prominence in the 1960s, partly as a reaction against the > gestural painting of the > Abstract Expressionists. More common in sculpture than painting, Minimalism employed elemental geometric shapes that operated with what Richard Wollheim called in a 1965 article a 'minimal art content'. For Wollheim, Duchamp's > ready-mades provide an example of this 'minimalism' in that they introduce into the domain of art an increasingly wide and > eclectic category of objects that cannot be easily differentiated from objects in the non-art world.

Minimalism in the 1960s eschewed representation and narrative in favour of representing, in the first instance, itself. Thus the 'primary structures' of Donald Judd or Carl Andre, who often employed foundry-produced steel cubes or commercially made house bricks, offer the > beholder little information about their purpose beyond the fact of their industrial origin. Unlike the autograph techniques of the Abstract Expressionists, Minimalist artists embraced the impersonality of industrial production as the vehicle of their expression. In painting Minimalism is characterized by rejection of gestural painting and an emphasis on either > Hard Edge > abstraction, as with Frank Stella and the Ellsworth Kelly, or un > painterly qualities, as in Morris Louis's understated stained > canvases.

The apparent simplicity of Minimalist art hides the complexity of its intellectual structure. While the work may exhibit a 'minimal art content', it challenges the beholder to experience a layered and complex aesthetic response based on each individual's expectations and prejudices. In this way an art work with minimal content demands of the beholder a maximal response, and perhaps for this reason Minimalism is often seen, at least in popular opinion, as a difficult and intractable movement best discussed within the narrow confines of the art world.

● *Three American Painters: Kenneth Noland, Jules Olitski, Frank Stella*, exhibition catalogue, Fogg Art Museum, Cambridge, Mass. (1965); G. Battcock (ed.) *Minimal Art: A Critical Anthology* (1968); *Don Judd*, exhibition catalogue, Whitney Museum of Art (1968); D. Waldman, *Ellsworth Kelly: Drawings, Collages, Prints* (1971); *Morris Louis*, exhibition catalogue, Tate Gallery, London (1974); *Carl Andre: Sculpture*, exhibition catalogue, Whitechapel Art Gallery, London (1978).

MISERICORD

The seats in > mediaeval and later church choir stalls were usually hinged, with a ledge, known as a misericord, on the lower side so that when the seats were raised the monks might stand up and still have something to lean on during the long services. The underside of the ledge provided a popular area for small-scale sculpture, both religious and secular, sometimes serious but often amusing or whimsical.

● Dorothy Kraus, *The Hidden World of Misericords* (1976); G. L. Remnant, A *Catalogue of Misericords in Great Britain* (1969).

MOBILE *See* Kinetic art.

MODEL *See* Life drawing.

MODELLING

Although sometimes used as a painting term, it mainly refers to the building up of a sculpture from a suitable material such as wax or > clay. Modelling is an additive process, often requiring a caressing use of the hands rather than just a spatula to coax the material into the required conformation; it is to be contrasted with carving, which is a subtractive process using chisels or rasps to cut away > marble or stone. However, carvers (for example Bernini and Michelangelo) used small-scale models to work out their preliminary ideas for full-size works that would later be carved. These might be transferred to full size by the use of a > pointing machine.

MODERNISM

Unlike the term 'modern art', which simply refers to art of the period *c*.1850 to 1970, Modernism is a critical approach that stresses innovation over all other criteria. Modernism is characterized by the imperative to seek new solutions to pictorial problems and, consequently, by its rejection of the examples of the past. Among the first to alert > artists to the need to participate in an art for the present (as opposed to an art based on > imitating the > styles of past art: > historicism) was > Baudelaire in his essay 'The Painter of Modern Life' (1863), in which he called for an art that would take account of the transformation of 19th-century society. The ways in which modern life can affect art are diverse and to some extent confusing, but in the 19th century include the influences of science, > symbolism, > primitivism and > photography, and in the 20th, war, psychoanalysis (> Freud) and political ideologies.

Mid-20th-century theories of Modernism were inextricably bound up with the development of > abstraction. > Formalist critics such as Clement > Greenberg privileged this development by isolating qualities such as the lack of implied depth of the picture space and attention to painting procedure as the hallmarks of Modernism. These qualities, it was argued, were the fundamental concerns of painting, and could be

identified with progressively more certainty from Manet onwards. The teleological argument – using characteristics of Manet's paintings to 'explain' Modernism in his work – resulted in a self-defining line of descent through Cézanne, the > Cubists to > Constructivism, which shifted from description to prescription in the phase of 'High' Modernism, in > Abstract Expressionism, > Pop art and > Minimalism.

More recently, the advent of > Post-Modernism has allowed Modernism to be placed in a historical context. It may now be seen as an 'oppositional art' (Jameson) that subverted traditional ways of seeing. Post-Modernism's acceptance (or at least interaction with) past values has removed this oppositional element, which, along with the formalist notion that the art work should be accepted on its own terms, was a hallmark of Modernism.

● C. Baudelaire, 'The Painter of Modern Life', *The Painter of Modern Life and Other Essays*, trans. J. Mayne (1964); F. Jameson, 'Post-Modernism and the Consumer Society' in *Post Modern Culture*, ed. H. Foster (1985); F. Frascina (ed.), *Pollock and After* (1985); F. Frascina, 'Modernist Studies: The Class of '84', *Art History*, 8, no. 4 (1985) pp. 515–30.

MONOGRAM

A device consisting of the letters of a name, or some other construction, used by > artists (amongst others, including monarchs) to identify themselves, usually as a substitute for a signature. Albrecht Dürer's initials meant that the 'D' within a larger 'A' followed by the date indicated both the artist and 'Anno Domini'. Whistler used a butterfly, Lucas Cranach his initials with a dragon. A monogram – 'IHS' – is frequently used to identify Christ.

● H. H. Caplan, *The Classified Directory of Artists' Signatures, Symbols and Monograms* (1976); Malcolm Haslam, *Marks and Monograms of the Modern Movement 1875–1930* (1977).

MONOGRAPH

The *Shorter Oxford English Dictionary* defines a monograph as a 'treatise on a single object or class of objects'. In art history this means a study concentrating on one > artist, art work or group of art works. However, the 'monograph approach' most often means the biographical study of an individual artist, and this has been the dominant form since the 19th century, for example in C. Justi's *Velásquez and His Times* (1889) and E. Müntz's *Raphael, His Life, Works and Times* (1896) or Anthony > Blunt's *The Paintings of Nicolas Poussin* (1966–7). Monographs have been instrumental in the construction of the > methodology of > art history that aims to relate the life and, in the more ambitious studies, social situation or psychological (> Freud) state of the artist to his or her > œuvre.

This whole approach to art history has been challenged on the grounds that the study of an artist is not the same thing as the study of art, and that understanding the life and times of an artist is only one, and perhaps not the best, way of studying his or her work. This view has been given credence through the work of the French critical theorists Michel Foucault and Roland Barthes, who in their discussions of the > auteur

theory, have argued that the study of individuals perpetuates a romantic notion of > genius that militates against a fuller understanding of the art work(s).

More recently still, the monograph has enjoyed a revival among both > revisionist and > feminist historians who see it as the vehicle for the presentation of hitherto neglected information about their subjects. G. M. Ackermann's *The Life and Work of Jean-Léon Gérôme* (1986) or C. Stuckey's *Berthe Morisot: Impressionist* (1987) are good examples of the 'new' monographs. In both cases there is the intent to rehabilitate their subjects which echoes, at four centuries remove, the biographies written by > Vasari.

● R. Barthes, 'The Death of the Author', in *Image-Music-Text* (1977); M. Foucault, 'What is an Author?', in *Language, Counter-Memory, Practice: Selected Essays and Interviews* (1977); N. Hadjinicolaou, *Art History and Class Struggle*, trans. L. Asmal (1978) pp. 35–40; M. Pointon, *History of Art: A Students' Handbook* (1980) pp. 71–3; D. E. Pease, 'Author', in *Critical Terms for Literary Study*, ed. F. Lentricchia and T. McLaughlin (1990).

MONOTYPE

A > printmaking method whereby the reverse impression of an > oil painting painted on glass is transferred to paper using hand pressure. Monotypes can also be taken from > lithographic and > etching plates. Strictly speaking, only one impression is possible, as the name indicates.

● Phyllis Plous (ed.), *Collaborations in Monotype*, exhibition, University of California, Santa Barbara (1988).

MONTAGE

(French: 'mounting'.) A term to describe the reworking into a new art work of fragments of newspapers, magazines or other illustrated material chosen for their > iconographic significance. The > Surrealist Max Ernst was a leading practitioner of the technique.

MORBIDEZZA

The delicate rendering of flesh tones in a painting.

MORELLI, GIOVANNI

(1816–91). Italian critic who concentrated on the problems of > attributing works and believed that the ways in which artists treated details such as eyes, ears and fingers were as good as a signature, so that by grouping similar treatments an artist's > *œuvre* – if not name – could be assembled. There is no way of demonstrating Morelli's scheme to be either true or false, but it forms part of the attempted 'scientification' of > art history away from the 'eye' of the > connoisseur towards objectively verifiable criteria.

● Carol Gibson-Wood, *Studies in the Theory of Connoisseurship from Vasari to Morelli* (1988); Carlo Ginsburg, 'Morelli, Freud and Sherlock Holmes: Clues and Scientific Method', *History Workshop*, 9 (1980), pp. 5–36.

MORRIS, WILLIAM

(1834–96). Although a student of both > architecture and painting, Morris is particularly important for the contribution he made to the revitalization of the > decorative arts, through Morris, Marshall, Faulkner & Co, which he founded in 1861, and of typography and book illustration through the > Kelmscott Press, started in 1890. Morris's intention was not simply to produce wallpaper, tapestries, > stained glass, furniture, carpets and, later, books, but by so doing to demonstrate how standards could be improved by products being hand- rather than machine-made. In his antipathy to the trends inaugurated by the > Industrial Revolution, and in the strong influence (partly from the example of Rossetti) of the Middle Ages on his work, not only on his wallpaper designs but also on the black-letter typeface and claustrophobic foliage he developed for his books, Morris looked backwards rather than forwards – unlike the > Bauhaus, for example, which embraced industrial developments and techniques.

● Charles Harvey, *William Morris: Design and Enterprise in Victorian England* (1991); Nikolaus Pevsner, *Pioneers of the Modern Movement, From William Morris to Walter Gropius* (1936); Edward P. Thompson, *William Morris: Romantic to Revolutionary* (2nd edn 1977).

MOSAIC

Pictures for floors, walls or vaults made by arranging pieces ('tesserae') of > terracotta, glass, > marble, stone or pebbles, and occasionally silver. The technique goes back to the third millennium BC. The Hellenistic > Greeks made pebble mosaics, but the > Romans were the first to use the technique extensively – see almost any Roman villa – and to develop a healthy import/export trade in mosaics, many of which would perhaps have been made in factories and laid in sections. Mosaic is the main > 'painterly' > medium of late antiquity and the Middle Ages, especially in > Byzantium, and preserves for us precious information about lost > panel paintings, as well as about > iconographic traditions. In the West, the use of mosaic in a religious context depended largely on the importation of fashions from Byzantium (most conspicuously at S. Marco, Venice) or on > Early Christian models (S. Prassede, Rome). Charlemagne (> Carolingian art) appears to have been quite conscious that mosaics were part of the very stuff of empire; unfortunately, those in his chapel at Aachen have been lost.

Using glass tesserae, sometimes 'sandwiched' with gold, the technique was ideal for images of religious awe, being essentially non- > realistic – see representations of the Creator in the half-domes of church apses (Cefalu and Monreale). Never able to be laid absolutely level, the tesserae glitter and flash as one moves about a building, some of which (for example the Palatine Chapel, Palermo) are extensively covered. Following the effects of > iconoclasm and then the Muslims in Constantinople, Ravenna is the site with the largest surviving acreage of > mediaeval mosaics, being for a time the western capital of the Roman Empire.

As well as figured mosaics, floor, wall, transenna and pulpit decorations in marble were (following the example of the Roman West) of continuing popularity in churches during the Middle Ages, often using recut >antique veneers, some of precious marbles such as *verde antico* or *giallo antico*. Mosaics of pseudo-secular subjects may have been common, for instance the splendid whole-floor mosaic in Otranto, which indicates the geographical horizons of the world of the Crusades.

Mosaic largely died out with the >Renaissance, when >fresco was preferred, but it was employed by Ghirlandaio (for the façade of Florence Cathedral) and Raphael (in the Chigi Chapel, Sta Maria del Popolo, Rome). Examples exist from subsequent centuries, and its anti-naturalistic appearance has made it once more popular in the 20th century.

● Bernard Andreae, *Das Alexandermosaik aus Pompeji* (1977); Peter Fischer, *Mosaic: History and Technique* (1971); Grazio Gianfreda, *Mosaico di Otranto: civilta senza frontiere* (1974).

MULTIPLES

While >prints and casts of sculpture are multiples in one sense, here the term describes an >artefact produced in unlimited numbers without necessary recourse to an artist's prototype. >Pop art's interest in consumerism made the idea of repetition a key concept in the work of Andy Warhol, who often did little other than oversee the production of his silkscreen prints. Thus a multiple is the opposite of the >limited-edition >fine art print, where the limited number of examples helps to boost their value. The true multiple is analogous to a consumer article – an industrially produced fashion accessory, disposable, freely available and antagonistic to the notion of 'fine' art.

MURAL *See* Fresco.

MUSE

Goddesses (the daughters of Zeus and Mnemosyne, or Memory) considered by the ancients to preside over and personify, often with attributes, music, literature and the >liberal arts. None was attributed to the visual arts because of their low status during antiquity, but the Muses themselves are a frequent subject in painting, often seen inspiring their subjects: Clio for history, Euterpe for music, and so on.

MUSÉE D'ORSAY

An ex-railway station by the Seine in Paris, opened in 1986 to house art of the late 19th century (*c*.1848–*c*.1905) following further systematization of the >Louvre. The reuse of the station is novel, even courageous, the architecture interesting, the acoustics resounding.

MUSÉE IMAGINAIRE

André Malraux (1901–76; Minister of Culture 1960–9) wrote *Le musée imaginaire de la sculpture mondiale* in three volumes (1952–4), and *Les Voix du silence* (1951). The main thrust of his argument was that art transcends history, and should not remain in thrall to the deterministic theories of > Marx or > Freud.

● Pascal Sabourin, *La réflexion sur l'art d'André Malraux: origines et evolution* (1972).

MUSEOLOGY

The study of museums and the way they > display their > collections. In the sense that museums have always drawn comment and criticism, museology has existed as long as there have been museums, but more recently > curators and commentators have begun to question assumptions (which might have seemed timeless but were in fact a product of the early 19th century) about the way a museum should be organized. While few would question the necessity of balancing the needs of > conservation with those of display, the traditional 'transparent' approach that assumes a museum is essentially a 'white space' designed to provide an unobtrusive setting for the art works has been challenged, not least by those advocating a more robust > revisionist approach that offers alternatives as varied as breaking with orthodoxy of hanging paintings 'on the line' (in a row at eye-level) to grouping works according to criteria other than > artist or > genre. Even more radical proposals include a 'living museum' approach in order to recreate a past era. However, it is difficult to imagine any conservator agreeing to hang valuable paintings in a recreation of a Dutch 17th-century auction or > varnishing day of the > Royal Academy > exhibition.

● B. O'Doherty, *Inside the White Cube: The Ideology of the Gallery Space* (1986); Ian Finlay, *Priceless Heritage: The Future of Museums* (1977); P. Vergo, *The New Museology* (1989).

MUSEUM OF MODERN ART

New York. Founded in 1929, MOMA houses the greatest collection of work from the modern (post-*c.*1850) period in the world. Its unparalleled holdings were the result of founding bequests by Lillie P. Bliss and other American collectors, and have been extensively augumented by private benefactors. It has a brilliant history of scholarship through publications such as *Cubism and Modern Art* (1936), written by the museum's first director, A. H. > Barr Jr., whose construction of > Modernism has had a profound influence on 20th-century attitudes to art.

MUSEUMS AND GALLERIES

In the ancient world, the 'home of the muses' was often a series of gifts made to a temple, or even a collection of booty made by a victorious general. The great houses of Rome were adorned with art works, but these remained 'private', and are thus a branch

of >collecting, although many of them offered a distinctly political message, if only that of the conquering power of their owners.

The first museums and galleries of the modern world were also private ones, and the public museums and galleries we know today, such as the >British Museum, grew out of great private collections. Perhaps the best distinction between collections and galleries is provided by the avowed aim of the latter to raise the level of public education, rather than to appeal to a few devotees. The development of the museum is therefore intimately connected with that of the >academy, which it could often serve, as well as with increasing levels of general education. Not surprisingly, the growth of democracy has proved a catalyst: the first steps towards extensive public collections were provided by the transfer of royal and aristocratic collections to the state during the French Revolution, when art was viewed as a tool for improving >taste, although plunder also played its part.

No sooner were museums constructed, often on the ruins of private collections, than the thoughtful began asking whether they offered value. In the early 19th century, during the first flush of enthusiasm for public (and often national) museums, Quatremère de Quincy said that museums were the death of art; Alphonse de Lamartine called them graveyards of the arts; and Constable worried that >imitating their contents would distract students from the real business of imitating >Nature herself. The sentiment survives to this day: 'Each living art object, taken out of its native habitat so we can conveniently gaze at it, is like an animal in a zoo. Something about it has died in the removal' (Daniel J. Boorstin, 1962). What has gone is the context, which is why so many galleries offer 'art in context' >exhibitions, which seek to reconstruct the setting (as well as the mind-set, political and social context, etc) that gave the work life. Context is not necessarily a problem with much 19th- and 20th-century art, which has often been expressly made for hanging in a gallery rather than in a private collection.

It is an irony that those great private houses on which modern museums used to be modelled have melted like the snows, and the institutions that once aped them are now so frequently criticized for being unable to offer their contents a suitable context.

● Walter Grasskamp, *Museumsgrunder und Museumsturmer: zur Sozialgeschichte des Kunstmuseums* (1981); Eileen Hooper-Greenhill, *Museum and Gallery Education* (1991); Daniel J. Sherman, *Worthy Monuments: Art Museums and the Politics of Culture in Nineteenth-Century France* (1989); Alma S. Wittlin, *Museums: In Search of a Usable Future* (1970).

MYCENAEAN ART

The art of the late Bronze Age in Greece (>Greek art), from *c.*1580 BC to *c.*1100 BC, when influences from >Egyptian, Syrian, Cycladic and Minoan art and >architecture helped the development of a truly Hellenic manner, as seen in pottery and precious metals, >frescos and >ivories, the majority discovered as grave goods by Heinrich Schliemann and his successors. Mycenaean art was a >court art in dangerous times, and several prestigious and fortified palaces (notably Mycenae and Tiryns) survive, together with some truly spectacular vaulted 'beehive' tombs. The 12th century saw its collapse (reflected in the Trojan Wars, and in Homer), and then the Dark Ages of Greece, before a revival during the >Archaic period.

• Reynold A. Higgins, *Minoan and Mycenaean Art* (rev. edn 1981); Gisela Walberg, *Tradition and Innovation: Essays in Minoan Art* (1986).

MYTHOLOGICAL PAINTING

A term describing paintings whose subject-matter is > Classical mythology, usually treated in an elevated and ennobling way. It was particularly important during the > Renaissance, when emphasis was placed on > imitation of both the > form and subject-matter of the works of Classical antiquity, which by the 16th century rivalled the > Bible as the repository of appropriate themes for the > history painter, although not all the subjects portrayed in the resulting works, or indeed the models imitated, may be considered as morally edifying. From the 16th century, mythological painting may be seen as an element of history painting, the pre-eminent > genre of the > academies, and until the downfall of history painting early in the 19th century, it was an accepted part of the > academic artist's repertoire. It was revived on occasion, often in a spirit of parody, by > Modernists such as Picasso.

• M. Jacobs, *Mythological Painting* (1979); C.B. Bailey, *The Loves of the Gods: Mythological from Watteau to David*, exhibition catalogue (1992).

N

NABIS

A group of young French painters influenced by the > Symbolist aesthetic, who exhibited together under the name of 'Nabis' (from the Hebrew word meaning 'prophets'). The group was formed by Paul Sérusier, who met Gauguin in 1888 while still a student in the Académie Julian. Sérusier executed a small painting in Pont-Aven in Brittany under Gauguin's guidance, which he called *The Talisman*. Back in Paris its strong flat areas of > colour impressed his fellow students Pierre Bonnard, Édouard Vuillard and Maurice Denis, who adopted it as a model. They believed painting should cease to > imitate > nature but instead be an expression of the > artist's subjective feelings. The group exhibited together from 1892 to 1899. Their bold use of colour and expressive use of line influenced artists such as Toulouse-Lautrec, and had considerable influence on the decorative aspects of > Art Nouveau.

● *The Nabis and their Circle*, exhibition catalogue, Minneapolis Institute of Arts (1962); C. Chassé, *The Nabis and their Period* (1969).

NAÏVE ART

Not to be confused with > folk art, > primitive art or > Art Brut, naïve art is the work of > artists without formal training (> art education and training) who exhibit a lack of concern with such conventions of representation as scientific > perspective or consistent use of > chiaroscuro. Naïve artists, such as Henri Rousseau (France), Grandma Moses (USA) and Alfred Wallis (UK), favour strong colours and literal > drawing to express an intensely personal interest in narrative. Not all naïve work is by untrained artists. L. S. Lowry in his industrial > landscapes, and the Die > Brücke group used the freedom enjoyed by the naïve artist to infuse their work with a directness of vision and a 'common-sense' focus on narrative.

NARRATIVE PAINTING

A form of 19th-century > Salon painting in which narrative played the key role. To represent their sentimental and novella-ish themes, narrative painters invariably employed a window-onto-the-world structure (as if the > beholder were seated in a theatre), with the accent on legibility, > academic handling of > paint and an attention to circumstantial detail. Narrative painting is the antithesis of the > Modernist interest in surface > abstraction, which draws attention to the processes of painting. Leading

exponents of the > genre include Paul Delaroche, Sir Edwin Landseer, Sir David Wilkie and Paul Baudry.

● S. Bann, *The Clothing of Clio: A Study in the Representation of History in Nineteenth-Century Britain and France* (1984); P. Duro, 'Marat, Charlotte Corday and the Assassination of History', *Australian Journal of Art*, VIII (1989/90).

NATIONAL ACADEMY OF DESIGN

New York. An > academy founded in 1826 under the presidency of S. F. B. Morse. Initially it offered a progressive alternative to the conservative American Academy of Fine Arts, but by the end of the 19th century it had itself become reactionary and today is known for its traditional values.

NATIONALE, SALON DE LA *See* Salons.

NATIONAL GALLERY

London. Supported by members of the > Royal Academy, the British Institution for the Promotion of the > Fine Arts was formed in 1803. Sir George Beaumont offered his > collection to the country in 1828 after the pictures of John Julius Angerstein were purchased and both collections opened to the public in Pall Mall. The present building (weak > Neoclassicism by William Wilkins) opened in 1838, and a yearly purchasing grant was made available from 1855. The Sainsbury Wing, designed by Robert Venturi, opened in 1991.

● *National Gallery, Director's Choice: Selected Acquisitions 1973–1986*, 1986, > exhibition to mark the retirement of Sir Michael Levey as Director of the > National Gallery (1986); '*Noble and patriotic': the Beaumont gift, 1828*, exhibition, National Gallery, London (1988).

NATURALISM

In art, the term describes the attempt to > imitate the appearance of the everyday world without the intervention of preconceived ideas or conventions. While much recent thinking has shown this 'innocent-eye' approach to be itself conventionalized and open to the play of the imagination or the intellect, naturalism has formed part of the occidental way of seeing since the > Renaissance, witness > Alberti's opening remarks in his treatise of painting, *Della Pittura* (1436), where he asserts it is the > artist's business to > copy > nature.

This idea became central to naturalism, and by the 17th century was commonplace if not universally accepted. Naturalism is not, however, incompatible with notions of > idealism: > academic theorists argued that the most naturalistic art had been produced by the artists of ancient Greece (> Greek art; > Classicism and the Classical tradition) who had been close to 'true' nature by being anatomically correct and

showing the limitless potential of the human spirit. By the 19th century, however, naturalism had taken on its current meaning of referring to art that is both > representational, and associated, by analogy, with the empirical procedures of science. Thus naturalism refers to the rendering of appearances through minute observation of the natural world, as in the work of the > Impressionists.

● Max Dvorak, *Idealism and Naturalism in Gothic Art* (Eng. trans. 1967); E. H. Gombrich, *Art and Illusion* (1960); Johan Huizinga, *The Waning of the Middle Ages: A Study of the Forms of Life, Thought and Art in France and the Netherlands in the Fourteenth and Fifteenth Centuries* (Eng. trans. 1924); J. Ruda, *Filippo Lippi Studies: Naturalism, Style and Iconography in Early Renaissance Art* (1982).

NATURE

Along with 'realistic', one of the most difficult terms for art historians, since its art-inclined meaning differs radically from its everyday use, being much more specific. By 'nature' we tend today to mean birds and flowers, mountains and streams, and we sometimes consider that representing this (beautiful) external world is 'representing nature', and therefore a true aim of the > artist. Theoreticians and artists since ancient Greece have had other ideas.

As an 18th-century > Royal Academy lecture had it, nature means 'the general and permanent principles of visible objects, not disfigured by accident or distempered by disease, not modified by fashion or local habits. Nature is a collective idea, and, though its essence exists in each individual of the species, can never in its perfection inhabit a single object.' In other words, the 'nature' we see around us, in our friends or the birds or mountains, is, for the theorists, essentially flawed – although Alexander Pope believed that 'All nature is but art, unknown to thee' – and the task of the artist is to use knowledge and skill to distil true nature from what he or she observes. This requires both selection and combination – as shown in the well-known story of the Greek painter Zeuxis (active in the latter 5th century BC), who needed a host of beautiful girls from Croton to help construct his picture of Helen of Troy. Clearly, choosing just one girl (with all her faults, as it were) would not serve to construct nature, which is an idea, not an observable reality.

From this special meaning of 'nature' the interest of artists and teachers in the > antique becomes clear: ancient art had followed this refining process and produced works difficult to surpass (although the modern side in the > quarrel of the ancients and moderns thought differently) so the way to learn to do the same would be to > imitate them. What may now appear bald > copying was simply considered the easiest way to train an artist to imitate nature itself (> art education and training). In the 18th and 19th centuries, as interest in the antique and in this specific concept of nature declined, so did interest in a more general application rise to prominence, especially in those countries weak in the antique tradition but with strong naturalistic (> naturalism) and > landscape traditions to continue, such as England and the Low Countries.

As in so many aspects of 18th-century art, the > Industrial Revolution was crucial in altering attitudes both to the landscape itself and to ways of representing it in art. Thus

the cult of nature as a desire to recreate a wilderness in the tamed environment of a garden or > park became a feature of a society that knew less of nature the more it lived in cities. In the same fashion, this kind of 'nature' is the opposite of > civilization. It was also an important element in the > Romantic notion of the > pathetic fallacy.

● Alasdair Clayre (ed.), *Nature and Industrialization* (1977); John House, *Monet: Nature into Art* (1986); Edward W. Taylor, *Nature and Art in Renaissance Literature* (1964); Carl Woodring, *Nature into Art: Cultural Transformations in Nineteenth-Century Britain* (1989).

NAZARENES

The Lukasbrüder, or Brotherhood of St Luke, formed in Vienna in 1809, were known derisively as the Nazarenes because of their adoption of biblical dress and hairstyles. This group of young Austrian and German idealists wished to revive the Christian mission of art. In emulation of the spiritual values and working conditions of the Middle Ages, which they regarded as their model, they revived the social and professional practices of the > guilds. In 1810 they moved to Rome the better to revive the moribund but authentically pre-> Renaissance practice of > fresco, and succeeded in obtaining commissions, thereby bringing the group international recognition. Stylistically their > compositions exhibit the linearity and elementary colour schemes of the > quattrocento, and they shared many aims with the later English > Pre-Raphaelite Brotherhood. The leading members of the group were Cornelius, Overbeck and Pforr.

● K. Andrews, *The Nazarenes: A Brotherhood of German Painters in Rome* (1964).

NEOCLASSICISM

A movement of the late 18th century and early 19th century, when European art, reacting against the frivolity of the > Rococo, turned once again to antiquity for high-flown subject-matters expressed in a chaste and restrained > style – 'logically sound, emotionally pure, and morally improving', as the art historian Hugh Honour has put it in his contribution to *Age of Neoclassicism*. Discoveries at > Pompeii and Herculaneum helped urge artists and scholars back to the > antique, but this was only part of the story, for those same discoveries were perfectly capable of a 'Rococo' interpretation. More important were earlier > revivals of interest in the antique, especially those of the > Renaissance and 17th-century French > Classicism. Poussin (1594–1665) in particular espoused a similar programme, so that the Classicism of both David and Ingres is essentially part of a continuing French tradition.

'Neo' means 'new', but 18th-century Neoclassicism is more correctly yet another classicism, although more austere than earlier ones, at least partly because newly fashionable > Etruscan vases gave licence to an extreme simplification of > style. The quest for simplicity, and even for > primitivism, was partly a result of the > Grand Tour, which included pre-Classical Greek temples, and partly a > historicist desire to generate a new and yet still antique art that threw over the > naturalism and three-dimensionality of Renaissance forms in favour of a 'clean slate' – a *tabula rasa*. Elements of this are visible in the later style of David, who was partly influenced by > Flaxman.

● *The Age of Neoclassicism*, exhibition catalogue, Royal Academy and Victoria and Albert Museum, London (1972); Hugh Honour, *Neoclassicism* (1968); Ann M. Hope, *The Theory and Practice of Neoclassicism in English Painting: The Origins, Development and Decline of an Ideal* (1988); David Irwin, *English Neoclassical Art: Studies in Inspiration and Taste* (1966); Robert Rosenblum, *The International Style of 1800: A Study in Linear Abstraction* (1976); Damie Stillman, *English Neoclassical Architecture* (1988).

NEO-DADA

A term coined in the late 1950s to describe the work of the proto- > Pop artists Jasper Johns and Robert Rauschenberg. The term refers to these artists' > Dada-like use of non-art motifs and materials, including > found objects such as the paint-splattered bedcovers and quilt of Rauschenberg's *Bed* (1955). Neo-Dada anticipated Pop art's interest in popular icons, as in Johns's *Three Flags* (1958), which depicts three superimposed Stars and Stripes.

NEO-EXPRESSIONISM

A label first used in the early 1980s to describe the work of narrative-based > Expressionist painters working principally in Germany who reacted against the banalities of > Conceptualism and the impersonality of > Minimalism. Neo-Expressionism saw a return to the traditional concerns of > history painting, that is, the representation of narratives through the format of > easel painting. Anselm Kiefer, for example, treated his country's recent past in *To the Unknown Painter* (1983), a commentary on the tragedy of the Nazi period, while Georg Baselitz seems to comment on the human condition in figurative paintings in which people are represented upside down. Rejecting the purist concerns of High > Modernism, Neo-Expressionism contributed to the development of a new agenda in part (but only in part) represented by > Post-Modernism. Leading Neo-Expressionists include Francesco Clemente, Jörg Immendorf, A. R. Penck and Julian Schnabel.

● K. Honnef, *Contemporary Art* (1988).

NEO-IMPRESSIONISM

The name was coined by the critic Félix Fénéon in 1886 to describe the paintings of Georges Seurat and his followers. Neo-Impressionism was both a development and a revision of the subjective (impressionistic) paintings of Monet and Renoir. The movement originated in 1884, the year Seurat exhibited his first major painting, *Une Baignade* (1883–4) at the > avant-garde > Salon des Indépendants. That same year he met Paul Signac, who later became the publicist and theoretician of the movement. Despite attracting converts such as Pissarro, the movement did not survive the death of its gifted founder. When Seurat died in 1891 there was no > school to continue his ideas.

The importance of Neo-Impressionism lies in its attempts to consolidate the aims of

the >Impressionists while introducing a new scientific rigour into their interest in the representation of light. The theory behind Neo-Impressionism was based on an >eclectic selection of ideas from science and aesthetics, including M. E. Chevreuil's *De la loi du contraste simultané des couleurs* (1839), which offered an explanation of how the perception of one >colour may be affected by its juxtaposition with another, contrasting colour. The American O. N. Rood's *Modern Chromatics* (1879) and Charles Blanc's very influential *Grammaire des arts du dessin* (1867), in which he discussed the sophisticated but unscientific colour theories of >Delacroix, were likewise sources. The Neo-Impressionists were also influenced by the aesthetic theories of David Sutter, Professor of Aesthetics at the >École des Beaux-Arts, whose L'*Esthétique générale et appliquée* (1865) offered a bridge between scientific theory and the concerns of picture-making.

The fundamental principle of Neo-Impressionism was that two colours juxtaposed on the >canvas will mix optically to produce a tone brighter than one mixed on the >palette. This resulted in a technique known as 'divisionism', in which the application of small touches of pure colour offers the >beholder a brilliance, luminosity and harmony absent from conventional paintings. The term >'pointillism' is sometimes used to describe these small regular dots. However, not all Neo-Impressionist paintings, especially those of the early 1880s, exhibit such a regular application of >paint.

Neo-Impressionism may thus be seen as a manifestation of positivist philosophy's attempt to draw analogies between all aspects of human life and science. Some of Seurat's less convincing appropriations were the ideas of Charles Henry, whose article 'Introduction à une esthétique scientifique' in 1885 pretended to offer a scientific explanation for the way colour and line provoke emotions in the beholder. Henry even devised an 'aesthetic protractor' for measuring off the degree of emotion. However implausible these theories may sound, the formal and tonal arrangement of Seurat's *Le Chahut* (1889–90) owes much to Henry's ideas.

When deployed by Seurat, these techniques resulted in monumental >compositions that restored to >Modernist painting some of the rigour of the >Classical >ideal. However, in the hands of Seurat's followers – Signac, Cross, Luce and van Rysselberghe – the decorative aspects of Neo-Impressionism too easily overwhelmed Seurat's tension between surface and structure, focusing instead on the novelty of the technique in superficial, vaguely >symbolist paintings.

● P. Signac, D'*Eugène Delacroix au néo-impressionisme* (1899; 1978); J. Rewald, *Post-Impressionism: From van Gogh to Gauguin* (1962); J. House, 'Meaning in Seurat's Figure Paintings', *Art History*, 3, pp. 345–56 (1980); R. Thomson, *Seurat* (1985); A. Lee, 'Seurat and Science', *Art History*, 10, pp. 203–26.

NEO-PLASTICISM *See* Stijl, De.

NEOPLATONISM

The ideas of the >Greek philosopher Plato (*c*.428/7 – *c*.348/7 BC) were particularly important throughout Europe during the >Renaissance, mainly through the ideas of the Neoplatonic philosophers of the 3rd century BC, whose revival of Platonic thought

influenced Christian philosophy through St Augustine; and also through the 15th-century philosopher Marsilio Ficino, who translated the works of Plato into Latin and attempted to reconcile Platonic and Christian philosophy. As a result, a philosophy developed that had both the cachet of the Greeks and the approval of Christianity.

Plato taught that true reality is not in this world, but in the higher world of ideas and the spirit (> idealism). He believed human knowledge to be recollected from what the soul knows in heaven but forgets when in a mortal shell, presupposing, therefore, the immortality of the soul. He also believed that there are two kinds of beauty, the sensual and the spiritual, with the soul questing after the higher form by shuffling off the sensuality of this world in favour of the Idea, in which the virtues of both thought and action are encapsulated.

For the artist, then, Neoplatonism sanctified both the quest for beauty and the > imitation of the > antique (in which the Renaissance believed beauty chiefly resided), especially when beauty reaches towards Truth, for Beauty, Truth, and Virtue are all part of the Idea.

● Moshe Barasch, *Theories of Art: From Plato to Winckelmann* (1985); André Chastel, *Art et humanisme à Florence au temps de Laurent le magnifique: études sur la renaissance et l'humanisme platonicien* (1959); Konrad Eisenbichler et al. (eds.) *Ficino and Renaissance Neoplatonism* (1986); James Hankins, *Plato in the Italian Renaissance* (1990); Rupert C. Lodge, *Plato's Theory of Art* (1975); Iris Murdoch, *The Fire and the Sun: Why Plato Banished the Artists* (1978); Julius Moravcsik et al. (eds.), *Plato on Beauty, Wisdom and the Arts* (1982).

NEO-ROMANTICISM

A term current in the 1980s, never accepted by all its exponents and now little used, describing the expressive, figurative painting that reacted against > Conceptualism. An international movement, it overlaps with > Neo-Expressionism and the term is most often applied to painting produced in Germany, Italy, the United Kingdom and Spain in the 1980s.

NEUE KÜNSTLERVEREINIGUNG (NKV).

An association of artists founded in 1909 by > Kandinsky, Jawlensky and Munter in opposition to the > Jugendstil-dominated art world of Munich. The group held its first > exhibition in 1909 and a second, larger show in 1910, to which many of the French > avant-garde were invited.

NEUE SACHLICHKEIT

(New Objectivity). A German > social realist movement of the 1920s. The name was given to an > exhibition of > figurative art organized by the director of the Kunsthalle in Mannheim in 1923. The 1920s in Germany was a time of disillusionment after the hopes of the immediate postwar years, and the graphic representation of this in social satire

was a characteristic of the 'new objectivity', which focused on the foibles and corruption of contemporary society. The most notable exponents of this approach were George Grosz and Otto Dix, who continued the political commentary implicit in much of > Expressionism and > Dada. Their disgust at German military adventurism allied with capitalist corruption was articulated in violent expressionistic works of wilful ugliness portraying the victims of society, from the working class and prostitutes, to crippled war veterans, the old and the insane.

The movement ran directly counter to the ideal of a new Germany reflected in > academy-inspired art, and could not survive the rise to power of the Nazis. Dix had his work shown in the exhibition of > Degenerate art in 1937. Grosz emigrated to the USA in 1933.

● *Paris/Berlin: rapports et contrastes, France/Allemagne* 1900–1933, exhibition catalogue, Centre Georges Pompidou (1978); *Neue Sachlichkeit and German Realism of the Twenties*, exhibition catalogue, Arts Council (1978); J. Willett, *Art and Politics in the Weimar Republic: The New Sobriety 1917–1933* (1978); B. Schrader and J. Schebera, *The Golden Twenties: Art and Culture of the Weimar Republic* (1988).

NEW ART HISTORY

A term coined in the 1980s to describe the series of initiatives which challenge the more traditional > iconographic, > formalist and > connoisseurial approaches to the discipline as well as the 'social context' approach of > Marxist theories of art. A list of those most prominent in the New Art History would include Stephen Bann, Svetlana Alpers and Norman Bryson as well as those who have adopted a > feminist approach such as Marcia Pointon and Griselda Pollock.

● A. L. Rees and F. Borzzello, *The New Art History* (1986); N. Bryson, *Calligram: Essays in New Art History from France* (1988).

NEW ENGLISH ART CLUB (NEAC).

A club founded in 1886 as a progressive alternative to the > Royal Academy. Stylistically, its members practised a polite form of French > Naturalism, itself a bland reworking of > Impressionism. Principal members included John Singer Sargent, Sir George Clausen, Wilson Steer, Stanhope Forbes and Sir John Lavery. By the early 20th century the Club came to be seen as essentially conservative, and in 1911 the > Camden Town Group was formed to offer a new forum for avant-garde English art.

NEW REALISM

A vague term applied to, among other things, > Pop art at its inception. The principal use of the term describes those > figurative > artists working in opposition to > Abstract Expressionism such as Lucian Freud, Philip Pearlstein and Alice Neel.

NEW WAVE

(French: *nouvelle vague*). A term used initially to describe young French film-makers of the 1950s such as Jean-Luc Godard and François Truffaut. It has been applied, with little success and less precision, to > graffiti > artists and > Neo-Expressionist groups centred on New York in the 1980s.

NEW YORK SCHOOL *See* Abstract Expressionism.

NEO-OBJECTIVE Art. *See* Abstraction.

NORTH AMERICAN INDIAN ART

Even the briefest survey must emphasize the enormous cultural diversity of the art of the American native peoples, which stretches from the Eskimos of the Arctic to the Navajos of the South-West. The continent is usually divided into six broad, although cu'turally relatively discrete, regions: the Arctic, the West Coast, the North-West Coast, the South-West, the Great Plains and the East. The form a > culture takes is of course highly dependent on the materials available and the social structure and philosophy of each tribe or group. Thus the Eskimo principally carve > ivory, the tribes of the North-West such as the Chinook made totemic art, the South-Western Pueblo Indians ceramics, the Californian Gabrieleonño and Pono Indians pottery and basket-weaving, the tribes of the East wooden, copper and fabric > artefacts, and the nomadic tribes of the Great Plains, whose lifestyle demanded ease of transportation, decorated the hide of their tepees and pouches with highly stylized designs.

As with the art of > Aboriginal Australia, these once-ignored cultures, formerly of interest only to anthropologists, are now seen as eminently worthy of study, and their cultural production has been claimed as part of the heritage of all Americans.

● G. C. Valliant, *Indian Arts of North America* (1939); F. Douglas and R. d'Harnoncourt, *Indians Art of the United States* (1941).

NORWICH SCHOOL

The early 19th-century English > landscape > school, led by the > watercolourists John Crome and John Sell Cotman. In 1803 Crome founded the Norwich Society of Artists, which organized > exhibitions between 1805 and 1825. Influenced by the landscape traditions of the Netherlands, the school is a good example of English artists favouring the representation of > nature over Continental > history painting.

● H. Mallalieu, *The Norwich School: Crome, Cotman and their Followers* (1974).

NOVECENTO ITALIANO

An Italian 20th-century movement, founded in 1926 and disbanded in 1943. It sought to counter the contemporary > avant-garde by returning to Italian > naturalistic traditions. Gradually, this led to a stance imbued with Fascist ideals of nationalism not just in politics but also in artistic sources, and it tended naturally towards the same > Classical tradition espoused by Fascist artists.

NOVEMBERGRUPPE

A group of German > Expressionists and > Dadaists formed in Berlin in November 1918 with the aim of creating a dialogue between art and the people. Their left-wing ideas found expression in the > Bauhaus established by Gropius in Weimar in 1919 and in the > social realism of the > Neue Sachlichkeit.

● H. Kliemann, *Die Novembergruppe* (1969); J. Willett, *Art and Politics in the Weimar Republic: The New Sobriety 1917–1933* (1978).

NUDE

The human figure, either completely naked or draped, has been a central subject for art since 6th-century BC > Archaic Greece, forming a mainstay of > academies, and still retaining prestige today. In this Western tradition, the figure is generally treated as > ideal and even heroic, with perhaps understated parallels being made between > beauty of the body and purity of the mind. > Naturalism was encouraged, but > realism less so. If 'nude' implies beautiful and perhaps posed, 'naked' tends to mean simply undressed, and can be vulgar.

Only those societies that value the human figure in their art interest themselves in the nude. > Islam and Judaism (> Jewish art) do not, and neither did Persia or prehistoric societies (although perhaps the 'idols' from the Cyclades represented worshippers rather than gods and goddesses). African societies frequently represent naked humans, but without that element of idealism that attracts from us the epithet of nudity.

This can be explained by understanding how, to the Greeks who originated the genre, body and mind were a package. A veritable cult of the display of the young body in particular was seen in gymnasia and at sporting occasions. The Archaic institution of the > kouros usually showed the young man completely naked, although in korai (> kore) the girls were always dressed; as these figures have been found in a religious context, it seems that nudity was god-blessed as well. As a result, a large proportion of > Greek, Hellenistic and, in > imitation, > Roman statues are nude.

Nudity found little favour in the Middle Ages, being seen as a trigger for lasciviousness, so nudity in > mediaeval art was restricted to those occasions when it could not be avoided, such as medical illustrations, copies of > antique manuscript > illuminations, the creation of Adam and Eve, or the Entombment (the crucified Christ was always draped, if not fully clothed). The embargo was broken by artists such as Nicola Pisano, whose pulpit in the Pisa Baptistery (1260) includes a depiction of one of

the Christian virtues, namely Fortitude, imitated and transformed from a nude Hercules on a nearby Roman sarcophagus.

The > Renaissance, with its assimilation of > Classical ideas about the aims of art, featured nudity in a thoroughgoing fashion. Painted and sculpted nudes were common, for example Signorelli's figures in Orvieto Cathedral, or Donatello's > bronze *David*. In both instances the context is Christian but the sources pagan, as is the case with the most famous of them all, Michelangelo's *David*. Within the Renaissance tradition nudity was also seen as an essential stage in the preparation of a clothed figure: initially drawn nude to get the stance and movement correct, it was then clothed. Male apprentices would pose as required, even for female figures, for there is no hint of female models being available (and then rarely) until the > Baroque.

In the Middle Ages and Renaissance the scientific study of the body using corpses was frowned upon: > Leonardo dissected corpses, but perhaps not principally for artistic reasons. Actual dissection has, indeed, never been a desire of artists. Casts of Houdon's famous *écorché* figure (made in Rome in the early 1760s) served the purpose well, especially when conflated with the > academic regime of > drawing from the > antique, a practice, it was believed, that would teach students about > nature better than nature herself.

● Kenneth Clark, *The Nude: A Study of Ideal Art* (1956); Janet Hobhouse, *The Bride Stripped Bare: The Artist and the Nude in the Twentieth Century* (1988); Marcia Pointon, *Naked Authority: The Body in Western Painting, 1830–1908* (1991); G. Saunders, *The Nude: A New Perspective* (1989); Susan R. Suleiman (ed.), *The Female Body in Western Culture: Contemporary Perspectives* (1986).

O

OBJET TROUVÉ *See* Found object.

ŒUVRE

(French: 'work'). In art-historical parlance, the *œuvre* of an > artist refers to her or his output considered as a whole. To include a work in the *œuvre* of an artist is to accept it as an authentic (> attribution) example of that artist's output.

OIL PAINT

> Paint in which the > pigment is finely ground then mixed with a vegetable-oil > medium, such as > linseed, poppy or walnut. Its origins are unclear, but its rise to pre-eminence as the principal painting medium began in the 15th century with the Flemish artist Jan van Eyck, popularly but erroneously credited with its invention. Its advantages over other paints such as > tempera are decisive. It can render broad areas and minute detail with equal facility; it may be worked over, scraped off, rendered in thin > glazes or in > impasto; it may be blended > wet in wet, and > colours on the > palette will last longer than other paints; its colour is strong and relatively permanent, and when dry (which takes some months) the surface is durable.

There is no other paint so responsive or better able to communicate an > artist's expression. It encouraged the development of > easel painting, which in turn allowed artists to abandon working on location, as is necessary with > fresco; and its relative ease of application allowed > academic artists to cultivate art as an essentially noble employment, far from the building-site conditions of fresco painting or the workshop mentality of tempera. In the 19th century oil paint became transportable when the collapsible metal tube was invented, thereby facilitating the development of > *plein air* painting. In the 20th century it remains pre-eminent but is increasingly challenged by > acrylic paint.

OMEGA WORKSHOPS

Founded in London in 1913 by Roger > Fry with the aim, inspired by William > Morris, of improving the > decorative arts and encouraging > artists to develop a modern art that everyone could use. The war killed them, as did low prices, the anonymity they required of their artists, and a lack of business aptitude very different from the later > Bauhaus.

● Judy Collins, *The Omega Workshops* (1983).

OP ART

(Optical art). As its name suggests, Op art exploits, in a > abstract context, visual ambiguities to trick the eye into misreading the image. Thus the wavy pinstripes of Bridget Riley's paintings, such as *Drift* 2 (1966), seem to shimmer before the eye, while Victor Vasarely, the most successful exponent of Op art, has used various devices, such as positive-negative shapes, to make his paintings flicker like a movie image. Op art works by focusing interest exclusively on the question of visual perception while reducing to insignificance any potential interest in subject-matter and avoiding a > gestural handling of > paint liable to draw attention back to the physicality of the painting.

● E. H. Gombrich, *Art and Illusion* (1960); C. Barret, *An Introduction to Optical Art* (1971).

OPTICS

The study of human vision, important for > artists interested in the representation of aspects of the external world. > Perspective forms a main part. An understanding of optics has allowed artists since ancient Greece to distort perspective to accommodate awkward viewpoints (for example, sculpture high on a building), and the 17th century also delighted in trick perspectives such as > anamorphosis, where distorted images were deliberately produced to be viewed from one particular and unusual viewing angle. Also bound up in the subject is the matter of > colour, and congenital problems that lead to distortions of colour balance, > palette, figure and picture construction.

● Martin Kemp, *The Science of Art: Optical Themes in Western Art from Brunelleschi to Seurat* (1990); Patrick D. Trevor-Roper, *The World Through Blunted Sight: An Inquiry into the Influence of Defective Vision on Art and Character* (1970).

ORDERS

In > architecture an Order is the package of entablature, capital, shaft, base and, where necessary, plinth that made up the original > marble or stone equivalent of a wooden support (such as a column) holding up a beam (entablature). The forms for the three main Orders of Doric, Ionic and Corinthian were developed by the Greeks, according to the characters of the buildings for which they were used: robust and squat Doric, elegant Ionic, decorated Corinthian. > Vitruvius attempted to systematize the Orders by giving relative proportions, but in truth the Romans themselves misused them according to Greek fashions and instead of using them as supports, they were often used against a wall or to flank the structure of a > triumphal arch. In other words, they ceased to be functional and became extravagant surface decorations, only appearing to support walls. In > Renaissance theoretical texts which attempted to make sense of Vitruvius, a canonical approach that retained the structural integrity of the Orders was counselled.

This loose state of affairs continued until the later 18th century, when the taste for > archaeology became allied to a delight in accuracy – in what the ancients actually did, rather than what the Renaissance interpreted them as having done (> Neoclassicism).

This attitude was reinforced by an increase in travels to Greek lands (including Syria, Palestine and North Africa), when, for the first time, the West learned how the > Classical and Hellenistic Greeks had treated the Orders, leading to some stiff but 'correct' buildings. Nevertheless, practising architects such as Adam, observing just what the Romans had done, usually did likewise, and John Nash in the early 19th century further contributed to making them decorative rather than structural.

● John Onions, *Bearers of Meaning: The Classical Orders in Antiquity, the Middle Ages and the Renaissance* (1988); Claude Perrault, *A Treatise of the Five Orders in Architecture* (Eng. trans. 1722); Arthur Stratton, *The Orders of Architecture: Greek, Roman and Renaissance with Selected Examples of Their Application* (reprinted 1986); Dora Wiebenson, *Architectural Theory and Practice from Alberti to Ledoux* (1982).

ORIENTALISM

The Orient has fascinated Western > artists, scholars and littérateurs from ancient Greece onwards because of its strangeness and mystery, but until the 18th century the Orient was generally understood as the Middle, not the Far East. Middle Eastern contacts with the West were made through trade, embassies and sometimes as a result of Westerners collecting luxury objects usually unavailable further west, such as carpets, lapis lazuli, lustre pottery, > ivories and certain types of glass, along with porcelain from the Far East.

The great Spanish and Portuguese voyages of the > Renaissance were important in opening up sea trade with cultures beyond Arabia, but they simply made goods cheaper than those brought overland, without changing their variety. The ethnographic art brought back from such voyages was placed in > cabinets of curiosities, rather than considered as art likely to interest Western > artists. Dutch trade in the 17th century introduced several crazes to the West, not least those for tulips and blue and white Delftware. Ambassadorial missions from the East, travelling to Western countries, were remarkably exotic, and the East was represented thus in contemporary art and literature, its products also reflected in Western > imitations, especially in the > decorative arts.

In the 18th century, travel began to change the picture, as did military conquest (> Egyptian art), but the mystique was both preserved and enhanced through the > Romantic vogue for Orientalism in literature. The > Industrial Revolution opened up the world still further as raw materials were imported from the East and manufactured products sold or exchanged there, while the extended travel of the later 19th century assured Orientalism a continuing place in literature and art. *See* > Symbolism.

● R. A. Jairazbhoy, *Oriental Influences in Western Art* (1965); Donald A. Rosenthal, *Orientalism, the Near East in French Painting, 1800–1880*, exhibition catalogue, University of Rochester (1982); Edward W. Said, *Orientalism* (1978).

ORIGINAL

A work of art considered to be by the hand of a given > artist, or a work of a given period, > school or > style that does not > copy an existing work of art.

ORIGINALITY

In art appreciation, originality has long played a determining role in the construction of the > methodology of > art history. However, originality defined as 'by the hand of the > artist' is a modern and over-narrow interpretation of the term. In the 17th century originality was considered an integral part of the artist's powers of > invention and the opposite of the servile > copying of > nature. Despite this, > connoisseurship has focused exclusively on originality (which it confounds with authenticity; > attribution) to exclude other notions of artistic production from serious critical attention. More recently this focus – which is based on preconceived ideas of the nature of artistic creation, the role of the artist, and aesthetic and monetary value – has been questioned by those who wish to separate originality from authenticity, thereby widening the parameters of the discipline to include all art, whether 'original' or not.

● R. Shiff, 'The Original, the Imitation, the Copy and the Spontaneous Classic', in *Yale French Studies*, 66 (1984); R. Krauss, 'Originality and the Avant-Garde', in *The Originality of the Avant-Garde and Other Modernist Myths* (1985); 'Retaining the Original: Multiple Originals, Copies and Reproductions', *Studies in the History of Art*, 20, National Gallery of Art, Washington (1989), reviewed by P. Duro in 'Quotational Art: *Plus Ça Change, plus c'est la même chose*', *Art History*, 14 (1991).

ORNAMENT

A Latin term for 'trapping', 'embellishment', 'trinket', hence also items added to decorate an art work. From one point of view, it is essential adornment, whether to buildings or picture frames, because it adds stylishness; from the opposite view, its value for an art work is in no sense intrinsic and is therefore unnecessary, and indeed detracts from any required effect. The > Great Exhibition of 1851 highlighted the question of the degree, as well as the nature, of ornament (often used profusely and in unsuitably vegetational forms in this period) as accusations were made that it concealed bad design rather than aided and enhanced good design. The > Industrial Revolution underlined the problem, for ornamentation could be and was cranked out mechanically. An extreme but rational reaction was provided by the > Bauhaus, which sought to design buildings and objects that suited mass production and whose streamlined nature, eschewing ornament, also expressed the way in which they were made.

● Dietrich Drost and others, *Ornaments and Sculpture in Primitive Society: Africa, Oceania and Asia* (1966); George L. Hersey, *The Lost Meaning of Classical Architecture: Speculations on Ornament from Vitruvius to Venturi* (1988); Owen Jones, *The Grammar of Ornament* (1856).

ORPHISM

Also known as **Orphic Cubism**. A romantic or expressive offshoot of > Cubism. > Apollinaire applied the name to the works exhibited by Delaunay, Duchamp, Picabia and Léger in the 1912 > Section d'Or > exhibition held in the Galerie la Boétie. The aim of the group was to sever Cubist links with the objective world in favour of the

development of > abstract painting. Apollinaire described Orphism in *Les peintres cubistes* (1913) as 'the art of painting new structures out of elements which have not been borrowed from the visual sphere, but have been created entirely by the artist.' Delaunay, in particular, was interested in the expressive quality of > colour used independently of > nature, and studied the theory of the simultaneous contrast of colours adopted by the > Neo-Impressionists. The > Futurist idea of dynamism had much in common with Orphism, which sought a 'simultaneity' of experience articulated in a non- > figurative pictorial language. The expressive qualities of Orphism were influential on > Kandinsky, Klee, Macke and the artists of the > Blaue Reiter.

● R. Delaunay, *Du cubisme à l'art abstrait* (1957); V. Spate, *Orphism* (1980).

OVERPAINTING

The laying on of > paint after the > underpainting is dry, either as part of the process of building up the surface of a painting in the course of excecution, or as an afterthought. The last case is described as > pentimento.

P

PAINT

Particles of > pigment suspended in a > medium. Glue, gums, egg, wax and oil are the most frequently used media, and earth pigments the oldest, dating back to the Stone Age. Gold, tin and lapiz lazuli added to their richness, and the 18th century saw the ever more widespread development of chemically synthesized pigments, although some (such as white and red lead) were manufactured in antiquity.

PAINTERLY

In *Principles of Art History* (1915), the > formalist > art historian Heinrich > Wölfflin analysed the development of art as a series of paired concepts, one such pair being the 'linearity' of the > Renaissance and the > 'painterly' > Baroque. By this he meant to indicate the broad approach of > artists such as Tintoretto, Velásquez and > Rubens who privileged > colour, irregularity and a free > handling of > paint over the > academic emphasis on line. In the 17th century partisans of the two positions were known as the Rubensistes (colour) and the > Poussinistes (line).

A renewed impetus to painterly qualities was given by the > Romantics, who believed they expressed the spontaneity and emotion of the artist better than the classicizing (> Classicism) qualities of premeditated line. In modern art 'painterly' has been an important thread running through art > criticism. Interest in painterly qualities was revived by Clement > Greenberg's formulation of modern painting as a > medium that draws attention to itself, as exemplified by the > Abstract Expressionists' interest in the bravura, the > gestural and the mark-making. Indeed, Greenberg refered to Abstract Expressionism as 'painterly > abstraction' in order to distinguish it from geometric abstraction. The 1980s saw yet another revival of the painterly in the work of the > Neo-Expressionists.

PALETTE

A platter-sized board, usually in wood such as mahogany or a ceramic material, designed to be held in the hand, on which painters can arrange a chromatic range of > colours. While up to and including the > quattrocento paints such as > tempera were mixed in separate containers, palettes became popular during the 16th century with the rise of viscous > oil colour, which > artists could blend on the palette prior to applying it to the > canvas. 'Palette' also means the range or complexion of colours chosen by an artist.

PALLADIAN

The architect Andrea Palladio (1508–80) produced houses and villas showing how the columns, porticoes and pediments of > classical temples could be used in an exciting new form of domestic and civic > architecture. He also produced books explaining, illustrating and giving added status to his work through comparisons with > antique practice, for example his illustrations to Barbaro's edition of > *Vitruvius* (1556) and his own *Quattro libri dell'architettura* (1570). The result was a Europe-wide popularity for his ideas, as seen in the great Palladian country houses of England, Russia and, also, the USA. With > Post-Modernism, Palladianism has seen a > revival, as it encapsulates suitably > historicist references to the 18th and earlier centuries, and is convincingly anti-modern. *See* Lord > Burlington.

● Howard Burns, *Andrea Palladio, 1508–1580: The Portico and the Farmyard*, exhibition catalogue (1975); Joseph C. Farber, *Palladio's Architecture and its Influence: A Photographic Guide* (1980); Robert Tavernor, *Palladio and Palladianism* (1991); Rudolf Wittkower, *Palladio and English Palladianism* (1974).

PANEL PAINTING

A term referring to paintings made on a panel > support as opposed to > canvas or some other material. Most usually the panel is made of wood, but a metal such as copper, or occasionally slate or stone can also be used. The scale is usually, but not always, small, and the panel can be built into an ornately carved and > gilded frame (> picture frame). The planks of the panel are prepared by sanding and a > ground of > gesso applied in several coats. Originally the paint used for panels was > tempera – many > quattrocento paintings were executed in this way – but increasingly from the 15th century > oil paint was used.

PANOFSKY, ERWIN

(1892–1968). German > art historian. He joined the University of Hamburg in 1921 as a 'Privatdozent' and became a professor in 1926. In 1933 he was dismissed by the Nazis and settled in New York, where he had been a visiting professor since 1931. In 1934 he was visiting professor at Princeton, then professor at the Institute for Advanced Study there, where he remained until his death. In Hamburg Panofsky had been associated with the group, including Ernst > Cassirer and Fritz > Saxl, which formed around Aby > Warburg. Fundamental to Panofsky's thinking was the idea that art, like literature, poetry and philosophy, is a form of knowledge and therefore open to rational appraisal. This belief in the interconnectedness of cultural history led Panofsky to employ a dazzling variety of philosophical, intellectual, political, cultural and poetic sources to contextualize the art work.

This approach, facilitated by his knowledge of all the major European languages and familiarity with an impressive amount of > classical and modern literature, enabled Panofsky to account for a variety of cultural influences on the making of a given art work. Much of his work focused on > iconography, the opposite approach to that of

> Wölfflin, who based his account of > style exclusively on the > formal properties of the art work. Wölfflin's essay 'Das Problem des Stils in der bildenden Kunst' (1912) is an early expression of this approach.

Panofsky applied his interest in iconography mainly to North European art, especially German and Netherlandish painting, in essays such as 'Albrecht Dürer and Classical Antiquity' (1921), books such as *Gothic Architecture and Scholasticism* (1957) and most notably in the monumental *Early Netherlandish Painting* (two vols, 1953). As with many other thinkers who have seen their approach vulgarized, his iconographical approach was overemphasized by followers who treated it not as an element in an interpretative strategy but as the goal. While more recent art history has tended to focus on areas ignored by Panofsky, such as the reception of the art work or the status of 'texts', 'discourses' and the nature of historical evidence, his > methodology has had a lasting impact on the way art historians analyse art works.

● M. Holly, *Panofsky and the Foundations of Art History* (1984); E. Panofsky, *Idea: A Concept in Art Theory* (1924), trans. J. J. S. Peake (1968); *Studies in Iconology* (1939; 1962); *The Life and Art of Albrecht Dürer* (1943); *Early Netherlandish Painting*, 2 vols (1953); *Gothic Art and Scholasticism* (1957); *Renaissance and Renascences in Western Art* (1960); *Meaning in the Visual Arts* (1970; 1987); M. Podro, *The Critical Historians of Art* (1982; 1989).

PANORAMA

'Wide-screen' paintings of cityscapes and > landscapes have been part and parcel of wall-painting from antiquity onwards, but true panoramas, foreshadowed by the deliberately broad landscape views of > artists such as Hollar, come into fashion in the later 18th century either as an all-round 360-degree view for which the spectator stands in the centre, or as a section of a scroll that passes before a static spectator. The craze was transferred to photography, and panoramas have been found in the travelling > exhibitions that took art to the paying masses.

PANTOGRAPH

A mechanical device used to reproduce the outline of an image on a larger or smaller scale. It is essentially an articulated arm with a stylus at one end and a > pencil or > crayon attached to the other. The copy is executed by tracing the stylus over the original image, which is then reproduced by the pencil or crayon set over a sheet of > paper.

PAPACY

'The Papacy is not other than the ghost of the deceased Roman Empire, sitting crowned upon the throne thereof.' Hobbes's dictum explains in shorthand terms the sense of the guardianship of the Empire passing, seamlessly and with a similar purpose, to the papacy. Certainly, the infrastructure of the Empire – roads, lines of authority, language,

land divisions, law – was invaluable to the only institution that could now lay claim to a Europe-wide control, if not rule.

The papacy often saw the support and exposition of culture as a means of >propaganda that could underpin its heritage and justify its power: in the >collecting stakes, the >Renaissance and >Baroque popes beat the world. Like the artists they employed, they frequently viewed art through Roman spectacles. Some of the greatest of all projects were commissioned by them, from the new St Peter's to the reurbanization of sections of Rome. As arbiters of artistic >taste, their influence was especially high from the late 15th century through to the late 17th century, by which time there was sturdy competition from the likes of Louis XIV of France and a clutter of German princelings. In other words, with the rise of nation states the cultural and political influence of the papacy declined, and has not yet recovered.

● Giovanni Morelli, *Raffaello e la Roma dei Papi* (1986); E. Muntz, *Les Arts à la Cour des Papes* . . . (1878; 1898); Leopold von Ranke, *A History of the Papacy, Political and Ecclesiastical, in the Sixteenth and Seventeenth Centuries* (many editions and translations); *The Vatican Collections: The Papacy and Art*, exhibition, Metropolitan Museum of Art, New York (1982).

PAPER

Palm leaves and papyrus were used for writing and painting well before the invention of paper, which we know was being made in China in AD 105, although the technology reached Europe only in the 14th century. In the East, paper was made from vegetable fibres; in the West, rags were used as being more capable of withstanding the (acidic) oak-gall >ink. Although all paper was handmade until the 19th century, this did not prevent its use occasioning a revolution in the 15th century in the accessibility of the printed word, replacing vellum manuscripts and bringing reading and writing to a wider audience. Henceforth students could use it for notes, >artists for >drawings and >prints. Paper was quickly perceived by artists such as >Dürer as a vehicle for the diffusion of >multiples, and so it remains today.

Paper can be useful to >art historians for dating, since papermakers often incorporated some publicizing device or motto in the mesh formed by the pulp when it was made into sheets – the watermark. Chronologies of papers are thus possible through artists' birth and death dates, as well as through the publication dates of paper-printed books and advertisements.

● Dard Hunter, *Papermaking: The History and Technique of an Ancient Craft* (1947); Paulette Long (ed.), *Paper: Art and Technology* (1979).

PAPIER COLLÉ *See* Collage.

PARIS, SCHOOL OF

A term applied to two very distinct groups of artists both centred in Paris. In connection with manuscript >illumination, it refers to the >mediaeval >school of manuscript

illuminators that flourished under the > patronage of St Louis and which continued in the work of Master Honoré, Jehan Pucelle and the Limburg Brothers. It is also an umbrella designation for the various > Modernist tendencies focused on Paris in the first half of the 20th century, such as > Cubism and > Surrealism, as well as for the many artists who are not easily pigeon-holed but who worked in Paris in this period, for example Henri Rousseau, Derain, Miró, Chagall, Modigliani, Ernst, Mondrian, de Chirico, Delaunay and Picasso, amongst others.

● B. Dorival, *The School of Paris in the Musée d'Art Moderne* (1962).

PARKS AND GARDENS

Ever since the Garden of Eden, the Elysian Fields and the Hanging Gardens of Babylon, the garden or larger park enclosed by a wall or hedge has been a thing of delight, and usually of relaxation. Enormous sums have been expended on them. A garden tames > nature, and often improves on it by organizing its elements into regimented combinations. In arid zones such as Persia, for example, the garden is the very symbol of heaven, with water, grass and trees. In many climates, control of water requires technology: for the Arabs in Spain or the princes in Bali, gardens are often the result of irrigation; at the Villa d'Este at Tivoli, and Hadrian's Villa down on the plain, the lavish use of water was only made possible through tapping and tunnelling the cascades (made famous by 18th-century > veduta painters). At Versailles, the works needed to construct the park and its huge extents of water (sometimes equipped with gondolas) were for no other purpose (certainly not running water in the palace itself) than to stagger the visitor.

In the European tradition, the tone was set by Italy, from Hadrian's Villa to the great gardens of the > Renaissance. The rest of Europe imitated and modified Italian models, for example at Versailles, Karlsruhe and Nymphenburg. The English gardens of the 18th century defied tradition under the influence of the > picturesque. The formal, regimented garden withered as devotees of a more 'natural' nature sought to re-create the accidents, irregularities, mysteries and surprises of nature in a fashion that may have come from China. Certainly, the outbreaks of > revivalism in the 18th and 19th centuries found full expression in gardens: whilst a > mediaeval- or even Indian- or Chinese-style house was usually considered to be going too far, a conservatory or gazebo in such a > style was fine, and the > genre easily accommodated the building of artistic ruins that made a garden look like a painting by Claude. Stourhead, Wiltshire was surely designed with just such a vision.

To the taming of nature, 18th-century garden designers added > architecture, often miniature and usually playful, although sometimes, like a present-day theme park, the garden had a story to tell, as at Stowe in Buckinghamshire or Bomarzo in central Italy. Sometimes it was the setting for theatre (Versailles) or jousting (the courtyard of the Vatican Belvedere before its subdivision). Always, sculpture was a part of the whole effect and, depending on the theme of the garden, > classical gods and goddesses were popular, as were nymphs suitable for trees or streams, and Diana, out hunting. Both architecture and sculpture thus helped to bolster the knowledgeable spectator's education by making the ensemble come alive, as it were; and, in turn, the art works cannot function without such knowledge.

● David R. Coffin, *The Villa d'Este at Tivoli* (1960); David R. Coffin, *The Villa in the Life of Renaissance Rome* (1979); Georgina Masson, *Italian Gardens* (1961); Monique Mosser and Georges Teyssot (eds.), *The Architecture of Western Gardens: A Design History from the Renaissance to the Present Day* (1991).

PASTEL

A stick of colour made from pure, dry > pigments used for 'painting' on > paper. It was developed in the 18th century and used in particular by French and English > portrait and > landscape > artists, although it derives from the > Renaissance and 17th-century use of > chalk and > crayon. Pastel provides a rich but delicate surface, and it is this feature, with its suggestion of sensitivity, that brought about its revival with the > Impressionists.

● Doreen Bolger et al., *American Pastels in the Metropolitan Museum of Art* (1989).

PASTICHE

A work executed in the > style of another > artist. The most successful pastiches are not direct > copies but combine elements of several of an artist's works into a new > composition (this was the method used by Tom Keating with his copies of Samuel Palmer). When these works are fraudulently passed off as the work of the artist copied they are difficult to detect, since the pastiche recalls not a particular work (easy to trace) but the entire > *œuvre* of that artist. Another form of pastiche is when an artist is unduly influenced by another (as Ingres was influenced by Raphael) or when a student remains under the spell of a charismatic teacher (as Amaury-Duval did with his teacher, Ingres). The term may also be used derogatively to describe a work lacking individuality.

● Amaury-Duval, *Atelier d'Ingres* (2nd edn 1924); *Fakes and Forgeries*, exhibition catalogue, Minneapolis Institute of Arts (1973).

PASTORAL

In literature and art, pertaining to shepherds and rustic life. Pastoral wall-paintings were popular from > Pompeii onwards, and were usually elegantly unrealistic to match the literary vision and fiction of the unspoiled beauty of the countryside. During the Middle Ages there was not much interest in the > genre, but as a literary and artistic form it was revived with the > Renaissance, and is exemplified in the work of artists such as Giorgione, Titian and Claude, with 18th-century English artists and even Turner continuing much the same tradition. The popularity of > parks and gardens provides a tangible extension of the fascination with pastoral.

● Luba Freedman, *The Classical Pastoral in the Visual Arts* (1989); Simon Pugh (ed.), *Reading Landscape: Country, City, Capital* (1990).

PATER, WALTER HORATIO

(1839–94). English aesthete (> Aestheticism) connected with the > Pre-Raphaelites and enamoured of Italian art and especially the > Renaissance. His criticism concentrates on the idea of the spontaneous reaction to exposure to art and on what became almost a cult of > beauty and paganism, which makes most of his work seem overwritten and precious, all the more so since it often shows no regard for historical context.

● William E. Buckler, *Walter Pater: The Critic as Artist of Ideas* (1987); Paul Barolsky, *Walter Pater's Renaissance* (1987); Carolyn Williams, *Transfigured World: Walter Pater's Aesthetic Historicism* (1989).

PATHETIC FALLACY

The belief that > nature is somehow in tune with human emotions. Best seen in literature (for example, Egdon Heath in Hardy's *The Return of the Native*), but also a powerful rationale for the expressiveness of > landscape painting with figures, from the heroic > Classicism of Poussin to the storminess of some Turners. When William Hazlitt said in 1839, 'We do not see nature with our eyes, but with our understandings and our hearts', he was perhaps indulging in this fallacy.

● Josephine Miles, *Pathetic Fallacy in the Nineteenth Century: A Study of a Changing Relation between Object and Emotion* (1965).

PATINA

The complexion acquired by a material surface. The term is used particularly of > bronzes, where the greenish tinge results from oxidation, and furniture, where it usually results from time, polishing and handling. In both cases, false patination can be applied to make a new object look old. In painting, false patinas consisting of artificial > craquelure lines, or newly created craquelures with old dirt rubbed into them, are common. *See* forgery.

PATRONAGE

The > artist as a free agent is a 19th-century idea. Previously (and nowadays, with the age of company, town and organizational sponsorship) the artist needed a patron in order to flourish. The arrangement might be temporary, to complete one work or series, or the artist might be employed for a considerable period. Most patrons were by definition rich, and holding court both confirmed their status and fed the desire to increase it by commissioning art works.

The notion that patronage stifles creativity is a misconception: artists must produce for the market, and the patron gives them the opportunity to do so, often bolstered by the example of fellow employees in other media, whether musicians, poets, librarians or scholars. Most grand schemes – Raphael's Stanza della Segnatura, the sculptures at

Tiberius's villa at Sperlonga, the > iconography of the garden (> parks and gardens) at Bomarzo – were surely developed through interaction between the patron and his courtiers, including the artist – as reflected in Baldassare Castiglione's *Book of the Courtier* (1528).

● D. S. Chambers (ed.), *Patrons and Artists in the Italian Renaissance* (1970); Barbara K. Gold, *Literary and Artistic Patronage in Ancient Rome* (1982); Niels Hannestad, *Roman Art and Imperial Policy* (1986); Francis Haskell, *Patrons and Painters. A Study in the Relations between Italian Art and Society in the Age of the Baroque* (2nd edn 1980); Hartmut Hoffmann, *Buchkunst und Konigtum im ottonischen und fruhsalischen Reich* (1986); Walter Hussey, *Patron of Art: The Revival of a Great Tradition Among Modern Artists* (1985); F. W. Kent and Patricia Simons (eds.), *Patronage, Art and Society in Renaissance Italy* (1987); Joseph F. Merriman, *Aristocratic and Imperial Patronage of the Decorative Arts in Rome and Constantinople, AD 337–395: The Role of Sculpture, Painting, Mosaics, and the Minor Arts in Fourth Century Society* (1975); Lillian B. Miller, *Patrons and Patriotism: The Encouragement of the Fine Arts in the United States, 1790–1860* (1966); Louis G. Redstone, *Public Art: New Directions* (1981); Dianne C. Strickland, *Maximilian as Patron: The 'Prayer Book'* (1980).

PEN AND WASH

The pen was originally a bird quill, as its name (*penna* is Latin for 'feather') suggests. Earlier drawing instruments include the reeds probably used by the > Egyptians, and pens of > bronze have been found at > Pompeii. Steel pens were manufactured from the 18th century. The main > drawing instrument of the > artist for > sketches (whether rough or precise) as well as 'finished' drawings, it was found during the > Renaissance that an even greater variety of tone and texture could be attained by adding diluted Indian > ink with a > brush, a technique still used today.

PENCIL

First heard of in the 1560s, the pencil was probably a stick of graphite in a holder to begin with, but the English were selling them in the familiar wooden casing by the 1680s. The advantage of the pencil was that (unlike > silver point) the > paper did not need to be treated beforehand, and the discovery by Nicolas-Jacques Conté in 1790 that graphite could be tempered with clay to produce varieties of hardness further increased its flexibility.

PENTIMENTO

(Italian: 'repentance'). A term used to indicate repainting or > overpainting of a picture by the > artist in the course of its execution. It does not refer to later overpainting by careless or unscrupulous restorers (> restoration of art works). Pentimenti are visible when an overpainted area has become transparent through age or overcleaning, or because of imperfectly covered brushmarks in the > underpainting. They may be scientifically viewed, and photographed, by X-ray.

PERFORMANCE ART

A term describing the presentation of an event that may include music, poetry and dance as well as the visual arts of painting, sculpture, film and video. The context is usually theatrical in the sense that the performance takes place in front of an audience, but most Performance artists will insist that it is not theatre but an event in which the 'action' takes place in real time and with 'real' content. There was a strong element of > Performance art in the manifestations of the > Futurists and > Dadaists, and this social dimension was continued in such early expressions of Performance art as the > Action painting of Yves Klein, who created paintings in front of an audience by dragging naked women covered in paint over a > canvas laid on the floor. In the 1960s > happenings developed Performance art towards audience participation and the spontaneous unfolding of the event. Outside the USA the Gutai group in Japan and Fluxus in Europe drew Performance art into the political arena with Dada-like attacks on social and aesthetic norms. Essentially, Performance art is an aspect of > Conceptual art in so far as it embraces the view that what matters is not the physical art object but the idea that lies behind it.

● A. Kaprow, *Assemblage, Environments and Happenings* (1966); F. Popper, *Art Action and Participation* (1975).

PERIODICAL *See* Journals and periodicals.

PERPENDICULAR STYLE

The final expression of the > Gothic > style in English > architecture, with an almost chaste geometrical simplicity generated by an emphasis on vertical and horizontal divisions, large windows and large, plain expanses of wall. The effect was strengthened by the later use of fan vaulting, a profusely decorative network employed for surface decoration rather than for any structural purpose.

● John H. Harvey. *The Perpendicular Style*, 1330–1485 (1978).

PERSPECTIVE

In painting, the deployment of lines on a two-dimensional surface to create the illusion of three-dimensional space. Perspective, however, is not a transcription of how the human eye perceives, but must be understood as a > representational system with specific geographic and temporal associations. Many cultures have developed highly sophisticated systems of representation without recourse to a coherent use of perspective; see, for example, Australian > Aboriginal, ancient > Egyptian, pre-Columbian or Western > mediaeval art.

Linear perspective may be likened to a 'window on to the world'. Just as the eye of the > beholder embraces a scene through a window, so the artist creates the illusion of space by treating the surface of a > canvas as a window, tracing outlines that pass

'through' the canvas and so into the eye. The systematic use of such devices makes parallel lines appear to converge as they recede into the picture space to meet at a given point (often called the vanishing-point). Objects of similar size will seem smaller the further they are from the picture plane.

In a short space of time in 15th-century Florence a group of > architects and painters evolved a means of executing architectural plans and paintings in perspective. The architect Filippo > Brunelleschi is often credited as being the inventor of perspective in around 1420. His fellow architect > Alberti codified many of Brunelleschi's theorems into his treatise *Della Pictura* (On Painting), written in Latin in 1435 and translated into the vernacular the following year. Alberti offered an infallible method of > drawing in perspective such classics of illusion as a chequer-board floor with orthogonals and transverse parallels correctly indicated.

Alberti's treatise stated as a truth: 'No one will deny that things which are not visible do not concern the painter, for he strives to represent only the things that are seen'. Emphasis on appearance, not essence, thus became the goal of the painters who strove to apply Alberti's theorems. In paintings such as the *Battle of San Romano*, Uccello used a rigorous geometric construction to show fallen soldiers in extreme > foreshortening. It is Piero della Francesca who most of all personifies the sense of the > humanist values of reason, order and > decorum (perspective having something of all these qualities) gave to the paintings of the > quattrocento. In his art he exhibits a clear understanding of the mathematical foundations of > Renaissance painting, and later in life he wrote a treatise on perspective.

Northern European artists were also developing perspective. > Dürer travelled to Italy in the 1490s and met with artists familiar with the new theorems. A little earlier, van Eyck had employed a complex multipoint perspective (that is, where several vanishing-points are used instead of one) in paintings such as *The Arnolfini Wedding* (1434). Here perspective is used to facilitate the representation of > nature, not, as in Italy, to regulate it. In the 17th century these different roles of perspective became the cause of a dispute in the French > Academy between the director Charles > Lebrun and the Professor of Perspective, Abraham Bosse. The former argued that perspective was a useful servant of the artist, but a tyrannical master; Bosse saw it as a judge to whom no appeal could be made.

Since the advent of > Romanticism, perspective has been seen as a constraint on artistic freedom. Furthermore, > Modernism frequently plays on the difference between 'seeing' and 'knowing', that is, how the laws of perspective alter the reality of a given object such as a plate when seen from an oblique angle. But it is > Cubism that has posed the strongest challenge to the conventions of linear perspective. By breaking up the subject into a series of overlapping planes that have to be reconstructed in the mind as much as in the eye of the beholder, Cubism denies the validity of perspective as a system of representation.

● G. C. Argan, 'The Architecture of Brunelleschi and the Origins of Perspective Theory in the Fifteenth Century', *Journal of the Warburg and Courtauld Institutes*, IX (1946) pp. 96–121; Erwin Panofsky, 'Die Perspektive also symbolische Form', *Vortraege der Bibliothek Warburg* (1924–5), pp. 258–81; J. White, *The Birth and Rebirth of Pictorial Space* (1957); E. H. Gombrich, *Art and Illusion* (1960); Cecil Grayson (ed.), *Alberti On Painting and On Sculpture* (1972).

PEVSNER, SIR NIKOLAUS

(1902–83). German-born refugee from Nazism, best known for his lively > *Buildings of England*, and his editorship of the *Pelican History of Art* (1953 onwards), as well as for *Academies of Art* (1940) and *An Outline of European Architecture* (first published in 1942). Pevsner brought (more) Germanic rigour to the study of > art history in Britain, and his 1956 Reith lectures on 'The Englishness of English Art' were an attempt at characterizing its complexion that arguably could only have been written by a foreigner.

PHILOSOPHY OF ART

A generic term for the various ways of reasoning about art, for example a particular way of establishing the limits of art, such as the arguments advanced by Plato, or an enquiry into the nature of > beauty or the proper exercise of the critical and aesthetic faculties, as in the writings of > Kant. Because the philosophy of art deals with concrete realities – the paintings and sculptures made by > artists – it is particularly difficult, and perhaps inappropriate, to attempt too categorical a use of the domain of philosophy to understand art works. At the very least those whose engage in this branch of philosophy must, at some stage in their thinking, recognize the necessity of confronting the historical and perceptual reality of the object of their studies.

● M. Podro, *The Critical Historians of Art* (1982; 1989).

PHOTOGRAPHY AND ART

Since the very beginnings of photography, the > medium has been seen as both an aid and a threat to > artists. Photographs have been used in the production of paintings and sculptures by artists from > Delacroix to Bacon and beyond, and the memorable images produced by this documentation have played a part in shaping our perception of the world, as it did for the > Futurists, who were especially inspired by time-lapse photography. But the medium has also been seen as competition – *The Pencil of Nature* (the title of Fox Talbot's 1844 book of photographs with text) rather than the pencil of the artist.

In some areas, photography soon proved its worth and overtook painting: > portrait painting slumped in the face of the huge and affordable popularity of the photographic visiting card and the studio portrait; war photography proved itself in the Crimea and the American Civil War, although reproductive reportage, often using photographs as sources, still needed artists to turn them into > prints for the illustrated papers of the day. One artistic response to photography was to pose large > historical or > mythological > compositions as if they were to be painted, and then to photograph them; multiple copies could then make a profit. Another was to realize that group portraits could conveniently be made (either as composite photographs or paintings) by taking individual photographic portraits and using them for the finished works.

Photography is accepted as an art form by at least three external measuring sticks: artists wield cameras as well as > brushes; > exhibitions of photographs are regularly held and examples collected by the major museums; and many departments of > art

225

history teach the history of photography just as they teach > Roman art or > Impressionism. All these arguments are, of course, circular ones, but they indicate a decided change in taste since World War II.

One area where photography has positively helped art has been in the dissemination of images of works of art, sometimes on a large scale, as with companies such as Alinari. Without photographs and slides, it is doubtful whether the discipline of art history could have developed.

● Jean L. Daval, *Photography: History of an Art* (1982); Estelle Jussin, *Visual Communication and the Graphic Arts: Photographic Technologies of the Nineteenth Century* (1974); Volker Kahmen, *Art History of Photography* (1974); Beaumont Newhall (ed.), *Photography. Essays and Images. Illustrated Readings in the History of Photography* (1980); Aaron Scharf, *Art and Photography* (rev. edn 1979).

PHOTOMONTAGE

Related to the > collages of the > Cubists, photomontage uses photographs or other graphic images which are cut up and then pasted into new and often disturbing configurations. The technique was particularly used by the > Dada and > Neue Sachlichkeit artists, for example John Heartfield and George Grosz, for political ends. It was likewise used by the > Surrealist Max Ernst to disrupt perception of reality. Pictorially, the anarchy resulting from the indiscreet juxtaposition of disparate images with a variety of themes, points of view and techniques questions the narrowly defined conventions of > fine art.

● D. Ades, *Photomontage* (1976).

PHOTOREALISM

Also known as Hyperrealism and Superrealism, the movement flourished in the 1970s, especially in the USA. Photorealist > artists, working large-format in > acrylics, made paintings that resembled photographs, especially of the snapshot kind, employing techniques that imitated the effects of amateur photography, such as informal > compositions and banal subject-matter – family picnics, suburban life or > portraits. Leading exponents of the > style include Malcolm Morley, Richard Estes and Chuck Close.

● L.K. Meisel, *Photo-Realism* (1980).

PICTURE FRAME

The surround, usually of wood but sometimes of metal, plastic or other materials, which contains a painting, > drawing or > print. The purpose of the frame is to protect the art work from damage or degradation, to designate the 'art space' – isolate the picture from its surroundings – or, conversely, to integrate the picture into a decorative ensemble or context. > Frescos or other decorative ensembles frequently have a > *trompe l'œil* frame to distinguish the picture area from the surrounding decoration.

The type of frame used is determined by the nature of the art work. > Oil paintings usually have a heavy wooden frame to lend strength to the light > stretcher, while a > print or > watercolour is usually mounted on to board and sealed under glass to prevent the intrusion of dust or damp.

The frame grew out of the practice of > panel painting, where the > support and the surround were constructed as one. With the advent of > easel painting the frame was made separate from the > canvas and stretcher and was not, for the most part, considered by artists to be part of their work, but given to an artisan who worked on the 'non-art' part of picture-making.

The traditional 'Old Master' frame, coated with > gesso and > gilded, continued to be used into the modern period, and most paintings of the > Impressionist > school are so framed, although Degas stipulated plain, ungilded frames for many of his canvases. In the 20th century, especially from mid-century, it has been fashionable not to frame a painting at all.

PICTURE PLANE

The picture plane is not the literal surface of a painting but, rather, a conceptual one, although for practical purposes they are identical. In pre-> Renaissance and much non-Western art the picture plane carries the > composition so that figures may appear to 'float' on the surface of the picture. With the advent of > perspective in the Renaissance, the picture plane came to be considered as a 'window on to the world' – like the glass of a window with the composition etched on to it. Disruption of the order imposed by the Renaissance soon followed. While Renaissance painting depended on the picture plane remaining perpendicular to the scene represented, the > Baroque angled the picture plane up to give the subject – Assumptions and Last Judgements were popular – a literal ascendancy over the viewer. In > Modernism, the picture plane was again called into question, first by the > painterly techniques and weak recessional properties of Manet and the > Impressionists, who thereby drew attention to it, then more explicitly by 20th-century artists who seek, through works that display little or no recession into depth, to maintain the integrity of the picture plane as an indication of their engagement with 'pure' painting and their distaste for > illusionism and > narrative.

PICTURESQUE

An 18th-century > aesthetic concept applied to scenes occupying the mid-ground between the > ideal landscapes of the 17th century and the > sublime landscapes of > Romanticism. The leading advocate of the picturesque, the Revd William Gilpin, in his *Three Essays on the Picturesque* (1792) defined the picturesque as that which stimulates the imagination to reverie or admiration. To call any landscape picturesque was to imply that it had picturesque potential, and many artists used a > Claude glass for concentrating the picturesque qualities under observation. In an important departure for English landscape painting, Uvedale Price in his *Essay on the Picturesque* (1794) arued that consideration of the picturesque would bring landscape painting back to a celebration of > nature after its involvement with the > academic 'ideal'. Outside the English

context, Piranesi's > vedute of the ruins of > antique Rome obviously calls upon qualities of the picturesque. The idea of the picturesque influenced not only painting, but also > architecture and, most notably, landscape gardening (> parks and gardens).

● W. J. Hipple, *The Beautiful, the Sublime and the Picturesque in Eighteenth-Century British Aesthetic Theory* (1951); N. Pevsner (ed.), *The Picturesque Garden and its Influence Outside the British Isles*, exhibition catalogue (1974).

PIETÀ

(Italian: 'pity'.) The dead Christ supported in the lap of His mother, who mourns His death. This German theme, first seen in the 14th century, was very popular in the Italian > Renaissance, largely because of the restrained emotion it could express (as in Michelangelo's Pietà of 1500 in St Peter's), as well as its poignant parallels with representations of the Virgin with the Christ child.

● Hans Belting, *The Image and its Public: Form and Function of Early Paintings of the Passion* (1990).

PIGMENT

The actual > colour used in > paint, originally from natural sources, but now almost exclusively chemically formed. Pigment plus > medium equals paint.

PILES, ROGER DE

(1635–1709). French critic and art theoretician, who published, among other studies, *Dialogues sur le coloris* (Dialogues on Colour) (1673), *Abrégé de la vie des peintres* (Brief Lives of Painters) (1694), and *Cours de peinture par principes avec une balance des peintres* (Principles of Painting) (1708). In the last decades of the 17th century he championed Rubens and struggled against > academic antipathy to the 'Rubeniste' faction (> *Poussinistes* vs. *Rubenistes*); his entry into the French > Academy in 1699 as an 'honorary counsellor' saw his views prevail.

● T. Puttfarken, *Roger de Piles' Theory of Art* (1985).

PINX

(From the Latin *pinxit*, meaning 'he painted it'). Often inscribed on the margin of a > print to indicate the > artist of the > original.

PITTI PALACE

Florence. Begun in 1458 perhaps after designs by > Brunelleschi, much extended by Ammanati in 1558–70, and given the extensive Boboli gardens, it was the seat of the grand dukes of Tuscany from 1550. It contains the famous Galleria Palatina, with many

>masterpieces of the Italian >Renaissance, as well as important >collections of jewellery, >ivories, silverwork, etc., the majority formed from the >Medicis' collecting activities.

● Malcolm Campbell, *Pietro da Cortona at the Pitti Palace: A Study of the Planetary Rooms and Related Projects* (1977).

PLANIMETRIC

A term describing a >composition in which the figures are disposed across the >picture plane, usually occupying the >foreground of the picture space with little recession into depth. >Neoclassical painters frequently resorted to this device, as in J.-L. David's *Brutus and His Sons* (1789).

PLASTER CASTING

A method used for replicating existing sculptures (i.e. as plaster casts), as well as for producing a 'negative' of a work as a stage in >bronze casting. The process, which is cheap and simple, is documented back to Hellenistic (>Greek art) times, and provided the >Romans with quick copies of Greek and Hellenistic >masterpieces. These in their turn were used as models by Roman >artists. The practice is still in use in some >academies as a stage prior to >drawing from the living model (>life drawing). The casting of living and dead heads – life masks and death masks – was also a Roman practice, bound up with the cult of fame and of one's ancestors, and reappeared in the >Renaissance when plaster moulds taken from various live body parts were (according to >Vasari) also made to help artists. The lightness of casts meant that they could be transported across Europe, and knowledge of the >antique would have been less thorough had students needed to rely on drawings alone.

PLASTICITY

When used of sculpture, a term describing malleability of the material (clay, wax); of painting, a critical term indicating three-dimensional, sculpture-like characteristics.

PLATO. *See* Neoplatonism.

PLEIN AIR

(French: 'open air'). A term used to denote paintings executed, in part or wholly, in the open air (*en plein air*). In the course of the 19th century factors as varied as the invention of the collapsible metal tube for >oil paints (thus facilitating the transport of equipment) and the dislike of the formula >landscapes of the >academic >schools persuaded progressive >artists to attempt to paint the spontaneity and freshness of

directly perceived nature. The artists of the > Barbizon School were early exponents and their methods influenced the younger > Impressionists.

POCHADE

(French, from *pocher*, 'to make a rough sketch'). As its French meaning suggests, a *pochade* is a rough, rapidly executed > sketch done as an *aide-mémoire* or to train the eye in rapid observation of the transitory effects of > nature.

POINTILLISM

The term was coined by the critic Félix Fénéon in 1886 to describe the > Neo-Impressionist technique of applying > paint in small regular dots of pure colour so that when viewed from an optimum distance (held to be three times the diameter of the > canvas) the colours appear to blend optically (> optics). It was believed that the resulting colour would be more vibrant than paint mixed on the > palette, although many critics considered that paintings executed in this way to be dull and lifeless. The Neo-Impressionists themselves preferred the term 'divisionism'.

POINTING MACHINE

In sculpture, an aid to the accurate translation of the proportions of a model on to a block of stone. While pointing may be carried out using plumb-lines suspended from a frame – a method known to > Alberti – the pointing machine is a refinement. This device is similar to a > pantograph (used for copying > drawings) in that it is essentially an articulated arm with a stylus attached at each extremity. By placing the stylus at a given point on the model, the measurement will be transferred to the stylus at the other end of the arm, thereby indicating to the sculptor the degree of excavation needed. By repeating this process as many times as is necessary a quasi-mechanical copy may be made.

● L. B. Alberti, *On Painting and On Sculpture*, ed. and trans. C. Grayson (1972), pp. 129–33, 141.

POLYCHROMATIC SCULPTURE

The great majority of all sculpture, worldwide, is and always has been polychromatic, that is, painted in many colours, usually to enhance lifelikeness. (Real hair was not unusual, nor ivory teeth, pearl eyes, and so forth.) Sculpture in wood (by far the most popular material) was usually painted on top of a coating of plaster, which helped fill in the grain. > Greek sculpture, even in > marble (for example the > Elgin Marbles), was routinely painted, and this tradition continued into the Middle Ages, so that the great portals of the > Gothic cathedrals might, to our chaste, > Renaissance-influenced > taste, have seemed garish, if not vulgar, with their multicoloured stone figures. Plenty

of traces remain from all periods: for example, the tympanum of the Puerta de la Gloria at Santiago de Compostela, or Sluter's *Well of Moses* in Dijon. Polychromatic multifigure wooden > altarpieces, often > gilded, adorned Spanish and northern altars until well into the 17th century, when > canvases usually took their place.

It seems to have been a misunderstanding of > Roman sculpture that encouraged Renaissance sculptors to promote plain marble for their works. The Roman material they studied had long since lost its colour, or perhaps they chose to ignore it. The liking for polychromy continued to challenge Renaissance ingenuity with other materials, and the development by the della Robbias of a vitrified lead > glaze for > terracotta meant that material could be brightly coloured and made virtually weatherproof as well.

The Renaissance taste for 'pure' marble sculpture was broken by Bernini, who observed and wished to > imitate the Roman use of different-coloured stones and marbles to produce composite busts or even complete groups, as can be seen from his > funerary monuments in St Peter's.

The Renaissance 'interlude' was, however, reconfirmed in the 18th century when the > Neoclassical quest for purity came up against incontrovertible proof of polychromy amongst the much-admired ancients – and still won. There are a few academic examples of the technique in the 19th century, especially during the various > revivals, but a renewed interest in the natural > beauty of materials has meant that 20th-century sculptors have not been well disposed to hiding it under layers of polychromy.

● Patrik Reutersward, *Studien zur Polychromie der Plastik: Griechenland und Rom. Untersuchungen uber die Farbwirkung der Marmor- und Bronzeskulpturen* (1960).

POLYPTYCH

A painting, usually religious, in many panels (> diptych). In European art from the 14th to the 16th centuries, such constructions were common. They could be in one plane and therefore simply a patchwork of framed panels (such as Duccio's huge *Maestà* in the Cathedral Museum, Siena), or they could be formed from an intricate arrangement of hinged panels, to be hidden or revealed according to some liturgy, for example Grünewald's Isenheim > altarpiece, or Jan van Eyck's Ghent altarpiece. Most polyptychs are by definition big and therefore occupy prominent altars; by the same token, many are double-sided.

The polyptych fell out of fashion during the 16th century (although Dürer kept the tradition going), and the last well-known examples are Rubens's *Raising of the Cross* (1610) and *Descent from the Cross* (1611–14) in Antwerp Cathedral.

● Mathis G. Nithart, *Grünewald: der Isenheimer Altar* (1973).

POMPEII AND HERCULANEUM

The romance of the two cities buried by an eruption of Vesuvius in AD 79 still attracts travellers, and their rediscovery in fits and starts during the 18th century promised to provide > artists with whole series of exact models for the re-creation of the > antique world. Unfortunately, few great works of art were discovered at either site, thereby

dashing the expectations of > connoisseurs such as > Winckelmann, who hoped their example would regenerate art away from the frivolous > Rococo towards something more austere, based on the antique principles partly demanded by > Neoclassicism. Ironically, Neoclassicism might have been more powerful without their example, since they tended to encourage a punctilious and deadening interest in historical accuracy.

For today's historian of things Roman, both sites (neither of which is yet completely excavated) provide invaluable evidence not only of the succession of painting > styles or furniture construction, but also of social organization and of how gardens (> parks and gardens) were planted. Being 'time capsules', providing a complete picture of Roman life (helped sometimes by the improvident who didn't bother to remove their valuables or even themselves), the cities are 'cleaner' to study than, say, Roman villas that might have been used and misused over centuries.

● *Pompeii as Source and Inspiration: Reflections in Eighteenth- and Nineteenth-Century Art*, exhibition catalogue, Ann Arbor Museum (1977); *Rediscovering Pompeii*, exhibition catalogue, IBM Gallery of Science and Art, New York (1990); *Pompeii AD 79: Treasures from the National Archaeological Museum, Naples; and the Pompeii Antiquarium*, exhibition catalogue, Museum of Fine Arts, Boston (1978).

POMPIDOU CENTRE

Named after Georges Pompidou, the French president who initiated the scheme, this gallery, library and > exhibition space replaced (but only after an outcry) the cast-iron Les Halles, or central markets, themselves a monument of 19th-century industrial construction materials and techniques. The building, by Piano and Rogers (1971–7), is a prime example of High Tech, with the services – pipes, escalators, air vents, etc. – displayed as sculpture on the exterior.

POMPIER, L'ART

(From the French *pompier*, meaning 'fire fighter'.) A pejorative term used in the 19th century to describe a kind of overblown > history painting in which bronze-helmeted warriors usually played a key role. The similarity of their attire to the uniforms worn by fire fighters is the origin of the name.

● W. A. Bouguereau, L'Art *Pompier*, exhibition catalogue (1991).

PONT-AVEN

A small town on the Brittany coast which has given its name to a loose association of anti- > naturalistic and > Symbolist painters, including Gauguin and Bernard, who worked there sporadically in the late 1880s.

POP ART

'Advertising art advertising itself as art that hates advertising' (Harold Rosenberg).

Pop art flourished from the 1950s through to the 1970s primarily in the UK and the USA. It found its imagery and many of its techniques from the realms of advertising, consumer packaging and > popular culture, including comic books, pop stars and cinema idols. Thus the name 'Pop', coined in 1958 by the critic Lawrence Alloway, refers at once to the subject-matter, the technique used and to the audience anticipated by these artists. In the first instance, Pop art was an attempt to break with conventional notions of art, rejecting, for example, distinctions between high and low art that had in no way been challenged by the > painterly excesses of the then dominant > Abstract Expressionists.

The collapse of the high/low distinction was reinforced not only by the use of popular imagery such as Warhol's Coke bottles or Brillo boxes, but also by Pop art's characteristic means of reproduction, the screenprint (> silk-screen printing) and the > poster. A series of > exhibitions publicized the new art in England, beginning with 'This is Tomorrow' at the Whitechapel Art Gallery in 1956, which featured the influential > collage by Richard Hamilton, *Just what is it that makes today's homes so different, so appealing*? In England the principal Pop artists include Edouardo Paolozzi, Richard Hamilton, Peter Blake, Allen Jones and David Hockney.

In the USA Pop art was seen by its practitioners as a reaction against the heroics of the Abstract Expressionists. It both fed on and ridiculed the hold consumerism and popular culture had over the American mind. Roy Lichtenstein imitated on a vast scale the subject-matter and reproduction techniques of the American comic book in works such as *Whaam!* (Tate Gallery, London, 1963), while Claes Oldenburg emphasized the > Dadaist element always implicit in Pop by making giant 'soft' sculptures of everyday items such as hamburgers and telephones out of vinyl or fabric. Other American Pop artists include Jim Dine, Robert Indiana, Edward Ruscha and Larry Rivers.

As well as questioning many of the accepted norms of > fine art, Pop art also explored the nature of representation. While some Pop artists seized the chance to adopt the techniques of mass production (thereby questioning the authorial gesture of the > artist), others perversely chose to imitate them by hand, as with Warhol's Coke bottles. In these pieces the 'minimal art content' shows them to be connected to > Minimalism, and questions fundamental notions about the aims of art and the contextualization of the art work, and not least about the role of > imitation in the art-making process.

● L. Alloway, 'The Arts and the Mass Media', *Architectural Design* (1958); *Pop Art*, exhibition catalogue, Arts Council of Great Britain (1969); *Pop Art*, exhibition catalogue, ed. Marco Livingstone (1991); J. Russell and S. Gablik, *Pop Art Redefined* (1969); L. Alloway, *American Pop Art* (1974); S. Wilson, *Pop* (1974).

POPE, ALEXANDER

(1688–1744). English poet, essayist and satirist. He translated Homer's *Iliad* (1715–20), and then the *Odyssey* (1725–6); both were free adaptations rather than translations, but are symptomatic of the new desire to read the 'wild' literature of the > Greeks rather than the more 'civilized' *Aeneid*. This focus on Homer was a characteristic of contemporary interest in the > sublime, and in Greek rather than > Roman themes in art, a feature of later > Neoclassicism. For his villa at Twickenham, Pope designed a

pioneering and intricate landscape garden (> parks and gardens) and grotto, which proved to be a model for many later layouts.

Alongside his interests in > architecture and landscape gardening, Pope initiated or took part in many of the artistic debates of his day. His Homer 'translations' earned him good money, and his interests and horizons made him one of the legion of gentlemen > amateurs – Lord > Burlington was another – responsible for the complexion of artistic > culture in 18th-century Britain.

● Morris R. Brownell, *Alexander Pope and the Arts of Georgian England* (1978); G. F. C. Plowden, *Pope on Classic Ground* (1983).

POPULAR CULTURE

While there have long been forms of popular culture such as folk tales, > folk art and popular theatre that to some extent have opposed the 'high' art forms of > fine art, opera and > Classical literature, 'popular culture' is the relatively recent offspring of the mass media – newspapers, pop music, movies, television and advertising. The modern definition of popular culture initially emerged in the 19th century, although its impact on fine art was limited. Although Courbet in *Bonjour, Monsieur Courbet* (1854) borrowed his > composition from a popular > woodcut of the Wandering Jew, and Manet and the > Impressionists depicted the popular nightspots of Haussmann's Paris, there was little interaction between 'high' and 'popular' art.

This attitude was not to change significantly until the 1950s, when the > Pop artists incorporated into their compositions the > icons of popular culture such as Coca-Cola and similar products of the consumer society. Since the 1960s the interaction between the two cultures has increased, with artists actively embracing the new forms of communication such as television and video, spawning such movements as > Conceptualism and > Performance art. Most recently, > feminist artists such as Cindy Sherman have focused on the media's representation of women in advertising and the cinema, while the > Post-modern artist Jeff Koons has made whisky decanters in the form of replicas of cartoon characters and media personalities.

● K. Varnedoe, *High and Low: Modern Art, Popular Culture* (1990).

PORTABLE ALTAR

Attending Mass was an important duty for a good Christian, and whether in one's own home or on one's travels, prayer in front of a suitable devotional image, often a > diptych, was also common. Suitably consecrated portable altars, often constructed from semiprecious materials and small enough to fit in a saddlebag, were also plentiful from the Middle Ages onwards.

PORTRAITURE

The evocation of a physical (and sometimes spiritual) likeness in painting and sculpture goes back to the > Egyptians, who for royalty and gods chose an > idealized impression, but a > naturalistic one for most mortals. The > Greeks adopted from them

the heroic and idealized portrait, but eschewed naturalism (and attendant physiognomical description) until Hellenistic times, when we find for the first time an almost >caricature-like exaggeration of physical features. The >Roman Republic sometimes went for the same 'warts and all' approach, but the Empire, tapping the art of the Greek world it now largely owned and whose artists were in its employ, usually chose the heroic, idealized image. In the >Renaissance both idealized and naturalistic approaches were used, inspired by surviving examples from antiquity. Examples of attitudes to portraiture are also clearly seen in >coins and >medals.

Portraiture occurs when living individuals are highly valued, but there are also traditions of likenesses (as with the Apostles and Christ) that are generic and highly stylized rather than specifically physiognomical. Hence the Middle Ages passed on the stylized pseudo-portraiture of the holy figures to the Renaissance, and at the same time people of position (bishops, kings, abbots) were frequently represented characterized through their attributes, but we find few indisputable portraits before the 12th century since individual likeness – nowadays perhaps the crux of a portrait – was of little interest. Following the Renaissance emphasis on the individual (partly based, as already noted, on antique example), portrait painting and sculpture became (and still remain, despite the incursions of >photography) one of the staples of European art, providing more bread to more artists than >history or religious painting ever did.

● James D. Breckenridge, *Likeness: A Conceptual History of Ancient Portraiture* (1969); Jane B. Friedman, *An Iconological Examination of the Half-Length Devotional Portrait Diptych in the Netherlands 1460–1530* (1977); Desmond Shawe Taylor, *Genial Company: The Theme of Genius in Eighteenth-Century British Portraiture*, exhibition catalogue, Nottingham University (1987); *The Georgians: Eighteenth-Century Portraiture and Society* (1990).

POSTER ART

With the growing commercialism of the 19th century, publicly posted paper advertisements for goods and services became popular, as >graffiti for the same purpose always had been. Artists were commissioned to produce posters, often as >lithographs, Toulouse-Lautrec being the best-known example. In the 20th century, the term has increasingly taken on political overtones (for example during the Russian Revolution, in post-Mao China, or in Paris in 1968), as the poster has been used as >propaganda to sway the emotions as well as the mind.

● Harold F. Hutchison, *The Poster: An Illustrated History from 1860* (1968); Alain Weill, *The Poster: A Worldwide Survey and History* (1985).

POST-IMPRESSIONISM

Although the >Neo-Impressionism of Seurat is 'post'-Impressionist in one sense, the term usually denotes those artists, from van Gogh to Cézanne, who were influenced by, or who reacted to, >Impressionism, and who would otherwise be difficult to categorize. The term originated in the title of an >exhibition – 'Manet and the Post-Impressionists' – organized by Roger >Fry in 1910–11. There is no stylistic unity or

common agenda between the Post-Impressionists. Thus while Seurat, for example, sought the aid of science to analyse the Impressionists' > colour sensations; van Gogh, after adopting an Impressionist > palette, moved towards > Expressionism; Gauguin, whose early > manner was likewise Impressionist, developed a > Symbolist use of colour; and Cézanne, perhaps the most radical of them all, reconstructed pictorial space, rendering Impressionism, in his oft-quoted phrase, 'something durable like the art of the museums'. In terms of linking the 19th and 20th centuries, the artists mentioned above formed the principal conduit connecting early > Modernism to > Fauvism, > Cubism and beyond.

● J. Rewald, *Post-Impressionism from van Gogh to Gauguin* (new edn 1978); *Studies in Post-Impressionism* (1986); G. H. Hamilton, *Painting and Sculpture in Europe*: 1880–1940 (3rd edn 1981).

POST-MODERNISM

As implied by the use of the prefix 'post', which simply means 'after', Post-Modernism is a critical term that suggests either the influence of, or the reaction to, > Modernism. Used only rarely in the 1960s, then increasingly in the 1970s, especially in relation to the > architecture of Robert Venturi (also a notable theorist, with studies including *Complexity and Contradiction in Architecture* (1966)), Post-Modernism has come to mean a break with the concerns of > Modernism. With hindsight, many of the shifts in consciousness that characterize Post-Modernism – such as the embracing of > popular culture, the use of technology and the electronic media, multimedia events and > feminism – were issues of the 1960s.

Among the most striking features of Post-Modernism has been its espousal of 'theory', a term frequently used to ward off searching questions about artistic intention, reference and meaning. However, for some artists as well as critics, a positive use of 'theory' has become an indispensable entry point into art, a position from which the terrain may be seen to advantage. Examples of this are the attack on the role of the artist (> auteur theory) and the 'recycling' of images from the art of the past and from advertising, challenging the Modernist notion of the > avant-garde as well as embroiling Post-Modernism in an open-ended dialogue with popular culture.

These changes have not been universally welcomed. Frederic Jameson in his seminal essay, 'Post-Modernism and the Consumer Society', attacked these notions for robbing art of its social context (and potential for political intervention), reducing it to mere imagery, a 'signifier in isolation', with meaning only within the narrow confines of Post-Modern discussions on art. While many contemporary artists such as Jeff Koons actively embrace this dimension of art practice, ably exploiting the art world's congenital insecurity over language, innovation and money, others, for example the German > Neo-Expressionist Anselm Kiefer, have profited from the overthrow of Modernism by returning to a dialogue with history, in this artist's case with his country's Nazi past. Whether or not the term Post-Modernism survives, it is clear to some that a sea change has been effected in art since the 1970s, one that will see a fundamental shift in values. Only the long-term direction of the shift remains unclear.

● Andreas Huyssen, *After the Great Divide*: *Modernism, Mass Culture, Post-Modernism* (1987);

F. Jameson, 'Post-Modernism and the Consumer Society', in *Post-Modern Culture*, ed. H. Foster (1985); K. Honnef, *Contemporary Art* (1988); Charles Jencks, *What is Post-Modernism?* (rev. edn 1987); L. Appignanese and G. Bennington, *Post-Modernism* (1986; 1989); E. Ann Kaplan, *Post-Modernism and its Discontents: Theories, Practices* (1988).

POST-PAINTERLY ABSTRACTION

The name derives from the title of an > exhibition curated by Clement > Greenberg at the Los Angeles County Museum in 1964. By Post-Painterly Abstraction Greenberg meant to give a name to an otherwise heterogeneous group of > artists who had, in various ways, reacted to the gestural or > painterly > abstraction of the > Action painters. Post-Painterly Abstraction is characterized by non-calligraphic washes of > colour that do not distinguish between the painting itself and the thing represented, but fuse the two into an art work that 'represents' nothing but itself. Leading practitioners include Morris Louis, Kenneth Noland, Ellsworth Kelly and Al Held.

● *Three American Painters: Kenneth Noland, Jules Olitski, Frank Stella*, exhibition catalogue, Fogg Art Museum, Cambridge, Mass. (1965); *Morris Louis*, exhibition catalogue, Tate Gallery, London (1974).

POST-STRUCTURALISM

The term refers to a school of thought which challenges many of the beliefs of the > structuralists, principally arguing that signification (that is, the signs or processes we use to make sense of the world) is unstable and only structured, if at all, momentarily. This led Post-structuralists such as Jacques Derrida to formulate a theory of > deconstruction where the impossibility of ever fixing on one transcendent meaning is affirmed. The importance of this for the study of the visual arts, so the arugment goes, is that > art historians need to be aware that signification is a slippery concept, and the search for a central meaning, an immutable identity (such as the > connoisseur's notion of 'authenticity' (> attribution)) futile. Furthermore, the means – i.e. language – employed by the historian to undertake these explorations is not itself value-free, but open to a kind of dialectic process where it might abruptly cease to be the tool of analysis and become the object analysed. Thus a new challenge to > historiography is to make the discipline of art history aware of its own limitations and strategies.

● T. Eagleton, *Literary Theory: An Introduction* (1983; 1985); M. Sarap, *An Introductory Guide to Post-Structuralism and Postmodernism* (1989).

POUNCING

The act of hitting a porous bag loaded with lampblack or powdered > charcoal against a > cartoon. The cartoon will already have had the lines pricked through, so that a dotted line following the cartoon design is transferred to the wall or panel ready for painting.

POUSSINISTES vs. RUBENISTES

A shorthand designation for a dispute – sometimes known as the debate between line and > colour – within the 17th-century French > Academy in which the Poussinistes, who advocated the > Classical values of line (> *disegno*), reason and restraint, were opposed to those championing the > painterly > Rubens as the leading exponent of the expressive use of colour. (This is not to say that either Poussin or Rubens would have wanted to be associated with this kind of reductionist thinking.) Although in the 1670s the Poussinistes, led by the director of the Academy > Lebrun and its historiographer > Félibien, held sway, at the end of the century the critic Roger de > Piles's championship of Rubens put the colourists on top.

PRADO

Founded in Madrid in 1818 as the Spanish Museum of > Fine Art, the gallery houses the royal > collections of the Habsburg and Bourbon kings of Spain. Because of the political reach of the royal families and their involvement with > artists, the galleries are rich in the works of the > Early Netherlandish > school, Titian, Rubens, Goya and, of course, Velásquez.

PREDELLA

The small paintings forming the lower section of a large > altarpiece or > polyptych, and often dedicated to > narratives of incidents from the life of the saint depicted in the larger panels.

● Arno Preiser, *Das Entstehen und die Entwicklung der Predella in der italienischen Malerei* (1973).

PRE-RAPHAELITE BROTHERHOOD

(PRB). A movement formed in 1848 by a group of young English > artists who wished to recapture the directness and simplicity of painting before Raphael. The seven founder members were William Holman Hunt, Dante Gabriel Rossetti, John Everett Millais, James Collinson, Frederick Stephens, Thomas Woolner and the art > critic William Michael Rossetti, brother of Dante. Although not a member of the Brotherhood, Ford Maddox Brown was associated with the group.

The movement was intensely literary. When Hunt and Rossetti compiled a 'List of Immortals' in 1848 they included far more writers than artists. As the art historian J. Whiteley has noted, 'It is difficult to think of another group of artists that wrote so much poetry or painted so many pictures inspired by it.' Patronized (> patronage) by English industrialists who admired their fidelity to > nature and didactic subject-matter, they aimed to restore to painting a moral seriousness lacking in the stale > academic art of their time, and in their early works frequently turned to Christian themes and episodes from > mediaeval and > Romantic authors, supplemented by sentimental themes common in 19th-century > narrative painting. They painted in

strong > colour on a wet white > ground (in imitation of the technique of > fresco), thereby giving their pictures a brilliant quality quite different from mid-century painting and not equalled until the > Impressionists. Believing that art since Raphael had ignored nature, they painted directly from nature, giving all the elements in a painting equal value.

When the meaning of the initials PRB was disclosed, the group was vehemently attacked for its views, but was defended by > Ruskin. The members of the group soon grew apart. Millais abandoned PRB painting for an academic style, whilst Rossetti moved into the circle of William > Morris. Holman Hunt alone continued to use the technique to express his religious and social convictions.

● *The Pre-Raphaelites*, exhibition catalogue, Tate Gallery, London (1984); D. Cherry and G. Pollock, 'Women as a Sign in Pre-Raphaelite Literature: A Study of the Representation of Elizabeth Siddall', *Art History*, 7 (1984); K. D. Kriz, 'An English Arcadia Revisited and Reassessed: Holman Hunt's *The Hireling Shepherd* and the Rural Tradition', *Art History*, 10 (1987); J. Whiteley, *Pre-Raphaelite Painting and Drawings* (1989).

PRIMARY COLOURS

Namely red, yellow and blue, so called because any > colour in the visible spectrum may be mixed by blending them together.

PRIMING *See* > Ground.

PRIMITIVISM

The awareness of human societies other than one's own has, throughout history, tended to be characterized in opposition to domestic familiarities out of which notions of self-esteem are nurtured. Most often this 'otherness' in Western > culture has been construed in detrimental relation to the known social formation, that is, as 'primitive'. The basis for this is the arguably erroneous view that Western > civilization has progressed beyond this 'primitive' stage exhibited by some non-European societies. However, this has not prevented European art being challenged and sometimes invigorated by the concept of either the distant past or the geographically distant.

The art of 'primitive' cultures has had important consequences for many Western art movements, for example Oceanic art on the > Post-Impressionist Gauguin, African tribal sculpture on Picasso's *Les Demoiselles d'Avignon* (1906–7), and the illustrations of primitive art in the > Blaue Reiter Almanac. More recently, critics have become wary of employing 'primitive' as a critical concept implying 'inferior' or 'underdeveloped', as we now recognize the artistic production of these cultures to be a highly developed expression of societies that are different but not necessarily inferior to our own.

The term primitive may also be applied to artists who work in an unsophisticated or > naïve > manner outside the prevailing orthodoxy or traditional norms of, for instance, > perspective, > narrative structure or similar pictorial conventions. Artists celebrated

for their 'primitivism' include Henri Rousseau, the German > Expressionists and > folk artists such as Grandma Moses.

A final and now discredited use of the term is its application to some forms of European art, for example the Italian painters of the period before the > Renaissance and > Early Netherlandish painters such as the van Eycks and Rogier van der Weyden. This sense of primitive as 'precursor' possibly derives from the French *primitif*, meaning early.

● S. Hiller, *The Myth of Primitivism: Perspectives on Art* (1991); Joseph Rykwert, *On Adam's House in Paradise: The Idea of the Primitive Hut in Architecural History* (1972).

PRINCETON INDEX OF CHRISTIAN ART

A card index, with illustrations, of the > iconography of Christian art, and now being computerized. *See* ICONCLASS.

● Helen Woodruff, *The Index of Christian Art* (1942).

PRINT

The transfer of a master design from wood or metal on to > paper (usually), the number of impressions to be pulled depending on the resilience of the plate or block. There are three main types of process: 1. relief, such as > wood engraving and > woodcut, where the design prints from the proud surfaces, the unwanted (i.e. those that will print white) areas having been cut away; 2. intaglio, such as > etching and > engraving, where > ink is forced into the cut channels, which will print, whilst the surface of the plate is wiped clean in order to print white; and 3. surface, such as > lithography, which is based on the antipathy of water to the grease in the > crayon used. Each method leaves tell-tale signs by which it may easily be identified (although > photographic methods can sometimes be deceptive), and > catalogues of the main printmakers' work exist detailing changes to the plates (whether by the > artist or after his death), each of which constitutes a new 'state' distinguishable from others, and sometimes also > copies and > imitations.

Prints are an essential tool for the > art historian not simply because they are themselves art, but because they reflect the diffusion of > styles, > forms and ideas from country to country and century to century. As evidence, they are much more abundant than paintings or > drawings: for example, the Bibliothèque Nationale can produce well over 30,000 prints dealing exclusively with the French Revolution.

● William M. Ivins, *Prints and Visual Communication* (1953).

PRIX DE ROME

Founded by Colbert in 1664, a French government scholarship administered by the > Academy to enable young > artists to study in Rome for a period of five (later

reduced to four, then three) years. When the 'Académie de France' in Rome – a branch of the Academy – was established in 1666 to promote the value of studying the art of the past, it offered an institutional base for the painters, sculptors and > architects who received the Prix. The importance of the prize rests on its promotion of > history painting, and by extension (since notionally all academically trained students aimed for honours), on its stranglehold over the training (> art education and training) curriculum. Winners were selected after having undergone examination in > life drawing, compositional > sketching and the execution of a finished history painting. Laureates of the Prix include Fragonard, Houdon and David in the 18th century and Ingres, Flandrin, Baudry and Bouguereau in the 19th. Its prestige increased until the late 19th century, when the value of art based on the study of the > antique declined. It was not abandoned, however, until the educational reforms of 1968 abolished the 'Grands Prix'. Today candidates for the Rome scholarship are selected by committee.

● A. Boime, *The Academy and French Painting in the Nineteenth Century* (1971); P. Grunchec, *Les concours des Prix de Rome: 1797–1863* (1986); J. Laurent, *A propos de l'Éole des Beaux-Arts* (1987).

PROOF

A > print pulled from the plate by the > artist or artist's agent before the plate is handed over for production. A 'proof before letters' is a print before the titling and other information have been added to it. The practical reason for taking proofs is so that the artist may check the work, and perhaps make changes to the plate. Proofs can therefore be important indicators of the artist's thinking (as with Rembrandt), and therefore invaluable for > art historians, but the practice has been latched on to and distorted by commercial considerations, whereby higher prices are squeezed from an ignorant public for early evidence of an artist's > genius.

PROPAGANDA

For Bernard Shaw, a definition of 'All great art and literature'. In common parlance, we tell the truth, whereas the enemy churns out propaganda (just as we have governments and they have regimes). The word means 'those things which need to be put forward' (as in the institution in Rome known as the Propaganda Fide), in order to persuade people of the justice of a particular point of view.

In general terms, then, all art – all the arts? – is propaganda for something, whether a 'world view', a prince or a religion. Its propaganda value is one of the reasons why so many hard-headed rulers from Pericles to Augustus to Pope Urban VIII to Hitler have devoted so much time and investment to art and > architecture. In other words, they have considered that the enormous costs usually involved in this form of concealed advertising have short-term as well as long-term benefits, even when the Treasury is exhausted in the process: long after death, their works survive, giving them the continuing fame that is (said Balzac) the sunshine of the dead. The Parthenon, Trajan's Column, the > mosaics of Monreale, the Sistine Ceiling and war-bond posters from the Second World War, all are propaganda. The Parthenon, paid for quite illegally with the treasure of the Delian League, confirmed Athens' image of herself as the very visible

leader of all Greece; Trajan's Column was erected for the admiration of visitors to the multistorey > Greek and > Roman libraries that flanked it; and the Sistine Ceiling and the whole of the Chapel proclaim and confirm the key position of the > papacy and the commissioning papal family in the history of the world and of the Church.

● James A. Leith, *The idea of art as propaganda in France 1750–1799: a study in the history of ideas* (1965); Anne-Marie Leander Touati, *The great Trajanic frieze: the study of a monument and of the mechanisms of message transmission in Roman art* (1987); Zybnuk A. B. Zeman, *Spelling the war: art and propaganda in World War II* (1978).

PROPORTION

In the 6th century BC Pythagorean philosophers noted a concordance between the ratios dividing the string of a musical instrument and the notes of the octave that resulted. Numbers could therefore be linked to > beauty, and the relationship between the numbers needed to produce beauty was strictly governed by proportion – a set of ratios, divine harmonies erected by the Almighty, not for nothing called The Divine Geometer. From this it was but a short step to believing beauty to be the result of properly applied mathematical formulae, whether dealing with the human body, or the proportions of a painting or building. Indeed, the practice of laying out buildings according to mathematical convention goes back at least to the > Egyptians.

Studies in geometry and proportion run, therefore, throughout the history of art. > Villard de Honnecourt drew human faces and bodies as geometrical figures; Donatello and > Alberti studied and measured the > antique in order to discover the > canon that would unlock the secrets of beauty; and > Dürer did likewise, basing his inquiries on both contemporary Italian studies and > Vitruvius. In architecture, Palladio (> Palladian) devised a system of proportion for his villas with the same intention, whilst in painting the use of the > Golden Section was common.

The notion of canons of proportion was perpetuated by the > academies, not least because this form of mathematics was teachable. But scholars from Alberti to Roger de > Piles and Sir Joshua > Reynolds conceded that number was not everything, and that beauty, whether generated by an ancient Roman or by a contemporary, was in the eye rather than the measuring-rule of the > beholder.

● H. E. Huntley, *The Divine Proportion: A Study in Mathematical Beauty* (1970); Erik Iversen, *Canon and Proportion in Egyptian Art* (2nd edn 1975); Erwin Panofsky, *The Codex Huygens and Leonardo da Vinci's Theory of Art* (reprint 1971).

PROVENANCE

The history of the ownership of a work of art from the time of its making up to the present. A provenance able to keep track of an art work in this way is the surest guarantee of a work's authenticity (> attribution). Such a pedigree is used by both > art historians and > connoisseurs as a secure basis on which to build.

● M. J. Friedländer, *On Art and Connoisseurship* (1942).

PROVINCIALISM

An approach to art (or morality, politics, or any other field of human endeavour) that prizes the values of the periphery rather than those of the centre. Provincialism in art espouses subject-matter and exhibits stylistic characteristics that are old-fashioned, conservative, traditional and vernacular, rather than the advanced, often exploratory and sometimes innovative ones of the city. The opposition between the metropolitan and the country or provincial outlooks is probably as old as art itself: influential > patrons lived their political and social lives in cities (or country estates as big as cities, such as Versailles), and artists in any medium who could not or would not serve the fashions of the city therefore had to cater for a radically different audience.

If being behind the times – recapitulating, as it were, traditional themes and > styles – is one aspect of provincialism, then another revolves around quality. Just as echoes of metropolitan styles survive in the provinces, sometimes for generations or even centuries, so a misunderstanding of their original appearance or content, coupled with an inferior training, often leads to art works of low quality, indeed crudity, being turned out in large quantities by unsophisticated admirers of metropolitan art for a scarcely educated clientele. Examples include the production of > sarcophagi and stelai in the provinces of the Roman Empire, or popular > prints at any period from the 16th century, such as the *Images d'Epinal*.

We may also use the city/province dichotomy in international terms, so that centre/periphery can be applied to > Florence with > Rome in the 15th century, to Italy with France and England in the 16th and 17th centuries, and then to France with England or England with the new United States in the 18th century. In all these cases, the > imitator begins by being provincial (though often using imported artists to guard against this), but then becomes its own centre, and develops provincial peripheries of its own.

PSYCHOANALYTIC THEORY OF ART

Theories of art that focus on the psychic life not of whole societies or periods but of individuals (albeit seen as part of societies) may be called psychoanalytic. By these means > art historians attempt to discover the particular neuroses, sexual preferences, repressions and desires of a given individual in order to explain his or her art. Most pertinent to a discipline such as art history, which studies factors as ineffable as > creativity, is the psychoanalytic theory of the 'sublimation' of desire into a socially acceptable activity. In this way, psychoanalysis offers a motivation for the making of art, perhaps the most famous example of this approach being > Freud's study of > Leonardo. A difficulty with the psychoanalytic approach, however, is that its theories cannot be tested, and its > methodology tends to determine the outcome, a fact not lost on those, like the philosopher Karl Popper, who are antagonistic to prescriptive theorizing.

Freud's interest in the unconscious was enthusiastically taken up by the > Surrealists, who saw his studies of dreams as central to their own desire to disrupt the norms of perception. But their own difficulty, namely that of articulating the unconscious, is shared by a psychoanalytic theory of art in general, which finds it hard to prove the connection between psychosis and the form it takes in art. For example,

are the acidic > colours and tortuous contours of van Gogh's paintings a manifestation of the artist's madness or of > Expressionism, which shares many stylistic conventions with him?

● L. Bersani, *The Freudian Body: Psychoanalysis and Art* (1986); P. Fuller, *Art and Psychoanalysis* (1980); J.J. Spector, *The Aesthetics of Freud: A Study in Psychoanalysis and Art* (1972).

PSYCHOLOGY OF PERCEPTION *See* Gombrich.

PURISM

A 20th-century movement, led by the painter Amédée Ozenfant and the > architect Le Corbusier, against the decorative tendencies of > Cubism and in favour of an impersonal, ordered > machine aesthetic. The movement's two protagonists jointly published *Après le Cubisme* (After Cubism) (1918) and *La Peinture Moderne* (Modern Painting) (1925). The philosophy of the movement has had greater influence on > design than on the > fine arts.

● C. Green, 'Purism', in *Concepts of Modern Art*, ed. T. Richardson and N. Stangos (1974).

PUTTO

A little boy, 'cherub' or 'amorino'. Derived from the naked or sparsley draped children who often decorated > antique Roman friezes, especially on > sarcophagi, the pagan putto easily converts into the Christian > angel, and appears in both guises in > Renaissance art.

Q

QUADRATURA

A type of > illusionism where walls, or more usually ceilings or vaults, are decorated with architectural elements that appear to be extensions of the room's real > architecture. Although some artists did all the work themselves, it was common to employ a *quadraturista* who would design the architecture (first on squared-up paper and then on to the surface to be painted) so that it would look correct. *See* > *Sotto in su*.

● Ingrid Sjostrom, *Quadratura: Studies in Italian Ceiling Painting* (1978).

QUARREL OF THE ANCIENTS AND MODERNS

A running dispute, active for most of the 17th and 18th centuries, on the relevance and relative worth of > antique and modern art. The difference revolved around the excessive reverence accorded to the ancients by those who held it as an article of faith that modern art might and should seek to match that of antiquity, but could never surpass it, and the confidence of others in contemporary achievements that, as they reminded their adversaries, were unknown in antiquity. The quarrel (as between > Diderot and Falconet, for example) may seem silly today, but it affected attitudes not merely to > Renaissance art and the > Classical tradition, but also to the teaching of art in the > academies. Some sought to strike a balance: 'Speak of the moderns without contempt', wrote Lord Chesterfield to his son in 1748, 'and of the ancients without idolatry: judge them all by their merits, but not by their age'.

● August Buck, *Die 'Querelle des anciens et des modernes' im italienischen Selbstverstandnis der Renaissance und des Barocks* (1973); H. R. Jauss (ed.), *Charles Perrault: Parallèle des anciens et des modernes en ce qui regarde les arts et sciences* (reprinted 1964); Stanley Rosen, *The Ancients and the Moderns: Rethinking Modernity* (1989); Jean Seznec, *Essais sur Diderot et l'antiquité* (1957).

QUATTROCENTO

The 'four hundreds' – that is, the 15th century in Italian art.

R

RAPHAEL'S BIBLE

> Frescos of biblical scenes in the Loggie of the > Vatican designed by Bramante. They were executed under Raphael's direction by his assistants in the later teens of the 16th century.

RAYONISM

(Variously spelled Rayonnism or Rayism). An early 20th-century > avant-garde movement, led by the Russian artists Goncharova and Larionov, which claimed to be a synthesis of > Cubism, > Futurism and > Orphism. In practice this meant that it attempted, as had Futurism, to represent the action of 'lines of force' – light rays – on moving or stationary objects. It was influential on > Constructivism.

READY-MADE

From 1913, the > Dada > artist Duchamp began to exhibit mass-produced non-> fine art objects, such as a bottle rack and a urinal, as art. His purpose was twofold: to isolate the ready-made from its functional everyday environment and reveal its aesthetic potential, and to challenge the accepted limits of fine-art practice.

REALISM

This difficult term, since it is by definition relative, must constantly be redefined in light of the art under discussion; it cannot be referred to in the abstract. It is not a synonym for > naturalism or > illusionism, nor does it describe a mirror image of the world. Neither is Realism (the capital 'R' denotes the movement) synonymous with 'realism' (used to describe a quality). Historically, Realism is the offspring of the > Romantic interest in finding > beauty in the bizarre or the conventionally ugly, and is epitomized by the mid-19th-century artist Gustave Courbet. The > school focused on worker and peasant scenes depicted in a gritty or earthy > manner, for example Courbet's *Burial at Ornans* (1849), in which > composition and application of > paint mirror the down-to-earth nature of the subject-matter.

But one may also speak of realism in art both earlier and later than the 19th century. Giotto is realistic in the sense that his compositions are psychologically plausible, and Caravaggio is a realist in his representation of > biblical characters as 'real' people.

Thus realism is the opposite of > idealism, and may be widely applied to paintings as different as Rembrandt's *Jewish Bride* (1669) and Chardin's *La Raie* (1728). More recently, realism has been used to designate the work of those, like Lucian Freud, whose > figurative paintings tacitly oppose > Abstract Expressionism, but the term in this last sense is inadequate, a work being 'realist' only in the sense that it is not > abstract.

● L. Nochlin, *Realism* (1971); B. Taylor, *Modernism, Post-Modernism, Realism: A Critical Perspective for Art* (1987).

RECEPTION AESTHETICS

Under this heading may be grouped those approaches to art that focus not on the > artist but on the > beholder. This represents for some a justified > revision of those approaches where the attention paid to the artist (> Romanticism), or to the art work (> formalism or > iconography) is too exclusive to include the beholder in the process of signification. A leading exponent of reception theory was the French literary theorist Roland Barthes, and in the domaine of > art history proper, Michael Fried's *Absorption and Theatricality: Painting and the Beholder in the Age of Diderot* (1980) and T. Crow's *Painter and Public Life in Eighteenth-Century Paris* (1985) are good examples of studies that privilege the beholder as the generator of > meaning.

● T. Eagleton, *Literary Theory: An Introduction* (1983; 1985).

RED-FIGURE VASE PAINTING

The later of the two methods of > Greek vase painting (after *c.*530 BC) and preferable to > black-figure in that the natural reddish clay > colour could be used for the body of the human figures. The technique was much more > naturalistic and indeed subtle than black-figure because it involved the draughtsman > sketching often lively and expressive figures against a black background. This is the technique that captivated Europe in the 18th century in the form of > Etruscan vases, and led to the nervous linearity of late 18th-century > Neoclassicism.

● John Boardman, *Athenian Red-Figure Vases: The Archaic Period. A Handbook* (1975); *Athenian Red-Figure Vases: The Classical Period. A Handbook* (1989); Tom Rasmussen and Nigel J. Spivey, *Looking at Greek Vases* (1991).

REFORMATION

The reform of the Universal Church in the early 16th century, at first from within but ultimately from without by those who protested against her worldly excesses as well as against her theology. The various Protestant Churches set up as a result profoundly influenced the nature and scope of art in those countries where they flourished, and this impacted upon the employment of > artists. In reaction against the rich furnishing, paintings and sculptures of the Roman Church, the Protestants favoured simplicity, and

church commissions declined as a result. This is not to say that Protestant art is a-religious – witness the work of Rembrandt – but rather to underline the Reformation as a trigger helping the breakup of the old artistic hierarchies (> genres, hierarchy of) and the validation of fields such as > genre and > landscape painting, as well as private, devotional religious painting, all of which (often with nationalistic tinges) are to be found in, for example, 17th-century Dutch art.

However, if art in the North changed its complexion, the Roman Church fought back with the > Counter-Reformation, which offered a new programme of vigorous church building and decoration for artists in Catholic countries.

● Erik Larsen, *Calvinistic Economy and Seventeenth-Century Dutch Art* (1979); Craig S. Harbison, *The Last Judgement in Sixteenth-Century Northern Europe: A Study of the Relation Between Art and the Reformation* (1976).

REFUSÉS, SALON DES

In 1863, the selection jury of the official > Salon in Paris was particularly harsh in rejecting a large number of works. Following a petition to Emperor Napoleon III by the rejected artists, the Moniteur Universal announced, on 24 April 1863, a 'Salon des Refusés' in which those rejected by the jury could exhibit their work. Among those who exhibited was Manet, whose *Déjeuner sur l'herbe* (1863) was the most celebrated refusal and the main object of public mockery. Whistler, Pissarro, Boudin, Jongkind and Cézanne also exhibited.

● A. Boime, 'The Salon des Refusés and the Evolution of Modern Art', *Art Quarterly*, XXXII.4 (1969), pp. 411–26; G. Lacambre, 'Les institutions du Second Empire et le Salon des Refusés', *Atti de XXIV Congresso Internazionale di Storia dell'Arte*, 7 (1979), pp. 163–75.

RELIEF PRINTING

A method of printing in which the design is on the proud surface of the block (usually a > woodcut or > wood engraving), and the areas to be printed as white are cut away. *See* Print.

RELIEF SCULPTURE

A type of sculpture where the designs or figures are anchored to a determinable planar surface. Sometimes they stand out in low relief (for example, some of the bas-reliefs of Donatello); sometimes the figures are almost fully three-dimensional (Ghiberti's Gates of Paradise, or much > Classical > sarcophagus sculpture). In > marble low relief, sensitive atmospheric effects and a suave delicacy may be achieved; high relief is equally skilful, as the nearly three-dimensional figures (which are sometimes given metal accoutrements to increase verisimilitude) must be carefully worked if they are to remain intact. Relief sculpture is a mainstay of > architectural decoration (see, for example, the

Parthenon), but sometimes the figures are separately worked and then attached to the marble or stone backing.

● Leonard R. Rogers, *Relief Sculpture* (1974).

RENAISSANCE

Usually defined as the rebirth of art in Italy under the influence of > antique models, the term originated in the > quattrocento itself, with its > revival of interest in > Classical texts and learning, from history to law. The concept was therefore an intellectual one before it was a strictly artistic one.

Chronologically, it has a much wider application than just the 15th century, as can be seen from the title of Erwin > Panofsky's *Renaissance and Renascences in Western Art*. Rather than simply accepting the convention of starting the Renaissance in sculpture with the competition for the bronze doors of the Florence Baptistery in 1401, Panofsky makes it clear that the Italian Renaissance is by no means the only example of the phenomenon of rebirth in the arts, having been preceded by a whole series of > mediaeval rebirths, from Charlemagne (> Carolingian art) and the Ottonians to the 12th century in France. Indeed, it is easy to use the same term to describe the 12th century in the North (for example the work of Renier of Huy) and the 13th century in Pisa (Nicola Pisano's 1260 pulpit in the Baptistery), periods that also predicated their art and > architecture in some measure upon that of the > Classical past. In painting, if the influence of Classical models is the measure, we should surely begin with Giotto (*c.*1267–1337) rather than with Masaccio (1401–28).

A problem with the term itself is that 'rebirth' must imply death and is thus a value judgement upon those benighted individuals who did not acknowledge antique illumination. > Vasari is a good example of this attitude since the whole of his approach towards the 'progress' of the arts depends upon picking the winners – those interested in antiquity and > nature – from the losers – those apparently stuck in the slough of the > International Gothic. This is simply a caricature of how the arts he chose to describe actually developed.

Renaissance forms of art, concerned as they were with the reconstruction of the Classical past to fit the > humanistic, > naturalistic and political horizons of the day, were for all these reasons immensely popular. The 'product' (it was rather, perhaps, an approach to the world) was imported to > courts throughout Europe, often by Italian artists, architects, scholars and musicians. To periodize, we might say that the Renaissance ended when > Mannerism (itself succeeded by the > Baroque) began. But this is only partly true, for all movements in European art up to > Realism and > Impressionism depended on Renaissance forms and ideas, a hegemony maintained and increased by the > academies, and sustained by the continuing (if declining) artistic importance of the Italian Peninsula up to the end of the 18th century.

● Michael Baxandall, *Painting and Experience in Fifteenth-Century Italy* (1972); Phyllis P. Bober et al., *Renaissance Artists and Antique Sculpture: A Handbook of Sources* (1986); Andre Chastel et al., *The Renaissance: Essays in Interpretation* (1982); Sydney Freedberg, *Painting of the High Renaissance in Florence and Rome*, 2 vols (1961); Michael Levey, *High Renaissance* (1975); *Early Renaissance* (1977); Millard Meiss, *The Painter's Choice: Problems in the Interpretation of*

Renaissance Art (1976); Erwin Panofsky, *Renaissance and Renascences in Western Art* (1960); Warren T. Treadgold, *Renaissances Before the Renaissance: Cultural Revivals of Late Antiquity and the Middle Ages* (1984); Martin Wackernagel, *The World of the Florentine Renaissance Artist* (Eng. trans. 1981); Roberto Weiss, *The Renaissance Discovery of Classical Antiquity* (1969).

REPLICA

A > copy of a work made by the > artist or executed under his or her direct supervision. The reasons for making replicas are many, but the most common are the success of a > composition (Champaigne); to satisfy two or more > collectors (Chardin); to provide > patrons with a cheaper 'by the studio of' version (Rubens); and, not infrequently, lack of imagination (Ingres?). *See also* Reproduction.

● M. J. Friedländer, 'Artistic Quality: Original and Copy', *Burlington Magazine*, LXXVIII (1941), pp. 192–7.

REPOUSSOIR

(From the French *repousser*, 'to push back'). A pictorial device much used by > academic > landscape painters in which elements in the foreground are used to 'frame' the > composition. Thus Claude in *Landscape with the Father of Psyche Sacrificing to Apollo* (1660–70) has placed a copse of trees, typically rendered as near-silhouettes, to the right foreground and a > Classical temple to the left, thereby prompting the eye to wander towards a distant sea port and mountains painted with a very pale > palette. As a means of 'setting back' part of the composition, it is most often used in conjunction with the recessional devices of linear and > aerial > perspective.

● E. H. Gombrich, *Art and Illusion* (1960).

REPRESENTATIONAL PAINTING

A term most commonly denoting paintings that adopt a > figurative approach to subjects which form part of the everyday world. For example, a > still life by Chardin is a representational painting. In this sense it is the opposite of > abstract art. However, the > Surrealists Magritte and Dalí employed a representational technique to portray objects that had no reality outside their imaginations. Therefore, while representational painting may not be equated with either > naturalism on the one hand, or > realism on the other, it remains in the popular mind the touchstone of artistic normality, and the standard by which painting is judged. This, of course, quite overlooks the conventional nature of all representational painting.

● S.J. Blatt, *Continuity and Change in Art: The Development of Modes of Representation* (1984); E.H. Gombrich, *Art and Illusion* (1956; 1977).

REPRODUCTION

The multiplication of an > original art work or design by mechanical means. Reproduction may be in either three dimensions, such as > plaster casts, or in two

dimensions, for example images made by the techniques of > woodcutting, > engraving or > etching. While a > bronze made from a > maquette by Rodin is a kind of reproduction, permitting a foundry to make any number of > 'copies' of Rodin's original, reproduction most commonly serves to make multiple copies of an independent art work, for instance the six engraved scenes of Hogarth's *Marriage à la Mode* (1742–4). Engravings of this kind are called reproductive engravings. A similar kind of reproduction would be a plaster cast of the > *Laocoön*.

The invention of the printed book provided an impetus for the production of illustrations. These early prints were woodcuts, that is, > relief prints in which a raised surface receives the ink. The invention of the technique of intaglio printing, where the ink is held in a groove cut into a metal (usually copper) plate, improved the precision of the image which could cope with much more detail. As a means of reproduction, the engraving allowed engravers to publicize the work of > fine artists, for example Marcantonio Raimondi's engravings after the work of Raphael. Indeed Raphael owes his pre-eminence among artists to the quality and availability not only of his own works, but also of their reproductions.

Until the 19th century little changed. Works of art continued to be reproduced by engraving, aided by the development of new techniques such as etching (where the copper plate is bitten back with acid to provide the vehicle for the ink); > mezzotint (the plate is roughened to accept the ink); and > aquatint (the surface is treated with powdered resin). The invention of > lithography early in the 19th century meant that the artist was able to draw directly on to the stone. This was important as it meant that the lithographic print did not express the artist's ideas second hand, but directly. However, all of these mechanical means of reproduction shared an inability to reproduce the material properties of the original. In response to this failure, manual copies offered a reproduction imbued with the human touch. > Museums of these copies, such as the Musée des Copies in Paris, and the Cast Court at the > Victoria and Albert Museum in London, offered the public surrogate originals. But the advent of > photography, seen erroneously as translating an original without interposing its own processes, cost the manual copy its audience.

The invention of photography led to the development of photo-mechanical reproductive processes such as photo-engraving, in which the original to be copied is photographed on to a sensitized zinc plate which is then immersed in acid, which etches away the areas to be inked (as in the intaglio method of printing). Modern colour printing such as we see today is a reproductive process based on the successive overprinting of three, sometimes, four, colours to give the reproduction a full range of lifelike tones. But no more than the woodblock are these prints able to transcribe the true material aspect of the original, and nor can they possess what Walter > Benjamin called the 'aura' of the art work – its living presence in space and time. Following Benjamin, John > Berger based an important chapter of his *Ways of Seeing* on the impact of reproductions on our perception of art. Today colour slides and colour illustrations are the tools of > art historians, students of > art history and large numbers of the public. However, although a reproduction facilitates access to any number of images, it also distorts and, if Benjamin and Berger are right, impairs our ability to experience directly the authentic art work.

● W. Benjamin. 'The Work of Art in the Age of Mechanical Reproduction' in *Illuminations* (2nd imp. 1977), pp. 219–55; J. Berger, *Ways of Seeing* (1972); P. Duro, ' ''Un Livre Ouvert

l'Instruction": Study Museums in Nineteenth-Century Paris', *Oxford Art Journal*, 10/4 (1987), pp. 44–58

REREDOS *See* Altarpiece.

RESTORATION OF ART WORKS

The restoration of art works has become increasingly specialized in response to the escalating value of art and the ethics of art appreciation which demand that the integrity of an art work should not be materially altered by later generations.

Whereas the > conservation of art works is essentially preventative and aims to keep the art work in the best conditions possible to ensure its future well-being, a more radical intervention would consist of the partial or total restoration of damage. Here the aim is to replace or stabilize areas of damage or loss. Common examples of restoration in > oil painting include the strengthening of a > canvas by relining and the replacement of > paint loss on the surface, while works on > paper are often bleached to remove 'foxing' (mould grown from impurities in the paper).

The effects of restoration are often spectacular. Anyone who has seen a yellowed coat of > varnish removed to reveal often brilliant tones will appreciate the effects of cleaning. However, such actions are not without risk. Overcleaning, where not only varnish but also the final > glazes are removed, risks a loss of subtlety, resulting in a harsh and insensitive surface, – a criticism that has been levelled at many restorations of the works of Titian, for example, and more recently at the major restorations of Michelangelo's > frescos in the Sistine Chapel. A responsible restoration will allow both the specialist and the public to distinguish between original elements in the art work and restoration.

Unlike the restorers in the past (often artists in their own right and quite often commissioned by the owner to bring an art work 'up to date'), modern restorers shun overpainting and only apply paint where necessary, such as to a repair. If the repair is large, a restorer will usually apply a uniform tone to indicate that this work is not part of the original > composition. This implies that the restorer should go no further than ensuring the continued well-being of the art work, and certainly stop short of undermining the integrity of the original artist's conception or execution. However, the line between thoughtful restoration and unwarranted interference is a fine one and open to debate.

● H. Kuhn, *Conservation and Restoration of Works of Art and Antiquities* (1986); H. Ruhemann and J. Plesters, *The Cleaning of Paintings* (1969); G. Thomson (ed.), *Recent Advances in Conservation* (1963).

REVISIONISM

Originally a term denoting deviation from > Marxist orthodoxy, it now means, in > historiography generally, reconsideration of accepted or > canonical ideas. In > art history it often refers to the work of historians engaged, often in a confrontational manner, in the re-establishment of derelict reputations, for example those of 19th-

century French > Salon painters such as Thomas Couture or Jean-Léon Gérôme. These revisions are not always accepted by those holding more orthodox opinions (for instance in the example given, > Greenbergian > Modernists), on the grounds that such artists have justly been allocated a minor place in art history. Against this, the revisionists would argue firstly that the construction of a history, such as Modernism, is an exercise in value judgement; and secondly that Couture and Gérôme were of great importance in the 19th century and are therefore worth studying today (this is a > historicist position). A balanced opinion might hold that while it is a historian's duty to revise the canon in the light of new thinking or new data, the fact that the canon exists does not make it automatically open to revision.

REVIVALISM

Much of > art history is the history of revivals – the resurrection of forms and ideas slightly or radically adapted to suit new contexts and horizons. Most revivals are not simply stylistic, but have an intellectual rationale and often echoes or originations in literature. Nor is revivalism frequently a protest against the > taste of the time; rather, it is complementary, succeeding if it fills a need, failing otherwise. The > Renaissance was a revival of > Classical ideas and themes, as was Fascist art and > architecture under Mussolini (> Novecento Italiano). In both cases, a programme is identifiable, but such assimilation of the past is not necessarily a bar to > originality or innovation.

However, although there have always been revivals (> mediaeval revivals of Early > Christian art; > Baroque interest in Hellenistic (> Greek art) antiquity; 19th-century revivals of the Middle Ages), in the 18th and 19th centuries the phenomenon was especially strong and varied. Thanks to trade, travel, scholarship and conquest, a whole series of non-European revivals occurred, including Indian, > Chinese and Persian, but they were short-lived because of interest to only a few, and impractical to apply thoroughly except in the > decorative arts. The > Greek and > Etruscan Revivals were much stronger, being part of the > Classical tradition, itself a constant in European arts.

Perhaps the strongest of all the European revivals were the mediaeval > Romanesque and, especially, > Gothic movements, not only because they mirrored a developing interest in history, but because they helped fulfil specific yearnings to reinvigorate national pasts. (The same applies to the Colonial Revival in the United States.) France, England, Scotland, Wales and the German states all gave their separate flavours to these movements, bolstered by mediaeval literature (some of it recently > forged) and by the belief that Gothic was a suitable language for church > architecture which matched the Classicism largely accepted for civic life.

REWALD, JOHN

(1912–). German American > art historian whose impressive scholarship from the 1940s onwards largely set the agenda on > Impressionism until the 1970s, when > revisionist tendencies pointed to his lack of interest in women artists such as Berthe Morisot on the one hand and subject-matter on the other. His books include the classics *The History of Impressionism* (1946), *Post-Impressionism: From van Gogh to Gauguin* (1956); *Studies in Impressionism* (1985) and *Studies in Post-Impressionism* (1986).

REYNOLDS, SIR JOSHUA

(1723–92). > Portrait painter, the most important English contributor to 18th-century art > theory and first President of the > Royal Academy. Unlike most of his painter contemporaries, Reynolds was born into an educated family (his father was a former Fellow of Balliol). Reynolds in later life could count Samuel Johnson, Burke, Goldsmith and Garrick as his friends. His ideas and career mark a high point in English painting, offering the > artist a way out from the provincial 18th-century fascination with > genre and > landscape painting in favour of an anglicized version of the > Grand Manner. After a brief training with the portraitist Hudson from 1740 to 1743, he went to Italy (1750–2) to study the works of Michelangelo, Raphael and Titian. On his return to England he set up as a society portraitist in London. His knowledge of the art of the past elevated his portraits from their lowly genre as > copies of > nature to something near > history painting, for example in *Garrick Between Tragedy and Comedy* (1762).

His success in marrying portraiture and history painting was such that when the Royal Academy was founded in 1768 Reynolds was the natural choice for its first President. Few painters believed more firmly than Reynolds in the dignity of the artist and the prestige of the > fine arts when informed by > Classical learning. In his 15 *Discourses* delivered to Royal Academy students between 1769 and 1790, Reynolds argued for the practice of painting as a reasoned, principled and moral discipline governed by rules and attainable, at the highest level, through hard work and application. For Reynolds > 'beauty' was neither a personal nor a particular quality, but the representation of the > ideal behind the > form. In practice this meant avoiding the mean, the ugly and the wicked in favour of the pictorial representation of virtue. His ninth discourse put this most succinctly: 'The art which we profess has beauty for its object; this it is our business to discover and to express; but the beauty of which we are in quest is general and intellectual; it is an idea that subsists only in the mind . . . which, if it does not lead directly to purity of manners, obviates at least their greatest deprivation, by disentangling the mind from appetite, and conducting the thoughts through successive stages of excellence, till that contemplation of universal rectitude and harmony which began by Taste, may, as it is exalted and refined, conclude in Virtue'. These views were commented on by Hazlitt and violently attacked by > Blake.

Reynolds's frequent transgressions of these rules in his own work serve only to enliven what might otherwise have proved to be a damaging influence if too rigorously applied. His Grand Manner is an amalgam of Classical poses and allusions executed with a > painterly *élan* that owes much to > Rubens and the > Baroque. Taken together, Reynolds's theories and practice were the single most important advance in English art and taste since the arrival of van Dyck. Reynolds is a paradigm of the cosmopolitan, well-bred, learned artist for whom the > academies were the institutional embodiment of great art, and history painting the ultimate justification.

● E. H. Gombrich, 'Reynolds' Theory and Practice of Imitation', *Burlington Magazine*, LXXX (1942), pp. 40–45; R. W. Lee, *Ut Pictura Poesis: The Humanistic Theory of Painting* (1967); J. Reynolds, *Discourses on Art*, ed. R. R. Wark (1959; 1981).

RIJKSMUSEUM

In Amsterdam. Begun by Louis Bonaparte in 1808, the > collection is rich in the works of Rembrandt (some transferred from the city), Vermeer, 15th-century masters, and 17th-century > landscape painters.

RILA

Even a conscientious student can read no more than a portion of the ever-increasing literature of > art history, let alone for more than one country or period. All disciplines now offer excerpting services that scan a stated range of the periodical literature month by month (or sometimes weekly, quarterly or yearly) and list what appears under a more or less useful set of categories. RILA, the *Répertoire Internationale de la Littérature d'Art*, was begun in 1975, and is now available on CD-ROM. It was merged with the *Répertoire d'Art et d'Archéologie* in 1991 to form the *Bibliography of the History of Art*.

ROCOCO

At the beginning of the 18th century the amalgam of the > Baroque with elements of > Classicism that had characterized the > court art of Louis XIV gave way after his death to the lighter, more playful and private art of the Rococo, which demonstrated a need for elegance and comfort quite absent from the 17th century. Stylistically, while the Rococo continued the complexities of Baroque surface structure, it treated it as pure decoration, justified only in so far as it charmed the eye and amused the senses. Although Rococo was essentially a > decorative art, the period produced some magnificent painters, such as Watteau, Boucher and Fragonard in France, Tiepolo, Longhi and Guardi in Italy and Hogarth and Gainsborough in England. Very different stylistically, these painters nevertheless all share the common traits of the period: a move away from the grandiloquent > history painting of the 17th century towards a smaller, more intimate art, a love of decorative effect, a lightness of touch often revealed by a > bravura and sparkling application of > paint, and (though this was not universal) erotic or amorous subject-matters, typified by the > fête champêtres of Watteau.

In > architecture, interior decoration and porcelain manufacture (Sèvres and Meissen were the leaders), the Rococo exhibited a love of intimacy, with the ubiquitous asymmetrical curves of its surface structures, transforming an interior into a pastel-coloured confection reminiscent of a wedding cake. In Bavaria and Austria the Rococo survived until the end of the century, but in France it had given way to the new austerity of > Neoclassicism by the 1770s.

● A. Schönberger and H. Soehner, *The Age of Rococo* (1960); T. Pignatti, *The Age of Rococo*, trans. L. Andrade (1969); W. G. Kalnein and M. Levey, *Art and Architecture of Eighteenth-Century France* (1972).

ROMAN ART

The art produced under the Roman Republic and the Roman Empire. This is a term as broad as that > civilization itself.

Until recently, the art (and > architecture) of the Roman Republic and Empire received a bad press from most > art historians. It was criticized as commonplace, plebeian and crude, its good features being merely derivative of > Greek and Hellenistic art and its bad ones the result of the influence of barbarians who could not appreciate the importance and > beauty of the human figure.

Even accepting that the heavy > revivalism of the Fascist period in Germany and Italy did not help, such attitudes are puzzling given the evident importance of Roman artistic traditions – and the clearly minimal importance of Greek ones, except through the filter of Rome – for the > Renaissance, which everyone agrees was A Good Thing. Indeed, the study of Roman art illuminates much of later Western art, for Roman civilization passed on many of its attitudes and achievements to later cultures, and it was on these that they built their own > styles. Recent re-evaluations of Roman art have presented it as vigorous, original and diverse; and studies of its influence on later centuries have confirmed this view. If 'What is history but the praise of Rome?', then for many later periods, 'What is art history but the praise of Rome?'.

The reasons for the durability of Roman forms are various: the Empire was widespread throughout Europe, the Near East and North Africa, leaving behind monuments that later ages found difficult or impossible to match but fascinating to > imitate and even to reuse; Roman law, roads, writing, literature and bureaucracy were immeasurably influential upon civilizations enthralled by the > Classical tradition; the Christian Church had taken up and disseminated Roman art in its churches and its own art; and, above all, the available forms were very varied indeed, offering models in all branches of the > fine and > decorative arts, as their adoption by the > academies almost as a > canon underlines. Above all, the quantity and quality of the architecture and other antiquities in the city of > Rome surpassed anything available until the opening-up of Asian Minor and North Africa.

● Bernard Andreae, *The Art of Rome* (1977); Otto J. Brendel, *Prolegomena to the Study of Roman Art* (1979); Anne-Marie Leander Touati, *The Great Trajanic Frieze: The Study of a Monument and of the Mechanisms of Message Transmission in Roman Art* (1987).

ROMANESQUE

Used especially of sculpture and > architecture with features derived from > Roman antiquity, the term describes a > style that flourished especially in those areas where > Roman art and cultural influence through art works had been especially strong, such as Provence, Sicily and Central Italy, although the great extent of the Empire meant that the style found favour from Spain to Britain and from Germany to the Holy Land. In architecture, the characteristics of the style are the use of rounded barrel vaults, with large expanses of wall pierced by slit windows and often a wall decoration imitating the Classical > Orders, as well as acanthus friezes and > inhabited scrolls. In large-scale sculpture (revived after the millennium thanks largely to the influence of > antique example) the figures took on an antique elegance after the dumpy, earlier > mediaeval

mannequins (see, for example, the figures on the Arch of Constantine), and frequently had faces and hair modelled after Classical figures. Flowing Classical dress also reappeared.

The readoption of antique styles seems only infrequently to be value-neutral – done for style's sake only, as it were. In most instances a conscious desire to tap into the prestige of the antique can be assumed, if rarely proven, along with an awareness of the value and power of traditional forms.

● Kenneth J. Conant, *Carolingian and Romanesque Architecture, 800 to 1200* (3rd edn 1973); Joan Evans, *The Romanesque Architecture of the Order of Cluny* (1971); Pierre Francastel, *L'humanisme roman: critique des théories sur l'art du XIe siècle en France* (1971); Anton Legner (ed.), *Ornamenta Ecclesiae: Kunst und Kunstler der Romanik*, exhibition catalogue (1985); Victor Lassalle, *L' influence antique dans l'art roman provençal* (1970); Meyer Shapiro, *Romanesque Art* (1977).

ROMANTIC CLASSICISM

A term coined from two apparently opposing terms and used to characterize the confused art of the early 19th century, especially in France. The existence of this > style, seen, for example, in the art of > Géricault, demonstrates not only that > Romanticism was far from being the opposite of > Classicism (as the famous but inaccurate opposition of > Delacroix to Ingres would suggest), but also that aspects of Classicism were influential in the development of Romanticism. Another way of looking at the matter would be to suggest that any style contains the germs of its opposite; or, more specifically, that the so-called Classicism of the 18th century, with its heavy emphasis on a long-lost past, was basically romantic, because that past could not be recovered. This attitude was a distinct departure from Renaissance Classicism, in which the recovery of antiquity was judged practicable. And if Romanticism was above all focused on the individual, was anti-Establishment and, what is more, had a longing for the distant past, then Romantic Classicism fulfilled a social and political rather than a poetic and individual role.

● Hans Eichner, *'Romantic' and its Cognates: The European History of a Word* (1972); Lorenz Eitner, *Neoclassicism and Romanticism, 1750–1550: Sources and Documents* (1971); Walter Friedlaender, *David to Delacroix* (reprinted 1968).

ROMANTICISM

A late 18th- and early 19th-century movement in the arts. Romanticism rejected the universalizing rules of > Classicism in favour of an emphasis on the > imagination and the relationship of the individuual to > nature, the expression of emotion and a profoundly subjective approach to > beauty. Nevertheless, Romanticism should not be seen simply as the opposite of Classicism, however convenient this might seem. Both approaches > idealized their subjects, eschewing the merely > imitative in favour of the representation of human experience, and both consider > Nature the ultimate referent for the > artist. However, while Classicism imposes order through the use of rules,

Romanticism stresses the uniqueness of the individual and the incompatibility of the Romantic aesthetic with any form of social or intellectual constraint.

The major problem with Romanticism is that no single, adequate definition exists. > Delacroix, seemingly the personification of the Romantic artist, rejected the label, claiming to be 'a pure Classicist', but could accept the appellation when it freed him from the constraining categorizations of > academic painting: 'If one understands by my Romanticism the free manifestations of my personal impressions, my aversion for the stereotypes of the schools and my repugnance for academic formulae, I must admit . . . that I am a Romantic'.

Romanticism exhibited a taste for, and identified with, the wilder manifestations of nature and natural disaster; see, for example, J. M. W. Turner's *Hannibal Crossing the Alps* (1812), in which an Alpine storm threatens to rout Hannibal's army, or Caspar David Friedrich's *Arctic Shipwreck* (1824), in which a ship is mercilessly crushed by great ice floes. Such paintings represent a break with the > ideal landscapes of Classicism, where humanity is seen to be in harmony with nature, in favour of a model where the individual is in conflict with his or her surroundings (> sublime). Another disaster, this time a shipwreck, allowed Théodore Géricault to link the individual's conflict with nature to political conflict. His *Raft of the Medusa* (1819) depicts the story of the *Méduse*, wrecked with tragically high loss of life due to the incompetence of a royalist captain. Likewise, Delacroix's *Liberty Leading the People* (1830) represents revolution, while Francisco de Goya's *The Third of May, 1808* portrays the suffering shared by all victims of unrest.

The Romantic attitude is, on the one hand, specific to the aspirations and philosophy of the generation following the French Revolution, expressed for the most part through a distrust of classicizing rules that occlude the personal dimension, and a horror of incipient industrialization, as well as of institutions and conventions. On the other hand, the Romantic emphasis on the individual, its scepticism about whether the past could teach the future, and not least its belief that art should be concerned less with imitating appearances and more with the expression of emotion, survived the advent of > Realism to contribute to the foundation of modern art.

● M. H. Abrams, *The Mirror and the Lamp* (1953); K. Clark, *The Romantic Rebellion* (1973); H. Honour, *Romanticism* (1986); W. Vaughan, *Romantic Art* (1985).

ROME

The epicentre of > Roman art and the Roman Republic and Empire, the City (the capital 'C' is appropriate and was always used) is also the focus of that > civilization's finest monuments, carefully guarded and even increased by the > papacy. Indeed, that the city survived at all is due to its adoption as the papal capital. Compared with other parts of the Empire, Rome's remains have survived remarkably intact, thanks to the decline of the City's importance in the 4th century and to low population levels during the Middle Ages and later; she did not fill the space within her 3rd-century walls until the end of the 19th century.

Whilst elsewhere in Europe (France, the United Kingdom, northern Italy) pressure of population meant that many antiquities were destroyed for building materials or burned for lime mortar (> destruction of art works), Rome continued to be a main focus of interest in the > antique. Thus the Middle Ages saw her remains plundered and carried

off to Pisa and Monte Cassino, for example, whereas during the > Renaissance artists such as > Brunelleschi and Donatello went there to measure her remains and draw from her statues, only to return to Florence or other northern states to create their art. However, from the later 1420s the revived papacy, newly re-established in Rome from Avignon, sought as a matter of policy to rival the Roman emperors in their building and other artistic projects. They attracted the chief artists of the High Renaissance and > Baroque to build and decorate their palaces, as well as those of the clerical and civil aristocracy.

From the 16th century, just as the peninsula was exporting the Renaissance to the rest of Europe, so foreign artists began to visit Rome to improve their art and drink at the fountainhead of > Classical culture, from the Netherlanders and > Rubens to Vouet, Poussin, Inigo Jones and then David and a host of British in the 18th century. The City's importance continued during the ascendancy of the > Grand Tour, although tourists continued to denude her of her portable treasures. Foreign governments, recognizing her centrality for > art education, established schools in Rome, the French being the first in the 17th century. These still flourish, now for > archaeological as much as for artistic purposes, but the epicentres of art creation have moved away to elsewhere in Europe, North America and Asia.

● Ferdinand Gregorovius, *History of the City of Rome in the Middle Ages* (many editions, translations and abridgements); Giovanni B. Passeri, *Vite de' pittori, scultori ed architetti che hanno lavorato in Roma* (1976); Maragert M. Scherer, *Marvels of Ancient Rome* (1955); Lindsay Stainton, *British Artists in Rome*, 1700–1800, exhibition catalogue, Kenwood (1974).

ROSE + CROIX, SALON DE LA

An annual > exhibition in Paris between 1892 and 1897 of > Symbolist art, organized by Joséphin Péladan, the leader of the mystical brotherhood of Rosicrucians.

ROTULUS *See* Scroll.

ROYAL ACADEMY OF ARTS, London.

Founded in 1768 under royal > patronage, the Royal Academy marked Britain's very late provision of > academic training for her > artists. Behind its foundation was the desire to encourage and develop a national school of art (such as the French and Italians, thanks to their > academies, already possessed), and to provide a market for art by raising the levels of public > taste. Annual exhibitions were to be held, and professors appointed in > design, anatomy, > architecture, painting and > perspective and geometry. The best known of these was > Reynolds, who as Professor of Painting defined the parameters of artistic training for generations. As with the French Academy across the Channel, it was seen in the later 19th century as the supporter of tradition and mediocrity against the exciting innovations of the > avant-garde.

● Sidney C. Hutchinson, *The History of the Royal Academy 1768–1986* (1986).

ROYAL COLLEGE OF ART

London. Founded in 1837 as the School of Design to train students in the applied (>decorative) and industrial arts, the College underwent several moves and changes of name before becoming the Royal College of Art in 1896. In 1961 it moved to its present buildings in Kensington Gore.

● C. Frayling, *The Royal College of Art: One Hundred and Fifty Years of Art and Design* (1987).

RUBENS, PETER PAUL

(1577–1640). Flemish painter of the early >Baroque, he trained himself largely in the popular >Italian manner, which he adapted for Northern tastes. The very type of the educated (indeed scholarly) artist, he was at ease with kings, princes and cardinals because he 'spoke their language'; indeed, he was at home in Latin, French, Italian, Spanish, English, German and Dutch. Well travelled, well read and urbane, he was frequently entrusted with diplomatic missions. As well as writing a short treatise (*On the imitation of antique statues*), he redefined the political dimensions of painting (cf. the cycle of paintings he did for Maria de' >Medici now in the >Louvre, or the Whitehall Banqueting House ceiling in London); his many letters to scholars, >patrons, dealers (>art dealing), diplomats and other artists give a vigorous picture of his manifold activities; his manner spread through the many >prints made after his work; his general example – the nature and range of his art – influenced the Flemish School for almost a century; and finally, his published book illustrating the >triumphal arches, stage sets, paintings and other decorations he designed for the Triumphal Entry of Ferdinand of Austria in Antwerp in 1635 not only broadened the range of his achievements, but also provided models for later generations.

● A. Michael Jaffe, *Rubens and Italy* (1977); Ronald Millen, *Heroic Deeds and Mystic Figures: A New Reading of Rubens's Life of Maria de' Medici* (1989); Jeffrey M. Muller, *Rubens: The Artist as Collector* (1989).

RUSKIN, JOHN

(1819–1900). English writer and >critic on art and >architecture, and an admirer and >patron of Turner. In *The Seven Lamps of Architecture* (1849) and *The Stones of Venice* (1851–3), he proclaimed that the art of a nation is an expression of national aspirations and spirit (>Zeitgeist). Ruskin's attachment to >Italy, especially to Venice and Tuscany and the early >Renaissance, as well as his distaste for industrialization and what he believed to be its cheapening effect on human beings and on art, are themselves fine expressions of the contemporary *Zeitgeist*, reflecting current interests and preocupations. Thus Ruskin the Utopian socialist reformer (or, rather, the impractical Oxford >idealist) was crucial for William >Morris and the >Arts and Crafts Movement (as well as for similar movements abroad).

Noted for the force of his opinions, his court case with Whistler in 1877 (when the

latter sued him for denouncing *Nocturne in Black and Gold* as 'flinging a pot of paint in the public's face') is a symbolic landmark in the development of modern art.

● Michael W. Brooks, *John Ruskin and Victorian Architecture* (1987); Elizabeth K. Helsinger, *Ruskin and the Art of the Beholder* (1982).

S

SACRA CONVERSAZIONE

A formal grouping, usually painted but sometimes in sculpture (e.g. by Donatello) of the Virgin and Child surrounded by saints. The format is > mediaeval, but its popularity in Italian art was extensive during the > Renaissance, for example in several of the > altarpieces of Giovanni Bellini.

● Millard Meiss, *La sacra conversazione di Piero della Francesca* (1971).

SACRED ART *See* Christian art.

ST IVES PAINTERS

A group of 20th-century English > figurative > Modernists who worked in St Ives in Cornwall from the outbreak of the Second World War. The most important were Ben Nicholson, Barbara Hepworth and Patrick Heron.

SALON DES REFUSÉS *See* Refusés, Salon des.

SALON PAINTING

So named after the 19th-century Paris > Salon. With the rise of > exhibitions, artists began painting pictures expressly for public display. Important exponents of the > style include the mid-century artists Thomas Couture, Charles Gleyre, Jean-Léon Gérôme, Paul Baudry, Ernest Meissonier and Adolphe-William Bouguereau, all of whom showed a willingness to offer the public what they desired – legibility, > narrative, exoticism and frequently lascivious > nudity in subjects borrowed from literature or the more sensational episodes of the historical past. Typical examples of the > genre include Alexandre Cabanel's *The Birth of Venus* (1863) and Paul Delaroche's *The Execution of Lady Jane Grey* (1834).

● J. C. Sloane, *French Painting Between the Past and the Present 1848–1870* (1951); A. Boime, *The Academy and French Painting in the Nineteenth Century* (1971); *Thomas Couture and the Eclectic Vision* (1980); G. M. Ackermann, *The Life and Work of Jean-Léon Gérôme* (1986).

SALONS

> Exhibitions of contemporary art in Paris. From the 17th century, the French
> Académie Royale de Peinture et de Sculpture held exhibitions of members' work.
Although at first these were infrequent, after 1737 they became regular biannual
events. The name 'Salon' derives from the practice of holding exhibitions in the Salon
Carré in the > Louvre. In the 19th century Salons were held (usually) annually,
although revolution and government policy occasionally reduced their frequency. After
the Revolution they were no longer the exclusive domain of the academicians; instead
a jury – usually biased in favour of > academic painting – selected the work for
exhibition.

Housed at the beginning of the 19th century in several rooms in the Louvre, then
briefly in the Palais Royale, the Salon moved in 1857 to the Palais de l'Industrie on the
Champs-Elysées. The average number of submissions grew by mid-century to some
4,000 works of art, of which about half would be accepted for display. Selection was
open to abuse, and in 1863 the outcry from artists was so great that Napoleon III
ordered a parallel Salon, the Salon des > Refusés, to exhibit the works rejected by the
jury, including Manet's *Déjeuner sur l'herbe*. By the beginning of the 1880s, submissions
had risen to more than 7,000 with almost 4,000 exhibited. The government withdrew
its official mandate and from 1881 the Salon was managed by the newly formed
Société des Artistes Français. This change spelt the end of a system whereby one
exclusive Salon could dominate French art. In 1884 the Société des Artistes
Indépendants, an > avant-garde faction led by the > Neo-Impressionists, founded a
juryless salon, the Salon des Indépendants. In 1890 another breakaway faction, the
Société Nationale des Beaux-Arts, led by Rodin and Puvis de Chavannes, held a
separate Salon, the Salon de la Nationale, sometimes called the Salon du Champs de
Mars after its location. Finally, in 1903, the Salon d'Automne was established by a
circle around Matisse and Bonnard.

While many independent and avant-garde artists eschewed the pre-1881 'official'
Salon, others such as Manet continued to submit work. Towards the end of the century,
the Salon as a battleground between progressive and conservative tendencies became
less important as the progressives increasingly either exhibited independently with
dealers (> art dealing) such as Goupil and > Durand-Ruel in one of the independent
secessionist Salons, or, like the > Impressionists from 1874, organized their own shows.
However, for the general public the 'official' Salon (after 1881 the Salon des Artistes
Français) remained, up to the First World War, the most visible showcase of con-
temporary art.

● A. Boime, *The Academy and French Painting in the Nineteenth Century* (1971); J. Whiteley,
'Exhibitions of Contemporary Painting in London and Paris 1760–1860', and P. Vaisse,
'Salons, expositions et sociétés d'artistes en France 1871–1914' in *Atti del XXIV Congresso
Internazionale di Storia dell'Arte*, 7 (1979); T. Crow, *Painters and Public Life in Eighteenth-Century
Paris* (1985); L. Eitner, *An Outline of Nineteenth-Century European Painting*; vol I (1987), pp.
275–81; P. Mainardi, *Art and Politics of the Second Empire: The Universal Exhibitions of 1855 and
1867* (1987); Neil McWilliam, *A Bibliography of Salon Criticism in Paris from the Ancien Régime to
the Restoration* (1991).

SAND PAINTING

The making of designs and pictures in sand, often with ritual connotations, is known from the > North American Indians to the Australian > Aborigines. In most cases, the work is destroyed after serving its magical, religious, healing or other purposes.

SANGUINE

Red > chalk or crayon.

SARCOPHAGUS

Literally, a 'body-eater'. A vessel of > marble or sometimes limestone, more or less decorated, used to contain the corporeal remains of the deceased. The > Classical Greeks cremated their dead, and therefore had cinerary urns or vases. The Hellenistic Greeks, however, often buried their dead in sarcophagi, frequently with full-size representations of the deceased (and sometimes the spouse) on the lid, with magnificently cut representations of the actual or imagined life of the deceased, or mythological stories, on the front and sides (and more rarely the back). The publication of figured examples by the German Archaeological Institute in Rome, begun in 1890, still continues. The > Romans, although they oscillated between cremation and inhumation, > imitated Greek forms, and snobbery caused the rich to have vessels imported from Asia Minor, usually to be finished off by local craftsmen, whilst the not-so-rich had local and less-decorated imitations made.

The thirst for sarcophagi continued into the Middle Ages, long after trade with the East had stopped and local quarries closed down. The demand was satisfied, therefore, by reusing older Christian or even pagan sarcophagi, and recutting them where necessary. Examples are to be found throughout Europe, although the best collections are in the Campo Santo in Pisa and the atrium of Salerno Cathedral.

Given such a tradition, any self-respecting cleric, prince or intellectual of the > Renaissance or later was buried in a sarcophagus, whether a reused one 'borrowed' from elsewhere, or a new one made more or less in the traditional way and even with Christianized semi-pagan motifs. Good examples can be seen throughout Sta Maria del Popolo and in many other churches in Rome, including St Peter's itself and the > Vatican grottoes underneath the present basilica.

● Elizabeth S. Malbon, *The Iconography of the Sarcophagus of Junius Bassus* (1990); Erwin Panofsky, *Tomb Sculpture: Four Lectures on its Changing Aspects from Ancient Egypt to Bernini* (1964).

SAXL, FRITZ

(1890–1948). Austrian > art historian who studied under Max Dvorak in Vienna and Heinrich > Wölfflin in Berlin. In 1929 he became, on the death of Aby > Warburg, Director of the Warburg Institute in Hamburg, a post he held until his death in 1948. In

1944 the Institute was incorporated into the University of London, where Saxl was Professor of the History of the > Classical Tradition.

● G. Bing, 'Memoir', in Fritz Saxl 1890–1948, ed. D. J. Gordon (1957), pp. 1–46; E. H. Gombrich (intro), F. Saxl, A Heritage of Images: A Selection of Lectures, ed. H. Honour and J. Fleming (1970), pp. 9–12.

SCHAPIRO, MEYER

(1904–). American > Marxist > art historian and Professor of Art History (1965–73) at Columbia University, New York. In the 1930s he espoused a > humanistic Marxism in articles such as 'The Nature of Abstract Art' (Marxist Quarterly, 1, 1937), in which he attacked A. H. > Barr Jr.'s analysis of > abstraction as unhistorical and teleological. His work, > eclectic and highly scholarly, exhibits his interest in relating art to the socio-cultural climate that engenders it. He is the author of Van Gogh (1950) and Cézanne (1952). His essays, on topics ranging from > Romanesque art through to > Modernism, have been collected together in four volumes.

SCHILLER, JOHANN CHRISTOPH FREIDRICH VON

(1759–1805). German poet, dramatist and philosopher. As a child of the > Enlightenment, concerned with the themes of personal and political freedom and inspired by the romantic concept of > Classical Greece, Schiller also wrote on aesthetics, defining > beauty as 'freedom in appearance'. His use of themes from North and South in his drama and poems (along with his fervent Christianity) demonstrate the multiple interests of > Romantic Classicism.

● Anthony Savile, Aesthetic Reconstruction: The Seminal Writings of Lessing, Kant and Schiller (1987).

SCHOOL

A term used to describe a group of artists whose work exhibits stylistic, geographical or temporal similarities. In the language of > connoisseurship, when a work is referred to as 'school of' Titian, for example, it means an unattributed work in the > style of, but not by, Titian – perhaps the work of a student or follower. When > 'Bolognese' School is used it means the painting exhibits stylistic traits of that school, without being more closely identified as the work of a particular artist.

SCROLL

The ancestor of the book, common in > Egyptian, > Jewish and Graeco-Roman antiquity. Strips of parchment, papyrus or > paper were joined together to form a continuous scroll, attached at each end to the stick around which it was rolled. The

scroll would usually be unrolled horizontally from the left hand, the already read portions going to the right hand, although some, such as Exultet rolls, could be read top to bottom, the illustrations inverted in relation to the text so that the priest could read the text and the congregation in front of him see the pictures. Representations of ancient philosophers often show them with scrolls kept in a kind of hatbox – a motif commonly used to add 'class' to the representation of the deceased on a > sarcophagus. In late antiquity, the > codex or book gained popularity, which meant that the individual sheets were piled up and sewn together at one edge, with the advantage that both sides of the material could be used, and several volumes could be much more conveniently manipulated at the same time.

● Kurt Weitzmann, *Ancient Book Illumination* (1959); *Late Antique and Early Christian Book Illumination* (1977); *Illustrations in Roll and Codex: A Study of the Origin and Method of Text Illustration* (rev. edn 1970).

SCULP

The way an > artist signed the work. Usually seen preceded by a name – 'he or she sculpted this'.

SCUMBLE

A technique whereby painted outlines are softened by having opaque or semi-opaque > colours painted or rubbed over them.

SECCO

(Italian: 'dry'). The term used to describe > fresco painting made on dry as opposed to wet ('fresco') plaster. It is considered the inferior technique (except for finishing touches) because the resultant > colours tended to be fugitive, especially blues and whites.

SECONDARY COLOURS

Any > colour resulting from the mixing of > primary colours.

SECTION D'OR

(French: > 'Golden Section'). A group formed by a number of artists influenced by > Cubism. They held their first > exhibition in the Galerie la Boétie in Paris in 1912. The core group included Gleizes, Metzinger, Kupka, La Fresnaye, Léger, Picabia, Duchamp and Duchamp-Villon, while on the fringes were Marie Laurencin, André Lhote, Archipenko and Juan Gris. Robert Delaunay also exhibited with the group, thereby

providing a connection with >Orphism. Their aim was to place Cubism on a more theoretically sound footing than the subjective approach of Picasso and Braque. Believing that Cubism needed to go beyond timeless, >still-life themes they adopted >Futurist subject-matters that glorified the dynamism of the modern world. The group splintered at the outbreak of the First World War.

● V. Spate, *Orphism* (1980); C. Green, *Cubism and its Enemies* (1987).

SELF-PORTRAIT

Although there are indications in the literature of ancient art that >artists made self-portraits, none have survived, any more than they have with any certainty from the Middle Ages. The >genre depends upon the heightened esteem of the artist as a suitable subject of his or her own, or, indeed, for inclusion in other scenes. >Dürer's self-portraits, for instance, focus on the artist now as the Man of Sorrows, now as >Renaissance Gentleman. Velásquez's representation of himself in *Las Meninas* is at least partly a statement about the status of artists in general, and this artist in particular. Benozzo Gozzoli was perhaps making a similar point about the fame and glory accorded by art in his *Adoration of the Magi* in the chapel of the >Medici palace in Florence.

Another type of self-portrait is more introspective and open to psychological interpretation (>psychoanalytic theory of art). Although there are many 20th-century examples, the leader here is Rembrandt with some 80 self-representations from the flamboyant to the fashionable to the tragic.

Generally, the offbeat aspects of an artist's involvement in his or her work – psychoses, melancholia, eccentricity, vice – sometimes displayed in the urge to self-portraiture, are a rich field for historical investigation. See R. and M. Wittkower's *Born Under Saturn. The Character and Conduct of Artists: A Documentary History from Antiquity to the French Revolution* (1963).

● Pascal Bonafaux, *Portraits of the Artist: The Self-Portrait in Painting* (1985); Ernst Kris, *Legend, Myth and Magic in the Image of the Artist: An Historical Experiment* (1979); *Staging the Self: Self-Portrait Photography, 1840s–1980s*, exhibition catalogue, National Portrait Gallery, London and Plymouth Arts Centre (1986).

SEICENTO

The 'six hundreds', or 1600–99, conventionally used only of >Italy and its art.

● Denis Mahon, *Studies in Seicento Art and Theory* (1947).

SEMIOLOGY

Also, Semiotics. Since the 1960s >art history, somewhat reluctantly following the lead of literary criticism, has come under increasing pressure to recognize that art, far from

being an exclusive and somewhat mysterious language, shares common ground with other forms of communication, from road signs to mathematical equations. We owe to the Swiss linguist Ferdinand de Saussure the insight that all languages, whether visual, verbal or > symbolic, use 'signs' in a conventional, not natural way. For example, Western > naturalism, which in post- > Renaissance art is a transparent rendering of reality, must recognize that not all human societies will understand the transcription, or wish to portray reality (itself an ideological construct) in the same way. > Aboriginal painters, for example, may represent a snake in a way that bears little relation to the snake in a Renaissance Adam and Eve.

This has led to the rethinking of many of the traditional cornerstones of art > criticism, including that of the > artist's intention (an artist is now seen by some to use a set of predetermined signs, not, as the > Romantics thought, an inspired vocabulary). Roland Barthes, a central figure in the development of semiology, spoke of an author selecting from the 'already written', that is, rearranging not > inventing. Semiotics has opened up further potential for the study of art to embrace not just > fine art but also design, fashion, advertising, film and the mass media, on the grounds that all of these forms employ visual language and therefore share the same discipline. Whether the name of that discipline should remain unchanged, since the designation 'fine' has narrow connotations of artistic worth, is at present under debate. *See* Auteur theory; Structuralism.

● F. de Saussure, *Course in General Linguistics*, trans. W. Baskin (1959); R. Barthes, *Elements of Semiology*, trans. A. Lavers and C. Smith (1967); R. Barthes, 'The Death of the Author', in *Image-Music-Text*, trans. S. Heath (1977; 1989); L. Matejka and I.R. Titunik (eds.), *Semiotics of Art: Prague School Contributions* (1976).

SEPIA

A semi-transparent cuttlefish > ink, much used for > pen and wash drawings.

SERIAL ART

A branch of > Minimalism, in which uniform elements are assembled on a modular principle, as in the brick > assemblages of Carl Andre.

SEZESSION

The name taken by a cascade of German and Austrian movements of the 1890s which broke away from > academic restrictions under the > influence of new > styles such as > Impressionism, > Symbolism and > Art Nouveau. The most famous breakaway was the Vienna Sezession (1987) under Klimt.

● Robert Waissenberger, *Vienna Secession* (1977).

SFUMATO

(From the Italian *fumo*: 'smoke'). The transition from one > colour to another done so gradually and smoothly as to be imperceptible, the colours blending as if they were smoke. It can be seen in the works of > Leonardo, who used the method for psychological as well as atmospheric effect.

SICCATIVE

A substance added to oil paint to make it dry more quickly.

SIENESE SCHOOL

An amalgam of > Byzantine and > Gothic trends brought together in Siena during the 14th century in the works of Duccio, his pupil Simone Martini, and then Pietro and Ambrogio Lorenzetti. Their sweetness, high colouring, love of detail and insistently sinuous line show their part-parentage of > International Gothic. Belonging to a radically different tradition, Sienese art was little touched by Florentine > naturalism, let alone by the worship of the > antique (except perhaps in the stylish productions of Jacopo della Quercia), and the School degenerated until, by the 16th century, it could only offer > Mannerist > imitations of > Leonardo in the works of Il Sodoma and Beccafumi.

● Bruce Cole, *Sienese Painting, from its Origin to the Fifteenth Century* (1980); *Sienese Painting in the Age of the Renaissance* (1985).

SIGNATURE *See* Attribution.

SIGNIFICANT FORM *See* Bell, Clive.

SILHOUETTE

A > paper cut-out, named after its inventor Étienne de Silhouette (1709–67). This cheap form, usually of > portraiture, coincided with a > Neoclassical delight in the simplicity of outline (derived in part from > Etruscan vases), but its popularity declined as > photography began to offer more for a similar cost.

● Sue McKenzie, *British Silhouette Artists and their Work 1760–1860* (1978).

SILK-SCREEN PRINTING

A colour stencil > printing process in which non-printing areas are blocked out and the

colour squeezed through a screen on to > paper or cloth. Similar techniques are applied in the Orient, but its use in the West is known from the time of the First World War, since when it has been very popular.

● Brian Elliot, *Silk-screen printing* (1971).

SILVER POINT

A method of > drawing with a silver stylus, which when worked against a whitish > ground > pigment give a very fine grey line. Popular from the later Middle Ages and in the 15th century both in the North and in > Italy, the technique requires a sure touch, and reworking is possible only by relaying the ground, whether on panel, parchment or > paper.

SIMULACRA *See* Baudrillard, Jean

SINGERIES

(From the French *singe*: 'monkey'). A > mediaeval > symbol for everything from wisdom to sexuality, the ape served a serious philosophical purpose in > Renaissance art and > emblems. The use of anthropomorphic apes and monkeys in the > decorative arts was most popular in the 18th and 19th centuries, especially with the advent of > chinoiserie, when they could replace > classically derived motifs to give an added sense of playfulness and an > Oriental flavour.

● Jurgis Baltrusaitis, *La Moyen Age fantastique: antiquités et exotismes dans l'art gothique* (1955); Horst W. Janson, *Apes and Ape Lore in the Middle Ages and the Renaissance* (reprinted 1976).

SINOPIA

A red ochre used to brush the design on to the > ground plaster in > fresco, before the wet plaster that will receive the visible > paint layer is applied. Modern techniques allow the Sinopia layer to be revealed by removing what is on top of it from the wall, thereby demonstrating more about preparatory techniques, > drawing types, etc. than can be learned from the finished work.

SIZE

A dilute glue or resin added to a surface to reduce absorbency and thus prepare it for > paint or some other coating.

SKETCH

There are several kinds of sketches, but the terminologies distinguishing them are often used interchangeably, although all senses imply a loose finish or preparatory intention. A 'thumbnail' sketch is a small drawing or note recording an idea or > composition. A compositional sketch sets out the broad outlines of a whole composition without regard either to detail or, necessarily, > nature. A > study, however, implies a careful rendering of observed nature and is often used to finalize a figure or other component of a composition before transferring it to a > canvas through > squaring up. By the 19th century the sketch was valued for its spontaneous qualities revelatory of the > genius of the > artist. Although this line of reasoning was opposed by > academic artists, who kept the preparatory sketch phase and the finished canvas separate, the > Impressionists fused the two stages into one process, leaving in their works 'unfinished', sketch-like passages. Contemporary appreciation of sketches makes no distinction between sketches and finished works, seeing admirable qualities in both, but it is important to understand that until the 20th century the sketch occupied a distinct category from that of the finished work.

SKETCHBOOK

A small, portable > drawing-book used to record impressions while travelling or to work out > compositions prior to consigning them to a > canvas, or, in the case of architects, building them. Notable users of sketchbooks include Turner, who recorded many views on his > picturesque tours of England and the Continent, and Degas, whose > studies after older art reveal his interest in the > classical tradition. In the age before > photography or the wide diffusion of > prints, sketchbooks were a vital channel for the dissemination of artistic ideas, and also a means by which we may judge the horizons of > artists and art-making. > Villard de Honnecourt's sketchbook reveals how widely he travelled, whilst many sketchbooks made by > Renaissance artists feature antiquities, and it can be proved that several books were copied and passed from hand to hand throughout the > Italian peninsula.

● Phyllis P. Bober, *Amico Aspertini: Drawings After the Antique. Sketchbooks in the British Museum* (1957); T. Reff, 'New Light on Degas' Copies', *Burlington Magazine*, CVI (1964); L. Herrmann, *Turner: Paintings, Watercolours, Prints and Drawings* (1975).

SLADE

The Slade School of Fine Art, founded in 1871 with money provided by Felix Slade (1790–1868), was quickly recognized as more 'advanced' and less > academic than the > Royal Academy in the teaching of painting, sculpture and the > graphic arts. It has had distinguished > artists as its professors (beginning with Poynter), and has trained many 20th-century British artists.

SLIDE COLLECTIONS

In order to function, every department teaching > art history needs substantial collections of slides – perhaps a minimum of 60,000 – to teach courses on Western art from the Middle Ages to the present day. Slides are bought from the > copyright holders of the various images, and in some cases made from books. Departments usually need at least one full-time > curator responsible for the making, refiling, repairing and updating of such a collection, which deteriorates according to the ambient conditions under which it is stored and the length of time for which each slide is projected, i.e. subjected to intense light and heat. 35mm slides (the same format as most miniature cameras) have now been in vogue for about 25 years, replacing lantern slides of a much larger format. They may survive another quarter-century, but are already being partially replaced for some uses (although not yet for dual projection in lectures) by the > videodisk and by > digital images.

● H. C. Rahn, *Eine ikonographische Klassifizierung von Meisterwerken der Malerei von 1430–1810* (1975); Helene E. Roberts, *Iconographic Index to Old Testament Subjects Represented in Photographs and Slides of Paintings in the Visual Collections*, Fine Arts Library, Harvard University (1987).

SMITHSONIAN INSTITUTION

Washington, DC. Founded by the bequest of James Smithson (1765–1829) in 1846, the Smithsonian is an immense centre for research and education, administering not only the Hirshhorn Museum and the National Portrait Gallery, but the National Gallery of Art as well.

● Paul H. Oehser, *The Smithsonian Institution* (rev. edn 1983).

SOANE, SIR JOHN

(1753–1837). One of the greatest and most original of English > architects, and one whose star has risen again with > Post-Modernism. He left his house in Lincoln's Inn Fields, London and its rich > collections of paintings, > drawings and (especially) architectural fragments and models to the country. The collections formed, as it were, building blocks for his own version of > Neoclassicism, and their 'message' is of the continuing relevance of the > Classical tradition.

● Pierre de la Ruffinière du Prey, *John Soane, the Making of an Architect* (1982); Susan F. Millenson, *Sir John Soane's Museum* (1987).

SOCIALIST REALISM

Following the October Revolution of 1917, Soviet > artists were initially allowed to associate political radicalism with artistic revolution. However, with the rise to power of Stalin, the Soviet regime's dislike of 'bourgeois' > avant-garde > abstraction was

confirmed, the model of 19th-century Russian > naturalist painting preferred instead as more conducive to the dual goals of the representation of revolutionary 'reality' and the education of the masses. This explicitly > propagandist art was the officially approved visual language of Communist regimes in the USSR, China and the Far East. Its hallmarks are clear > narrative structure, > academic > handling of > paint and the > idealized portrayal of the working class.

● M. Parkhomenko (ed.), *Socialist Realism in Literature and Art* (1971).

SOCIAL REALISM

Originating in 19th-century > Realism, Social Realism is less a particular movement than an approach, and the term may be used to describe any > artist, > school or movement examining the conditions of the socially disadvantaged through > representational painting, for example the > Ash-can School. It has been more specifically associated with the artists of the > Federal Art Project of the 1930s, including Ben Shahn and Jack Levine. Outside the USA the work of Diego Rivera and > Neue Sachlichkeit artists Otto Dix and George Grosz may also be considered as Social Realism.

● J. Treuherz, *Hard Times: Social Realism in Victorian Art* (1987).

SOCIETY OF ANTIQUARIES

Granted a charter in 1751, the Society, which still flourishes today and continues to publish *Archeologia* (1770 onwards), is important for its scholarly place in the development of > archaeology and for having helped to fuel the 18th- and early 19th-century > revivals of > Neoclassicism. *See* Antiquarian.

● Joan Evans, *A History of the Society of Antiquaries* (1956).

SOFT-GROUND ETCHING

A variety of > etching in which the > drawing is done not on the resinous surface of the plate, but through an interposed sheet of > paper. The fineness or otherwise of the etched result depends on the characteristics of the paper. The technique has been used since its invention in the late 18th century to mimic > chalk, > crayon, and > pencil. It is important becaue it offers texture as well as lines, hence its frequent combination with > aquatint to offer a simulacrum of a wash drawing (> pen and wash).

SONDERBUND

The name of an > exhibition in Cologne in 1913 which brought together various > Expressionist tendencies. It included the work of the Die > Brücke and Der > Blaue Reiter groups as well as Munch, Gauguin, van Gogh and, as a precursor, El Greco.

SOTHEBY'S

The oldest firm of auctioneers, founded in 1744 by a bookseller, although the primacy in art auctioneering is held by > Christie's. The company began in earnest to auction material other than books only after the First World War. Partly as a result of its acquisition of the American firm of Parke Bernet in 1964, Sotheby's now has branches throughout the world.

● Nicholas Faith, *Sold: The Rise and Fall of the House of Sothbey* (1985); Frank Herrmann, *Sotheby's: Portrait of an Auction House* (1980).

SOTTO IN SU

(Italian: 'From underneath looking upwards'). A form of > illusionism and often of > *quadratura* painting in which extreme > foreshortening is required. In early schemes, such as Correggio's in S. Giovanni Evangelista in Parma (1520–3), the figures tend to hang on clouds or hover in the air, although Mantegna introduced architecture in his Camera degli Sposi in the Castello in Mantua in 1474. From the 17th century, architectural frameworks were especially popular and designed in an intricate fashion whereby everything would appear to 'stand up' from one point only. Andrea Pozzo's vault for S. Ignazio, Rome (1691–4) is a good example, and his work was an exemplar for the flights of the > Rococo under the Tiepoli.

SQUARING UP

A method of transferring a > drawing on to another, usually larger, surface, for example from a > sketchbook to a > canvas. This is achieved by drawing a grid of squares over the picture, then drawing a similar number of squares on to the larger surface. Where the grid intersects the drawing, points are taken and transferred to the corresponding square on the canvas, thereby assuring an accurate transposition of the > proportions.

STAFFAGE

Incidental figures added as makeweights to > landscape paintings in order to add interest, and often painted on contract by someone other than the main > artist of the work, whose expertise will lie elsewhere.

STAINED GLASS

Cut pieces of translucent stained or painted glass fitted together to form a picture within a lead framework, and used in windows, where they are illuminated by the light shining through. The technique is probably of > Byzantine origin, but came to prominence in the West with the transition from the small windows possible in > Romanesque > architecture to the much larger > Gothic expanses technically

engineered in the 12th century and extended in the 13th. The window is made up by laying the pieces on a full-size > cartoon and constructing the > colours and shapes required.

The heyday of stained glass was more or less coterminous with Gothic's, lasting into the later 16th century but then dying out until the > Gothic Revival of the 19th century and the technique's adoption by 20th-century > artists such as Chagall and Matisse. The majority of the great early > compositions – Chartres, the Sainte Chapelle in Paris – are religious, but secular subject-matters (battles, heraldry) also flourished, although much has disappeared through the accidents of time.

● Wolfgang Kemp, *Sermo corporeus: Die Erzahlung der mittelalterlichen Glasfenster* (1987); Andrew Moor, *Contemporary Stained Glass: A Guide to the Potential of Modern Stained Glass in Architecture* (1989).

STANZE

The set of rooms decorated by Raphael and his assistants and collaborators in the > Vatican, often called the Vatican Stanze, or Raphael's Stanze. *See* Raphael's Bible.

STIJL, DE

(Dutch: 'The Style'). An art movement founded by the painter and > architect Theo van Doesburg in Leiden in 1917. Founder members of the group included the painter Mondrian, the sculptor Vantongerloo, the architect J. J. P. Oud and the designer and architect Rietveld. In October 1917 van Doesberg started a magazine, *De Stijl*. Mondrian's article 'The New Plastic in Painting' best expresses their ideas for a universal, elemental art divorced from the need to serve > representation: 'The new plastic art . . . can only be based on the abstraction of all form and colour, i.e. the straight line and the clearly defined > primary colour.'

'Neo-Plasticism' (a name by which De Stijl is alternately known) rejected figuration as the goal of art and replaced it with the pared-down vocabulary of elemental shapes and > primary > colours, thereby allowing art to express its own > 'plastic' language free of the concerns of representation. The > artist in this environment became less the author of a subjective art work than the agent of a universal harmony. The depersonalization of the art work was carried through into the execution, which was also anonymous and impersonal, as in Mondrian's *Composition with Red, Yellow and Blue* (1930), although many De Stijl paintings are > abstractions of natural phenomena, for example van Doesburg's *Rhythms of a Russian Dance* (1918).

In the 1920s, while Mondrian's work adhered to the strict principles of Neo-Plasticism, van Doesburg sought to broaden the influence of the movement into architecture. The austere forms of De Stijl were well suited to the geometric structures favoured by the > International Modernist movement, while the primary colours favoured by the painters could be used as decorative elements to articulate an otherwise plain façade, as in Oud's Café de Unie in Rotterdam (1925). Likewise, Rietveld's Red-Blue chair (1918), painted in primary colours, offers itself for analysis alongside a Mondrian painting.

The principles of De Stijl art and > design had considerable influence on the > Bauhaus in the 1920s, and after Mondrian's emigration to New York in 1940, in the USA.

● P. Overy, *De Stijl* (1969); K. Frampton, 'De Stijl', in *Concepts of Modern Art*, ed. T. Richardson and N. Stangos (1974); Hans L. C. Jaffé (ed.), *De Stijl: 1917–1931. Visions of Utopia* (1982); N. J. Troy, *The De Stijl Environment* (1983); C. Blotkamp et al., *De Stijl: The Formative Years* (1982; 1986).

STILL LIFE

A painting or > drawing of fruit, flowers, game or household objects. The > genre of still life is mainly associated with the northern European > schools, for example the German, > Dutch and English. While still lifes were painted in > Renaissance art, it was only as background or in a supporting role to human action, as in the brilliantly executed still life of the basket of fruit in the foreground of Caravaggio's *Supper at Emmaus* (1598–1600). In some art, for example by van Eyck, what appears to be a still life might more probably be considered as an > emblematic or > symbolic representation.

True still life is concerned with the representation of intimate objects of the day-to-day world for its own sake, free of any symbolic or hierarchical function. Its popularity in 17th-century Holland is no doubt partly due to the twin factors of the lack of ecclesiastical > patronage and the rise of a merchant class who appreciated paintings both as aesthetic objects and as commodities. Some of these still-life paintings were also > vanitas, warning the > beholder of the folly of taking comfort in the tangibility of the everyday, while others were disguised biblical (> Bible) themes. In the 18th century the still life found a great exponent in the French academician Chardin, but he remained something of an exception. The weakening of the hierarchy of the genres (> genres, hierarchy of) in the 19th century saw this formerly inferior form become a vehicle for the > avant-garde in the work of the > Impressionists and van Gogh, but most especially in Cézanne, who invested the still life with all the structural and perceptual complexities once reserved for > history painting. The 20th century has seen still life continue as a legitimate form of expression for artists, but without the revolutionary potential of either the 17th or late 19th centuries.

● S. Alpers, *The Art of Describing: Dutch Art in the Seventeenth Century* (1983); Norman Bryson, *Looking at the Overlooked: Four Essays on Still-Life Painting* (1990); John M. Nash, *The Age of Rembrandt and Vermeer: Dutch Painting in the Seventeenth Century* (rev. edn 1979); Charles Sterling, *Still-Life Painting from Antiquity to the Present Time* (1950).

STIPPLE ENGRAVING

A method of > intaglio > printing whereby minute dots, produced by manipulating a roulette (an > engraving tool with a small rigid wheel at one end), show as a soft tone on the > print.

STRETCHER

The wooden frame over which the > canvas of an > oil painting is stretched. The corner joints of the stretcher are so designed that a triangular wedge may be tapped in to adjust the tautness of the canvas.

STRUCTURALISM

Structuralist theories of > culture stem from the work of the Swiss linguist Ferdinand de Saussure, whose work on sign systems in the early years of the 20th century established linguistics as a discipline. As its name suggests, structuralism is concerned with the structure of a given system, not its particular expression (the study of which only serves to occlude the overall structure). Most importantly, like > semiology, structuralism argues that individual components in a sign system only have meaning in relation to other elements in the same system; thus signs have no intrinsic or immanent meaning, but are literally functional.

The importance of this for the study of art is that it cuts through much > Romantic rambling about the ineffable qualities of > genius, leaving the > artist as the animator not of new thoughts and images but, in the words of the seminal structuralist thinker Roland Barthes, the 'already written'. However, this is not to remove all sense of volition; the study of art is the study of a 'poetic' sign system that self-consciously separates itself from other outwardly similar systems such as traffic signs or road maps. The study of structuralism has advanced > art history towards a 'science' of signs, but has by no means ended the debate surrounding the origins and nature of art.

● T. Eagleton, *Literary Theory: An Introduction* (1983; 1985); L. Jackson, *The Poverty of Structuralism: Structuralist Theory and Literature* (1991).

STUCCO

Dehydrated lime mixed with > marble dust and glue and formed into patterns (which can be painted) using a spatula. In a sense, a cheap way of providing bas > relief sculpture. The technique goes back at least to the > Egyptians, was immensely popular in Hellenistic (> Greek art) and > Roman times and was thus enthusiastically revived during the > Renaissance. Little used north of the Alps in the Renaissance period (Primaticcio at Fontainebleau being an exception), its glories are to be found in southern Italy and Sicily, especially in the works of Giacomo Serpotta (1656–1732), during the > Rococo period in France, and with Robert Adam's reinvention of > Classical decorative techniques in great houses such as Kenwood in London.

● Geoffrey Beard, *Stucco and Decorative Plasterwork in Europe* (1983); Harald Mielsch, *Romische Stuckreliefs* (1975).

STUDIO

The > artist's > workshop, often a large room, and ideally with good light and north-facing. Usually in a private house, the room would serve for selling art as well as

making it. Its size depended on the artist's success, so that 'studio' often refers to the crowd of people contributing to the making of an art work rather than the place itself. Few artists before the 19th century made an art work completely on their own and > patrons would pay according to the amount of input the master artist had in the work's production; 'studio work' therefore means work in the master's manner, and probably from his shop, but certainly not by his hand. > Rubens, for example, established a scale of fees for his paintings according to the various gradations of studio involvement, and it is a fine exercise of > connoisseurship to determine which members of Raphael's large and even overstretched studio had a hand in which works. See Bottega; Attribution.

● Ettore Camesasca, Artisti in bottega (1966); B. Cole, The Renaissance Artist at Work: from Pisano to Titian (1983).

STUDIOLO

A small study to which a > Renaissance potentate of intellectual disposition would affect to retire. The room's decoration would proclaim and enhance the potentate's thoughtfulness through being put together by excellent > artists or because it contained priceless works. The best surviving examples are in Palazzo Vecchio, Florence (> Vasari's Studiolo of Francesco I) and in the Ducal Palace in Urbino (the Studiolo of Duke Federico, by various artists). The Studiolo at Ferrara belonging to that formidable woman Isabella d' > Este is very important in the history of Renaissance art because of the great artists whom she pestered to paint examples of their work for her.

● Luciano Cheles, The Studiolo of Urbino: An Iconographic Investigation (1986); Virginia G. Tenzer, The Iconography of the Studiolo of Federico da Montefeltro in Urbino (1985); Egon Verheyen, The Paintings in the Studiolo of Isabella d'Este at Mantua (1971).

STUDY

An > anatomical > drawing, compositional > sketch, or similar preparatory work, in any > medium, which serves as an aide-mémoire or guide to all or part of a finished work. Many highly finished studies, often running into hundreds for each painting, were executed by > history painters whose complex > compositions, often on a monumental scale, required this kind of preparatory drawing to resolve compositional or other difficulties.

STÜRM, DER

(German: 'The Assault'). The name of an art gallery and art periodical (> journals and periodicals), both of which were founded (in 1912 and 1910 respectively) by Herwarth Walden as forums for modern art in Berlin.

STYLE

'Style,' wrote Lord Chesterfield to his son in 1749, 'is the very clothing of thought'. Thus style itself can be a system of signs used to enhance meaning, whatever the art or its > medium. Every work of art and > architecture has a meaning – an > iconography – and a set of characteristics special to it. In a statue these might include the way the marble is cut and polished; in a drawing, the way the > pencil or > chalk is handled to produce line and > form; in a building, the particular combination of elements and masses. It is an article of > art-historical faith that art works may be grouped together through stylistic features, so that unsigned ones may nevertheless be attributed (> attribution) to one specific artistic personality because of the characteristics they all share. Periods and even countries might also share characteristics that will allow unattributed art works to be assigned to a country, a period, a school or even to an individual > artist.

If it were not possible to handle stylistic characteristics in this fashion, there would be little art history, since the discipline would be restricted to signed works of unimpeachable authenticity or > provenance, and neither of these factors takes into account the propensity of us all to increase our understanding by classifying our material. Some scholars are noted for possessing an 'eye' that enables them to group works together – Beazley for > Greek vases, or > Berenson (with 'B.B.'s Lists') for early > Italian paintings and > drawings – the proof of the attribution being only that it stands the test of time. Others, such as > Morelli, have found this too hit-and-miss and have sought to erect stylistic analysis into a science.

● E. H. Gombrich, 'Style', in *Encyclopaedia of the Social Sciences*, 15 (1958), pp. 352–61; Gottfried Semper, *Der Stil in den technischen und tektonischen Kuensten*, 3 vols (1860–3); Meyer Schapiro, 'Style', in *Anthropology Today*, ed. A. L. Kroeber (1953), pp. 287–312; Heinrich Wölfflin, *Principles of Art History* (1932).

STYLIZE

The process of stylization involves not the 'direct representation' (if such a thing exists) of objects from the natural world (in particular), but the application of a 'filter' of some kind, for example simplification, insistent swinging linearity, geometricization, reworking, or some other transformation. Perhaps all two-dimensional art is in some way stylized, not least because it seeks to make a flat pattern out of a three-dimensional object.

SUBLIME

From the 18th century the term was used to describe the extraordinary, the stupendous, the wild, the awesome and the marvellous, particularly in > Nature. Although Richardson in *An Essay on the Theory of Painting* (1715), followed by Sir Joshua > Reynolds in his last *Discourse* (1790), associated the sublime with overriding

excellence – in this sense Raphael is 'sublime' – it is usually employed to describe natural grandeur. It was with this understanding of the term that Edmund Burke wrote his *Philosophical Enquiry into the Origin of our Ideas of the Sublime and Beautiful* (1757), in which he recognized the potential of the sublime to fire the > imagination – whereas the ordered universe of the > Enlightenment admitted no such flights of fancy. In painting an example of this would be Turner's *Snow Storm: Steamboat off a Harbour's Mouth* (> Tate Gallery, London, 1842), where humanity is not at one with nature as in a > pastoral, but in danger of being overwhelmed by its limitless power. > Kant emphasized this quality of the sublime in *The Critique of Judgement* (1790) when he identified the sublime qualities that transcend understanding. Although primarily an 18th-century aesthetic concept, it contributed the important principle of grandeur and terror to the > Romantic frame of mind.

● W. J. Hipple, *The Beautiful, the Sublime and the Picturesque* (1957); A. Wilton, *Turner and the Sublime*, exhibition catalogue, British Museum (1981).

SUPERREALISM *See* Photorealism.

SUPPORT

The generic term given to the > canvas, > panel, > paper, > ivory or other material on which a painting is executed.

SUPREMATISM

An early 20th-century form of geometric > abstraction. Suprematism avoided representing the visible world in favour of a non-objective abstraction in which the art work stood only for itself – in other words, as 'pure' art. Malevich, the movement's founder, published a manifesto explaining his aims in 1915. Stylistically (> style), Suprematism used simple geometrical shapes, such as the circle, square or cross, disposed across the > picture plane with little or no recession into depth, as, for example, in Malevich's *Suprematist Composition: White on White* (> Museum of Modern Art, New York, 1918). The movement, which reached its apogee in revolutionary Russia, had a significant influence in the development of > Constructivism.

● S. Bann (ed.), *The Tradition of Constructivism* (1974); *Kasimir Malevich: 1878–1935*, exhibition catalogue, Tate Gallery, London (1976).

SURREALISM

Having its origins in the absurdist and associative art of the > Dadaists, Surrealism came to prominence in the early 1920s. André Breton defined it in his first *Manifesto of*

Surrealism (1924) as 'Pure psychic automatism, by which it is intended to express . . . the real processes of thought'. By this Breton meant that reality is governed not by reason but by unfathomable chance. It was therefore up to the Surrealists to exploit the irrationality of the unconscious to reach a surreality – a reality beyond perceptual or rational proof. The Surrealists were greatly interested in > Freud's theories of the unconscious and especially in his interest in dreams.

The difficulty was in finding a means to represent the unconscious in concrete terms. > Automatism, as practised by Arp, was one way, as was Ernst's > frottage. A major initiative was the juxtaposition of apparently unrelated objects, as in Dali's *Persistence of Memory* (1931) or Magritte's *Le Viol* (1934), which aimed to provoke the recognition of previously unconscious connections in the mind of the > beholder. The hallucinatory clarity of such pictures only serves to increase the sense of dislocation between the idea and its representation.

The blatantly subject-based and irrational art of Surrealism provided an important interwar alternative to the > formalist interpretations of > Modernism, which had established a line from Cézanne through to > Constructivism and beyond.

● A. Breton, *Manifestos of Surrealism* (Eng. trans. 1969); J. H. Matthews, *The Imagery of Surrealism* (1978); D. Ades, *Dada and Surrealism Revisited* (1978).

SURVEY APPROACH TO ART HISTORY

Although there is no one satisfactory way of teaching > art history, the historical survey (once known as 'Pyramids/Prehistory to Picasso' and now revamped as 'Pyramids to > Post-Modernism') has met with particular disapproval because the outline discussion of a succession of > styles encourages the beginner to believe that any given movement, style or > artist necessarily has depended on what preceded it (the *'post hoc, propter hoc'* notion being one of the most insidious in any branch of history). This contains just enough truth to be dangerously misleading, especially since all art works are in some way affected by their chronological circumstances, and all depend to some extent on what comes before, even if only by revolting against it. Again, just who chooses what to survey is of extreme importance in determining what attitudes are insidiously inculcated in innocent minds by not-so-innocent teachers pushing a particular slant on the past.

Nevertheless, despite all its faults of prejudgement, oversimplification, built-in inevitability and traditionalism, most art historians start beginners off with surveys, and if their lecturing is more trendily problem- or method-oriented, few dispense with recommending a survey textbook such as > Gombrich's *The Story of Art* or one of its imitators/followers, partly because a problem-oriented approach can encourage myopia. The dilemma is, of course, that knowledge in depth is impossible without knowledge in breadth, although the latter is by definition more or less superficial.

● Arnold Hauser, *The Philosophy of Art History* (1959); P. Hills, 'Art history textbooks: the hidden persuaders', *Artforum*, 14/10 (1976), pp. 33–42; Eugene W. Kleinbauer, *Research Guide to the History of Western Art* (1982); J. Adolf Schmoll, *Epochengrenzen und Kontinuitat:*

Studien zur Kunstgeschichte (1985); Hans Sedlmayr, Kunst und Wahrheit: Zur Theorie und Methode der Kunstgeschichte (1978).

SYMBOL

An object which has both a literal or primary meaning, and a secondary or conventional meaning. For example, while the representation of an apple in a > still life by Cézanne stands for an apple, in a van Eyck it might recall Adam and Eve and the fruit of the Tree of Knowledge. Thus a symbol gives concrete form to an abstract quality or notion. The study of symbolic imagery in art is known as > iconography.

● E. H. Gombrich, Symbolic Images: Studies in the Art of the Renaissance (1972).

SYMBOLISM

A movement in literature, art and > architecture from the mid-1880s through to the First World War. Symbolism was a reaction against the view that the aim of art is to portray the appearance of things, exemplified by the > Realism of Courbet and the > naturalism of > Impressionists. The Symbolist poet, Jean Moréas, author of Le Symbolisme, a manifesto published in the review Figaro littéraire in 1886, held that the goal of art was to find an adequate pictorial language to express ideas. The Symbolists shunned objectivity to give pictorial form to the inner world of the emotions.

Symbolism was a loose-knit movement, attracting very different > artists who were united only in their distaste for the prevailing belief in science and naturalism. The 'literary' Symbolists were led by Gustave Moreau, teacher of Matisse and a professor at the École des > Beaux-Arts, who sought to revitalize historical subjects in his jewel-like paintings of the more fantastic and exotic espisodes of the > Bible and the classics. Other literary Symbolists included Puvis de Chavannes and Odilon Redon. In 1888 it led to the establishment of the Rosicrucian movement, or the 'Ordre de la Rose + Croix du Temple et du Graal'. The group held a series of > exhibitions from 1892 to 1897 called the > Salons de la > Rose + Croix, organized by the eccentric Joséphin Péladan.

Historically more significant is 'pictorial' Symbolism, with its origins in the work of Paul Gauguin. After a visit to > Pont-Aven in Brittany, Gauguin simplified his hitherto > Impressionist > palette into broad areas of pure > colour enclosed by black lines. This > style is therefore sometimes known as 'Cloisonnism', from cloisonné enamels (cloison is French for 'partition'), or as 'Synthetism', in an effort to distance it from the literary connections of some Symbolists. Maurice Denis, the theorist of the movement, expressed the approach in the following terms: 'Remember that a painting, before being a war-horse, a nude or an anecdote, is essentially a flat surface covered with colours disposed in a certain pattern'. In 1888 Paul Sérusier fell under the influence of Gauguin, adopted Synthesism and, along with several fellow students from the > Académie Julian, founded the > Nabis group.

The influence of Symbolism was primarily in freeing colour and > form from the referent of > nature, thereby facilitating the development of true > abstraction in the

20th century. In a different vein, its emphasis on the >imagination suggests a connection with >Metaphysical painting and >Surrealism.

● S. Lovgren, *The Genesis of Modernism: Seurat, Gauguin, van Gogh and French Symbolism in the 1880s* (1959); J. Rewald, *Post-Impressionism from van Gogh to Gauguin* (1962; 1978).

SYNTHETISM *See* Symbolism.

T

TACHISME

(From the French *tache*, a 'blot' or 'spot'). A name given to European, particularly French, non-geometric > abstraction. Tachisme is used interchangeably with a series of other terms – Art Informel, Art Autre and Abstraction Lyrique. While the descriptor, 'Tachiste' had been used, pejoratively, as early as 1889 by Félix Fénéon with reference to > Impressionism, Art Informel (Art Without Form) and Art Autre (Other Art) were coined by Michel Tapié for an exhibition and book, *Un art autre*, in 1952. The aims of the artists working under these appellations paralleled those of the American > Abstract Expressionists. They laid emphasis on the value of the spontaneous expression of the artist's emotions, which they saw best communicated through the use of the unpremeditated > gestural stroke. The principal practitioners of the movement were Hans Hartung, Jean Fautrier, Georges Mathieu, Wols, Henri Michaux, Jean Dubuffet and Antoni Tàpies.

● J. Alvard and R. van Gindertael, *Témoignages pour l'art abstrait* (1952); G. Mathieu, *Au-delà du Tachisme* (1963).

TAINE, HIPPOLYTE

(1828–93). French philosopher, historian and critic. His *Philosophie de l'art* (1881) represents the apotheosis of 19th-century positivism and determinism. According to Taine, everything in > art history is explicable by a study of the national psyche and the immediate context, and he believed that writing about art boils down to collecting facts. It is an approach that, by trying to borrow from the taxonomic grouping common in the natural sciences, leaves little room for individualism, whimsy or the > romantic attitude to life because in it every art work becomes the product of an almost chemical, test-tube-like reaction amongst easily determined elements.

● Thomas H. Goetz, *Taine and the Fine Arts* (1973).

TAPESTRY

Penelope wove (and then unpicked nightly) a shroud to keep the suitors away, so woollen wall decorations probably go back as far as Homer (*c*.8th century BC) if not as far as the Trojan Wars themselves. Certainly, there are some fascinating fragments from the > Roman and > Coptic (i.e. Early Christian in > Egypt) periods. Tapestries were

especially popular during the Middle Ages, not least because they helped keep out draughts and were portable. The nobility moved from estate to estate, and took their tapestries with them, perhaps partly as a token of their prestige and wealth to place alongside carpets and silk or velvet hangings and cloths (both luxury imports from the Middle and Far East).

The majority of tapestries were made for secular use, and the stories they contained (often within sumptuous borders, sometimes decorated with > grotesques) naturally reflected aristocratic life and its pretensions. Popular areas were > mythology, heroic deeds, love, dalliance and make-believe – the woollen equivalent, so to speak, of the Arthurian legends and the > mediaeval French tales of romance.

If the majority of surviving tapestries are secular, recording battles or treaties, well-loved stories of chivalry or romance, sets were also routinely made for churches and a few still survive (in central France, for example). The best-known work made with such a destination in mind (the Bayeux Tapestry) is needlework, not tapestry, and was made for the apse of Bayeux Cathedral.

Because of their dual need to tell a story and fill a room, tapestries were frequently made in series, and such large and complicated works meant that they were also expensive, luxury items. Learning from experience, a small range of light-fast dyes came to be used, and these could be extended by the addition of gold or silver thread, as in the tapestries for the Sistine Chapel, woven in Flanders after designs by Raphael and partly melted down for the metal they contained during the Sack of Rome in 1527.

In > Renaissance Italy, tapestry not only survived but flourished, thanks in part to Raphael's set of > cartoons for tapestries for the Sistine Chapel. Large > workshops were also established by the 16th century in the Low Countries – Arras in the 13th century and Antwerp in the 15th. In France tapestry weavers were active in Aubusson by the early 16th century, and the famous > Gobelins factory was established in 1663. In England the Mortlake factory was founded in 1619, with Flemish weavers. Spain had her own factory, for which Goya worked, just as works by Boucher were prepared in tapestry in 18th-century France. The various mediaeval > revivals of the 19th century (see, for example, the > Pre-Raphaelites or William > Morris) continued to ensure a market for tapestry which, in the 20th century, is once again a vehicle for original art works and not just translations from other mediums.

● *International Biennial of Tapestry*, Lausanne (1987); William G. Thomson, A *History of Tapestry from the Earliest Times until the Present Day* (3rd edn 1973).

TASTE

There are two aspects to taste, one fugitive, the other innate. In the words of the critic John Steegman, taste 'expresses both an immutable quality of discernment, criticism and perception, independent of special knowledge or training . . . and also an always active sensitiveness to temporary fashions; it can . . . imply both standards and enthusiasms and can include both those who not only know what they like but know why they like it, and those who only know what the majority of other people like.' Fugitive taste is subject to the appetites of fashion and the market-place, and is just as swift-changing. In this form it is most clearly discerned in the > decorative arts, traditionally quicker to change than painting, sculpture and > architecture, although the

latter is certainly subject to taste/fashion in the less substantial constructions of > parks and gardens. It frequently lives amongst high society, serving as a tool by which its members may be distinguished from the common herd, for whom fashions, whilst certainly existing even in the pre-industrial age, are slower-moving and, even then, usually the result of percolation after a time lapse from their betters.

But taste can also be innate. For > Kant in *The Critique of Judgement*, taste is the completely disinterested faculty for judging an object or a > manner of representation as either pleasing or displeasing. The object judged pleasing is beautiful (> beauty).

Of inestimable benefit to the > artists who survive by catering for it, taste changes the faster the more sections of society have access to funds to satisfy their desires, hence the importance of the > Industrial Revolution and its social changes in influencing art. Conversely, taste changed more slowly when controlled only by a ruling class, the more so when sumptuary laws regulating which degrees of society might wear what were in force.

Changing taste also affects the ways in which the art of the past is viewed, thereby subjecting it to continuing re-evaluation. This can be clearly seen in the fluctuating fortunes of > Classical sculpture, for example, and its appreciation during periods of > revivalism such as the > Renaissance shows how the re-evaluation of the past can also affect the production of new art. And not only the art works themselves, but the parameters of the discipline of art history, as discussed at some length in the Introduction.

● Frank R. Chambers, *The History of Taste: An Account of the Revolutions of Art Criticism and Theory in Europe* (1932); James S. Curl, *The Egyptian Revival: An Introductory Study of a Recurring Theme in the History of Taste* (1982); Francis Haskell, and Nicholas Penny, *Taste and the Antique: The Lure of Classical Sculpture 1500–1900* (1981); Gerald Reitlinger, *The Economics of Taste: The Rise and Fall of Picture Prices, 1760–1960*, 3 vols (1961–70); John Steegman, *The Rule of Taste from George I to George IV* (1968).

TATE GALLERY

London. Opened in 1897 as an annex to the > collections of the > National Gallery, the Tate became independent in 1954. It houses largely 19th- and 20th-century art.

● John Rothenstein, *Brave Day, Hideous Night: Autobiography, 1939–1965* (1966).

TCI

The red pocket guidebooks to the cities and regions of > Italy produced by the Touring Club Italiano are essential companions for any serious visitor. Other guidebooks may list the highlights of a particular church, but the TCI will usually list every > altarpiece and every interesting piece of sculpture. Unillustrated, they may be read in conjunction with the quarto books of pictures also produced by the TCI. Along with > Baedekers, TCIs are particularly useful since they offer thorough guides to those areas of North Africa which used to be under Italian control.

TEMPERA

A term of confused usage, but chiefly associated with paint where an > emulsion of egg yolk is mixed with ground-up > pigments. It was an important technique for > panel painting in Europe. Used from the 12th century and the chief > medium of the > Renaissance prior to the introduction of > oil painting, tempera is an exacting technique with a small range of colours and tones, which can give a 'painting by numbers' effect unless semi-transparent layers are artfully combined. Oil killed it because of the greater subtlety, range of > colours, and effects such as > *sfumato* offered.

TENEBRISM

A type of painting greatly interested in shadows and a low-key tone, especially used by those Neapolitan and Spanish followers of Caravaggio known as > Caravaggisti. Such an exaggerated interest in > chiaroscuro, with a preference for dark rather than light, suited the intentionally startling design formats and majestic subject-matters of the early > Baroque and was especially useful for 'tying together' often very large > altarpieces, which was particularly important when they were to be viewed in the uncertain lighting of a church or chapel.

● *The Age of Caravaggio*, exhibition catalogue, Metropolitan Museum, New York (1985); Richard E. Spear, *Caravaggio and His Followers*, (rev. edn 1975).

TERRACOTTA

Baked clay has been used since prehistoric times to produce not only pottery, but also figurines, utensils and > architectural decorations. Although pieces can be individually modelled (as in the monumental > Etruscan figures that strode along the ridges of their temples, or those energetic groups on the tympana), the material is suitable for pressing into a mould, and therefore for the kind of multiple-production techniques needed to turn out terracotta in the form of decorated tablets to cover the friezes of wooden temples; votive offerings to gods and goddesses for the pious (a practice that continues today with a diversity of materials); representations of body parts as elements in a healing process; or dolls, carts, animals and games as children's playthings.

Such objects were produced in > Greek, Hellenistic, > Roman and Etruscan times in truly huge quantities. They are useful to > art historians as they often illustrate art at the 'low end', reduced in finesse and price so that ordinary people could buy them. Possibly during the Middle Ages, but almost certainly in the > Renaissance, > antique terracottas provided artists with a continuing point of reference for the > Classical tradition.

● Reynold A. Higgins, *Greek Terracottas* (1963); *Tanagra and the Figurines* (1986).

THEFT OF ART WORKS

One of the few constants in the history of art, whether casual (i.e. for financial gain) or institutionalized. Given that art is an important vehicle for > propaganda, it follows that art works can have an almost magical power which enhances their possessor – hence the attractiveness of disabling, as it were, a victim by appropriating his works of art and where possible reusing them or displaying them in the most taunting and insulting location possible. Military might was in part celebrated in > Roman antiquity by a triumph at which the booty would be displayed (cf. Mantegna's famous *Triumphs of Caesar*). In other words, plunder was institutionalized, frequently as a way of paying the troops or rewarding the general.

Large-scale and bureaucratically organized theft is a vehicle not only for the transfer of power but also for assimilation and diffusion of > style, as can be clearly seen from the Roman depradation of things > Greek, whether on the mainland or from the cities of Sicily. Such imports to Rome further invigorated and enriched Roman art, and are matched by the actions of conquerors from the Sack of Constantinople by the Crusaders in 1204 to the sack of nearly the whole of Europe by Napoleon and later by Hitler and Goering.

In the 20th century, the theft of art works from digs has also become organized thanks to the development of a worldwide market for most forms of art, and a network of middlemen, dealers (> art-dealing) and auctioneers willing to satisfy it. To serve distant > collectors, tombs are sacked in Etruria and Central America, and temple reliefs sawn from monuments in Asia. Most countries have put in place laws prohibiting the export of works of art without a licence, but it is widely believed that this does little to deter some collectors because of the large sums of money involved. Several important treasures, and innumerable individual objects, are said to repose in the basements of > museums that should – and, in public at least, do – know better. Such theft matters because it destroys the context for works of art, and therefore radically diminishes their significance for scholarship.

The scale of all kinds of art theft in the 20th century has also been much larger than previously thanks partly to casual theft during wars, but largely because of the artistic policies of revolutionary and aggressor nations, especially the Soviet Union, Japan and Nazi Germany. Japan appropriated a lot of material of Japanese and Japan-related origin from the countries she conquered and occupied, and many Korean art works, for example, have yet to be returned. The Soviet Union took many art works from the nobility who fled during and after the Revolution, and sometimes used these as a means of generating hard currency from the West. Nazi Germany, needing art to stock its Thousand-Year Reich and wanting the > icons of Western civilization in order to prove its commitment to > culture, plundered trainloads of works from occupied territories, and did so in a methodical manner recalling the > Baedeker-like care with which Napoleon's commissioners went about much the same task over a century before.

With the phenomenal rise in the price of art works since the Second World War, it is difficult to see how the transfer of riches to the First World from illegal digs in the Third World can be halted, especially with a predatory and occasionally unscrupulous art market acting as nanny.

● Russell Chamberlin, *Loot! The Heritage of Plunder* (1983); Karl Meyer, *The Plundered Past* (1974); M. Pape, *Griechische Kunstwerke als Kriegsbeute und ihre Öffentliche Aufstellung in Rom*

(1975); Wilhelm Treue, *Art Plunder: The Fate of Works of Art in War, Revolution and Peace* (1960).

THEORY OF ART

The generic if rather vague term used to describe the various approaches to thinking about art. It has largely taken over from the > philosophy of art as the term used to describe ideas in art, and in its contemporary usage, 'theory' implies that former ways of practising > art history and > criticism were untheoretical, or at least deficient in intellectual rigour. In this sense, to demonstrate an interest in the theory of art is to be a practitioner of the > New Art History. However, this interest in 'theory', never too closely defined, has tended to be confused with > methodology in that theory is often seen as a tool for shaping ideas about art. Although few art theories can expect to be free of the concerns of aesthetics or philosophy, most subscribe to the currently fashionable ideas of > post-structuralism and > deconstruction. In this sense, an interest in art theory is little more than a laudable interest in being aware of the limits and potential of art-historical/critical methods. Recently, practising artists have been greatly influenced by this upsurge in theory, and few schools today subscribe to the view that art is about a hands-on struggle with an intractable material. Some art centres, such as New York, have adopted theory as their own, while within > Post-Modernism generally, the rhetoric of theory is considered to be a necessary part of the legitimizing process of contemporary art production.

THUMBNAIL SKETCH *See* Sketch.

THYSSEN-BORNEMISZA

A rich > collection of northern and southern European painting and sculpture from the > Renaissance to the 19th century, founded by Heinrich, Baron Thyssen-Bornemisza (1875–1947), and presented to the city of Lugano in Switzerland in 1937. It is housed in the 17th-century Villa Favorita, in the suburb of Castagnola.

TONDO

(Italian: 'round'). A circular work of art, popular from the > quattrocento in painting and sculpture. Michelangelo produced tondi both in sculptured > relief and in paint.

● *Michelangelo: The Taddei Tondo*, Victoria and Albert Museum (1966).

TOPOGRAPHICAL PAINTING

A type of > landscape or cityscape painting that focuses on the 'mapping' of a prospect rather than on the representation of > nature. Before the invention of > photography, every scientific expedition included a topographical > artist to record the regions visited.

Torso

While such records are not without a degree of > invention – the artist often included 'typical' examples of indigenous animals, human populations, and fauna – their purpose was not aesthetic but scientific, although the origins of landscape art in infant colonies such as Australia was confounded with the work of artists employed by the administration to assist in the survey of the region. A sub- > genre of topographical painting is > panorama painting, which is effectively a prospect seen through 360 degrees.

● Bernard Smith, *European vision and the South Pacific*, (rev. edn 1985).

TORSO

The human trunk and a term often indicating a > classical statue missing head, arms and legs (i.e. the most fragile sections), for example the > *Belvedere Torso*. They were useful to > artists (especially Michelangelo) as models for their own art, providing a bodily form into which they could inspire the spirit they required when used as a building block in their own productions. From the later 19th century, the torso as a 'complete' art work, sometimes with legs (as in Rodin) became a suitable subject for art.

TRECENTO

The 'thirteen hundreds' in > Italian art.

TRIPTYCH

A painting, usually religious, on three separate but related panels, often hinged together. Sometimes small enough to be carried on journeys. *See* Diptych; polyptych.

TRIUMPHAL ARCH

From the 2nd century BC, the custom was for a victorious Roman general to receive an ovation (at which a sheep would be killed), or, better still, a triumph, which often included a procession of the vanquished, sometimes through makeshift arches of lath and canvas. Later, > marble triumphal arches recorded such triumphs or their associated campaigns, and the examples in > Rome, repeated throughout the Roman world, were highly influential in the > Renaissance, when the triumphal entry into a city of some monarch or nobleman was often accompanied by temporary arches, pageants and tableaux. The triumphal arch, both decorative and useful, has been a staple of town planning since Roman times and thrives today, as can be confirmed by a glance at Paris, from the Arc de Triomphe du Carrousel to the Arc de Triomphe de l'Étoile to Mitterrand's monument, the Arche de la Défense.

● Gilbert Charles-Picard, *Les trophées romains: contribution à l'histoire de la religion et de l'art*

triomphal de Rome (1957); Sandro De Maria, *Gli archi onorari di Roma e dell'Italia romana* (1988); Ernst Kunzl, *Der romische Triumph: Siegesfeiern im antiken Welt* (1988); Andrew Martindale, *The 'Triumphs of Caesar' by Andrea Mantegna in the Collection of Her Majesty the Queen at Hampton Court* (1979).

TROMPE-L'ŒIL

(French: 'deceives the eye'). A type of > illusionism, a *trompe-l'œil* is a painting or a detail of a painting that deceives the viewer, such as a violin painted on a door (at Chatsworth), the 'labels' popular (often on pseudo-stone parapets) in northern-> Renaissance > portraits, or the fly painted by Giotto on the nose of one of Cimabue's figures, which, so > Vasari tells us, the master attempted to flick away (an idea that goes back to the > Greeks).

● Martin Battersby, *Trompe-l'œil: The Eye Deceived* (1974); Marie L. d'O Mastai, *Illusion`in Art: Trompe-l'œil, a History of Pictorial Illusionism* (1976); Miriam Milman, *Trompe-l'œil Painting: The Illusions of Reality* (1983).

TURPENTINE

A resinous solvent distilled from the conifer tree, used to thin > oil paint. The use of turpentine causes oil paint to dry quicker than thinning it with > linseed oil.

U

UFFIZI PALACE

Florence. Designed by > Vasari in 1560 for the > Medici prince Cosimo I, Grand Duke of Tuscany, the ground floor of the building housed the offices (*uffizi*) of the city administration. In 1789 the Uffizi became the public gallery of the city art > collection, which had its origins in the private collections of the Medici family bequeathed to the Tuscan state by Maria Ludovica, Grand Duchess of Tuscany in 1737. It is one of the world's great > museums and houses an uparalleled collection of Florentine > quattrocento painting.

UHDE, WILHELM

(1874–1947). German > collector, resident in Paris from 1904. He was a major > patron of the > Cubists and an early supporter of the > naïve painter Henri Rousseau, about whom he published a > monograph in 1910.

UKIYO-E

(Japanese: 'pictures of the floating [fleeting] world'). A > school of Japanese > genre painting of the Edo period (1615–1868) that depicted, as its name suggests, scenes of everyday life and fashion. Designed for popular > taste, the usual form of these pictures was the woodblock (> woodcut) > print, at first in outline and coloured by hand, but from the middle of the 18th ccentury in several > colours. It was these prints, exhibiting a strong sense of design through the use of flat areas of colour, that so influenced the > Impressionists Manet, Degas, van Gogh and Mary Cassatt, as well as the > Symbolists Gauguin and Émile Bernard. Among the most celebrated practitioners of the genre are Sharaku, Utamaro, Hokusai, Kunisada and Hiroshige.

● P. Swann, *Art of China, Korea and Japan* (1963).

UNDERPAINTING

The preparatory stage of execution, after a > composition has been established, but before the painting is worked up. This preparatory stage is often executed in monochrome heightened with white, a process known as > grisaille.

UT PICTURA POESIS

(Latin: 'as in painting, so is poetry'). The expression, which occurs in Horace (*Ars Poetica* 361), suggests a similarity between the arts of painting and poetry, especially with regard to > imitation, in that both represent the appearance of the world and the actions of beings in it, and also, through the means of art, improve on > nature. Its importance rests principally on the justifications it gave the painter to be regarded as a practitioner of a > liberal art (poetry was so considerd by the ancient world), and it also established > history painting, which most closely resembled the subject-matter of > Classical poetry, as the pre-eminent > genre. From the 16th to the 18th centuries especially, the notion provided the principal starting-point for the discussion of the arts, particularly in the 17th-century French > Academy, although perusal of this discussion leads one to suspect that part of its complexity is based on nothing more than semantic laxity. In the 18th century > Lessing argued in his *Laokoon* that the doctrine had caused unnecessary confusion in the arts, a point taken up in the 20th century by the > Modernist critic Clement > Greenberg in 'Towards a Newer Laocoön, in which he argued that each art should address concerns proper to it, and not those of another art form.

● R. G. Saisselin, 'Ut Pictura Poesis: Du Bos to Diderot', *Journal of Aesthetic and Art Criticism*, 20 (1961); R. W. Lee, *Ut Pictura Poesis: The Humanistic Theory of Painting* (1940; 1967).

V

VANISHING-POINT

In a painting employing scientific or linear > perspective in order to create an illusion of recession, the notional point at which parallel lines approaching a central point on the horizon line appear to converge.

VANITAS

A type of pious > still life (usually painted and especially popular in the north during the 17th century) depicting groups of objects that express the brevity of life and its pleasures, for example skulls, clocks, scythes, wilting flowers, etc. Similar motifs have made the same point throughout the history of painting and especially in > funerary sculpture (e.g. the broken column, the broken bough, skull and crossbones).

● K. Koozin, *The Vanitas Still Lifes of Harmen Steenwyck: Metaphoric Realism* (1990).

VAN MANDER, KAREL *See* Mander, Karel van.

VARNISH

A solution of resin in solvent that provides a transparent coating when applied to the surface of a painting, thereby both enhancing its appearance and protecting it. It is sometimes mixed with > paint during the painting process, in which case it acts as a > medium.

VARNISHING DAY

A custom developed from the days of > academy > exhibitions, supposedly to allow > artists to > varnish their works after they had been hung, but also enabling them to retouch or even finish their paintings often with an eye to the adjacent competition.

VASARI, GIORGIO

(1511–74). > Italian painter, > architect and historiographer, born in Arezzo near Florence, and best known for his history of Italian painting, *The Lives of the Most Excellent Italian Architects Painters and Sculptors*, first published in Florence in 1550 and reprinted in a much enlarged edition in 1568.

Vasari trained as a painter first under a distant relation, Luca Signorelli, then briefly in 1524 with Michelangelo in Florence. Although Michelangelo was soon called to Rome and Vasari completed his training in the > workshops of Andrea del Sarto and Baccio Bandinelli, the encounter with Michelangelo was decisive for the > methodological structure of the *Lives*. Vasari's work as a painter (the decoration of the Palazzo Vecchio for his masters the > Medici, for example) and architect (his design for the > Uffizi and the tomb of Michelangelo in Sta Croce) show him to have been a highly competent > artist in the > Mannerist tradition. In 1563 he founded the Accademia del Disegno, the model for many other > academies up to the 18th century. The Academy, which served to promote the social and professional status of artists, was the institutional equivalent of his *Lives*. The last years of his career saw Vasari respected not only as a major artist but as a friend of Michelangelo and Grand Duke Cosimo de' Medici, and celebrated as the historiographer of the Italian > Renaissance.

The *Lives*, which gave the Italian Renaissance a worthy account of the progress of painting from Cimabue to Michelangelo, starts from the quite orthodox > humanist view that the artists of antiquity had attained perfection, but that subsequently the > fine arts had declined into the barbarism of > Gothicism, only to be revived in the Renaissance. Vasari gave Giotto the credit for being the first to return to using > nature as the model, and praised him for having 'rescued and restored the art, even though he was born among incompetent artists'. There are two important clues to Vasari's method here in his assumption, firstly, that the goal of art is the representation of nature, and secondly, that an artist may be called great among his contemporaries without embodying all possible virtues. In this way he could show how artists such as Masaccio and Donatello had built on the foundations laid by Giotto without detaching from the latter's achievements. The story culminates with Michelangelo, in whom all perfection resides.

The value of the *Lives* for > art historians lies in the mass of anecdotal and biographical detail it contains. Equally if not more importantly, Vasari's methodological assumption that progress towards the goal of the > imitation of nature was natural and logical had great influence on the way in which later centuries interpreted Renaissance art. It is not a coincidence that our assessment of the importance of the artists treated by Vasari echoes so closely that of their first biographer. In this way, Vasari may be said to have contributed as much to the Renaissance as any of its great artists.

● Hans Belting, 'Vasari and his Legacy: The History of Art as a Process?', in *The End of the History of Art?* (1987), pp. 67–94; T. S. R. Boase, *Georgio Vasari: The Man and the Book* (1979); A. Blunt, *Artistic Theory in Italy 1450–1600* (1940; 1989); *Il Vasari storiografo e artista*, International Congress in Arezzo-Florence 1974 (1976); Barbara I. Mitchell, *The Patron of Art in Giorgio Vasari's Lives* (1975); G. Vasari, *Lives of the Artists*, trans. G. Bull (1965; 1972).

VATICAN

The palace and indeed city of the > papacy, so named after the hill on which it stands, the Mons Vaticanus. The importance of the area in > Roman times derived from the (largely pagan) cemetery where St Peter was buried. Peter's tomb formed the focus for

later Christian burials, and for both the Old and the present St Peter's, because from Early Christian times it was considered helpful to one's immortal soul to be buried *ad sanctos* – near to the saints. The papacy, the successors to Peter, had a palace on the hill (and fortified it from the 8th century), but they only moved their main residence there from St John Lateran with the return of the papacy from Avignon under Martin V in the early > quattrocento.

During the course of the quattrocento and > cinquecento, and under the urging of influential scholars such as > Alberti, much building took place with a view not only of constructing a residence suitable for a Prince of the Church (and one equal to the accommodation their usually princely families already possessed), but also of creating attractive locations for the art > collections to which so many popes were addicted. Accordingly, they sponsored digs for antiquities, and acquired more by exerting their considerable influence throughout the peninsula. Art was viewed not only as > propaganda for any cultured individual or group (such as the aristocracy), but also as a tangible link with the > Roman emperors, whom the papacy had replaced as rulers of > Rome and also of part of the same Empire.

The best > architects built there (Bramante, Michelangelo, Pirro Ligorio, Bernini) and the best > artists decorated the results (Raphael, Michelangelo, Bernini), so that the Vatican Palace and its subsidiary buildings (such as the Casino of Pius IV) have remained important exemplars for later artists, especially, perhaps, the Sistine Chapel (in which the major artists of the day, and not just Michelangelo, participated) and Raphael's > Stanze.

Nor did collecting activity cease with the High Renaissance. 17th- and 18th-century popes were vigorous commissioners and collectors, with Clement XI assembling large quantities of antiquities, and Benedict XIV redressing the scales in 1753 with the Museum of Christian Sculpture. Other collections acquired in the following century include the Museo Gregoriano-Etrusco (1836), the Galleria Lapidaria, the > antique busts and statues of the Museo Chiaramonte and, in 1909, the Pinacoteca, assembled from works in various papal palaces. Today, the several kilometres of rooms and corridors that make up the Vatican Museums form arguably the largest treasure house in the world, the collections being especially rich in > Classical and > Etruscan sculpture and vases (reflecting the papacy's interest in the Classical tradition), in ethnographic art from non-Christian > cultures (used in the training of proselytizing clergy), and naturally in > Christian art of all periods.

● Maurizio Fagiolo dell'Arco (ed.), *The Vatican and its Treasures: A Pictorial History and Guide* (1983); Giovanni Morello, *Raffaello e la Roma dei Papi* (1986); Graham Smith, *The Casino of Pius IV* (1977); Valerio Volpini, *Vatican City: Art, Architecture and History* (1986).

VEDUTA

(Italian: 'view'). A drawing or, more usually, painting of a > landscape or more especially a town or city. Such works, which were popular from the 17th century but particularly so in the 18th when works by Piranesi, Panini, Canaletto and Guardi fetched high prices, catered to the aristocratic and gentle classes who travelled and wanted views of the places they had visited on the > Grand Tour, Italy in particular. Such views might be accurate (in which case their ancestry stretches back to 16th-century

> topographical artists such as Wenceslaus Hollar), but a favourite was the > *capriccio*, many examples of which remain in British and Irish country houses.

● Giuseppe Boffito, *Piante e vedute di Firenze: studio storico topografico cartografico* (1973).

VEHICLE

The substance in which the > pigment is suspended. The vehicle may be, for example, water, oil, > turpentine or egg yolk (> tempera). Together the pigment and the vehicle constitute > paint.

VENETIAN SCHOOL

Because of Venice's eastern and > Byzantine links, Venetian art is conspicuously different from, say, > Florentine art over several centuries. Thus Giotto's > naturalism leaves Venice's luminous formalism untouched; > Gothic flourished there (the Doges' Palace) when it scarcely touched Florence; the > Renaissance comes late in > architecture, with > Palladio; and in painting, Renaissance > forms and ideas arrive with an admixture of Flemish painting > styles and their > oil techniques, from which the Bellini, Giorgione and Titian developed a manner of painting that prizes *colore* above > *disegno*. Tintoretto and Veronese developed sumptuous > decorative styles, and the line from them to Guardi and the Tiepoli (and in architecture from Palladio to Longhena) is clear. > Baroque painting would have been seriously 'overdesigned' had not the Carracci and other members of the > Bolognese School added the sensuous lightness and brilliance of the Venetian manner to the rigorously linear > Mannerism found in the > Rome of the later 16th century.

● John Steer, *Venetian Painting: A Concise History* (1989); Johannes Wilde, *Venetian Art from Bellini to Titian* (1974).

VENUS DE MILO

The female portion of a group of Venus and Mars, discovered on the island of Melos in 1820, and one of the most popular ornaments of the > Louvre. This is arguably France's consolation prize to herself for being forced by Wellington to give up the multitudinous spoils taken during the Napoleonic Wars, and has acquired > iconic status alongside the *Mona Lisa*, the > *Apollo Belvedere* and the *Laughing Cavalier*.

● Alain Pasquier, *La Venus de Milo et les Aphrodites du Louvre* (1985).

VICTORIA AND ALBERT MUSEUM

London. Set up by the monarch and her consort in 1852, albeit following the recommendations of a select committee of 1835. Its founding principle was of

utilitarianism, the belief being that teaching the arts would enable them to be suitably applied to industrial production and thus offer Britain a lead over her competitors. A small Museum of Manufacturers was opened in 1852, and a Treasury grant enabled it to be stocked with many of the works from the > Great Exhibition. In effect, the V&A was initially an art school with a museum of the > decorative arts attached for study purposes, and a library. In 1857 the museum (first called 'The Museum of Ornamental Art') moved to South Kensington, but the present buildings, from designs by Aston Webb, were opened in 1909, when the name changed to 'The Victoria and Albert Museum'.

The V&A now contains the national art library, > architectural decoration, sculpture (Bernini), paintings, the Raphael > tapestry > cartoons, decorative arts (furniture, ceramics, metalwork), > watercolours and > miniatures, as well as Eastern art. Of interest to students who cannot travel is the gallery of casts of > antique, > mediaeval and > Renaissance works of decorative sculpture, from Trajan's Column through to the > Gates of Paradise.

● John F. Physick, *The Victoria and Albert Museum: The History of its Building* (1982).

VICTORY OF SAMOTHRACE

Another > icon of modern > museology, comparable with the > *Venus de Milo*, and taken by the French from the island of (Thracian) Samos in 1863. This magnificent statue of Victory landing on the prow of a ship originally stood on a terrace silhouetted against the sky. The > composition incorporated a small waterfall, having been erected above a rocky pool, and although this has not been reconstructed in the > Louvre, the statue is dramatically set on the landing of a magnificent staircase and is therefore usually seen from below, as the makers intended.

● Karl Lehmann, *Samothrace: A Guide to the Excavations and the Museum* (4th rev. edn 1975).

VIDEO ART

Video is a > medium like > oil painting or > photography, and like them has been employed by > artists in a wide variety of ways. With the advent of the portable video camera, a means of recording visual imagery has become available that, at an elementary level, needs little technical skill or equipment to operate. Video has had an impact on > Performance and > Installation art, media studies and 'Music Television' (MTV). Increasingly, video is seen as interactive with > computer art and graphics, and, like photography in the early 20th century, is now transcending its initial function as a transparent 'recorder' to generate its own visual language.

● *Artistic Creation and Video Art*, UNESCO (1982).

VIDEODISK

A disk the size of an LP record, both sides of which can store up to 54,000 'frames', each as a composite ('TV') signal. Each track is randomly accessible, whether by a

remote control or via a > computer. In the latter case, the data are usually regimented into a > database. For > art history, whether for private study or research, the videodisk provides easy and good-quality storage of a large number of images, with two disks able to hold the entire collections of many departments. However, the dissemination of videodisk images encounters several problems, notably in networking protocols (because the data are in analog not > digital form) and > copyright, although the recent introduction of disks the user can write (and, for some products, erase) makes the > medium more flexible. Consumer- and professional-quality still video camers with the ability to read, write and erase now mean that the user can make an image in the camera and write it on to either a VCR or a computer, or display it immediately on an analog TV monitor.

Its only present competitor is the > microfiche, although digital technologies will join it soon as an alternative medium for the storage and presentation of images.

● Judy McQueen, *Videodisk and Optical Digital Disk Technologies and their Applications in Libraries* (1986).

VIEWER *See* Reception aesthetics.

VILLARD de HONNECOURT

(Active *c.*1225–35). A well-travelled French > architect who made, about 1235, a > sketch- and patternbook of what he saw and where he went, which is now in the Bibliothèque Nationale, Paris. Included are sketches of buildings, statues, monuments, geometrically constructed figures and some inscriptions. Although it is perhaps similar to others that may have circulated amongst communities at the time, nothing like it survives before the 15th century, so it offers a unique insight into the interest and horizons of a working architect of the > Gothic period and thus into > workshop practice.

● Carl F. Barnes, *Villard de Honnecourt, the Artist and his Drawings. A Critical Bibliography* (1982); T. Bowie (ed.), *The Sketchbook of Villard de Honnecourt* (1975).

VINGT, LES, or LES XX

(French 'The Twenty'). A Belgian > artists' group which organized a series of > exhibitions from 1884 to 1893. The group was associated with the development of > Art Nouveau and facilitated the spread of > Neo-Impressionism and > Symbolism into Belgium through exhibiting the works of Seurat, van Gogh and Cézanne.

VIOLLET-LE-DUC, EUGÈNE-EMANUEL

(1814–69). French > architect and artistic and architectural theorist. His *Dictionnaire raisonné de l'architecture française du XIe au XVIe siècle* (Paris, 10 vols, 1854–79) is still important, and he lay part of the groundwork for > modernism, through – as befitted a

19th-century engineer – his interest in the construction techniques of > Gothic. He is best known for his often drastic > restorations of > mediaeval buildings, which he sometimes remade into the kinds of buildings the mediaeval architects might have contemplated had they had the benefits of reading Viollet's book. In 19th-century terms, then, he wanted 'complete' buildings, and therefore resurrected them that way, wiping away with the unswerving confidence of an > academic vandal the accreted 'garbage' of centuries, and in the process destroying much historical evidence and much of > beauty. On the other hand, had he not intervened, many buildings (Vézelay?) might simply not have survived to our day.

● Nikolaus Pevsner, *Ruskin and Viollet-le-Duc: Englishness and Frenchness in the Appreciation of Gothic Architecture* (1969); *Viollet-le-Duc*, exhibition catalogue, Grand Palais, Paris (1980).

VIRTU

Meaning excellence rather than virtue, the word indicates the whole range of > fine art objects in which a > connoisseur might be interested, from paintings to snuffboxes. Such > collectors were known as 'virtuosi' (for example the Virtuosi of the Pantheon, who were interested in antiquities), but the phrase was applied equally to learned scientists and to practising > artists.

VISIONARY ARCHITECTURE

A 20th-century term given to a loose group of > architects immediately before and during the period of the French Revolution who, although generally prevented by the insecurity of the times from actually building, concentrated on projects of megalomaniac scale and apocalyptic reach in a > style of breathtakingly abbreviated > Classicism. This, almost as much as the paintings of Cézanne were later, was predicated upon the cube, the cylinder and the sphere, with an admixture of meaningful > antique forms. Both simple forms and far-reaching ideas were the > taste of the times, which sought to rebuild society anew and therefore architecture (and people) with it. Its practitioners were thus frequently interested in architecture as social engineering; see, for example, Ledoux's seminal designs for the royal saltworks at Chaux-de-Fonds, which was a project for both the industrialization of cottage practices and the improvement of the working class. Part of this survives on the ground, and all of it including the fanciful unbuilt sections, is described in his L'*architecture considérée sous le rapport de l'art, des mœurs et de la legislation* (Architecture Considered Under its Relations with Art, Manners and Legislation) (1804; written after imprisonment in 1793).

The 'paper architecture' which resulted from much of the work of Boullée, Ledoux and Lequeu is Utopian in intent, but ultimately derives from the > Grand Prix tradition, and is saved from barren flatulence not only because it offered a worthwhile critique of contemporary taste, and signposted the actual buildings of architects such as > Soane, but also because of the renewed importance the group now has in demonstrating to > Post-Modernism how it might safely be allusively Classical and correctly modernistic at the same time.

● Jean M. Perouse de Montclos, *Étienne-Louis Boullée* (1728–1799): *Theoretician of*

Revolutionary Architecture (1974); Vittorio M. Lampugnani (ed.), *Visionary Architecture of the Twentieth Century: Master Drawings from Frank Lloyd Wright to Aldo Rossi* (1982).

VITRUVIUS POLLIO, MARCUS

(Active 46–30 BC). The Emperor Hadrian's > architect, He wrote the only handbook of architectural practice (*De architectura, c.*27 BC) to have survived the Middle Ages, when, judging by the number of surviving > mediaeval transcriptions, it was very popular; Charlemagne's (> Carolingian art) architects, for example, knew and used it. The text was partly how-to-do-it (sites, layout, materials), and partly theoretical, with information on the > Orders and on > proportion. From the 15th century, it was edited and translated into the main European languages, and it formed a model for modern books on the subject from Serlio and > Palladio to Vignola and Philibert de l'Orme.

There were two main problems with Vitruvius's text, which were probably a blessing in disguise. The first was that it came to the Middle Ages and the > Renaissance without illustrations, thereby obliging the more inventive architectural scholars such as Palladio and Perrault to provide them. The second problem also required scholarship, namely the quality of the Latin in which the text was written. This was so difficult that (as > Alberti maintained) the Romans thought he was writing in Greek and the Greeks in Latin. The net result was a text that allowed great leeway for interpretation, whilst offering the prestige of being the *ipsissima verba* of the > ancients themselves.

The combination of demonstrable > antique authority with the need for interpretation was irresistible, so that Renaissance and later architects could happily innovate with the supposed blessing of antiquity. Vitruvius was a mainstay of > academic architecture until well into the 20th century, but the greatest architects, observing that the 'rules' he promulgated rarely accorded with what the ancients actually built, paid him little more than lip-service, and treated the > Orders of architecture with the freedom accorded them by ancient practitioners.

● Erik Forssman, *Dorico, ionico, corinzio nell'architettura del Rinascimento* (1973); Alexander G. McKay, *Vitruvius, Architect and Engineer: Buildings and Building Techniques in Augustan Rome* (1978).

VITRUVIUS BRITANNICUS

The prestige of the > Roman > architect > Vitruvius was invoked in Colen Campbell's great illustrated survey of the new generation of British country houses, published in three folio volumes in 1715, 1717 and 1725. The general idea behind the collection was that just as Vitruvius (and his partial > imitator Palladio in his *Four Books of Architecture*) formed models for later generations – models, indeed, on which the British would claim to have based their new country-house architecture – so those very country houses would form models for the future. Additional volumes were published in 1767 and 1771, and the later > Palladian > revival is illustrated in the *New Vitruvius Britannicus* of George Richardson (two vols, 1802 and 1808).

● John Harris (ed.), *Colen Campbell: Vitruvius Britannicus*, 4 vols (1967 onwards).

VOLLARD, AMBROISE

(1865–1939). French > art dealer, publisher and writer. He opened a gallery in Paris in 1893 and gave important one-person > exhibitions to Cézanne in 1895, Picasso in 1901 and Matisse in 1904. He > patronized the publication of 'artists' books' illustrated by > artists of the Parisian > avant-garde and wrote an informative autobiography, *Recollections of a Picture Dealer* (1936).

VORTICISM

English 'rebel' art movement which seceded from the English > Post-Impressionists led by the > critic Roger > Fry in 1913. The Vorticists (from 'vortex') were influenced by Italian > Futurism and were in opposition to much French Post-Impressionism. The group was led by the painter Wyndham Lewis, who published a Vorticist magazine, *Blast*, in 1913/4, to which he contributed a Vorticist manifesto in emulation of the Futurist manifestos of Marinetti. > Exhibitions of Vorticist art were held in London in 1915 and New York in 1917. Stylistically (> style), Vorticist works are characterized by angular overlapping planes which comment on (or as Lewis insisted, rejected) both the Futurist obsession with dynamism and the static nature of > Cubism. Its real importance lay in its attack on the complacent and conservative values of an insular English art world. Other major exponents of Vorticism include David Bomberg, Jacob Epstein and C. R. W. Nevinson.

● W. C. Wees, *Vorticism and the English Avant-garde* (1972); *Vorticism and its Allies*, exhibition catalogue, Arts Council (1974); R. Cork, *Vorticism and Abstract Art in the First Machine Age* (1976).

VUE CAVALIÈRE

A > landscape painting or > drawing with the broader horizons and field of view of someone seated on a horse, and therefore able to see over hedges and other impediments. The term is more than merely formal, for many > sketches were doubtless made from horseback (cf. Gainsborough).

W

WALLACE COLLECTION

London. The large 19th-century private > collection of the Earls and Marquesses of Hertford, reflecting approximately 150 years of collecting of British and Continental art and > virtu by the time it was opened as a national > museum in 1900. French 18th-century art, furniture and the > decorative arts are especially strong, some of the settings rivalled only by those in the > Gulbenkian Collection.

● Donald Mallett, *The Greatest Collector: Lord Hertford and the founding of the Wallace Collection* (1979).

WALPOLE, HORACE

(1717–97). Writer of letters, historian of British art, initiator of the Gothic novel (*The Castle of Otranto*, 1764), harbinger of the > Gothic Revival with his > Rococo-like house at Strawberry Hill, and the object of Kenneth > Clark's disdain in his *The Gothic Revival* for the dryness with which he copied Gothic instead of improvising from it. Walpole is important in the history of English > taste since not only was he an arbiter of taste in the social swim (and a widely read and translated author), but also because of the conviction with which he entered into his version of the spirit of Gothic (often spelled 'Gothick' to distinguish it from the later, more scientific phase of the revival). Indeed, he dressed his house completely in Gothic, from > architecture to wallpaper, wrote a > catalogue of its contents, and had guided tours by ticket. On his printing press, he published his *Anecdotes of Painting in England* (4 vols, 1762–71), a 'Catalogue of Engravers in England' (1763), and a description of his villa (1774).

● W. H. Smith (ed.), *Horace Walpole, Writer, Politician and Connoisseur: Essays on the 250th Anniversary of Walpole's Birth* (1967).

WANDERJAHRE

Literally, 'years of travelling'. A Northern > artist of the Middle Ages or > Renaissance would usually complete his apprenticeship and then travel to work as a journeyman (i.e. paid by the day) in the shops of masters he admired, before returning to submit the work required for him to become a master craftsman in his > guild – that is, his > masterpiece. It was by such travels that artistic ideas and > styles were disseminated, as can be seen from the experiences of > Dürer, who travelled from Nuremberg to

>Venice in 1494/5, and again in 1505/7. His >style changed as a result of both visits, his meeting with Giovanni Bellini during the second being especially fruitful. In >architecture, of course, travelling (often abroad) was necessary to find work; see the work of >Villard de Honnecourt.

WAR ARTISTS

The depiction of war has long attracted >artists, from >Greek metopes and Hellenistic battle >sarcophagi through to Trajan's Column, Titian, and Goya's memorable paintings and >prints of events connected with the Peninsular Wars. Usually, however, the depiction was not a result of the artist's attendance at the events, but a >stylized version of them often based on heroic traditions. This changed with >Romanticism's love affair with blood, death and disease, so that Napoleon's campaigns offer the first chink in the façade praising the heroic rectitude of >battle art. The criticism and depiction of war and its effects is frequent in the work of 19th-century satirists (cf. Daumier). Only with the First World War, however, do we find both sides of the mirror, namely on the one side the straightforward reportage (with little heroism on view) of the war by officially commissioned war artists, and on the other, the artists' running dialogue with themselves, critical of the war.

● Matthias Eberle, World War 1 and the Weimar Artists: Dix, Grosz, Beckmann, Schlemmer (1985); Michael R. D. Foot, Art and War: Twentieth-Century Warfare as Depicted by War Artists (1990); Nigel Viney, Images of Wartime: British Art and Artists of World War 1 (1991).

WARBURG, ABY

(1866–1929). German art historian. The son of a banker, his personal wealth allowed him to pursue his studies in the >Classical tradition outside the constraints of institutional >art history. He sought to understand the reasons for the survival of >Classicism into the >Renaissance by looking not just at stylistic (>style) questions but at a whole range of social, intellectual and cultural practices. Indeed, Warburg was opposed to fencing off disciplines and always argued for an interdisciplinary approach. Warburg published little, but his influence on younger historians such as Ernst >Cassirer, Fritz >Saxl and Erwin >Panofsky was considerable. His large library became the >Warburg Institute, first in Hamburg, then after the rise to power of the Nazis, in London.

● Kurt Forster, 'Aby Warburg's History of Art: Collective Memory and the Social Mediation of Images', Daedalus, 105 (1976), pp. 169–76; E. H. Gombrich, Aby Warburg: An Intellectual Biography (1970; 1986); A. Warburg, Gesammelte Schriften (1932).

WARBURG INSTITUTE

London. Founded by Aby >Warburg in Hamburg with the help of Fritz >Saxl. It originated with Warburg's large library, which he, as a scholar of independent means,

had built up around his studies on the survival of the > Classical tradition. In 1933, four years after Warburg's death, Saxl moved the Institute to London to avoid Nazi persecution. In 1944 it was incorporated into the University of London. It remains a centre for the study of the history of the Classical tradition.

● E. H. Gombrich, *Aby Warburg: An Intellectual Biography* (1970; 1986); E. H. Gombrich (intro), F. Saxl, A *Heritage of Images: A Selection of Lectures*, ed. H. Honour and J. Fleming (1970), pp. 9–12.

WASH *See* Pen and wash.

WATERCOLOUR

Watercolour > paint is a water-soluble > pigment, bound (> binder) with gum arabic and laid on to a > support, which is generally > paper but may be papyrus, silk, rice-paper or parchment. True watercolour painting does not use white > body colour (an opaque pigment) to indicate light areas, but allows the whiteness of the paper to shine through where desired. As early as the late 15th century > Dürer used watercolour for > landscape > sketches, as well as in such a technical *tour de force* as *Young Hare* (1502). In the 16th and 17th centuries monochrome washes, often combined with > drawing with a pen, were popular (> pen and wash). > Artists of the > Italian > Baroque, as well as > Dutch > landscape artists, used the technique. However, the flowering of watercolour took place in England during the 18th and 19th centuries in the work of Paul Sandby, Cozens, Girtin, Turner and the > Norwich School painter John Sell Cotman. Acceptance of the > medium as the equal, at least in Britain, of > oil painting, was indicated by the founding of the Old Watercolour Society in 1804. While it has never played an important part in Continental > schools, the tradition of watercolour painting continued in England into the 20th century in the work of Steer, Nash, Sutherland and Piper.

● A. Bury, *Two Centuries of British Watercolour Painting* (1950); M. Hardie, *Water-Colour Painting in Britain*, 3 vols. (1966–68).

WET INTO WET

The application of > paint on to a layer of paint which is itself wet. Most frequently seen in > oil painting, the technique is admirably demonstrated in the rapid, > sketch-like brushstrokes of the > Impressionists.

WINCKELMANN, JOHANN JOACHIM

(1717–68). German librarian and scholar, who laid the theoretical foundations for > Neoclassicism in his books, especially *Reflections on the Imitation of the Ancients* (1755) and *History of Ancient Art* (1764). His friendship with the painter Anton Raffael Mengs gave

them a test bed for his theories and together they promoted an attenuated > Classicism that they thought they found in > Greek art, following an > ideal of 'calm simplicity and noble grandeur', which Winckelmann saw – most curiously – in the > *Laocoön*. One of the ironies of > art history is that Winckelmann knew few Greek works, but intuited their characteristics from those he wanted to see in > Roman > imitations; and he never got to Greece (despite several opportunities) to find out the truth for himself.

• Leopold Ettlinger, 'Winckelmann', in *The Age of Neoclassicism*, exhibition catalogue, London (1972), xxx–xxxiv; Carl Justi, *Winckelmann und seine Zeitgenossen* (reprint 1983); Wolfgang Leppmann, *Winckelmann* (1970).

WITTKOWER, RUDOLF

(1901–71). German > art historian. Wittkower's brilliant academic career began in Berlin (PhD 1923). He was research fellow at the Biblioteca Hertziana in > Rome from 1923 to 1933, on the staff of the > Warburg Institute from 1934 to 1956, reader and then Durning-Lawrence Professor at the University of London, 1945 to 1956, and became Chairman of Fine Arts and Archeology at Columbia University, New York, in 1956, the post from which he retired in 1969. He was Kress Professor at the National Gallery of Art in Washington from 1969 to 1970, Slade Professor at Cambridge 1970–71, and member of the Institute of Advanced Studies at Princeton. His books include *Gian Lorenzo Bernini* (1955), *Art and Architecture in Italy 1600–1750* (1958), and with his wife Margot Wittkower, *Born Under Saturn: The Character and Conduct of Artists* (1963).

WÖLFFLIN, HEINRICH

(1864–1945). > Art historian, born Winterthur, Switzerland, whose > formalist theories have proved both enduring and popular. He succeeded > Burckhardt in the Chair of Art History at Basle in 1893, then moved to the Chairs of Art History at Berlin in 1901, Munich 1912 and Zurich in 1924. Wölfflin wrote his first book, *Renaissance und Barock*, when he was 24 (trans. *Renaissance and Baroque*, 1964), and *Die klassische Kunst* (Classic Art) in 1899 (translated into English as early as 1903). With these two books he established an art history as the history of > styles. This 'art history without names' was most cogently formulated in *Kunstgeschichtliche Grundbegriffe* (1915), translated into English as *Principles of Art History* in 1932. Wölfflin posited the idea of an autonomous art history that is not dependent on any one, or any set, of particular works of art; rather the particular works may stand as examples of the style. As he wrote in *Renaissance and Baroque*, 'It is not the business of the historian of style to give a detailed account of the whole treasury of artistic activity or to treat in detail of the work of individuals'. In practice this meant that he could ascribe to a given period any characteristics he believed significant without being troubled by the facts.

As L. D. Ettlinger has noted in connection with Wölfflin's approach: 'The individual work of art and all its qualities became submerged in something larger. Instead of being apprehended as a result of a concrete task and a personal creative act, it became the expression of an inescapable super-individual force.' Wölfflin sought the big picture, to account in general terms for artistic development from the > Renaissance to the

> Baroque without descending into detail. To accomplish this he posited in *Principles* a series of visual oppositions between Linear and > Painterly, Plane and Recession, Closed and Open Form, Multiplicity and Unity, and Clearness and Unclearness. An example of this would be the linearity of a > nude by Dürer against the painterly approach of Rembrandt; the stylistic opposition would be present even when > drawings by the two artists were compared.

Wölfflin's approach is formalism to the exclusion of other factors that could have direct bearing on the > meaning of the art work. > Iconography is nowhere discussed in his works, often to the detriment of his argument. While formalists such as > Fry and > Bell privileged > form as the central fact of painting, Wölfflinn's formalism was so much a structuring element in his method as to preclude discussion of subject-matter, thereby weakening his entire approach. However, Wölfflin's place in art history is secure as he established a new > methodological rigour in a discipline that suffered, and continues to suffer, from the indiscreet mixing of history and > aesthetics.

● Joan Hart, 'Reinterpreting Wölfflin: Neo-Kantianism and Hermeneutics', *Art Journal*, 42.2 (1982), pp. 292–300; L. D. Ettlinger, 'Art History Today', inaugural lecture delivered at University College, London (1961); H. Wölfflin, *Renaissance and Baroque*, trans. K. Simon, intro, P. Murray (1964; 1966); *Principles of Art History: The Problem of the Development of Style in Later Art*, trans. M. D. Hottinger (1932; 1950).

WOMEN ARTISTS *See* Feminist art

WOOD CARVING

Used as a > medium since at least the Bronze Age and probably earlier, although little has been preserved. When used for figures, the practice since at least the third millennium BC in > Egypt has been to coat the carved figure with > stucco and add brilliant > paint, and many such figures and figurines have survived there, thanks to the dry climate. The > Archaic > Greeks and the Celts used wood alongside > terracotta for votive figures (see the mannikins from the source of the Seine, in Dijon), and wood covered with > ivory, gold, silver and other materials (the chryselephantine technique) often formed their cult statues, as it did some of those of the > Romans. In > Christian art, wood has a longer history than > marble or (probably) > bronze for statue groups of holy figures, annunciations and the like, and survives in use to this day (cf. Barlach). It was especially useful because it was light and easy to piece together, thereby allowing the Crucified Christ to be taken down from the Cross, His arms folded and laid in the tomb, and statues of the Virgin to be dressed in finery and a crown, their apparel changed according to the liturgical calendar. They could also be conveniently carried in processions. Such figures were venerated as the instigators of many miracles. Again, we may assume that churches unable to afford sumptuous bronze doors had them made in wood instead. Those of Sta Sabina in Rome (5th century), of cypress wood, are a priceless guide to contemporary > iconography.

Wood sculpture has always addressed the poorer market, but it could not be used outside, unlike terracotta, marble and bronze, as well as other 'artificial' inventions of the 18th century such as Coade stone.

● Ilene H. Forsyth, *The Throne of Wisdom: Wood Sculptures of the Madonna in Romanesque France* (1972); Deborah P. Strom, *Studies in Quattrocento Tuscan Wooden Sculpture* (1979).

WOODCUT

This entry is restricted to the strict definition of woodcut. See > engraving, > etching, > drypoint and > lithograph for the other main techniques, and > print for the importance of these media (> medium) in the art world.

Woodcut is a > relief technique where the areas of a wooden block to be printed are left alone, and the areas to print white are excavated with a knife. The main difficulty with the technique is getting sufficiently subtle detail and hence expression: the thinner the line, the less time it is likely to last; > cross-hatching is difficult to excavate and construct; and > bravura strokes such as one finds in > etching are completely out of the question. For these reasons, woodcut is rarely (but see below) a medium for > original art work. Technicians did not trust blocks much larger than octavo, because the larger the block, the more likely it was that the wood would split or warp, making it unsightly or difficult to print, although fairly large > compositions could be constructed from a number of blocks.

On the plus side, woodblocks accorded very well with typeset pages. Both were relief techniques, and the usually small woodcut blocks could easily be shuffled into place with the type around them and printed together at the same pressure. Treated carefully, such blocks were very long-lasting, so much so that 15th-century printers were somewhat cavalier about which blocks they used in which contexts, so that blocks with a certain subject, say a head of King David, might be blithely reused some years later, perhaps to represent Charlemagne. Because of cutting difficulties, any captions would usually (but not always) be added afterwards in metal type. In many early woodcuts, the effect would be improved by colouring, which was done by hand with a > brush.

Although the > Chinese had been using woodcut for centuries to print money, and the Koreans in the 13th century had cut the text of > Buddhist scriptures on no fewer than 81,258 blocks (the famous Tripitaka Koreana, in Haein-sa Temple), the first Western woodcuts seem to date from the early 15th century, and are single-sheet devotional images, probably sold cheaply, perhaps at fairs and markets.

Because of the apparent crudity of the technique, few 'original' artists were attracted to use and develop the woodcut, although there were exceptions. Dürer, who was very publicity-minded, fully grasped how he might make money by linking woodcut to printing by illustrating well-known texts, as he did with his *Apocalypse*. Surely intentionally, he used the non- > realistic and > formalistic features of the medium to conjure up the other-worldly, dreamlike ambience of St John's vision – an achievement nobody else could match.

The > 'chiaroscuro woodcut' was another attempt to improve the subtlety of woodcut, perhaps first practised by Ugo da Carpi (*c.*1480–*c.*1525). This introduction of 'mechanized' > colour was achieved by pushing the technique to incorporate tone – indeed, a whole variety of shades and colours – by designing a series of blocks, one for the lines and others for the tones. By astute selection, intermediate tones could be achieved by overprinting one tone block with another. The whole process depended on the registration of the various blocks, but the results were worth the effort, for the effect of > pen and wash > drawings was obtained, transforming the technique into

something artists such as Goltzius and Parmigianino could use to produce original work.

● Walter Chamberlain, *The Thames and Hudson Manual of Woodcut Printmaking and Related Techniques* (1978); Arthur M. Hind, *An Introduction to a History of Woodcut with a Detailed Survey of Work Done in the Fifteenth Century* (1963).

WOOD ENGRAVING

A technique of > printmaking that uses boxwood cut across the grain, which when cut with an > engraving tool, will take very fine lines. Whereas in engraving the incised lines are filled with > ink and print black, in wood engraving the ink is retained on the surface, the incised lines printing white. In effect, therefore, this is a > relief, not an > intaglio, technique, and the blocks can therefore be keyed in to the typeset page for printing. The first master of the technique was Thomas Bewick, who produced numerous book illustrations, but it has continued to thrive into the 20th century, and is much used by artists working for private presses.

● Walter Chamberlain, *The Thames and Hudson Manual of Wood Engraving* (1978); Albert Garrett, *A History of Wood Engraving* (1986).

WORKSHOP

A name for the > studio of an > artist, particularly in pre-High > Renaissance art practice. In the language of > connoisseurship, 'workshop of' refers to an art work from the intimate circle of the studio head – perhaps by an apprentice or assistant – but not considered to be by the hand of that artist. However, there is some danger in making too categorical a distinction between workshop and artist, especially when considering > craft-oriented > guild production. Artists up to and including the 15th century habitually produced work on a collaborative basis, which, given the range of skills required, from > gilding through to > woodcarving, was a necessity. Even post-Renaissance artists such as > Rubens and > Reynolds frequently involved assistants for at least part, sometimes the greater part, of a painting.

Y

YAMATO-E

A > school of Japanese > scroll painting (e-makimono). It originated in Chinese T'ang dynasty painting and included > landscape, > genre and > narrative subjects (monogatari-e). It flourished from the 11th to the 14th century. The scrolls, about 12 inches high and often in excess of 30 feet in length, are unrolled in sections from right to left, thereby unfolding a narrative often painted in a lively and engaging > manner, as in *The History of Mount Shigi* (Fugiwara period, 897–1185).

● D. Seckel, *E-makimono* (1959); P. Swann, *Art of China, Korea and Japan* (1963).

Z

ZEITGEIST

The 'spirit of the age', which, according to > Hegel, ensures a similar complexion in all the activities of a period, from art and science to literature and music.

● Ludwig Fertig, *Zeitgeist und Erziehungskunst: Eine Einfuhrung in die Kulturgeschichte der Erziehung in Deutschland von 1800 bis 1900* (1984).

ZOLA, ÉMILE

(1840–1902). French > Realistic novelist in the tradition of Balzac, and pioneering social reformer, famous for his intervention in the Dreyfus case in 1898. He was just as robust a champion of contemporary· > avant-garde art; see, for examples *Mes Haines*, which contains his famous dictum that a work of art is 'a corner of creation seen through a temperament', *Mon Salon* (1866) and *Edouard Manet* (1867).

● Anita Brookner, *The Genius of the Future. Studies in French Art Criticism: Diderot, Stendhal, Baudelaire, Zola, the Brothers Goncourt, Huysmans* (1971).